D0893631

MEDUSA'S GAZE

Emblems of Antiquity

Font of Life
Ambrose, Augustine, and the Mystery of Baptism
Garry Wills

Medusa's Gaze
The Extraordinary Journey of the Tazza Farnese
Marina Belozerskaya

Medusa's Gaze

THE EXTRAORDINARY JOURNEY OF THE *TAZZA FARNESE*

MARINA BELOZERSKAYA

OXFORD
UNIVERSITY PRESS

OXFORD
UNIVERSITY PRESS

Oxford University Press is a department of the University of Oxford. It furthers
the University's objective of excellence in research, scholarship, and
education by publishing worldwide.

Oxford New York
Auckland Cape Town Dar es Salaam Hong Kong Karachi
Kuala Lumpur Madrid Melbourne Mexico City Nairobi
New Delhi Shanghai Taipei Toronto

With offices in
Argentina Austria Brazil Chile Czech Republic France Greece
Guatemala Hungary Italy Japan Poland Portugal Singapore
South Korea Switzerland Thailand Turkey Ukraine Vietnam

Published in the United States of America by
Oxford University Press
198 Madison Avenue, New York, NY 10016, United States of America

www.oup.com

Oxford is a registered trademark of Oxford University Press
in the UK and in certain other countries

Library of Congress Cataloging-in-Publication Data
Belozerskaya, Marina, 1966–
Medusa's gaze: the extraordinary journey of the Tazza Farnese /Marina Belozerskaya.
pages cm—(Emblems of antiquity)
Includes bibliographical references and index.
ISBN 978-0-19-973931-8
1. Tazza Farnese. 2. Cameos, Classical. 3. Tazzas. I. Title.
NK5722.B45 2012
736'.2220932—dc23 2012000620

1 3 5 7 9 8 6 4 2

Printed in the United States of America
on acid-free paper

Antique gem carvings, because of their precious material and work-manship, and their easily portable character, have frequently more adventurous and romantic histories than other objects of art. It is only in rare instances, however, that one may trace with any degree of con-tinuity the wanderings of some particular gem, previous to its appear-ance in the great collections of the eighteenth and nineteenth centuries.

Marvin Chauncey Ross

("The Rubens Vase, its history and date." *JWAG* 1943)

Contents

CONTENTS

Acknowledgments

———

Among the many pleasures of writing a book, especially one ranging across time and geography, are the opportunities to meet and to talk to colleagues in a variety of fields, to learn from them, and to receive their generous help. I have been fortunate in many such encounters and am happy to acknowledge my debts and gratitude: to Maria Rosaria Borriello and Valeria San Paola for making my research possible at the Naples Archaeological Museum; to Lorenzo Lazzarini for discussing hard-stones with me; to Chavdar Chushev for teaching me about gem carving; to Jerry Podany and Erik Risser for educating me about restoration techniques; to John Boardman and Dimitri Plantzos for sharing their expertise on ancient gems; to Michael Vickers for stimulating discussions of ancient luxury arts and a detailed critique of the manuscript; to Gertrud Platz for imparting to me her knowledge of classical gems and their afterlife; to Susan Walker for help with Cleopatra as well as an invitation to share my research on the *Tazza* at the Timurid courts in Oxford; to Barry Flood for advising me on the Timurid material; to Adrienne Mayor for discussing Mithradates with me; to Xavier Salomon for his thoughts on Barbo's and Trevisan's ownership of the *Tazza*; to Clare Robertson for talking to me about the Farnese and to Giuseppe Bertini for sharing his findings on Margaret of Austria's inventories; to Jeffrey Collins for assistance on antiquities at the Vatican; to Louis Marchesano for elucidating

the Morghen album to me; to David Connell for introducing me to the fascinating William Dugood and kindly providing me with images of his *Tazza* replicas; to Elena Arsentieva for looking for the *Tazza* cast at the Hermitage; to Melissa Hamnett for discussing with me the V & A *Tazza* bronze cast; to Lucia Pirzio Biroli Stefanelli for clarifying the cast-making activities of Bartolomeo Paoletti; to Claire Lyons for alerting me to the Morghen album; to Pablo Vazquez-Gestal for sending me his work on Bourbon Naples; and to Peter Bonfitto for helping me track down and photograph a number of rare books.

Three people have been particularly big-hearted as I investigated the fate of the *Tazza* in nineteenth- and early twentieth-century Naples: Andrea Milanese unhesitatingly offered his expertise and help; Maria Rosaria Esposito combed the archives at the Naples Archaeological Museum for materials that shed light on the Aita story; and Mark Walters translated for me Aita's letter from prison, located at the State Archives by Ferdinando Salemme. The sad last chapter of the *Tazza* would have been impossible without them.

The book as a whole had a number of supporters who helped usher it into the world. My agent Rob McQuilkin encouraged it from the start and was instrumental in shaping the initial vision. My editor at Oxford, Stefan Vranka, enthusiastically signed it on and honed it through his thoughtful reading. Sarah Pirovitz took care of production logistics with remarkable efficiency and good cheer. Richard Hull and TAA generously helped with the image subsidy. Gary Berleth ably copyedited the manuscript, and Karen Kwak and Marian John Paul oversaw the production process. But I would not have undertaken this saga in the first place without Ken Lapatin, who first urged me to write about the *Tazza*, taught me all he knew about it, discussed the various twists of the story with me, showered me with useful books and articles, took photographs for me, and improved the text at every stage. I dedicate the book to him unreservedly and lovingly.

List of Illustrations

LIST OF ILLUSTRATIONS

LIST OF ILLUSTRATIONS

Cast of Major Characters

In order of appearance:

Cleopatra VII (69–30 BC)—Queen of Egypt
Julius Caesar (100–44 BC)—Roman statesman and lover of Cleopatra
Marc Antony (83–30 BC)—Roman general and lover of Cleopatra
Octavian, later **Augustus** (63 BC–AD 14)—Caesar's heir and first Roman emperor
Mithradates VI (134–63 BC)—King of Pontus
Photios I (ca. 810–ca. 893)—Patriarch of Constantinople
Basil I, Macedonian (830/835–886)—Byzantine emperor
Constantine VII Porphyrogenitus (905–959)—Byzantine emperor
Suger (1081–1151)—Abbot of Saint Denis, French historian and art patron
Frederick II Hohenstaufen (1194–1250)—Holy Roman Emperor
Timur (1336–1405)—Conqueror of Central Asia
Ahmed ibn Arabshah (1389–1450)—Syrian historian
Shahrukh (1377–1447)—Son of Timur, ruler of Herat
Baysunghur (1397–1433)—Grandson of Timur, son of Shahrukh
Alfonso of Aragon (1396–1458)—King of Spain and Naples
Ludovico Trevisan (1401–1465)—Cardinal and Captain General of the Church
Pietro Barbo (1417–1471)—Pope Paul II

Lorenzo de' Medici (1449–1492)—Ruler of Florence

Alessandro de' Medici (1510–1537)—Ruler of Florence

Margaret of Parma (1522–1586)—Wife of Alessandro de' Medici and Ottavio Farnese

Charles V Habsburg (1500–1558)—Holy Roman Emperor, father of Margaret of Parma

Alessandro Farnese (1468–1549)—Pope Paul III

Alessandro Farnese (1520–1589)—Cardinal and art patron, grandson of Paul III

Giovanni Bernardi (1494–1553)—Italian Renaissance artist and gem engraver

Fulvio Orsini (1529–1600)—Renaissance scholar and collector, Cardinal Farnese's secretary

Peter Paul Rubens (1577–1640)—Flemish Baroque artist and antiquarian

Philipp von Stosch (1691–1757)—Prussian antiquarian and spy

William Dugood (fl. 1715–1767)—Scottish jeweler and spy

Charles of Bourbon (1716–1788)—King of Naples and the Two Sicilies, later of Spain

Johann Wolfgang von Goethe (1749–1832)—German writer and polymath

Maria Amalia of Saxony (1724–1760)—Queen of Naples, wife of Charles of Bourbon

Johann Joachim Winckelmann (1717–1768)—German art historian and archaeologist

Filippo Morghen (1730-ca. 1807)—Engraver to Charles of Bourbon

Ivan Grigoryevich Chernyshov (Czernicheff) (1726–97)—Russian admiral and diplomat

Scipione Maffei (1675–1755)—Italian litterateur and archaeologist

Ennio Quirino Visconti (1751–1818)—Papal Prefect of Antiquities

Catherine the Great (1729–1796)—Empress of Russia

Bartolomeo Paoletti (1757–1834)—Roman gem engraver

Ferdinand I Bourbon (1751–1825)—King of Naples and the Two Sicilies

Maria Carolina of Austria (1752–1814)—Queen of Naples, wife of Ferdinand I

Salvatore Aita (1882–?)—Night watchman at the Naples Archaeological Museum

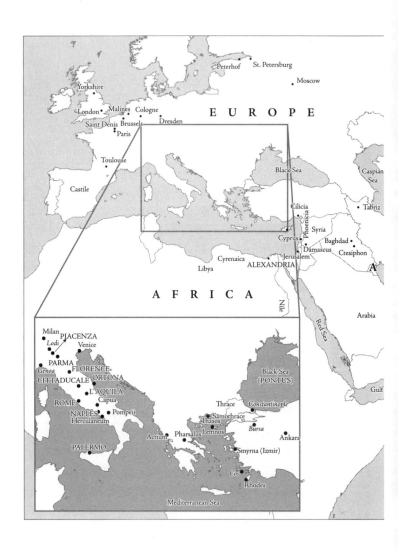

E U R O P E

Peterhof
St. Petersburg
Moscow
Yorkshire
London
Malines Cologne
Saint Denis Brussels
Paris
Dresden
Toulouse
Black Sea
Caspian Sea
Castile
Cilicia
Tabriz
Cyprus
Phoenicia
Syria
Damascus
Baghdad
Ctesiphon
Cyrenaica
Jerusalem
A
Libya
ALEXANDRIA
Arabia
A F R I C A
Nile
Red Sea
Gulf

Milan
PIACENZA
Lodi
Venice
PARMA
Genoa
FLORENCE
ORTONA
CITTADUCALE
L'AQUILA
ROME
Capua
NAPLES
Pompeii
Herculaneum
Actium
Pharsalus
PALERMO

Black Sea
(PONTUS)

Thrace
Constantinople
Samothrace
Thasos
Bursa
Lemnos
Ankara
Smyrna (Izmir)
Cos
Rhodes
Mediterranean Sea

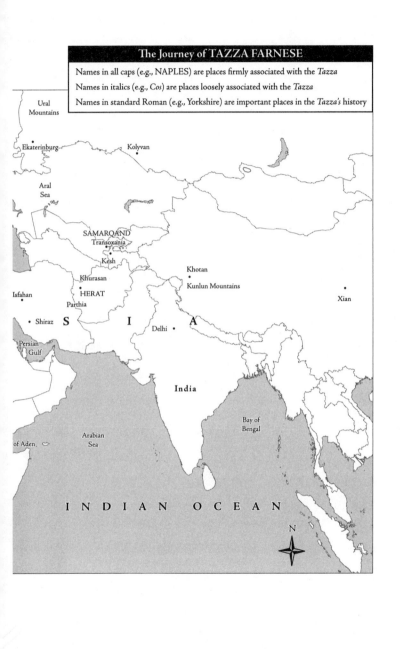

The Journey of TAZZA FARNESE

Names in all caps (e.g., NAPLES) are places firmly associated with the *Tazza*

Names in italics (e.g., *Cos*) are places loosely associated with the *Tazza*

Names in standard Roman (e.g., Yorkshire) are important places in the *Tazza's* history

Ural
Mountains

Ekaterinburg

Kolyvan

Aral
Sea

SAMARQAND
Transoxania

Kesh

Khotan

Khurasan

Kunlun Mountains

Isfahan

HERAT

Parthia

Xian

Shiraz S I A

Delhi

Persian
Gulf

India

Bay of
Bengal

of Aden

Arabian
Sea

I N D I A N O C E A N

N

MEDUSA'S GAZE

INTRODUCTION

Dealing with antiques, there are places where history
stops, then picks up again. The person who buys them
will make up another story.

<div align="right">—Jeweler Fred Leighton[1]</div>

Once the prized possession of the mightiest of rulers, the
Tazza Farnese (figs. I-1 and I-2)—a banded agate bowl
nearly 22 cm (8.5 in.) in diameter, with figures inside and outside
probably carved in the first century BC—is known today only to
specialists. A preeminent masterpiece for two millennia, it has
fallen into relative obscurity as taste has shifted from incised
gems to paintings that now dominate museum walls. Ancient,
medieval, Renaissance, and early modern collectors prized
cameos and intaglios as foremost works of art, competing fer-
vently to acquire them. These days the *Tazza* is less well known—
even to ancient art historians—than Greek pots, such as the
Euphronius krater, or broken marble statues, such as the Venus
de Milo. It appears fleetingly in art history books and excites

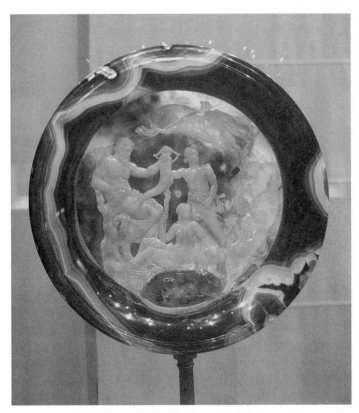

Figure I-1. Tazza Farnese, sardonyx cameo bowl, interior.

arcane scholarly debates about its origins and imagery. Most people have never heard of it. And even experts are not aware of its remarkable history.

Yet for most of its life the *Tazza* has been an irresistible magnet for Greek rulers, Roman, Byzantine, and Holy Roman Emperors, cardinals and popes, kings and queens, and even a Mongol conqueror. Lorenzo de' Medici valued it immeasurably higher than any other of his artworks. It aroused the lust of dignitaries of church and state, consoled a heartbroken duchess, inspired major artists,

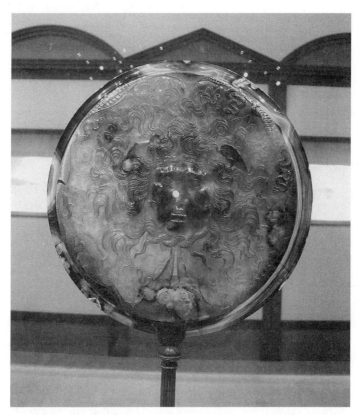

Figure I-2. Tazza Farnese, exterior.

tempted spies and thieves, and drew the ire of a mad museum guard
who nearly destroyed it.

Before setting out to recount this extraordinary odyssey, I had
seen photos of the *Tazza* in various books, and though it certainly
looked beautiful, I did not quite understand why it prompted so
much passion. But the first time I saw it in person, I could not tear
myself away. It was infinitely more gorgeous, majestic, and mesmer-
izing than the best photographs conveyed. Entranced, I scrutinized
over and over its minutest details, the confluences of carved lines

and colored veins, the radiance of sardonyx, the tangible presence of the opalescent figures against the honeyed background. Coming face to face with the *Tazza*—the way its owners did over the centuries— I understood viscerally why they became besotted with it and spent enormous sums to make it theirs. I felt that urge myself, expressed in my desire to buy as many postcards of the bowl in the museum shop as possible, along with two posters and the catalogue in which it was reproduced—as if this accumulation of images might somehow add up to the gem itself and allow me to take it home.

In the following pages, I try to recapture something of that sense of wonder and greed that the *Tazza* incited in those who were able to own it. It is people who give objects life, and it is the *Tazza*'s owners who gave it its shifting meanings. So in each chapter I attempt to bring to life the men and women through whose hands the *Tazza* passed and the settings in which they lived, struggled, and dreamt.

While we can account for many of the *Tazza*'s proprietors, there are also huge gaps when we lose sight of it entirely and can only guess at what became of it. The missing links both frustrate and spur the imagination. The suppositions I offer, some of them contradictory, are based on what we know about the times, places, and people with which the *Tazza* intersected, and I supplement the few facts we have with as much circumstantial information as possible in order to flesh out its saga. The book is, thus, a cultural history of the vessel, and I seek to reconstruct the locations it inhabited, the characters it enthralled, and the significance it held for them. The earliest chapters—when the *Tazza* was first made and used by those most familiar with its imagery and the politics behind it—are, ironically, the most speculative. We simply do not have the kind of binding evidence that would answer our questions. Though tentative, these sections aim to present a panorama of the ancient world that gave rise to this spectacular object and others like it. I propose a number of scenarios by which the *Tazza* may have moved from Alexandria, where it was almost certainly

created, to Rome and then Byzantium where it likely ended up for several centuries, before reappearing briefly in Southern Italy and intriguingly in Central Asia. From the mid-fifteenth century on we are on firmer ground and can trace the *Tazza*'s movements with clarity as it passed through the hands of Pope Paul II, Lorenzo de' Medici, Margaret of Austria, the Bourbon Kings of Naples, and into the Naples Museum where it resides today.

Throughout its journey the bowl has lived through momentous historic events, and they, too, add depth and drama to its story. The *Tazza* likely witnessed the rise and fall of Cleopatra; the sack of Constantinople by Christian knights in 1204; the flowering of the arts in Timurid Samarqand and Herat, and in Renaissance Naples and Florence; the rediscovery of Pompeii and Herculaneum; the turbulent aftermath of the French Revolution; and the birth of the modern Italian state. It is amazing that no one has until now told the full story of the *Tazza*'s long and colorful life.

1

CLEOPATRA'S ARTIFICE

When Caesar's favor was gained and bought by mighty
gifts, so joyful an event was followed by a feast; great was
the bustle, as Cleopatra displayed her magnificence—
magnificence which Roman society had not yet adopted.
—Lucan, *Pharsalia*, 10.107–110

I
n the fall of 48 BC Julius Caesar hurried to Egypt to finish off
his rival, Pompey the Great, having defeated his army a few
weeks earlier at Pharsalus in central Greece. Pompey had fled to
Egypt hoping to receive help from King Ptolemy XIII, whose
father, Ptolemy XII Auletes, had been in his debt. But the moment
Pompey set foot on the Egyptian shore, he was murdered by agents
of the young king. His head was cut off and saved for Caesar,
expected to arrive at any time. Caesar appeared four days later, but
was not pleased with the gruesome gift. Marching on Alexandria,
he occupied the royal palace and summoned the king and queen of
Egypt to come before him.

Ptolemy XIII was not the country's sole ruler, not at least so
far as his sister Cleopatra VII was concerned (fig. 1-1). Although

exiled from the capital, she was readying her troops to contest her right to the throne. Learning of Caesar's arrival, she decided to enlist his assistance. She could not easily appear at the royal palace. So, according to the ancient historian Plutarch, she devised a stratagem. Taking along her faithful courtier Apollodoros the Sicilian, she rowed up to the palace in a small boat in the dark. Since she could not enter unobserved, she stretched herself at

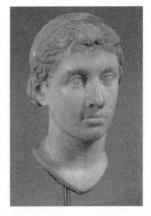

Figure 1-1. Cleopatra VII, marble head, ca. 50–30 BC.

full length inside a sleeping bag, and Apollodoros thus brought her in to Caesar. "This little trick of Cleopatra's, which showed her provocative impudence, is said to have been the first thing about her which captivated Caesar, and, as he grew to know her better, he was overcome by her charm and arranged that she and her brother should be reconciled and should share the throne of Egypt together."[1]

Whether Cleopatra indeed put on such a show for Caesar, making a dramatic appearance and pretending to tear her hair in grief over her situation, or she impressed him with her acute intelligence, the fifty-two-year-old general with a long career of military and amorous conquests—"his affairs with women are commonly described as numerous and extravagant," wrote the historian Suetonius—was clearly taken with the twenty-one-year-old queen.[2] Caesar was, in Suetonius's description, tall and well-built, with a broad face and sharp brown eyes (fig. 1-2). A dandy, he was always carefully groomed. He covered up his baldness—on which his enemies harped, to his exasperation—by combing it over with his remaining hair, "and of all the honors voted him by the Senate and People, none

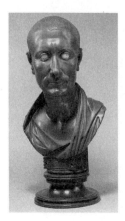

Figure 1-2. Julius Caesar, green basanite bust, ca. 1–50.

pleased him so much as the privilege of wearing a laurel wreath on all occasions—he constantly took advantage of it."[3] Though vain, Caesar was an astute politician. He had good reason to side with Cleopatra's brother, who was backed by the Egyptian army and political leadership. But he realized that Cleopatra would make a useful and clever ally, her ambitions being broader and her need of Roman cooperation greater.

Cleopatra was a remarkable woman.[4] Forced to navigate between perilous court intrigues and the encroachment of Rome, she skillfully put to use the resources at her command: the riches of Egypt, her sharp mind, and her personal magnetism. She was not incomparably beautiful. The few surviving portraits show her with a hooked nose and over-large mouth. But she possessed:

> an irresistible charm, and her presence, combined with the persuasiveness of her discourse . . . had something stimulating about it. There was sweetness also in the tones of her voice; and her tongue, like an instrument of many strings, she could readily turn to whatever language she pleased, so that in her interviews with Barbarians she very seldom had need of an interpreter, but made her replies to most of them herself and unassisted, whether they were Ethiopians, Troglodytes, Hebrews, Arabians, Syrians, Medes or Parthians.[5]

She was said to take sensuous pleasure in learning.[6]

Returned to power with Caesar's help, Cleopatra threw him a feast of such opulence as the Roman had never seen—to celebrate her restoration and to impress him with her worthiness. The poet Lucan, though likely exaggerating somewhat, conveyed the spirit of Ptolemaic royal splendor as he gushed that the reception hall had a golden ceiling, marble walls, alabaster floors, agate and porphyry adornments, and ebony doors inlaid with ivory and tortoise shell. Purple and scarlet couch coverings glimmered with gold embroidery and inset gems. Jasper dishes made the tables groan. Slaves of all nationalities proffered delicacies gathered from the earth, air, and sea. Guests washed their hands with water flowing from crystal pitchers and drank wine from bejeweled goblets. And Cleopatra herself bore a fortune in pearls draped around her neck and woven into her hair.[7] The poet thought Cleopatra mad to display such riches to the general of a conquering army. She saw it as a worthy risk.

Cleopatra had to persuade Caesar that she would make a valuable partner to Rome. Despite her kingdom's economic turmoil, both in her own day and in the reigns of her predecessors, Egypt's annual surplus remained enormous. Her father, Ptolemy XII Auletes, had been fleeced by the Romans and strapped by financial crises, yet he staggered onlookers by the lavishness of a banquet he threw for Pompey the Great in 63 BC. Cleopatra's wealth far exceeded that of any contemporary country. And she used it to show Caesar that her kingdom could be a profitable ally to Rome—and not its servant—if he helped her attain her aims.

The queen dreamt of restoring the Ptolemaic empire to its former greatness. Under her distant ancestors, in the third century BC, Egypt had been a mighty kingdom, founded by Ptolemy I, companion to Alexander the Great, and extending its reach and influence far beyond its borders. But by mid-first century BC, through the steady advance of Rome, it had lost most of its overseas possessions: Phoenicia, Palestine, Cyrenaica in Libya, Cyprus, and the Greek islands. When Cleopatra ascended the throne in

51 BC, together with Ptolemy XIII, her brother, co-ruler, and husband (royal brother-sister marriages being an Egyptian custom, regardless of the age of the parties—Cleopatra was then seventeen, her brother ten), she faced a tangle of challenges, of which the greatest was balancing her relationship with her Egyptian subjects against that with Rome. Miscalculations in domestic politics would give her brother and his supporters a chance to oust her. Disagreements with Rome could precipitate an invasion. Too eager an acquiescence to Roman demands would arouse the ire of the Alexandrian mob and lead to her expulsion from the city, as had happened to her father. Cleopatra began her reign by securing the economic well-being of her country. Then she turned her sights to regaining the territories lost by her predecessors. She realized that to achieve this goal, she needed the assistance of Rome, but offered on fair terms. In putting on a spectacular feast for Caesar, she showcased the resources she could share with him in exchange for his support.

It is possible that among the objects with which Cleopatra dazzled her guest was a striking sardonyx phiale (a libation bowl) carved on the outside with the head of Medusa and within with an assembly of gods (fig. 1-3). This object would later come to be called the *Tazza Farnese*.[8] But not before it would experience a rich and turbulent history.

No documents detailing Cleopatra's treasury survive, so we cannot demonstrate that the *Tazza* was in her possession. Yet its style, quality, and subject matter all suggest that it was likely made for and used at the Ptolemaic court. The date of the bowl's manufacture is debated by scholars. Some, comparing its shape to that of more numerously preserved metal vessels, argue that it was created as early as the third century BC. Others see it as Roman, made after the conquest of Egypt. Still others adduce technical, aesthetic, and historical reasons for the *Tazza*'s manufacture at the time of Cleopatra's father, or of the queen herself.[9]

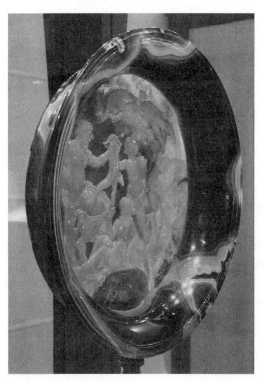

Figure 1-3. Tazza Farnese, side view.

An Alexandrian origin of the *Tazza* is most probable, based on the imagery and the quality of the piece. Artworks made in the Ptolemaic capital tended to display superb craftsmanship, and cameo carving was one of the city's specialties and the court's prized art forms. Ptolemaic rulers immortalized themselves in cameo portraits; and a number of sardonyx vessels have been found in Egypt, though none are decorated with designs in relief.[10] A *kantharos*, or a wine goblet known as the Cup of the Ptolemies, adorned with scenes related to the cult of Dionysos and Demeter, deities with whom the Ptolemies closely associated themselves, was likely also made for the Ptolemaic court.[11] The

Tazza, however, surpasses all other ancient hard-stone vessels and cameos in the quality and complexity of its decoration. It might not have been unique in its day, and possibly formed part of a pair or a set, as was the case with luxury silver cups, gold phialae, and obsidian bowls inlaid with colored stones.[12] But among the ancient gems that have come down to us, the *Tazza* stands alone at the pinnacle of artistry.

The sophisticated and opulent Ptolemaic rulers fostered the creation of the finest objects and displayed them at important religious and political events, which were often one and the same. In 275–74 BC Ptolemy II Philadelphos paraded outstanding artifacts during his festival of Dionysos and the accompanying banquets for dignitaries, as did his heirs.[13] Whether the *Tazza* was carved before or during Cleopatra's reign, it would have been a prized object in the Ptolemaic treasury, displayed and used on significant occasions. And it would have certainly impressed Caesar, himself a keen lover and collector of gems.[14]

Ancient Greeks and Romans valued stones both pure and worked. The naturalist Pliny the Elder opened his discussion of gemstones by summarizing their appeal:

> Here Nature's grandeur is gathered together within the narrowest limits; and in no domain of hers evokes more wonder in the minds of many who set such store by the variety, the colors, the texture and the elegance of gems that they think it a crime to tamper with certain kinds by engraving them as signets, although this is the prime reason for their use; while some they consider to be beyond price and to defy evaluation in terms of human wealth. Hence very many people find that a single gemstone alone is enough to provide them with a supreme and perfect aesthetic experience of the wonders of Nature.[15]

Though some ancients prized stones in their pristine state, most seem to have preferred them enhanced by human hand: made into seals, vessels, or plaques. Cameos in particular were favored by rulers for portraits and other images of dynastic propaganda. And hard-stone vessels, exhibited during state and religious ceremonies, formed an integral part of power politics, conveying a ruler's splendor and refinement.[16]

Intaglios—images cut into stone to produce an indented shape which, when pressed into sealing wax or clay, resulted in a three-dimensional impression—have been carved for millennia. Cameos—designs achieved by cutting away the area surrounding the figures to form depictions in relief—developed as a new technique, probably ca. 250-200 BC, quite likely in Alexandria. Fashioned from banded agates, such as sardonyx, cameos exploited the different layers of color within the stone to make the foreground elements stand out against the ground and to generate beautiful pictorial effects. By virtue of their exotic origins, innate beauty, and fine workmanship, intaglios and cameos were luxury arts, associated with elites and perfectly suited to articulating royal power.

Sardonyx—the preferred material for cameos—came to Alexandria through Egypt's far-flung trade connections.[17] Carried along caravan routes on the backs of camels, or transported aboard ships, such precious stones were procured in distant provinces of the kingdom, in Arabia and India, and possibly in Europe.[18] It used to be thought that the stone from which the *Tazza* was carved came from India because of its warm hues, attributed by Pliny to agates from that country, and the ancient notion that Indian stones were of highest quality thanks to sunlight and heat in that region.[19] "The agates found in India . . . have other remarkable qualities besides," wrote Pliny. "For they exhibit the likenesses of rivers, woods and draught-animals; and from them also are made dishes, statuettes, horse-trappings and small mortars for the use of pharmacists, for merely to look at them is good for the eyes. Moreover, if placed in the mouth, they allay thirst."[20]

Today some scholars and carvers suggest that the *Tazza*'s stone came from Thrace, in present-day Bulgaria (where traces of similar large geodes have been found on the surfaces of mountains), and that its honeyed hues were achieved by heating the mineral. For while some agates come naturally in beautiful shades of brown and peach, many are just white and gray, and for millennia craftsmen dyed them to produce a richer palette (surviving recipes go back to the ancient Near East). Honey was one substance in which agates were soaked because it could penetrate the microstructure of the mineral, and when heated, caramelize or carbonize, turning orange, brown, or even black. Dying was done before carving. Since the white layers are impervious to color, the craftsmen had to alternate dying and engraving as they revealed fresh layers of stone.[21]

If the *Tazza*'s sardonyx was not of Indian origin, it still resulted from Egypt's far-flung trade networks. The Ptolemies derived their income from two main sources—agriculture in the Nile valley and international commerce. They keenly cultivated links with Southern Arabia and India, which supplied raw materials for many Alexandrian crafts. In the third and second centuries BC trade with India had been conducted through Arab intermediaries, especially via the entrepôt of Aden. But after Alexandrian navigators discovered monsoons—winds that change direction with the season—they were able to make more extensive journeys and establish direct trade contacts. The *Periplus Maris Erythraei*, an anonymous text of the mid-first century BC, describes Egyptian traffic in the Red Sea, the Persian Gulf, and the Indian Ocean, and recounts the wares offered at each port along the way. Barbaricum (modern Karachi), Barigaza, Muziris, and Arikamedu in southern India were the marketplaces selling precious stones such as agate and carnelian, as well as ivory, costly fabrics, and spices.[22] In the first century BC a new office was created in the Egyptian administration, likely under Ptolemy XII Auletes: "Overseer of the Erythraian and Indian Seas."

The Ptolemies also eagerly pursued precious stones in their own territories. Agatharchides of Knidos, a geographer serving the royal court in Alexandria, talks about the mining of topazon—"a fine transparent stone, similar to glass, looking like gold," probably peridot—on the Snake Island (now Zabarjad).[23] Once infested with venomous reptiles, the island was cleared on the order of the Ptolemies and made off-limits to unauthorized visitors so that the royal house could enjoy a monopoly of its geological riches. Stones from other regions, such as Thrace, were doubtless welcomed as well.

Cleopatra's ancestors had transformed Alexandria into the jewel of the Mediterranean by drawing to their capital the finest natural resources of the known world and encouraging the city's skilled craftsmen to turn them into luxury wares.[24] The confluence of long-distance Egyptian commerce, Alexandria's artistic sophistication, and Ptolemaic patronage lay behind the creation of the *Tazza*.

The bowl's beauty stems to a significant extent from its material. Part of the chalcedony family, sardonyx measures 7 on the Mohs scale of mineral hardness—comparable to modern steel.[25] It is composed of thin layers of very small parallel-oriented fibers that make the stone hard and durable, and able to take and retain fine detail and polish.

There is nothing unusual in the technique by which the *Tazza* was created. Ancient gems were carved with iron and copper tools, though the actual job of cutting was accomplished not by these metals but by the slurry smeared on their tips—a mixture of olive oil and abrasive powder ground from a stone harder than chalcedony. Modern carvers use diamond powder; ancient ones typically employed corundum, mined on the Aegean island of Naxos, in India, and in southwestern Turkey. The metal tools—wheel-, ball-, point-, and cone-shaped at their tips, rather like modern dental instruments—were dipped in the slurry and, held at a 90-degree angle to the gem, turned either by a bow or a foot

pedal. The tips had to be frequently reshaped, for the combination of slurry and stone wore them away. The slurry also obscured the worked surface, so the carver proceeded more by intuition than by sight, his experience and feel for how the stone responded to the tools guiding him along.

The carving skills of the master (or masters) who fashioned the *Tazza* were extraordinary. It is the largest ancient cameo that has come down to us, measuring 21.7 cm in diameter and 3 cm in height. Initially it was a geode, a rock cavity with a limestone shell and concentric bands of chalcedony inside. Although the circular contour of the geode would have made it easier to shape the vessel into a phiale, it would have taken a long time to whittle down the stone to the desired form, carve the figures, and polish the final result, this last stage being as time- and labor-intensive as the formation of figures. The work required a thorough understanding of the stone and subtlety in manipulating it. The artist had to plan and adapt his design to the colored layers revealed by the sardonyx as he worked it. By carving to different depths and heating the stone to enhance its hues as he worked, the *Tazza's* master achieved a beautiful contrast between the luminous light-skinned gods and the undulating brown layers of the background. The play of light tones against the dark made the images more voluminous. By varying the thickness of the white layer, moreover, the carver allowed different amounts of the underlying dark tone to show through, thus creating an illusion of modeling in light and shade. The wave-like bands of color on the inside rim of the bowl endowed the grouping of the gods with greater dynamism. To complicate his task further, the *Tazza's* artist was commissioned to place the image of Medusa on the back of the vessel. Her tortoise-brown visage stands out against the honeyed tone of the layer below, and her carved locks echo the waves of color within the stone, making her hair seem even more alive.

The handling of the stone with such skill was a tremendous accomplishment. And the final result is striking: no other surviving

ancient gem combines the size and refinement of the *Tazza*, displays design on both sides, and exploits the colored layers within the sardonyx to such splendid effect. The *Tazza's* exquisite execution and double-sided carving intimates that it was meant to be handled and viewed up close by its illustrious owners and those they sought to impress.

The bowl was certainly not carved by just one man. Assistants would have done much of the laborious preparatory work, removing excess stone and creating the right shape. The master craftsman planned the figures, articulated them, and elaborated the details. Two different artists may have rendered the gods inside the *Tazza* and Medusa outside. The whole process could well have taken a couple of years: it took one modern German craftsman six months to make a replica of the *Tazza* using harder steel tools, sharper diamond powder (10 on the Mohs scale versus 9 for corundum), and electric drills.[26]

Painstaking transformation of exotic raw materials into refined products was an Alexandrian specialty. The city itself was a work of art: Diodorus, writing in the first century BC, commented that it surpassed all others in the world in size, wealth, and beauty.[27] Laid out on a grid along the sea, to take advantage of the cooling winds, Alexandria had white colonnades flanking its main avenues, numerous gardens flowering year-round, and the famous lighthouse that directed ships to the harbor from miles away. The city's waterfront was lined on the left by the brightly painted loggias and lush groves of the royal precinct and on the right by public buildings—the theater, the *agora*, customs offices, warehouses, and temples, all linked together by pavements, porticoes, and colonnades. The buildings were clad in bright limestone, marble, and granite, and adorned inside with mosaics and stucco reliefs.

The city's crafts attained unmatched sophistication. Alexandrian goldsmiths hammered exquisite jewelry from gold extracted from Ethiopian mines. Perfumers transformed plants, resins, and spices imported from southern Egypt, Somaliland, Southern Arabia,

and India into cosmetics desired by customers around the Mediterranean. Elegant glass vessels, papyrus, and fine linen fabrics were other highly prized exports. Alexandrian trade extended in all directions thanks to its geographic location. As the geographer Strabo noted, the city was washed on the north by the so-called Egyptian Sea and on the south by Lake Mareotis, which was supplied by many canals from the Nile that carried goods to Alexandria from inland, while her sea harbors sent out her products to the rest of the world.[28]

The subject matter of the *Tazza* was as carefully chosen as its stone and carvers, and whether it was made for one of Cleopatra's predecessors, or for her, it would have been highly relevant to this queen.[29] The traditional apotropaic image of Medusa on the outside of the phiale presented a clever trope (fig. 1-4). According to Greek

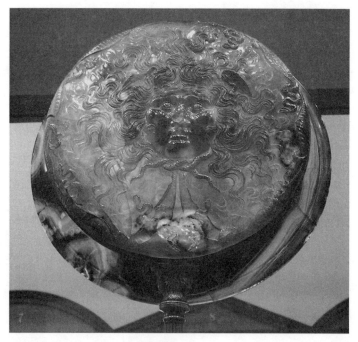

Figure 1-4. Tazza Farnese, Medusa head.

myth (which Cleopatra would have known, the Ptolemies being Macedonian Greeks), Medusa was once a beautiful woman, so lovely that Poseidon fell for her and proceeded to seduce her in the temple of Athena. The virgin goddess, impervious to love, was incensed at the desecration of her shrine. Unable to punish her divine uncle, she vented her fury on Medusa. To preclude any such behavior in the future, Athena braided snakes into Medusa's hair, rendering her so hideous that anyone who came across her turned to stone from horror.[30] The irony of the *Tazza* is that on its lustrous surface Medusa *herself* has been reduced to stone, but made so beautiful by the art of carving that she transfixes the viewer through her splendor.

The more important message appeared on the inside surface: a radiant vision of luminescent gods posed against the amber, orange, and brown layers of sardonyx. At the bottom of the tondo, reclining on a sphinx, is Isis, goddess of abundance and prosperity—the deity with whom Cleopatra associated herself. (The Ptolemaic rulers, particularly in their sibling marriages, presented themselves as Isis and Osiris, thus continuing Pharaonic traditions and cementing their power; they also fused Egyptian and Greek myths in their religious and political displays.) On the left, above Isis, an old man with a cornucopia in his hand—the personification of the Nile—sits on a tree stump, as on a kind of rustic throne.[31] Striding toward him and equipped with a bag of seeds and a plow is the muscular young Horus/Triptolomus, son of Isis and the bringer of agriculture. On the far right edge two scantily dressed young women are identified by some as Memphis and Anchirhoe, the daughters and main branches of the life-giving river, by others as the nymphs Satos and Anukis who controlled the flood, and by still others as Horai, the seasons. Through the sky above fly two representations of the Etesian Winds that blow during the Nile's inundation. This is one, quite plausible reading of the *Tazza*'s carved scene.[32] Various scholars have proposed others, including those that make the figures into specific Egyptian queens and kings.[33] Few dispute that the

depiction as a whole presents an allegory of the wealth of Egypt due to the Nile's annual flooding. As the river overflowed its banks in the summer and receded in the fall, it left behind highly fertile mud on which grew grain prized and exported around the Mediterranean. The Ptolemies, seeking to develop and capitalize further on this resource, which fed not only their subjects and trade partners, but also the royal coffers, introduced Syrian and Greek wheat as well as improved equipment and irrigation to enhance the harvests.

For whomever the *Tazza* was originally created, Cleopatra quite likely displayed it before Caesar to convey her power rooted in the prosperity of Egypt. She had to walk a fine line between seducing him with her resources and keeping him from taking them. As she set about turning him into an ally, but not a master, it helped that his stay proved longer than he had planned.

Caesar's siding with Cleopatra turned her brother, his army, and the Alexandrians against the Roman general. He found himself besieged in the royal palace until his reinforcements arrived in March 47 BC. In the meantime, he and Cleopatra got to know each other rather closely. At the end of June she gave birth to a son whom she named Ptolemy Caesarion.

Their union was, for both, a political gambit as much as a love affair. For Caesar to have the Queen of Egypt as his partner was a more efficient way of gaining access to the riches of her kingdom than a military approach. He was certainly greedy for wealth. According to Suetonius, "in Gaul he plundered large and small temples of their votive offerings, and more often gave towns over to pillage because their inhabitants were rich than because they had offended him.... He sold alliances and thrones for cash, making King Ptolemy XII of Egypt give him and Pompey nearly 1,500,000 gold pieces."[34]

Cleopatra's romance probably cost her dearly, but it allowed her to form a relationship with Rome on less subservient terms than her father was able to obtain (his acquiescence to Roman demands cost him his throne). Caesar arrived in Egypt as a potential enemy.[35] Cleopatra turned him into her lover and the

father of her son. It was likely less a matter of sentiment for her than a method of securing her position by producing an heir who bound Caesar and Rome more tightly to her, and on more equitable terms.

By the time the baby was born, Caesar had left Alexandria and embarked on further campaigns in Syria, Asia Minor, and Africa. He returned to Rome in July 46 BC, and Cleopatra soon followed, bringing along not only her child, but also her younger brother and new co-ruler, Ptolemy XIV (the older one having been defeated and drowned during the struggle with Caesar)—so that he would not plot against her while she was abroad. She likely returned to Egypt after a few months and came to Rome again in 44 BC, departing after Caesar's assassination on the Ides of March. Losing him and his support considerably weakened her position. She promptly elevated their little son, Caesarion, to the throne as Ptolemy XV (her other brother having fortuitously died) and thus asserted her power vis-à-vis her own kingdom and Rome. But she also began to cast around for a new ally.

Caesar's murder sparked a civil war first between his assassins and his friends, then between his heir Octavian and lieutenant Mark Antony, who, having joined forces to avenge their patron, soon came to divide the world between them. The former took the West, the latter the East.[36] To supply his army, Antony turned to Cleopatra, ordering her to appear at Tarsus, his base in southern Asia Minor.

The two had met before when Antony had served as an officer under Caesar in Alexandria and then as his lieutenant in Rome during Cleopatra's stay. Now Antony was at the peak of his career and power. Cleopatra decided to ally herself with him. Her kingdom could only survive with such backing. And she needed to assure her succession by producing more children.[37] She set out to captivate Antony.

Donning the guise of Isis-Venus, she arrived in Tarsus in a ship with golden stern, purple sails, and silver oars. As she reclined beneath

a gold-embroidered canopy, royal musicians played pipes and lutes around her; boys dressed as cupids fanned her from either side; and the air surrounding her was perfumed with incense. Antony styled himself as Dionysos; Cleopatra presented herself as his divine consort. Plutarch wrote: "the news spread everywhere that Aphrodite, for the good and happiness of Asia, met Dionysos at a festive reception."[38]

Cleopatra then offered Antony a lavish feast:

> a royal symposium, in which the service was wholly of gold and jeweled vessels made with exquisite art; even the walls were hung with tapestries woven of gold and silver threads. . . . He was overwhelmed with the richness of the display; but she quietly smiled and said the things he saw were a gift to him. . . . She invited him to come and dine with her again on the morrow. . . . On this occasion she provided an even more sumptuous symposium by far; the vessels used the previous time appeared paltry things; and once again she presented Antony with everything.[39]

She probably did not offer him the *Tazza* (its passage out of Alexandria is suggested below). But most likely her gifts included hardstone vessels, much prized by the Romans and royal presents par excellence.

Antony succumbed to Cleopatra's spell, and their relationship became the stuff of legend—though he also needed her financial resources to secure his power in the East.[40] He followed her to Alexandria, and over the winter of 41/40 BC they begot twins who would be named Alexander and Cleopatra.

Antony (fig. 1-5) was a very different man from Caesar. With his broad forehead, aquiline nose, and muscular physique, he modeled himself on Heracles, from whom his family claimed descent. He could be jesting and boastful, but also warm and easygoing, eating and drinking with his soldiers and winning their affection.[41] Cleopatra nimbly adjusted to his simple manner and

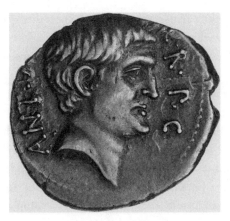

Figure 1-5. Marc Antony, silver denarius, 37 BC.

coarse jokes. "She played at dice with him, drank with him, hunted with him, and watched him as he exercised himself in arms; and when by night he would station himself at the doors or windows of the common folk and scoff at those within, she would go with him on his round of mad follies, wearing the garb of a serving maiden. For Antony also would try to array himself like a servant." So, at least, claims Plutarch.[42] Antony was not a difficult companion. "For there was simplicity in his nature, and slowness of perception, though when he did perceive his errors he showed keen repentance, and made full acknowledgement to the very men who had been unfairly dealt with, and there was largeness both in his restitution to the wronged and in his punishment of the wrongdoers. Yet he was thought to exceed due bounds more in conferring favors than in inflicting punishments."[43] His wife Fulvia, moreover, who "wished to rule a ruler and command a commander," had taught Antony "to endure a woman's sway," so Cleopatra "took him over quite tamed, and schooled at the outset to obey women."[44]

By the autumn of 40 BC, when Cleopatra gave birth to the twins, Antony had returned to Rome and married a new wife, Octavia, sister of Octavian, in order to shore up his relationship

with his political partner and rival. For the next three years Cleopatra concentrated on domestic politics. But by 37 BC Antony was back in the East, resuming his campaign to conquer Parthia and his liaison with the queen. He spent the winter of 37/36 BC with her in Antioch while consolidating his power over Syria, and would remain with her for the next few years, producing one more son, named Ptolemy. When Antony was away from Cleopatra, she sent him love letters written on tablets of onyx or crystal. So says Plutarch, and it is not hard to imagine, given the splendor of her court and the importance of hard-stones to the royal image.[45] Romance aside, Antony and Cleopatra's relationship was crucial to them both. Cleopatra depended on Roman goodwill and support to run her kingdom and return its frontiers to their extent under the first Ptolemies. Antony needed Egyptian grain to feed his armies, as well as reliable governors of territories in the East where he was forming his sphere of influence. He gave Cleopatra southern Syria, Ituraea (northern Palestine), and Cilicia (the southeastern coast of Turkey)—not as a mere largess or a love gift, but as a way of putting these lands under her loyal rule.

Antony's Parthian campaign in 36 BC proved disastrous: through poor tactics and treachery he lost 60,000 soldiers and 5,000 horsemen. He spent the winter licking his wounds in Alexandria and remained together with Cleopatra through 34 BC, when he set out on another Parthian expedition. This time he was more successful, gaining a limited victory in Armenia. He trumpeted his achievement through a festive display in Alexandria and a ceremony at which he affirmed Cleopatra as the queen of Egypt, Cyprus, Libya, and Coele Syria, and proclaimed his sons by her as kings—Alexander of Armenia, Media, and Parthia (when it would be conquered), and Ptolemy of Phoenicia, Syria, and Cilicia.[46] Though he was thus benefiting his own children, he was also following a Roman tradition of placing Eastern lands in the hands of client monarchs whom one could trust. And he sought to ensure the loyalty of Egypt, his chief source of funding and sustenance

in the East. One scholar has suggested that the *Tazza* was carved to commemorate one of these occasions on which Antony vastly extended Cleopatra's kingdom and made it more secure. According to this hypothesis, the scene within the phiale allegorically represented the new prosperity of Egypt as a result of Antony's gifts.[47] It is an interesting idea, though the imagery in the tondo seems to allude to Egypt proper, not to the territorial additions bestowed by Antony. The queen insisted on the sovereignty of Egypt, Antony's donations notwithstanding, for she wanted to be a partner to Rome, not its subject. She more likely viewed and used the *Tazza* as an assertion of her power based on her own resources, which she was willing to share with Rome but not give away.

Antony's bestowal of vast territories on Cleopatra and their children did not play well in Rome: it diminished the empire's valuable and lucrative Eastern lands. Octavian (fig. 1-6) was quick to exploit the situation. Cleopatra posed a threat to Rome by extending her dominion in the East. She caused the Roman general to forget his duties to his family, colleagues, and homeland. And she schemed to take over Rome itself. So Octavian painted her. There was good reason for such dark propaganda. He did not want to continue sharing power with Antony. Yet Antony enjoyed a great deal of support in Rome, and opening hostilities against him would result in a civil war of which the Romans were wary. By focusing on Cleopatra as a foreign threat that had to be destroyed, Octavian could cast the confrontation with her, and by extension with Antony, as a just cause.

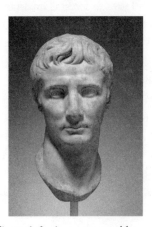

Figure 1-6. Augustus, marble head, 25–1 BC.

To fuel Roman hatred of the queen, Octavian read before the Senate Antony's purported will in which, blinded by his love for the Eastern seductress, he intended to give Rome to her and transfer the capital of the empire to Alexandria.[48] To prevent this calamity, Octavian proclaimed Cleopatra, rather than Antony (his name was not mentioned in the official declaration), the enemy.[49] The war was on.

What gave Octavian the advantage in the ensuing confrontation were not words, but better trained troops, superior generalship, and the defection of his opponents' officers and soldiers to his side. Although Antony and Cleopatra's ships and men far outnumbered those of Octavian, the latter's lieutenant Agrippa, a brilliant strategist and commander, succeeded in capturing Antony's base at Methone, on the west coast of Greece, then taking control of other positions stretching up to Actium, where he blockaded Antony and Cleopatra in a large bay. By September 31 BC Antony and Cleopatra had to make a choice: abandon their fleet and try to escape by land, or send part of the army that way and attempt one more break-out by sea. Cleopatra succeeded in fleeing with sixty ships. Antony followed her. Their remaining forces were destroyed, and Octavian declared a decisive victory.[50]

From Actium, Antony went to Libya to forestall an attack by his former officer, Lucius Pinarius Scarpus, who defected to Octavian and threatened Antony from Cyrenaica. Cleopatra hastened home to prevent a revolt by her subjects once they heard of her defeat. As she approached Alexandria, "she crowned her prows with garlands as if she had actually won a victory, and had songs of triumph chanted to the accompaniment of flute-players." As soon as she got home, she slew her political opponents and "proceeded to gather vast wealth from their estates and from various other sources both profane and sacred . . . and to fit out her forces and to look about for allies."[51] The historian Cassius Dio, who thus summarized Cleopatra's post-Actium actions, was not her champion and interpreted as deception the queen's customary practice of sailing into her port in a festive style appropriate to her role as Isis Navigans. He also criticized

her for gathering a treasure trove. Yet as the Queen of Egypt and an incarnation of Isis, Cleopatra was entitled to appear in a triumphant guise and to take what she wanted from her lands and subjects. More to the point, the wealth she was able to secure was her last resource against Octavian. With it she could escape to the East, perhaps to India, while leaving her son Caesarion on the Egyptian throne.[52] It is possible that among the objects she tried to safeguard was the *Tazza.*

A few weeks later Antony joined Cleopatra in Alexandria and they began to plan their next move. They did their best to show the Alexandrians that life went on as before, staging a huge festival to celebrate the coming of age of Caesarion and Antyllus (Antony's elder son by his first wife). But the noose was closing around them: their former allies turned against them, while Octavian and his lieutenants surrounded them from Syria and Cyrenaica.

As Octavian approached Alexandria in July of 30 BC, Cleopatra fled to her mausoleum, which she had erected next to the tomb of Alexander the Great at the heart of the city. According to Plutarch, she:

> collected there all the most valuable of the royal treasures, gold, silver, emeralds, pearls, ebony, ivory, and cinnamon; and besides all this she put there great quantities of torchwood and tow, so that [Octavian] was anxious about the treasure, and fearing lest the woman might become desperate and burn up and destroy this wealth, kept sending on to her vague hopes of kindly treatment from him, at the same time that he advanced with his army against the city.[53]

Octavian wanted her resources to buy land for his veterans, now that the war was nearly over and his troops had to be recompensed for their services.

With Octavian poised to take Alexandria, Antony and Cleopatra realized that there was no escape. Receiving false news that Cleopatra had killed herself, Antony fell on his sword. When

she learned of his suicide, she sent servants to bring her expiring lover to the mausoleum so that she could hold him one more time, as he died. Soon thereafter Octavian's men arrived, and though Cleopatra refused to leave the building, they tricked her into surrender and took her to the royal palace. Octavian wanted to ensure her safety so that he could take her to Rome and parade her as his captive. She would not suffer such an indignity. "I will not be led in a triumph," are a few of the queen's surviving words.[54]

On August 10, 30 BC, having taken a bath and eaten a sumptuous banquet, Cleopatra sent a message to Octavian begging him to bury her with Antony; then she locked herself in with her two faithful maids. Guessing at her intentions, Octavian rushed his messengers to her chamber. They found the queen dead on her golden couch, and her women dying by her side.[55] Suetonius and Cassius Dio claimed that Octavian tried to revive Cleopatra with the help of African experts skilled at curing snakebites—though the manner of her death has never been clearly ascertained. More likely she died of pricking herself with poison, for small puncture wounds were seen on her arm, while no snakes were found near her.[56]

What happened to the *Tazza*? The gods rising out of the depth of the bowl proved no match for the might and greed of Rome, nor for the determination of Octavian to crush his rival Antony and his Egyptian mistress. While Cleopatra, or her mortal remains, stayed in Alexandria, the *Tazza* likely traveled to Rome. Octavian had outmaneuvered Cleopatra first at Actium, then at her mausoleum, and taken away her treasures, both Egypt and possibly the *Tazza* which symbolically represented it. An embodiment of Cleopatra's court and kingdom—opulent, sophisticated, linked to the markets and materials of far-flung lands, and now subjugated by Octavian—the phiale would play new roles on Italian soil in the service of its Roman masters. Perhaps it happened this way, or maybe not. The *Tazza's* passage out of Alexandria could have taken several different routes.

MARINA BELOZERSKAYA

GEM MANIA IN ROME

> When we hear of the prices paid for these vessels, when
> we see the masses of marble that are being conveyed or
> hauled, we should each of us reflect . . . how much more
> happily many people live without them. That men should
> do such things . . . for no purpose or pleasure except to lie
> amid spotted marbles, just as if these delights were not
> taken from us by the darkness of night.
>
> —Pliny, *Natural History*, 36.1

Octavian would have had many reasons to wish to appropriate the *Tazza*—if he had been fortunate enough to lay his hands on it. An erstwhile Ptolemaic expression of power and wealth, it could now symbolize his possession of the country and its resources. The Romans were also crazy about exotic stones, viewing their carving as a preeminent art form. There may, however, have been other contenders from outside Egypt for the glorious phiale.

Romans became enthralled with colored stones through their foreign trade and military expansion. Traveling in the East both in

peace and in war, they encountered and were immensely impressed with these minerals and what could be made from them. Ptolemaic kings, they saw, embellished their buildings with porphyry and onyx quarried in Egypt, green marble imported from Euboea, and pink and white varieties from Teos, in Greece. Sardonyx, crystal, and jasper vessels adorned their rituals and feasts. Meanwhile, King Mithradates VI of Pontus, who ruled a kingdom on the Black Sea and was one of the greatest enemies of Rome, gathered thousands of such artifacts that the Romans coveted and would eventually seize.

And so they began to seek beautiful stones in places to which they sailed for business or marched their armies, and to bring them home for private use and public display. They imported yellow marble (*giallo antico*) from Tunisia; purple and white veined marble (*pavonazzetto*) from Turkey; red, green, and black marbles from Greece; red, gray, and black granite as well as obsidian from Egypt; jaspers, agates, and rock crystal from Europe and the East. The labor involved in extracting blocks from the mountains, transporting them from quarries to ports, across deserts and along rivers, cutting and polishing stones to bring their rich colors and patterns out of the dull natural rock was astonishing. Most of it was done by slaves, another product of Roman war and trade. The foreign origin of stones was part of their appeal. Italy has many beautiful varieties of its own in its mountains and riverbeds. But the Romans did not think much of these. Instead they exerted enormous energy on procuring minerals from around the Mediterranean and beyond.

Romans already traded extensively in the second century BC. As their empire grew, their commerce increased and became more varied, for various strata of the population required more and more commodities: grain, papyrus, granite, and porphyry from Egypt; wine, nuts, and olive oil from Greece and Asia Minor; silks from China; aromatic resins from Arabia; precious stones from India and

Thrace. Brought home and put on public view—in triumphal processions and state buildings—exotic stones vividly conveyed Roman dominion over the ever increasing portions of the known world.

Moralists condemned this extravagance, which contradicted the republican ethos of austerity. The politician Marcus Scaurus caused a scandal in 58 BC when he decorated a temporary theater he constructed with 360 columns and his own house with colossal shafts of Lucullean marble (black stone from the Greek island of Melos).[1] Pliny the Elder opened Book 36 of his *Natural History* with an ecological argument against the use of exotic stones:

> Mountains ... were made by Nature for herself to serve as a kind of framework for holding firmly together the inner parts of the earth, and at the same time to enable her to subdue the violence of rivers, to break the force of heavy seas and so to curb her most restless elements with the hardest materials of which she is made. We quarry these mountains and haul them away for a mere whim ...
>
> Headlands are laid open to the sea, and nature is flattened. We remove the barriers created to serve as the boundaries of nations, and ships are built specially for marble. And so, over the waves of the sea, Nature's wildest element, mountain ranges are transported to and fro, and even then with greater justification than we can find for climbing to the clouds in search of vessels to keep our drinks cool, and for hollowing out rocks that almost reach the heavens, so that we may drink from ice [rock-crystal].[2]

Pliny attributed the origin of the Roman craze for precious stones and for artifacts carved from them to a particular event: the victory of Pompey over Mithradates VI, the king who owned vast quantities of hard-stone vases, some of them previously taken by him from the Ptolemies.[3]

In the closing years of 100 BC, during the dynastic struggles between different members of the Ptolemaic ruling house, Cleopatra III, great grandmother of the famous queen, fearing an attack on Egypt by her son, Ptolemy X, sent the royal treasure from Alexandria to Cos along with her little grandson, Ptolemy XII (the future "Auletes")—baby princes being another precious commodity. The boy and the valuables remained in this safe spot until 88 BC, when the island was captured by Mithradates VI. The King of Pontus, the most hated and feared enemy of Rome at that time, claimed Alexander the Great and Darius of Persia as his progenitors, and aspired to create a vast eastern empire centered on the Black Sea. Fiercely opposed to Rome, he embarked on a campaign to conquer Greece and Asia Minor, which were being overrun by his western foe, and instigated the killing of some 80,000 Romans living in those areas—a genocide of staggering proportions, though one assisted by the inhabitants of Anatolia angry enough at the Roman expansion to participate in this crime. Three Roman generals were sent to fight Mithradates, but he eluded capture and surged back even after heavy losses. To forestall being assassinated, he had mastered the knowledge of poisons, building his own immunity to them while dispatching his opponents.[4]

In 88 BC Mithradates stopped at Cos. He was welcomed, or wisely not resisted, by the residents who turned over to him the young Ptolemy and the royal treasure. If the *Tazza* had been made by this time and taken to the island for safekeeping, Mithradates would have certainly grabbed it for his collection—his thirst for carved stones being unquenchable—and added it to his other war spoils, such as the cloak of Alexander the Great, another Ptolemaic heirloom apparently stored on Cos.

When the Roman general Pompey the Great (who modeled himself on Alexander) finally defeated Mithradates in 63 BC, he seized the king's spectacular possessions, including 2,000 cups of onyx in gold settings and so many other articles of this kind that

Pompey's troops took thirty days to inventory them. Some of Mithradates' stone vessels were gifts or heirlooms, others had been made for the king or collected by him, for he was a connoisseur. While the *Tazza* today is a unique object, there may have been others like it among Mithradates' treasures, and the fact that the king's onyx cups were set in gold mounts may suggest that the *Tazza*, too, had a gold lip and perhaps gilt highlights on its figures. If Mithradates had taken the phiale from Cos, Pompey would have appropriated it along with other vases and gems of the vanquished ruler and paraded it in his triumph in Rome in 61 BC. Seeing these artifacts, according to Pliny, sparked the Roman craze for such works.

Once exposed to hard-stones, the Romans could not get enough of them. The most coveted and costly articles were carved from myrrhine, or fluorospar, a translucent mineral with bands of color ranging from purple through green to white, found in the East, particularly in Parthia.[5] According to Pliny, it was Pompey's victory over Mithradates that brought myrrhine ware to Rome for the first time. "Lavish expenditure on this fashion is increasing every day," Pliny recorded:

> an ex-consul drank from a myrrhine cup for which he had given 70,000 sesterces, although it held just three pints.... When the ex-consul Titus Petronius was facing death, he broke to spite Nero, a myrrhine dipper that had cost him 300,000 sesterces, thereby depriving the Emperor's dining-room table of this legacy. Nero, however, as was proper for an emperor, outdid everyone by paying 1,000,000 sesterces for a single bowl.[6]

A sesterce was, at that time, a large brass coin. A loaf of bread cost about half a sesterce, a tunic 15 sesterces, a donkey—500. The sum Nero paid for his myrrhine bowl equaled the dowry of a patrician woman.[7]

Although Pliny singled out myrrhine ware, many highly valued vessels were fashioned from sardonyx, which also contains a range of colors. The Romans treasured such objects not just for their beautiful appearance and fine craftsmanship, but also for the magic of the minerals themselves. They admired agates in particular for seemingly containing within their very fabric images wrought by nature, rather than by human hand. Pliny described a stone owned by king Pyrrhus, who had fought a war against Rome in the third century BC, as "an agate on which could be seen the Nine Muses with Apollo holding his lyre. This was due not to any artistic intention, but to nature unaided; and the markings spread in such a way that even the individual Muses had their appropriate emblems allotted to them."[8] Sardonyx was especially prized by Roman elites, and various emperors wore it for personal adornment. Pliny noted that "according to Demostratus, the first Roman to adopt a sardonyx was the elder Africanus [Scipio Africanus, a Roman general in the second Punic War who defeated Hannibal], and hence arose the esteem which this gemstone enjoys at Rome."[9] Sardonyx produced an extremely clean impression in wax when used as a signet, and, the Romans believed, could allay thirst when placed in the mouth—which explains why it was often carved into drinking cups.

Such was the demand for sardonyx objects that forgers began to counterfeit them in cheaper materials. Pliny advised:

> To distinguish genuine and false gemstones is extremely difficult, particularly as men have discovered how to make genuine stones of one variety into false stones of another. For example, a sardonyx can be manufactured so convincingly by sticking three gems together that the artifice cannot be detected: a black stone is taken from one species, a white from another, and a vermilion-colored stone from a third, all being excellent in their own way . . . there is no trickery that is practiced against society with greater profit.[10]

Given the hunger for sardonyx artifacts in Rome, the *Tazza*, had it been seized by Pompey from Mithradates, would have been a most welcome object: a stunning example of nature's magic and human skill, a genuine article, a symbol of the final defeat of Rome's great enemy, and an heirloom from the most illustrious court of the day, that of the Ptolemies in Alexandria.

But the phiale may have also remained in Egypt, adorning the court of Cleopatra VII, especially if it were carved during her reign, and have come to Italy not as loot, but as a carefully chosen gift.

In 46 BC Cleopatra arrived in Rome to be with her lover and the father of her son. She may have come at Caesar's invitation, but more likely, the initiative was her own, as was often the case. She needed proximity to him to maintain their bond and her throne; he benefited by gaining Egypt's manifold resources. So he put her up as a guest at his villa across the Tiber and helped her secure the formal recognition of friendship and alliance from the Roman people.[11]

Caesar's courtship of Cleopatra incensed some Romans: he was a married man, she—a foreign femme fatale.[12] Cicero griped to his friend Atticus: "I hate the queen . . . Her arrogance, when she was living across the Tiber in the gardens. . . . I cannot recall without profound bitterness."[13] But many others were fascinated by Cleopatra and flocked to pay their respects. The Ptolemaic court was renowned for its splendor as well as learning, and a number of crucial developments around that time are credited to the influence of Cleopatra's scholars and scientists. The calendar reform, carried out by the Alexandrian astronomer Sosigenes, who likely came to Rome with Cleopatra, switched the Roman reckoning of time from the 355-day lunar cycle, which created many problems, to the more accurate 365-day solar one. Through the example and guidance of Ptolemaic engineers, Caesar undertook to build canals

to drain the marshes around Rome, form new waterways for commercial navigation around the city, and dig an opening through the Isthmus of Corinth in Greece to augment that city's economy. Caesar also planned to create a great library in Rome on the model of that of Alexandria. And he may have borrowed from Cleopatra some ideas on governance.[14]

Caesar probably did not spend that much time in Cleopatra's company: his wife and political business required his attention, and late in 46 BC he sped off to Spain to fight the sons of Pompey who threatened Rome. But he did honor the queen in an unprecedented way—for Rome—by erecting a gilded statue of her in his newly constructed temple of Venus.[15]

Roman temples were not places of worship like churches, synagogues, and mosques. The primary religious ritual, the sacrifice, took place at an outdoor altar in front of the shrine. The temple itself served as a terrestrial home for the divinity represented by a statue placed inside the building, and as a repository of precious offerings made to him or her: gold vessels, ivory furniture, rich textiles, carved gems, and other goods dedicated by individuals eager to gain divine favor and increase status among their peers. Roman temples and their contents were also political statements. By filling the shrine of Venus with an array of opulent dedications, including gems, Caesar displayed not only his piety, but also his nationalism. Not only did he provide the Roman people with an important center of worship, but he made it splendid with the spoils of his conquests achieved in the name of Rome. He also bypassed the opprobrium of accumulating personal luxury from his wars by presenting his gains to the temple, which made them available to all.

The Romans felt conflicted about luxury, torn between the republican virtues of sobriety and frugality, and the allure of riches flowing into the city through trade, tribute, and conquest. While moralists condemned expenditure on extravagant feasts

and furnishings crafted from exotic materials, those who could afford it found the siren call of acquisition hard to resist. One way of coping with the dilemma was to dedicate lavish artifacts to the gods as a gesture of public magnanimity and contribution to the greater social good. Hence victorious generals, having brought rich booty from their foreign campaigns and paraded it through the city's streets, took it to one of several shrines, presenting it to the deities to whom they credited their success. Through this process, temples became declarations of Roman militarism and its profits.

Caesar's temple of Venus both proclaimed his achievements in the name of Rome and competed with his rival, Pompey. Shortly after returning from the East, Pompey had built a splendid complex in the city composed of the first permanent theater in Rome (with a shrine to Venus atop its auditorium), a portico displaying artworks he had acquired during his campaigns, a garden planted with vegetation that had also formed part of his booty, and a meeting hall for the Senate in which Caesar would later be killed. In building his own forum at the heart of the city, to the southeast of the Capitol, abutting the Forum Romanum, Caesar was trying to upstage Pompey. The lavish scale of the new development prompted Pliny to compare it to the pyramids of the pharaohs.[16] Claiming Venus as the founder of his family, and crediting her with his military victories, Caesar honored her with a shrine in his forum, a larger than life-size statue of the goddess inside it, and a profusion of magnificent dedications, among them a cuirass made of British pearls, six cabinets of engraved gems, and two paintings by Timomachos of Byzantion.[17]

Caesar had an eye for beauty and affection for luxurious living. Suetonius wrote that he carried mosaic pavements with him on his campaigns in order to embellish his quarters, and that the lure of fresh-water pearls seems to have prompted his invasion of Britain.[18] Though inferior to those imported from the East, British

pearls were still valuable, and the quantity necessary to decorate a whole cuirass would have been enormous. In making this offering Caesar again sought to outdo Pompey, who, during his triumph in 61 BC, paraded not only the vessels of precious stone and metal captured from Mithradates, but also his own portrait made entirely of pearls—a proclamation of his advancement of Rome's dominion to the Red Sea and the Persian Gulf.[19] Caesar's pearly cuirass countered with a boast of extending the Roman Empire to Britain.

The carved gems which Caesar dedicated in his new temple may well have come from Alexandria and commemorated his victory there. In offering a treasure-trove of cameos and intaglios to his patron goddess he may have been trying to outdo Pompey in one more way. The latter had dedicated one gem cabinet, taken from Mithradates, in the temple of Jupiter on the Capitoline.[20] Caesar presented his goddess with six. The art of gem carving had come to Rome from the East, and the very term for collections of such stones—*dactyliothekai*, or ring cabinets—was Greek. Gem carving was a high art in Alexandria, and Caesar certainly came back from his sojourn in that city greatly enriched. His forum was built with the spoils of his wars in Gaul and Egypt. So it is quite possible that the gems were part of his Egyptian gains.

Caesar may have decided to place Cleopatra's gilded statue beside that of Venus as a result of his experience in Egypt, for there images of pharaohs stood in temples as companions to gods. Nothing of this sort had, up to this point, been done in Rome, and it probably shocked his compatriots. But Caesar was not concerned that such a tribute might be seen as verging on impiety; "religious scruples never deterred him for a moment," according to Suetonius.[21] Cleopatra's statue fit his program: as an honor paid to the queen whom he courted as much for the resources of her kingdom as for her personal charms; as an extension of the treasures dedicated to his patron goddess; and as her second image, since Cleopatra likened herself to Isis and Isis was an Egyptian incarnation of Venus.

Isis, Egypt's most popular divinity, was widely revered for her numerous benefactions. As the "mistress of life" and rebirth she brought the Nile flood and the new year, promoted harvests and fertility, and protected women, marriage, and maternity. Sailors of many nations prayed to her manifestations as Isis Epikoos ("of ready help"), Isis Euploia ("of fortunate sailing"), and Isis Pharia ("of the Pharos of Alexandria"). Egyptians ferrying grain to Puteoli, in southern Italy, introduced her cult to Campania and then to Rome. The Ptolemies associated themselves with the gods from the beginning of the dynasty, Cleopatra's father styled himself as the new Dionysos (as Ptolemy II had done in the third century BC), and she linked herself to Isis.

Whether the *Tazza* had been made in Cleopatra's time, or inherited by her as part of the dynastic treasury—if it did not go to Cos and fall into Mithradates' hands—the queen would have certainly seen herself in the figure of the goddess carved inside the phiale. Like Isis, she worked to ensure the prosperity of Egypt and the well-being of her subjects. Like Isis, she always made a splendid apparition. Aware of Caesar's devotion to Venus and his love for carved stones, Cleopatra may well have brought the *Tazza* with her to Rome as a special gift. Caesar would have admired such works at her banquets and religious ceremonies in Alexandria, and perhaps had coveted the *Tazza* while there. It is plausible that Cleopatra offered it to her lover, her son's father, Rome's master, and her most important political ally. And if he received such a present, Caesar probably placed it in the shrine of his patron goddess— alongside the statue of Cleopatra—as a symbol of bringing Egypt's resources to Rome through his association with the Queen.

But perhaps the *Tazza* did come to Rome as a captive of Cleopatra's greatest enemy. After defeating Antony and Cleopatra at Actium, Octavian was anxious to lay his hands on the Ptolemaic treasure to cover his war expenses, to take possession of fabulous artifacts, and

to score a propaganda victory by bestowing them on Rome. According to Suetonius, he took only one object from Cleopatra's palace as a sign of his moderation: a cup of myrrhine ware.[22] But in reality he clearly took a great deal more. He brought to Rome two obelisks, one of Pharaoh Ramses II from Heliopolis, erecting it at the center of the Circus Maximus, another of Psammetichus II, which he used as the needle in his monumental sundial. Octavian's triumph celebrating his conquest of Alexandria and the annexation of Egypt as a Roman province required three days to display all the magnificent spoils.[23] Where did all those riches come from, if not from Cleopatra's stores? Suetonius reported that "when he [Octavian] brought the treasures of the Ptolemies to Rome at his Alexandrian triumph, so much cash passed into private hands that the interest rate on loans dropped sharply, while real estate values soared."[24]

Having shown off his gains before the populace, Octavian, like his predecessors, dedicated many of them at temples around Rome. Cassius Dio wrote that "Cleopatra, though defeated and captured, was nevertheless glorified, inasmuch as her adornments repose as dedications in our temples and she herself is seen in gold in the shrine of Venus."[25] During his triumph, Octavian exhibited an image of the queen reclining on a couch.[26] It is unclear from the ancient sources whether it was a statue or a painting—both were used in such contexts. One scholar has suggested that the golden likeness of the queen in Caesar's temple was actually the triumphal depiction dedicated by Octavian.[27] Whichever is the case, if the *Tazza* had remained in Cleopatra's possession until her death, Octavian would have certainly taken it to Rome and likely presented it to the gods together with his other Egyptian booty. Placed in one of the city's shrines, the *Tazza* would have been viewed by contemporaries as a marvelous testament to Octavian's triumph over the opulent and decadent, learned and insubordinate Ptolemaic court. For him it would have also been a glorious symbol of defeating the vile Egyptian queen and making her treasures and her kingdom Rome's.

Or might he have kept the *Tazza* as a personal trophy? Octavian feigned modesty in his appearance and home. He was, Suetonius wrote, "remarkably handsome and of very graceful gait . . . but negligent of his personal appearance. He cared so little about his hair that, to save time, he would have two or three barbers working hurriedly on it together."[28] "His new palace [on the Palatine Hill] was neither larger nor more elegant than the first; the courts being supported by squat columns of *peperino* stone, and the living-rooms innocent of marble or elaborately tessellated floors."[29] Yet he did have a weakness for certain luxuries: "some found Augustus [the name Octavian assumed in 27 BC] a good deal too fond of expensive furniture, Corinthian bronzes, and the gaming table," noted Suetonius, who added that Octavian was thought to add to the lists of proscribed citizens names of men who owned such objects; and "his [houses] were modest enough and less remarkable for their statuary and pictures than for their landscape gardening and the rare antiques on display."[30]

The *Tazza*, were he to keep it in his home, would have been more than a material indulgence. Its imagery would have resonated with him in numerous ways. Octavian had annexed Egypt as his own province and brought its wealth to Rome. The figure of Horus on the *Tazza* could remind him of this accomplishment, alluding as it did to the grain of Egypt that he now made available to his people. The sphinx—which reclines at the center of the *Tazza*—was Octavian's personal symbol. He had used it since the late 40s on his seal as a sign of Apolline rule prophesied by the Sybil, which he now brought to Rome by ending the civil war and ushering in a golden age of prosperity and moral renewal.

Octavian claimed Apollo as his patron, the god who stood for discipline and morality (even though Apollo's various amorous escapades suggested otherwise), as opposed to the decadent Dionysos on whom Antony styled himself, all the more so as he took to living in sin and sloth with the oriental queen—according to Octavian's propaganda. As a protégé of Apollo, Octavian wore a laurel wreath

on various public occasions, and used a seal carved with the sphinx on his letters and decrees.[31] Cultivating Apollonian calm, "he always wore so serene an expression, whether talking or in repose, that a Gallic chief once confessed to his compatriots: 'When granted an audience with the Emperor during his passage across the Alps, I would have carried out my plan of hurling him over the cliff had not the sight of that tranquil face softened my heart; so I desisted.'"[32]

Octavian built a new temple to Apollo next to his own house and credited the god with his success at Actium. Try as he might for model behavior, Octavian did cause a scandal when at one of his dinner parties he presumed to appear in the guise of his divine patron, while his friends presented themselves as other Olympian gods.[33] The transgression was made worse by the fact that Rome was, at that time, suffering from a food shortage, and the following day people shouted in the streets: "The Gods have gobbled all the grain!" Such extravagance may have gone over in the corrupt East, but not in Rome. It was a rare lapse of political vigilance on Octavian's part.

Otherwise he remained restrained in his visual displays, so it is all the more telling that he made regular use of gems. A sardonyx cameo commemorated his victory at Actium, depicting him riding majestically over the waves in a chariot drawn by four tritons who helped him win that naval battle.[34] They were shown holding up symbols of the Roman Republic: a figure of Victory bearing the *corona civica*, and an oak wreath encircling a *clypeus virtutis* (a shield inscribed with the noble qualities and achievements of the honoree). Actium, Octavian claimed, allowed him to restore the Republic, even though what he really ushered in was imperial rule. But the gem presented the official version of events. They were portrayed in a different idiom, but with similar self-glorification, on an agate intaglio on which Octavian appeared in the guise of a nude Neptune riding a quadriga of sea horses over his enemy's body as it sank into the sea.[35]

A whole political program was carved on a sardonyx cameo measuring 19 by 23 cm, known today as the *Gemma Augustea*

(fig. 2-1).³⁶ Quite likely a present from Livia to Augustus in 12 BC, it depicted him enthroned together with Roma, the personification of the Roman state, in the center of the upper register. This pairing referred to the cult of Augustus and Roma established in Rome's Eastern provinces shortly after Actium and then brought to northern Europe through the military campaigns of Augustus's chosen successors: Tiberius, descending from a chariot on the left of the cameo, and Drusus standing next to him. Indeed, the gem was likely carved to commemorate the founding of the cult of Roma and Augustus in the Western provinces thanks to the efforts of Tiberius and Drusus, Livia's sons.³⁷ Their victories complemented those achieved by Augustus in the East—represented on the gem through the figures of Oecumene (the inhabited world), who crowns the emperor, and Oceanus and Tellus (the Earth), who appear behind

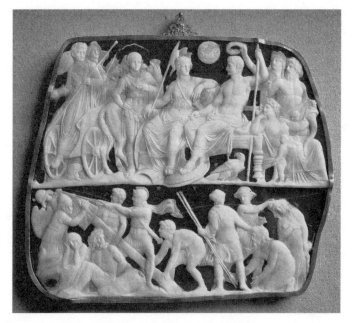

Figure 2-1. Gemma Augustea, onyx cameo, 1st century.

him. The cornucopia held by Tellus referred to the Earth made bountiful thanks to the peace ushered in by Augustus's rule.

Like the *Tazza*, the *Gemma Augustea* went on to have an eventful life. It was transferred to Constantinople, probably with other imperial riches, in the fourth century. It was then recorded in 1246 in the Treasury of the Basilica of Saint Sernin in Toulouse, whence it was expropriated in 1533 by King Francis I and taken to Paris. Disappearing from the royal collection in 1590, it was bought soon thereafter for 12,000 gold pieces by the Holy Roman Emperor Rudolph II. In the seventeenth century the gem was set in a gold mount, though, sadly, by that point the upper left side of the stone had broken off and at least one other figure was missing.

Cameo carving was a fundamental art form for Augustus. Throughout his reign he encouraged it for both political and aesthetic reasons.[38] His favorite cutter, Dioskourides, made a seal with his portrait and perhaps the *Gemma Augustea*. Dioskourides became the most famous gem carver in antiquity partly due to his outstanding skill and partly through his association with Augustus. Dioskourides was Greek, from Aigeai in Asia Minor. Solon, another gem carver who worked in the circle of Augustus and created idealized portraits of the emperor and his sister, was also Greek. The art of working colored stones came to Rome from the East and was seized upon by the canny Augustus as a great political tool. Some scholars have even sought to ascribe the *Tazza* to Augustus's commission.[39] But the subject of the bowl is strictly Egyptian and it makes no clear visual reference to Augustus, unlike other gems that extol him explicitly.

If the *Tazza* had still been in Cleopatra's palace at the time of her death, it is difficult to imagine Augustus not taking this stunning and symbolically potent object to Rome along with the other assets of the vanquished queen. And if he did get hold of it, he likely passed it on, together with his power, to his heirs, the bowl becoming part of the Roman imperial treasury.

THE PAST ACQUIRED, REVIVED, AND RANSACKED

Once out of nature I shall never take
My bodily form from any natural thing,
But such a form as Grecian goldsmiths make
Of hammered gold and gold enamelling
To keep a drowsy Emperor awake;
Or set upon a golden bough to sing
To lords and ladies of Byzantium
Of what is past, or passing, or to come.
—William Butler Yeats, "Sailing to Byzantium"

The Emperor Constantine (fig. 3-1) was not generally known for his subtlety or refinement.[1] Ambitious and ruthless in his pursuit of power, he murdered his second wife and son, assassinated friends and advisers, and overwhelmed his subjects with crushing taxes. But he did show remarkable foresight in turning Byzantium, previously a minor provincial town, into a splendid metropolis, to which he gave his own name.

By Constantine's day, Rome had long ceased to be the seat of authority. The old capital had retained its historical prestige

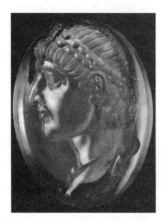

Figure 3-1. Constantine the Great, amethyst intaglio, 4th century.

and the Senate resided there, but imperial administration was carried out from where the emperor happened to be, and in the fourth century he was likely to be in one of the provinces, fighting encroaching "barbarians." For eight years prior to founding his city, Constantine spent much of his time in the Balkans, staving off Germanic invasions along the Danube. Byzantium, situated on the Bosporus, the strait linking the Black Sea with the Aegean, lay between the Balkans and Asia Minor, the empire's chief source of wealth and manpower, and offered numerous benefits that Constantine chose to exploit unlike anyone else before.

Before his arrival Byzantium was a backwater.[2] The Greeks had inhabited it unremarkably for several centuries; then the Romans arrived in the second century A D. But only Constantine decided to take full advantage of the place—washed by the sea on two of its three sides, which made it easy to defend, blessed with great harbors, and situated on important trade routes. Constantine, prone to assuming divine splendor by letting his tresses (some of them false) fall to his shoulders and covering himself with bracelets and elaborate jeweled robes with flowery designs, majestically paced out the perimeter of the city with a spear in hand, defining its new extent in the manner of Romulus laying out Rome. Then he set about transforming it into a capital of unparalleled splendor in a mere six years.

To make Constantinople grow and prosper, he expanded the city to four or five times its previous size and attracted immigrants and building contractors by offering them tax remissions and free bread, having diverted Rome's Egyptian grain shipments to Byzantium. He

built an imperial palace for himself, and to entertain the populace enlarged the Hippodrome to the size of Rome's Circus Maximus. To endow the city with historical and cultural cachet, he filled its libraries with Greek and Latin books removed from Rome, and dispatched agents across the Mediterranean to gather and bring back every art object they could find. In the words of St. Jerome, "Constantinople was enriched with the nudity of almost every other city." The emperor culled works from former capitals and sanctuaries, ennobling his new seat with masterpieces in bronze, ivory, porphyry, marble, and exotic stones. Relocated to Constantinople, this treasure-trove of classical art signaled Constantine's control over the Greek and Roman territories and cultural traditions. Constantinople was now the capital of the whole Empire, and its art collection reflected the new city's eminence.[3]

To get a sense of what Constantinople looked like and how important colored stones in particular were to its majesty, one need only visit the basilica of San Marco in Venice, which is covered inside and out with *spolia* taken by the Venetians from Byzantium in 1204. The variety and visual richness of the wall revetments, columns, and floor mosaics are breathtaking. Meanwhile, the church's treasury is full of sardonyx, agate, alabaster, and rock crystal vessels ransacked from the churches and palaces of the Eastern city. And this is just a fraction of the wealth that adorned Constantinople in its heyday.

Perhaps among the artifacts Constantine had imported into his capital was the *Tazza*. He may have brought it from Rome where it could have been preserved since the days of Octavian, if the latter had taken the bowl from Alexandria. Or, perhaps Cleopatra had deprived her enemy of this trophy after all and it had stayed in Egypt until Constantine's time. Might she have succeeded in spiriting her treasures out of Alexandria and securing them in some secret location, a religious shrine watched over by the gods and their priests?[4] Archaeologists have unearthed a number of ancient hoards across the Mediterranean, concealed by

their owners at moments of crisis and left undisturbed for centuries. If such was the fate of the *Tazza*, it could have come to light again in the fourth century AD when Constantine went collecting artworks for his city.

He used scouts to identify desirable objects and asked cities and sanctuaries to turn over the works he wanted.[5] Thus he was able to obtain a renowned dedication from the sanctuary of Apollo at Delphi—the bronze serpent column supporting a golden tripod and caldron that memorialized the Greek victory over the Persians at the Battle of Plataea in 479 BC and was allegedly made from the melted down enemy weapons. He also procured the Ass and Keeper group from Nikopolis that celebrated Octavian's victory at Actium.[6] Wherever the *Tazza* may have come from, given Constantine's greedy and far-flung hunting and gathering, it could well have become part of his *spolia*.

Constantine's appropriation of religious works in particular coopted their spiritual power for the benefit of his city: transferred to the new location, various gods who used to protect other places and rulers were made to serve as guardians of Constantinople and the emperor. Constantine had, of course, famously legalized Christianity, but in shaping his capital he astutely strove for a balance between honoring pagan and Christian divinities—to assure their benevolence toward him and the peace of his multi-national and multi-religious realm.

Constantine commemorated the foundation of Constantinople in a gold medallion in which he had himself portrayed gazing heavenward, like Alexander the Great, and wearing a gem- and pearl-encrusted diadem. Ostentatious attire and ceremonial would become hallmarks of Byzantine emperors, and the love of luxurious artworks, both ancient and contemporary, would be embraced by his successors.

By whatever means the *Tazza* may have arrived in Constantinople, it likely stayed there for some centuries, seemingly leaving a mark on Byzantine court art at a time of renewed interest in the classical

past in the ninth and tenth centuries. In the intervening time the bowl probably changed meanings as Byzantine culture and society evolved from paganism to Christianity.

In Constantine's day Christian monuments mingled with pagan ones throughout the city. Over the following centuries Christianity came to color the perception of pagan antiquities, yet Greco-Roman art and literature remained alive to a much greater degree in Byzantium than in Europe thanks to books preserved in the imperial library and numerous ancient monuments still visible in the streets and squares of Constantinople and at the imperial palace.

In the course of the seventh and eighth centuries, partly as a result of Persian and Arab invasions, the Byzantine Empire came close to collapse. Old urban structures and social patterns disintegrated, the capital fell into a pitiful state, its population shrunk, and intellectual life declined.[7] Already in the sixth century the imperial government, anxious to suppress paganism, forbade pagan scholars to teach, precipitating the waning of the study of classics. The iconoclastic controversy that tore apart Byzantium in the seventh and eighth centuries made theological concerns and debates foremost and overshadowed ancient literature and art. But after iconoclasm ended, the learned elite turned a curious eye back to classical objects and texts.[8] One of the pioneers in this revival was the Patriarch of Constantinople Photios I who saw familiarity with the achievements of the ancient world not as a threat to Christianity, but as part of a proper education. Having gathered some 400 books in his library, both Christian and classical ones, he described and discussed them in a volume called *Bibliotheca*, spurring others to undertake similar studies. This intellectual reawakening received further impetus from the new family of emperors who ushered in a larger political, economic, and cultural renewal of Byzantium.

The originator of this clan was Basil I. Though he later claimed descent from an Armenian princely family, he was actually a peasant from Thrace in a province of Macedonia—hence the

name of his dynasty. In 813, when he was a boy, his family had been captured by Krum of Bulgaria and carried into servitude. Escaping around 836, Basil returned to Byzantium and got a post as a groom to Theophilitzes, a relative of the uncle of the Byzantine Emperor Michael III. Basil attracted Michael's notice by winning a wrestling match. The emperor hired him as his bodyguard, then promoted him to the rank of his companion. He ordered Basil to divorce his wife and marry the imperial mistress, Eudokia Ingerina. It was widely rumored that Basil's son from this union, Leo, was Michael's child, and Basil apparently hated the boy. In 867 Basil killed Michael and took the imperial throne.

He proved a remarkably successful ruler, restoring the laws of the great sixth-century emperor Justinian, following a prudent fiscal course, and fostering good relations with the Roman church. Seeking to emulate Justinian, he undertook an extensive building program in Constantinople, its most splendid manifestation being the Nea Ekklesia (New Church), a rival to Hagia Sophia and a symbol of a new era of Byzantium's glory. To decorate this church as lavishly as possible, Basil stripped other buildings around the city, including Justinian's Mausoleum, and sent the imperial fleet to transport marble from further afield—which caused Syracuse, the main Byzantine stronghold in Sicily, to fall to the Arabs in the absence of a proper defense.[9]

The description of Nea Ekklesia by Basil's grandson Constantine VII (all the more valuable since the building does not survive) shows the taste for beautiful stones fostered by the Macedonian emperors who also prized and sought to emulate such objects as the *Tazza*:

> This church, like a bride adorned with pearls and gold, with gleaming silver, with a variety of many-hued marble, with compositions of mosaic tesserae, and clothing of silken stuffs, he [Basil] offered to Christ, the immortal Bridegroom. Its roof, consisting of five domes, gleams with gold and is resplendent with beautiful images as with stars.... The walls

... are beautified with costly marbles of many hues, while the sanctuary is enriched with gold and silver, precious stones, and pearls. ... As for the pavement, it appears to be covered in silken stuffs of Sidonian workmanship; to such an extent has it been adorned all over with marble slabs of different colors enclosed by tessellated bands of varied aspect, all accurately joined together and abounding in elegance.[10]

Basil was succeeded by his (or Michael III's) son Leo VI. Unlike Basil, Leo had received an extensive education, his erudition earning him the sobriquet "the Wise" or "the Philosopher." He nurtured learning and the renaissance of letters, but his reign was troubled by military defeats in the Balkans against Bulgaria and in Sicily and the Aegean at the hands of the Arabs, as well as by great difficulty in producing an heir. Three wives died without giving him a son, and it was only the fourth, his mistress Zoe Karbonopsina ("coal-eyed" beauty), who finally fulfilled his longing, though it cost him dearly. Byzantine civil and canon law prohibited more than two marriages. Leo wanted to be sure that Zoe's child was a boy before marrying her; and legalizing their union involved him in a protracted conflict with the church. But he took pains to ensure the legitimacy of his offspring by having Zoe deliver him in the Purple Room of the imperial palace, where official imperial children came into the world. And so the boy came to be called Constantine VII Porphyrogennētos, "born in the purple," (or Porphyrogenitus in Latin). To secure his child's status further, Leo symbolically elevated him to the imperial throne at age two, in 908. It would, however, take thirty-seven years for Constantine VII to actually attain authority, as various family factions, far more ambitious than he, struggled for control.[11]

In the interim years, marginalized by the power plays around him, Constantine devoted himself to scholarly pursuits. He worked on a book about his grandfather Basil, another on the imperial administration (De Administrando Imperio—intended as a domestic and

Figure 3-2. Constantine VII Porphyrogenitus, ivory relief, 10th century.

foreign policy manual for his son, the future emperor Romanos II), and a third on the elaborate ceremonial of the Byzantine court (*De Ceremoniis*).[12] He also supported the production of a number of compilations: a set of fifty-three encyclopedias, called *Excerpta*, containing extracts from ancient and Byzantine historians; the *Suda*, an encyclopedia of Greek history and literature; and the *Palatine Anthology*, a large collection of Greek poetry. These volumes brought ancient works to a wider audience (though one still limited to the educated class centered on the court). Byzantine emperors promoted secular learning as a way of training civil servants for the imperial bureaucracy, and they viewed the classics as an important part of the curriculum.

Constantine VII finally ascended the throne in January 945 (fig. 3-2). Aged thirty-nine, he was fair-skinned, beak-nosed, long-faced; tall and broad-shouldered, "he held himself as erect as a cypress tree."[13] Having had ample time to think about good government—while observing his squabbling predecessors and considering the matter in his books—he now took care to foster the economic and geographic expansion of Byzantium, spreading its political and cultural influence as far as Kiev, Baghdad, Damascus, Cairo, and Rome. Meanwhile, at home his court awed visitors. The Lombard bishop-diplomat Liutprand of Cremona described his visit to the royal palace:

> Before the emperor's seat stood a tree, made of bronze gilded over, whose branches were filled with birds, also made of gilded bronze, which uttered different cries, each according

to its varying species. The throne itself was so marvelously fashioned that at one moment it seemed a low structure, and at another it rose high into the air. It was of immense size and was guarded by lions, made either of bronze or of wood covered over with gold, who beat the ground with their tails and gave dreadful roar with open mouth and quivering tongue.[14]

The emperor's magical contrivances—the levitating throne, the roaring lions, the chirping bronze birds—must have been inspired by the writings of ancient Alexandrian scientists who had created mechanical wonders for the Ptolemaic court. It was in this environment of renewed interest in the past that an unknown goldsmith fashioned for a member of the Byzantine court a cylindrical silver-gilt inkpot with mythological figures on its body and the head of Medusa on the lid (fig. 3-3)—possibly copied from the *Tazza*.[15]

The inkpot has two engraved inscriptions. One, running under its rim, states "the holder of ink [is] for Leon every means of livelihood"; the other, on the bottom of the container, reads "Leon, the delightful marvel among the calligraphers." Four mythological figures separated by columns made of intertwined serpents decorate the body of the vessel: a seated nude and bearded man holding a sword is Ares; a winged boy approaching the warrior and offering him a helmet is Eros; a beardless man with a lyre and a plectrum is Apollo; and the seated man with a draped lower body and an inverted cornucopia is a river god. The choice of these figures reflects the associative and allegorical way in which antiquity was used by Byzantine artists in this era.[16]

Around the time of the inkpot's creation, Constantine's son, the twelve-year-old Romanos II, received as a gift two silver pens accompanied by verse:

Now sharpen, make ready your reeds, sharpen many thousands or tens of thousands. Prepare not weak reeds from tender blades, but make them all such as these are by nature,

Figure 3-3. Byzantine inkpot, gilded silver, 10th century.

strong from a silvered earth for writing of the worth of a golden race and of golden fingers. Have the vessel of red ink ready for use. Every nation and city of the enemy has come to be inscribed by your fingers, bending its neck to your scepter, which may lord over the earth from pole to pole; and the all-noble stock of Leo will rule until the end of time.[17]

The verse likened writing to conquest. The Eros and Ares on the inkpot likewise provided visual metaphors of conquering one's

readers and inspiring their love for the writer's offerings. Apollo's lyre, like an inkpot for a scribe, was a tool for persuasion and accomplishment. And the river god could allude to the flow of words, for Byzantines regularly compared writers (especially the Evangelists) to rivers or springs. Close to the time of the inkpot's manufacture, Leo Choirosphaktes praised a bath building restored by Leo VI by associating the river gods which decorated the structure with the rhetoric of the emperor: "Reject all babble of false words; Leo has now gathered all rhetorical eloquence."[18] Just as the textual scholars of this period collected and studied excerpts from ancient texts, so artists used classical images—drawing on various sources and combining figures as they saw fit, or fun. The tenth-century ivory box known as the Veroli casket, for example, was similarly adorned with snippets from classical mythology assembled for their loose thematic associations rather than narrative coherence: it showed the Rape of Europa as well as centaurs and maenads dancing to the music of Hercules on the lid; Bellerophon rejecting Queen Anteia and the Sacrifice of Iphigenia on the front; and a Dionysiac procession which included Venus and Mars on the back.[19] Some of these images may have been appropriate for a female owner of the box, but they did not add up to any story.

The models for the gods on the inkpot likely came from ancient statues still standing around Constantinople—the four figures being common classical types—or from books such as the popular *Bibliotheca* attributed to Apollodoros of Athens, a mythological compendium that supplied classical imagery to Byzantine artists. Patriarch Photios transcribed the epigram of this compilation: "Draw your knowledge of the past from me and read the ancient tales of learned lore. Look neither at the page of Homer, nor of elegy, nor tragic muse, nor epic strain. Seek not the vaunted verse of the cycle; but look in me and you will find in me all that the world contains."[20]

The serpent columns separating the figures on the inkpot were certainly based on a specific source. One of the most famous

monuments in Constantinople was a bronze column composed of three intertwined snakes supporting a gold tripod and caldron—a renowned votive offering from the sanctuary of Apollo at Delphi mentioned by numerous ancient writers including Herodotus, Thucydides, Demosthenes, Diodorus Siculus, Pausanias, and Plutarch. Constantine brought it to his capital in 324 AD and placed this trophy of his dominion over Greek history at the Hippodrome, where part of it still remains today. The maker of the inkpot depicted two, rather than three, snake heads atop each entwined column, probably using them as a shorthand, since it would have been hard to squeeze in one more head at an oblique angle on the already crowded body of the vessel. The one surviving snake head preserved at the Istanbul Archaeological Museum looks very similar to those on the inkpot in its dragon-like form and a long snout with serrated teeth.

The artist of the inkpot may well have looked at the *Tazza*'s Medusa in designing the lid—an image intended to guard the ink and protect Leon from bad writing and court intrigues. The latter were rife in Byzantium: Theodore Styppeiotes, who held the post of the Keeper of the Inkstand under Manuel I Komnenos in the twelfth century, received from the emperor as a sign of favor a gold inkwell adorned with precious stones. Envious of this preferment, a colleague denounced Theodore for treason and the Keeper was blinded in punishment.[21] Medusa's round visage on the inkpot, with dramatically undulating eyebrows, full cheeks, and fleshy cleft chin; the arrangement of the curls and the position and shape of little wings sprouting from the sides of her head; the way the image fills the entire space of the lid all resemble the appearance of Medusa on the *Tazza*. There were different ways to depict the gorgon in antiquity: in the sixth century BC artists gave her an ugly face with bulging eyes, protruding tongue, and fangs; in the fifth and fourth centuries BC a beautiful visage flanked by wreathing snakes became popular, appearing on fine metalwork, stone reliefs, and

coins.[22] It is possible that the maker of the inkpot looked at another image of Medusa, for it was a common motif that could have come from other sources. But the parallels between his image and that on the *Tazza* suggest this model, especially considering the history of Constantine's importation of ancient masterpieces to his city and the popularity of sardonyx vessels at the court of Macedonian emperors. All this makes it likely that the phiale was at the Byzantine court.

The imperial palace complex and its holdings provided its inhabitants with tangible links to the past. Constantine VII resided in the same building that had been occupied by the Byzantine emperors for hundreds of years. He used Roman dining couches, wore an archaic costume with Roman-style sandals, and had at his disposal the archives and objects that documented the lives and tastes of his predecessors for over a millennium. The luxurious artifacts preserved in the palace went back centuries and were brought out to add splendor to court ceremonies.[23] The anonymous author of a contemporary manuscript known as *Tarragonensis 55* noted that "all the relics of the palace are at all times showed to the faithful." One may assume that ancient treasures, many of which were treated as or actually converted into sacred objects, were likewise regularly displayed to those interested.[24] And so the *Tazza* was likely made accessible to the artist of the inkpot.

The *Tazza* would have resonated with Constantine VII and his entourage in a number of ways. Byzantine emperors and their courtiers relished splendid artworks. The interiors of Constantinopolitan palaces are gone, but contemporary royal residences elsewhere echo their magnificence. The apartments of King Roger's palace in Palermo, for example, were decorated by Byzantine artists with inlaid *cosmatesque* floors (made of small pieces of precious stones arranged into elaborate geometric compositions), patterned marble walls, and brilliant mosaics in the lunettes and vaulted ceilings. In dress, too, Byzantines strove for spectacular

effects: they wore richly embroidered robes accented with gold, gems, and enamels; and the emperor in particular carried a load of precious metals and jewels on the borders of his garments and in his crown. Visual opulence, intricacy, and conspicuous virtuosity were also manifested in the elaborate court ceremonials. In such an environment the *Tazza* would have been valued for its exquisite carving and rich pictorial effects achieved in exotic stone.

Stone carving became popular once again in this period.[25] Byzantines long prized hard-stones for their lustrous hues; now they began to carve them anew, and especially sardonyx vessels, a number of which are preserved at San Marco in Venice. These vessels have thick walls and far less elegant shapes than their ancient models, so the *Tazza*, along with other classical pieces, would have remained an invaluable treasure for its imperial owners and an unattainable ideal for court craftsmen.

Ivory and bone carving were likewise nurtured at the court of the Macedonian emperors, and the *Tazza* had affinities with this genre. To eyes accustomed to viewing and admiring reliefs executed in expensive and rare materials, the *Tazza* would have held an undeniable appeal. In addition, secular luxury objects, such as ivories and glass, were in this period frequently decorated with classical subjects. A glass cup made in Constantinople under one of the Macedonian emperors was painted with seven medallions containing figures of athletes and warriors, nude or draped in classical garments. They do not appear to be specific characters, but rather antique types. Like mythological figures on ivory boxes, or those on the inkpot, they displayed their owner's education, just as quotes from Homer and other Greek authors peppered the writing and speech of the Byzantine cultural elite.[26]

The *Tazza* also provided visual links to Byzantine icons. The Greek word *eikon* embraced painting as well as sculptural reliefs in different media. And a number of pagan gods had been turned into saints by medieval Christians. Early icons found in Syria and

Egypt venerated such divinities as Isis, Suchos (a water-god), Harpocrates (a god of silence holding a finger to his lips), and Heron (shown in a military dress with a gorgon head on his breastplate to ward off evil). Their worship must have continued for centuries as people prayed to them for health and safekeeping.[27] Could the figures on the *Tazza* have recalled for its imperial viewers the gods and "saints" of icons, shining with divine radiance against the golden hues of sardonyx as if against the painted icons' gold?

Besides all these visual associations, the *Tazza* would have offered Constantine VII a link to the golden age of his namesake who had placed Byzantium on the map and given it political and cultural preeminence in the ancient world—an accomplishment to which the Macedonian ruler aspired through his own diplomatic and intellectual efforts. It is unlikely that Constantine VII would have been able to discern exactly when and where the *Tazza* had been carved. But he could tell that it was the kind of superlative work that had been produced by the best masters of the past, the past which he was trying to bring back through his patronage of arts and letters. The *Tazza* could have thus beguiled him with a combination of its heritage, craftsmanship, numinous power, and imagery. And its splendor would have made him more regal. For, as one scholar of art and technology at the Byzantine court noted, "Daedalus didn't just make great things, he made great kings."[28]

Perhaps shortly after inspiring the maker of the inkpot, the *Tazza* went through a Christian conversion. Ancient artworks preserved in Byzantium underwent transformations of various kinds over the centuries. Constantine had legalized Christianity, but he had worshipped the old gods and collected works that had nothing to do with the new religion. Emperor Theodosios I in 380 AD proclaimed Christianity the official state religion and initiated a systematic suppression of pagan cults. He and his successor Theodosios II outlawed sacrifices at pagan altars and

decreed the closing of places of worship. But they ordered that pagan statues be saved for their aesthetic merits. A law passed in December 382 stated that "images . . . must be measured by the value of their art rather than by their divinity."[29] By being turned into artworks, pagan representations were stripped of their spiritual powers and made safe for viewing by Christians.[30] The fourth-century Roman Christian poet Prudentius exhorted his pagan contemporaries:

> You should give up your childish festivals,
> your laughable rites, your
> shrines unworthy of so great an empire.
> Oh noble Romans, wash your marble statues wet
> with dripping splatters of gore—
> let these statues, the works of great
> craftsmen, stand undefiled;
> let them become the most beautiful adornments
> of our native city—may no
> depraved purpose taint these works of art, no
> longer in the service of evil.[31]

At some point the *Tazza* would have similarly lost its significance as an expression of the benevolent protection that Isis and other Egyptian deities bestowed on the Ptolemaic dynasty, and then on the Roman rulers who controlled Egypt, and become just another beautiful artifact. Like other precious antiquities, it would have come to be viewed not as a sacred object, but a historical and cultural document—a representative of a tradition to which the fourth- and fifth-century Byzantines, who called themselves *Romaioi* (Romans), still traced their roots. For classical culture remained the standard by which the ruling and educated classes measured themselves.

As time went on, some ancient objects came to be perceived as works of magicians and containers of demonic powers—that

could, however, be harnessed to the benefit of their new Christian owners. Pagan statues might act as apotropaic images—and the *Tazza*, with its gorgon head, could have served this function very well. Other ancient artifacts received Christian interpretations. Statues of pagan philosophers were identified as Old Testament characters or Christian saints: in medieval book illustrations ancient thinkers appeared as toga-clad evangelists.[32] A Roman cameo stored in the Constantinopolitan palace treasury—originally carved to glorify Augustus and his clan—was reinterpreted as Joseph at the court of the pharaoh in Egypt. Charged with this meaning, the gem was set into a reliquary containing the remains of several saints.[33] Such conversions went on for centuries. Constantine I had not only imported old masterpieces to his city, but also commissioned new ones, including a great agate bowl measuring 29.5 inches in diameter. In the course of the Middle Ages there arose a legend that the name of Christ was miraculously inscribed into the veining of this agate and that the vessel was, in fact, the Holy Grail. The inscription proved finicky at best, appearing to some, invisible to most. But when the bowl came into the possession of the Hapsburg archdukes of Austria (likely brought to Europe by the Crusaders after the sack of Constantinople), it was put to use as a baptismal font and declared an inalienable treasure of the dynasty.[34]

A clue to the Christianization of the *Tazza* lies at the center of the bowl: in a hole drilled above the head of Isis and through the left side of Medusa's nose (fig. 3-4). We do not know when this disfigurement took place—perhaps during the reign of Romanos II, son of Constantine VII—but the most likely reason for the perforation is the attachment of a metal foot by which the pagan vessel was converted into a Christian chalice. Many ancient stone vases were refashioned into liturgical goblets through the addition of gold or silver feet and rims between the tenth and twelfth centuries. Several such hybrids, some of them made for

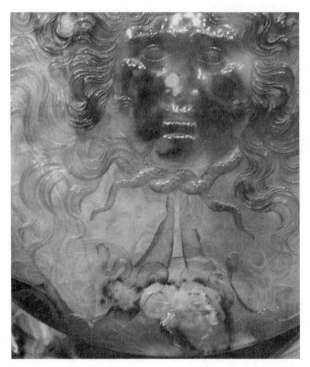

Figure 3-4. Tazza Farnese, detail of the hole drilled for attachment of a foot.

Romanos, were looted by the Crusaders from Byzantium in 1204 and brought to the treasury of San Marco in Venice and other European churches.

One of Romanos' chalices combined a sardonyx cup, carved sometime between the first century BC and first century AD, with a tenth-century Byzantine metal mount. On its rim enameled busts of Christ, the Virgin Mary, archangels, and saints appeared against the gold ground. An inscription on the foot—"Lord, hear the prayer of the true-believing emperor Romanos"—identified the vessel's owner.[35]

Another such goblet was acquired for his church treasury by Abbot Suger, the art-loving superior of the royal abbey of Saint Denis in France. The body of this chalice is a second- or first-century BC Alexandrian sardonyx cup exquisitely carved with delicate flutes; it is set in a twelfth-century silver-gilt mount adorned with pearls and gems (fig. 3-5). Suger did not record whence his cup came. It may have arrived in the West from the Byzantine royal treasury before the Fourth Crusade, or from elsewhere in Europe.

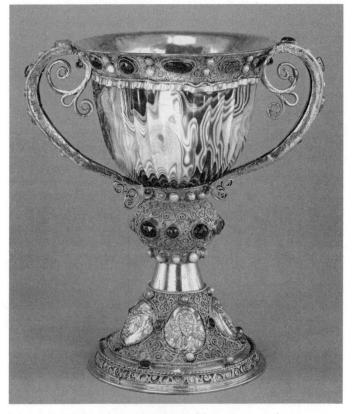

Figure 3-5. Chalice of the Abbot Suger of Saint-Denis, sardonyx cup, 2nd/1st century BC, in 12th-century gilded silver mount.

The abbey was inundated by dealers, their offerings so numerous that in Suger's words "the supply exceeded the demand."[36]

For Suger and his contemporaries, both in Europe and Byzantium, the value of the chalice lay not merely in its beauty, but in the spiritual connotations of its materials. Gold and precious stones were described in the Bible as substances reflecting the glory of God. In *Revelation* (21:11, 18–21) Heavenly Jerusalem was wholly composed of them:

> . . . and her light was like unto a stone most precious, even like a jasper stone, clear as crystal; . . . and the building of the wall of it was of jasper: and the city was pure gold, like unto clear glass. And the foundations of the wall of the city were garnished with all manner of precious stones. The first foundation was jasper; the second, sapphire; the third, a chalcedony; the fourth, an emerald; the fifth, sardonyx; the sixth, sardius; the seventh, chrysolyte; the eighth, beryl; the ninth, topaz; the tenth, a chrysoprasus; the eleventh, a jacinth; the twelfth, an amethyst. And the twelve gates were twelve pearls; every gate was of one pearl; and the street of the city was pure gold, as it were transparent glass.

Sardonyx, according to medieval theologians, particularly bestowed spiritual strength on its owner or user.

Beholding these materials brought the faithful closer to God. Suger described being transported from the mundane to the holy realm through his admiration of precious stones at Saint Denis:

> Often we contemplate, out of sheer affection for the church our mother, these different ornaments old and new . . . out of my delight in the beauty of the house of

God—the loveliness of the many-colored gems has called me away from external cares, and worthy meditation has induced me to reflect, transferring that which is material to that which is immaterial, on the diversity of the sacred virtues; then it seems to me that . . . by the grace of God, I can be transported from this inferior to that higher world.[37]

Gold and gems were, by extension, the most suitable offerings to God, and Suger was emphatic about the necessity of resplendence in divine service:

To me, I confess, one thing has always seemed preeminently fitting: that every . . . costliest thing should serve, first and foremost, for the administration of the Holy Eucharist. If golden pouring vessels, golden vials, golden . . . mortars used to serve, by the word of God or command of the Prophet, to collect the blood of goats or calves or the red heifer: how much more must golden vessels, precious stones, and whatever is most valued among all created things, be laid out, with continual reverence and full devotion, for the reception of the blood of Christ![38]

Some contemporaries, notably St. Bernard, Abbot of Clairvaux, objected that simplicity better expressed devotion, for splendor tempted the mind and soul away from God. Suger disagreed:

The detractors . . . object that a saintly mind, a pure heart, a faithful intention ought to suffice for this sacred function; and we, too, explicitly . . . affirm that it is these that principally matter. [But] we profess that we must do homage also through the outward ornaments of sacred vessels, and to nothing in the world in an equal degree as to the service of

the Holy Sacrifice, with all the inner purity and with all outward splendor. For it behooves us most becomingly to serve Our Saviour in all things in a universal way—Him Who has not refused to provide for us in all things in a universal way and without exception.[39]

Suger inscribed this striving to serve God in the most becoming manner on the very objects he acquired for His church. One precious ewer, for example, bore the verse,

Since we must offer libations to God with gems and gold,
I, Suger, offer this vase to the Lord.[40]

The Byzantine court and church wholly embraced splendor as a manifestation of divinity and honored God and his earthly representatives with utmost opulence, including rich liturgical objects.

A chalice, moreover, had to be the most precious of vessels because it contained the consecrated wine. Kept concealed until communion time, it was revealed by the deacon at the moment when the doors of the sanctuary were thrown open and the choir sang "Blessed is he that comes in the name of the Lord! God is the Lord and has revealed himself to us!" As the chalice was unveiled, its magnificence contributed to the mysticism of the occasion. Suger's sardonyx chalice was used to celebrate mass at the altar of the Three Martyrs—Saints Dionysus, Rusticus, and Eleutherius— the patron saints of the abbey and protectors of the French kingdom. To venerate God and the saints, the cup's rim was so densely bejeweled that no smooth surface was left for drinking the consecrated wine; it had to be sipped through special liturgical straws.

Ancient vases, finely carved from stones chosen for their beguiling colors, made perfect chalices, their beauty ideal for divine service. The hole at the center of the *Tazza* suggests that it was

treated with utmost care. Other than a carefully drilled opening for attaching a foot, no scars or scratches mar the stone. The goldsmith entrusted with converting the bowl into a chalice took great pains not to damage it. To make the cup stable on its mount, he may have obscured a portion of Medusa with a metal flange. But the figures inside would have remained visible, arousing admiration for their fine rendering in the emperors, their courtiers, and international visitors who had come to see the marvels of Constantinople.

The glory days of Byzantium came to an end in the opening years of the thirteenth century. In 1202 a great army of Western knights set out on the Fourth Crusade to liberate the Holy Land from the Infidel.[41] Alas, their commanders had significantly overestimated the number of participants when they first contracted with the Venetians to transport the crusaders across the Mediterranean. The Venetians had agreed to ferry the soldiers of Christ for a fixed price, based on a head count. When several thousand fewer men turned up (some of the crusaders embarking from other ports, others changing their mind about the whole venture), the Venetians insisted that they pay the full price, or there would be no crusade.

To the knights assembled in Venice, the financial burden was overwhelming and insurmountable. So when a pretender to the Byzantine throne, Prince Alexios, offered to pay for their passage to Jerusalem if they would first stop in Constantinople and put him in power, they agreed—not without misgivings, but with little choice. Once on the throne, Alexios changed his tune. He did not possess the resources to fulfill his promise, and his courtiers insisted that he turn the crusaders away. Enraged by his treachery and desperate to be paid and get on their way to Jerusalem, the Europeans, led by the Venetians, besieged Constantinople and sacked it in April 1204.

Having turned the fury of the Crusade from the infidels to their fellow Christians, the Franks, as the Byzantines called them, proceeded to reap spoils of astonishing richness. As Robert de Clari, one of the participants of this event, recorded:

> never since the world was established was so great wealth, or so noble, or so magnificent, either seen or won—no, not in the days of Alexander, or of Charles the Great [Charlemagne], or before, or after. Nor do I believe, of my own knowledge that in the fifty richest cities of the world could there be so much wealth as was found in the body of Constantinople.[42]

Entering the capital, the crusaders went on a rampage: they killed and raped the inhabitants, ransacked homes and churches, stripped the royal palace, and destroyed ancient masterpieces throughout the city. An eyewitness described these "war-maddened swordsmen, breathing murder, iron-clad and spear bearing, . . . baying like Cerberus and breathing like Charon, pillaging the holy places, trampling on divine things, . . . casting down to the floor the holy images of Christ and His holy Mother . . . "[43] They did not shy from ravaging the basilica of Hagia Sophia nor from carting away the contents of the imperial treasury. As they sailed home, giving up on Jerusalem altogether, their ships were weighted down with the most opulent loot.

Although Byzantine emperors had presented stone vases to Eastern and European rulers over the centuries, and may have done so with the *Tazza*, it seems more likely that the bowl would have left Byzantium—like so many other riches of the city—as a captive, pillaged from the imperial palace and transported to Europe in 1204 or shortly thereafter.

"A LARGE DISH OF ONYX" IN THE HOLY ROMAN EMPIRE

You may turn over and search through the history of the Caesars, starred with deeds of incomparable greatness, described in ancient chronicles and annals, you may scan the acts of individual Emperors, but the most diligent seeker will not find a gentle generosity comparable to ours wherewith God hath inspired us.

—Frederick II[1]

On November 4, 1239 a pair of Provencal merchants arrived at the court of Frederick II Hohenstaufen at Lodi, in Lombardy, where he was at war. According to his daily court register, they offered him an extraordinary object: a large dish of onyx (*unam magnam scutellam de Onichio*). The asking price was enormous, while Frederick's economic situation was precarious: he was deeply in debt, having long been embroiled in a conflict with the pope and the Lombard League, and in no position to make expensive purchases. Yet he bought the dish and some gems for 1,230 ounces of gold.[2]

Frederick II, the Holy Roman Emperor, was theoretically the most distinguished ruler in Europe, his domains extending over modern-day Germany, the Netherlands, Austria, Poland, the Czech Republic, Slovakia, France, Italy, Malta, Cyprus, Israel, and Lebanon. In reality, however, he struggled for political survival and, as a result of his complicated inheritance, did so on three fronts. Through his father, Emperor Henry VI Hohenstaufen, he reigned over northern Europe. Through his mother, Constance, the daughter of Roger II, the Norman king of Sicily, he claimed control not only of the island of that name but of much of Southern Italy, from the tip of the peninsula to the doorstep of Rome.[3] This vital territory commanded trade routes across the Mediterranean and grew widely exported wheat. Frederick spent his childhood in the royal palace at Palermo, and Sicily was his home. In the words of one contemporary, it enjoyed "an extreme fertility and abundance of victuals; indeed the whole island in this regard is one of the most remarkable in God's creation."[4] But Frederick was not able to settle there peacefully for long stretches of time. As did many medieval rulers, he led an itinerant life, journeying to his northern lands, fighting with his enemies elsewhere in Italy, and embarking on a Crusade to Jerusalem, which he claimed through his marriage to Yolande de Brienne. Frederick's far-spread domains were not easy to control, and he spent much of his reign seeking to consolidate his authority with ever insufficient resources. Because the German princes begrudged him troops, he could never raise a large army, nor did his southern kingdom provide him with adequate supplies. He never had more than 15,000 men at his disposal at one time, and few of them were trained soldiers, so even small city militias of northern Italy, protected by their defensive walls, could resist his army for months.

Frederick's greatest problem, however, was the papacy. As the Holy Roman Emperor, he claimed superior powers; the popes did the same on spiritual grounds. Their contest divided Italy into the

Ghibelline (pro-imperial) and Guelf (pro-papal) factions. Frederick's struggles with the papacy spanned several pontiffs, of whom his bitterest enemy, Gregory IX, called the emperor the Antichrist and excommunicated him twice—for not going on a Crusade when he promised to, and then for going after all, but without papal blessing.

Despite these troubles, or in part because of them, Frederick was keen to assert his imperial dignity. An eager reader of "histories," he cultivated his image as an heir of the great rulers of the past: Justinian, Constantine the Great, Julius Caesar, and especially Augustus, who had brought the golden age to Rome.[5] The lack of a Byzantine sovereign in Constantinople after its sack in 1204 made it easier for Frederick to claim to be the Roman emperor of his era.

Although medieval Europeans felt a certain sense of continuity between the Roman Empire and themselves, they knew that the golden age had long passed and yearned for its return. Frederick was not the first or only ruler who sought to emulate the illustrious monarchs of the past, but he did so more deliberately than his predecessors.

Aiming to revive Roman rule across the Mediterranean, in 1228 he embarked on a Crusade to reclaim Muslim-occupied Jerusalem for Christendom—without the pope's approval. Remarkably, he succeeded without armed struggle or bloodshed. Frederick was a man of great industry and energy, constantly exercising his mind and body. Of moderate height and strong build, he was myopic and balding, but his remaining red hair, beard, and ruddy cheeks enhanced his spirited expression. A skilled rider and fighter, he wielded the bow and the sword with great dexterity. But when it came to winning Jerusalem, he did so with words, through diplomacy with the Ayyubid Sultan of Egypt, al-Kamil, who controlled that territory and wanted to reach an agreement with the Christians in order to focus his attention on struggles against his opponents further East.[6] Jerusalem, to him, was not a great loss. A desolate city with

little economic importance, it was rich only in religious symbolism. So the sultan ceded it to the emperor without fighting (on the condition that the city remain unwalled and thus defenseless). He also gave Bethlehem and Nazareth to Frederick, and a narrow corridor to the sea. Frederick capitalized on this agreement by taking credit for regaining for Christendom the sites of the Annunciation, Nativity, and Crucifixion. European reaction to his achievement, however, was mixed. A Crusade was meant to be an arduous undertaking: dangerous, bellicose, and punishing to the infidel. To retake the Holy Land without Muslim losses struck many as a hollow victory.

But the emperor went on to maintain amicable relations with the Egyptian sultan long after the Crusade, not just for diplomatic reasons, but for the sake of knowledge. An inquisitive man, he was a great proponent of learning. He is said to have spoken French, German, Italian, Latin, Greek, and Arabic (his linguistic skills a testament to the cosmopolitan population of the Kingdom of Sicily), and he was interested in law, medicine, natural history, and philosophy. He founded the University of Naples in 1224 and carried on a widespread scientific correspondence, including with the sultan.[7]

Frederick expended relatively little effort or money on his palaces and their embellishments—perhaps because his finances were strained by constant wars. Instead, he focused on what most conveyed his imperial authority. In 1231 he minted gold coins called *Augustales* (fig. 4-1). Modeled on the Roman *aurei*, they showed his likeness on the front—in profile, crowned with a laurel wreath, and dressed in a Roman breastplate—and the imperial eagle on the reverse. Such self-consciously classicizing currency was innovative, and its inscription declared Frederick's ambition: CES/AVG/IMP/ROM—*Caesar Augustus Emperor of the Romans*. The *Augustales* circulated widely in Italy, spreading Frederick's prestige and influencing the revival of gold coinage elsewhere in Europe.

Figure 4-1. Frederick II Hohenstaufen, gold *Augustale*, 13th century.

The emperor pursued a similar program through his one major architectural project—the gate to the city of Capua. A key Roman town in antiquity, Capua had prospered by growing grain, making wine, and manufacturing prized bronze artifacts. Campania, of which it was the capital, was also the home of gladiatorial schools: Spartacus was trained in one of them. In Frederick's day Capua, situated on the Via Appia that ran from Rome to Brindisi, marked the beginning of the kingdom of Sicily, and the gate was intended to set the tone for his territory and rule, proclaiming the restoration of the Roman Empire. The structure was modeled on Roman prototypes: Porta Ostiensis, Porta Appia, the Arch of Constantine in Rome, and the Arch at Rimini erected by Augustus to commemorate his change of name from Octavian in 27 BC. The Capua gate, built of squared marble blocks likely taken from Roman ruins in the area, had two towers and a chamber over the opening adorned with classicizing figures of Justice, enthroned Frederick, and his ministers who implemented his laws.

Frederick had a very personal relationship with Roman monuments: he actually owned many of the ancient buildings of Rome. To strengthen his authority in central Italy and to counteract the antagonism of the pope, he had begun, after his victory over the

Lombards in 1236, to court Roman patricians by giving them posts in his administration and making them his vassals. As part of binding them to himself, he bought their property, then granted it back to them as fiefs. Many of the fortified residences of Rome's aristocratic clans incorporated ancient buildings: the Colonna owned the Mausoleum of Augustus, the Frangipani had appropriated the Colosseum, the Arches of Titus and Constantine and the Septizonium of Septimius Severus likewise formed part of private castles. As Frederick acquired these buildings (which made their owners happy, for they continued to inhabit them and be paid for it), he came to possess the foremost antiquities of Rome.[8] In this way he secured for himself the Rome of the Caesars, and, by including Roman patricians in his imperial bureaucracy, he could claim that his empire was ruled from Rome by descendants of the ancient senatorial class. Frederick also celebrated his military victories in a Roman manner: following his triumph over the Lombards in 1237, he paraded his booty, trophies, and prisoners through the streets of Cremona. The Capua gate, by alluding to Roman monuments and traditions through its form, statuary, and ancient blocks reused in its construction, communicated to Frederick's Sicilian subjects and Roman vassals his political and military aspirations and achievements.[9]

Frederick sought further connection with the past by acquiring antiquities from a variety of sources: he brought to Lucera from Grottaferrata a bronze statue group showing a man with a cow, which he turned into a fountain, and from Naples to Lucera certain *imagines clipeatae* (portraits affixed to Roman shields). He installed two bronze rams, possibly found in Syracuse, at the entrance to that city's Castello Maniace.[10] In 1240 he issued permits for excavations near Augusta, a new town he founded in 1232 close to the Greek city of Megara Hyblaea, seeking not only building materials, but interesting finds, especially in the ancient cemeteries. Royal documents also mention "stone statues brought

in the galleys, and now in the castle at Naples." In 1241 he took to Palermo from San Vitale in Ravenna two onyx columns and "other blocks."[11] And he paid handsomely for fine artifacts such as the great onyx dish. Although his court register does not provide a detailed description of this object, it could well have been the *Tazza*, given the description of its size and stone (many mentions of the phiale in later records use similar words without specifying its decoration), the scarcity of other surviving objects that fit this profile, and Frederick's passion for gems.[12]

The Emperor was a great lover of cameos and intaglios. These preeminent artworks of the classical world survived more or less intact—unlike buildings, sculptures, paintings, or textiles—and conveyed the majesty of the Romans and Greeks. Medieval Europeans did not have a romantic fascination with ruins: for them a broken object was just that. It had lost much of its value and aesthetic appeal. As one historian put it, "What the medieval mind chiefly sought in the remains of the past was—in contra-distinction to modern romanticism—the permanent form, the opposite of the ruin. The flawless appearance of ancient stones, their transparency, their stern resistance to corrosion or patina, which secures the permanence of the shape once assigned to them, fully corresponded to the medieval idea of the beautiful."[13] The contemporary philosopher and theologian Thomas Aquinas, in defining the beautiful, stated that it should have "in the first place integrity or perfection: things impaired are ugly for that very reason."[14]

Gems, thanks to the hardness of their material, tended to remain fairly whole and handsome. Frederick collected with zeal ancient cameos, intaglios, and stone vessels, and nurtured the revival of their manufacture. The *Noah* cameo, now in London, was almost certainly produced at his court and demonstrates the superb quality of work he sponsored (fig. 4-2).[15] Carved from onyx, it depicts the Biblical patriarch, his family, and animals emerging from the Ark after the Flood. The artist clearly knew

Figure 4-2. The Noah cameo, onyx, 13th century.

classical gems and sculptures and used them as models for his fig-
ures and drapery. And he did so with Frederick's urging, for the
Emperor was keen on such borrowings: his likeness on his gold
Augustales drew inspiration from Roman coins as well as from an
ancient cameo of Augustus that had been inserted into a cross at
Aachen cathedral, where Frederick was crowned in 1215. Not
wanting to be separated from his gems, the Emperor took many
of them with him on the road.[16] In 1235, on a trip to Germany,
the contemporary chronicler Salimbene de Adam recorded, "he
progressed with the utmost pomp, and many *quadrigae* [chariots]
followed him laden with gold and with silver, with byssus [extremely
fine fabric made from silky filaments secreted by mollusks] and
with purple, with gems and costly vessels." His trains also included
camels, leopards, apes, Saracens, and Ethiopians, the latter two

guarding his possessions.[17] In February 1248 Frederick lost a significant portion of his valuables when they were captured by his enemies as he failed to subdue Parma.[18] Yet he still retained a great deal.

Frederick loved ancient gems for their beauty, but even more for their direct links to the Roman Empire he strove to revive. The "large dish of onyx" arrived at his court at a difficult time: he was in the middle of the war with the Lombard League, an alliance of northern Italian cities fighting against the Holy Roman Emperor ever since the time of Frederick's grandfather, Barbarossa, who had first sought to assert his power over Italy. Frederick had been wrestling against the League over the same issue since 1226, had won a few battles against it, but had failed to bring it into submission. In September 1239 he was hoping to conquer Milan, but its citizens refused to engage in a confrontation, and Frederick felt that he could not take such a large and well-fortified city by siege. So he withdrew south, first to Lodi, then to Cremona, where he learned that Como, a town harboring ill-feelings toward Milan, was ready to side with him. It was at that point, on November 4, that the pair of Provencal merchants, named in the imperial *Regestum* as Gusbertus de Turano and Bernardus de Lyes, arrived with an offer of the striking onyx dish.[19] As we saw in the previous chapter, the *Tazza* likely traveled west following the sack of Constantinople in 1204, when ancient gems and vases flooded Europe. It is possible that the two traders acquired the bowl on what must have been a thriving market for such *spolia*, whether on the shores of the Mediterranean or elsewhere in Western Europe.

Frederick's registers in the late 1230s note a constant shortage of funds "especially since money is now necessary to us for the current struggle in Lombardy." One entry records that a royal page could not be provided with four ounces of gold as payment for two squires and three horses required for an imperial errand "since in our Chamber there is not at present enough money to pay his

expenses."[20] Another entry details that while at Lodi, Frederick borrowed some 2,270 ounces of gold from twenty Roman bankers to disburse to his troops. A few days later in Cremona he offset his debts by selling grain from his Sicilian territories. On the whole, in the fall of 1239, Frederick was 24,653 ounces of gold in debt and struggling to procure funds to cover even the smallest expenses. Yet he paid 1,230 ounces of gold for the *Tazza*.

The Emperor is unlikely to have understood what the bowl originally represented. Its allegorical figures keep modern scholars, equipped with far greater knowledge of ancient culture, debating, and he did not have their learned resources at his command. He probably would have taken it for a Roman work, having many reasons to wish it to be Augustan, perhaps even a masterpiece once owned by his role model. He was well aware that ancient gems were of superb quality and the *Tazza* was by far the best of such artifacts. And he could have known, from Pliny and Suetonius, that Augustus used a gem carved with a sphinx as his personal seal, and so may have concluded that the *Tazza*, with its prominent sphinx at the bottom of the tondo, had belonged to Augustus. Majestic and as fresh as when it was first made, the *Tazza*, for Frederick, would have been a pristine and magnificent relic from the era he aspired to revive.

Many, if not most ancient gems, however, were in his day reinterpreted as Christian subjects. Frederick was certainly familiar with and fond of classical imagery, imitating it in his coins, sculptures, buildings, and gems. And he may have guessed that the figures on the *Tazza* were pagan deities. But he may also have re-thought them as Christian saints. By reading ancient works through the lens of Christianity, medieval Europeans neutralized pagan gods and reclassified them as Christian ones.[21] Frederick himself did so with classical gems in his collection. He owned a Roman cameo depicting the contest of Poseidon and Athena over the control of

Attica—a composition that reflected the sculptural group on the west pediment of the Parthenon in Athens (fig. 4-3). He had his court artist carve another version of this gem, with a significant alteration: Poseidon and Athena were turned into Adam and Eve (though preserving their attire, including Athena's helmet); the olive tree became the Tree of Knowledge; and the god Erechtheus took the role of the Snake (fig. 4-4). An appropriate biblical verse (*Genesis* 3:6) was carved around the new cameo to clarify its revised meaning. Perhaps Frederick perceived the original gem, too, as a Biblical scene.[22] Christian glosses saved many ancient works from destruction. Most famously, the equestrian statue of Marcus Aurelius in Rome was not melted down in the Middle Ages because it was thought to depict the "Christian" emperor Constantine. The story of

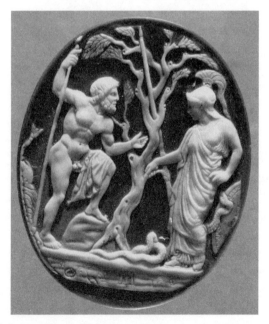

Figure 4-3. Poseidon and Athena, sardonyx cameo, 1st century BC.

Figure 4-4. Adam and Eve, onyx cameo, 13th century.

the so-called *Three Kings* cameo illustrates how gems underwent these conversions (fig. 4-5).

In 1162 Frederick's grandfather, Barbarossa, captured Milan. As part of his booty he took from the city the relics of the Three Kings—the Magi who came to pay their respects to the infant Jesus. He sent his prize to Cologne Cathedral, and before long the sacred remains were encased in a spectacular gold and silver container shaped like a church, adorned with a profusion of holy figures set in niches, and studded with jewels and 304 engraved gems, many of them ancient. The artist of the casket, Nicolas de Verdun, created the largest reliquary in the Christian world: 43 inches (110 cm) wide, 60 inches (153 cm) high, and 87 inches (220 cm) long. It was completed after his death, around 1225, and to the front of it was affixed a large cameo carved with two decidedly pre-Christian heads, quite likely of

Figure 4-5. Three Kings Cameo, onyx. Also known as the Ptolemäer-Kameo.

a royal couple from the Hellenistic or early Imperial era (scholars debate its date).[23] Where this gem came from is unknown, but it may have been another plunder from Constantinople.

The custodians of the shrine in Cologne and the pilgrims who flocked to venerate the relics of the Magi interpreted the cameo as a representation of the Three Kings, taking the queen for a male and a small head of a satyr on the cheek-piece of the man's helmet for the third magus.[24] Albertus Magnus, a thirteenth-century scholar and philosopher whose relics would also end up in the Cologne Cathedral, described this gem in his book on minerals (*De mineralibus* 2.3.2):

> There is at Cologne, at the shrine of Three Kings, an onyx of large size, having the breadth of a man's hand or more,

and on it, upon the material of the onyx stone, which is like a fingernail [in color], are pictured in pure white the heads of two young men; so that one is behind the other, but the nose and mouth project enough to be seen. And on the forehead is pictured a very black serpent which connects the heads. And on the jaw of one of them, just on the angle of the curve of the jaw-bone, between the part that comes down from the head and that which is bent toward the mouth, is the head of an Ethiopian, very black, with a long beard.... I have proved that this is not glass but stone, and therefore I have assumed that this picture was made naturally and not artificially. Many others like this are found. Nevertheless it is no secret that such images are sometimes made artificially.[25]

Albertus and his contemporaries believed that certain constellations of stars and planets had the power to produce animals and stones in human shape. He also thought that onyx was either a gum from trees or a mixture of earth and water, both materials being fluid enough to be molded by the stars before solidifying. Although Albertus knew that cameos were carved by men—also directed by the stars—the *Three Kings* cameo seemed to him too perfect to be fashioned by a mere human. On the Cologne shrine, moreover, the gem was affixed to a plate covering an opening through which, on certain days, the faithful could see the heads of the Three Kings inside. When the opening was closed, visitors saw the holy figures carved in onyx. It was appropriate for such sacred images to have been created miraculously. So Albertus' analysis made sense in its context.

Frederick could well have interpreted the *Tazza* as a Christian scene as well—perhaps a Nativity. He could take Isis for the Virgin Mary (the Egyptian goddess was viewed as such on gems on which she appeared nursing her son Horus); the adult Horus above her

was akin to the triumphant Christ (in the early centuries of Christianity he was depicted in various ways, including as a beardless young man with curly hair); the Nile looked like Joseph; the women on the right resembled maids attending the Virgin; and the breezes were like angels announcing the birth of Christ. If the *Tazza* was still set in the mount that made it into a chalice, its Christianized reading would have been doubly appropriate: for Christ took on human form when he was born to the Virgin Mary, and through his blood, drunk from the chalice during the Mass, he brought redemption to mankind. Such a reading would have also suited Frederick's Augustan orientation. For Augustus was the emperor under whom Christ came into the world. The *Tazza* would thus have been an ideal object for the Emperor, combining both Holy and Roman elements.[26]

And then there was the stone itself and its connotations. Medieval thinkers, like their ancient predecessors, read magical, as well as Christological, meanings into sardonyx. Among the stone's virtues they listed its abilities to satiate thirst and foster sight, make one pleasing to men and God, and do away with vice. According to the twelfth-century *Lapidary* of Marbode, one of many books detailing the properties of minerals:

> Sardonyx has three colors: the underneath is black, the middle white, and the above red. It represents those who support in their hearts the pains of the passion in the name of Christ; and inside the soul they are white, that is to say, without hypocrisy, although they themselves are despised by themselves and seem almost black themselves, that is to say, sinners.[27]

Other Christian writers equated the reddish hue of sardonyx with fire, blood, and earth, which they translated into Christ's human nature, Passion on the Cross, the Last Judgment, and redemption.

Thus it was a perfect stone for a scene depicting the salvation of mankind through Christ's birth.

Given so many resonances inherent in the *Tazza*, Frederick would have been thrilled to have it. And he could well have carried it with him as he moved from place to place, dividing his time between different residences in Sicily, waging wars against the Lombard League, or visiting his German lands. His imperial dignity at stake, Frederick brought an array of treasures wherever he went: jewels and carved stones, books from his library, rare beasts. These traveling possessions were by no means outlandish. Exotic animals and gems were fabulous specimens that endowed their owners with a magical aura.

It is unlikely that the Emperor would have parted with the *Tazza* willingly. He may have lost it to the Parmese in 1248, or left it in his treasury upon his death, from dysentery, in 1250. In 1253, his son Conrad IV, struggling to maintain power, sold or pledged as security against a loan extended by the Genoese the remaining gems of his father—547 intaglios and 133 cameos. Among the items listed in this transaction was a vase of onyx and chalcedony trimmed in gold. Might it have been the *Tazza* still encased in its medieval mount?[28]

For the following century and a half we lose track of the bowl entirely. No documents shed any light on its whereabouts. It is, therefore, all the more surprising to find it next in an entirely different part of the world.

5

TIMUR, WORLD CONQUEROR
AND CONNOISSEUR

And this is a sample of his pomp and magnificence and
vehement pride and arrogance and majesty: the kings and
sultans of surrounding countries . . . came to him and
offered him gifts. . . . The hyacinth was brought to him
from Balkhshan and the turquoise from Nisabur, Kazarun
and the mines of Khorasan and the ruby from India, and
from India and Sind the diamond and the pearl from
Hormuz and silk and down and agate and musk and
other things from Cathay.

—Ibn Arabshah, *Tamerlane*[1]

I n January 1401 Timur, the Mongol warlord also known in the
West as Tamerlane, arrived at the gates of Damascus. Laying
siege to the city, he promised to spare its inhabitants if they surren-
dered. When they did, he declared his amnesty void and proceeded
to rape, kill, and extort their wealth. At one point during the as-
sault he offered the distraught citizens a chance to save themselves

by taking refuge in the Great Mosque. When the shrine filled to capacity, he ordered the building surrounded with wood and ignited, incinerating everyone within. Then he set the rest of the city alight.[2]

A year earlier, during his sack of Sivas (in central Turkey), the citizens of that town proposed to surrender if Timur would avoid bloodshed. He accepted their condition and collected the tribute he had demanded. But as soon as the inhabitants marched out of the city, he dug great holes before its ruined walls and announced that while he had promised not to shed their blood, he did not propose to spare them. He buried them all alive and set his men to pillage and destroy the city. And in Smyrna (modern Izmir) in 1402, having massacred all the citizens, Timur chopped off their heads and piled them into two enormous towers. He did so after wiping out other cities as well. At Isfahan in 1388, in retaliation for the inhabitants' attack on his tax collectors, he erected some thirty such towers, each composed of 1,500 heads.[3]

Timur's ruthlessness was exacerbated by his ambition: to emulate and surpass his great model—Genghis Khan, the Mongol warlord who in the twelfth and thirteenth centuries had conquered Central Asia and China with unspeakable brutality.[4]

Timur (or Temur, which means iron), came into the world in April 1336 in Kesh, a small town in Transoxania (now southern Uzbekistan), a sparsely populated region in Central Asia bounded by the rivers Amu Darya and Syr Darya (the Oxus and Jaxartes of classical sources; in the Middle Ages they were considered to be two of the four rivers of Paradise). A rugged place, with the Zarafshan Mountains rising over the wide steppes, it was scorching hot in the summer and bone-chilling in the winter, breeding hardiness and harshness into its inhabitants.

Timur's family was minor nobility that traced its roots to the hordes of Genghis Khan. Nomadic folk, they moved seasonally

between prairies and mountain slopes southwest of Samarqand, impervious to hardship. The Spanish ambassador Ruy Gonzalez de Clavijo, who visited Timur in 1402, recorded that they "suffer cold and heat and hunger and thirst more patiently than any other nation in the whole world: when food is abundant they gorge on it gluttonously, but when there is scarcity, sour milk tempered with boiling water suffices them . . . for their cooking fires they use no wood, but only the dried dung of their herds, and it makes the fire for all purposes of roasting and boiling."[5]

Timur spent his youth on the road, honing his fighting skills in brigandage and cattle theft. One of his raids marked him for life. According to Clavijo:

> one night that he was engaged carrying off a flock of sheep, [the men of Sistan] fell on him suddenly and slew a great number of his men. Him too they knocked off his horse, wounding him in the right leg, of which wound he has remained lame all his life [whence he was sometimes called Timur the Lame]; further he received a wound in his right hand, so that he has lost the little finger and the next finger to it.[6]

These injuries were confirmed by Soviet archaeologists in 1941 when Stalin ordered a team of scientists to open Timur's mausoleum in Samarqand. An inscription cut into a slab of onyx covering the tomb warned that whoever dared disturb the burial would bring the demons of war onto his land. Fearing Stalin more than Timur, the archaeologists proceeded to break into the sarcophagus on June 22. That same day Hitler invaded Russia.[7] Still the scientists carried on their work, meticulously studying Timur's body, and one of them, Mikhail Gerasimov, created a forensic portrait from the bones (fig. 5-1).[8] The resultant face shows resolutely folded wide lips, high and broadly spaced cheekbones, and small

eyes buried in deep pouches and folds. Timur appears resolute and merciless.

The Syrian historian Ahmed Ibn Arabshah, captured by Timur during the sack of Damascus, described him as tall and stout, with broad shoulders, long legs, and lameness on his right side. He had a big head and brow, a long beard, piercing eyes "like candles, but without brilliance," and powerful voice. Though nearly seventy at the time, he "was firm in mind, strong and robust in body, brave and fearless, like a hard rock."[9] According to Gerasimov's

Figure 5-1. Forensic reconstruction of Timur by Mikhail Gerasimov.

report, Timur was indeed a well-built man of about 5′ 8″. His right thighbone had merged with his kneecap after his injury, so he dragged his right leg when he walked, and his left shoulder rose above his right one. He also had wounds in his right hand and elbow. But these handicaps did not slow him down.

Timur rose from an obscure bandit and thief to a world conqueror by being not merely a thug, but a clever strategist. Gathering a band of steadfast supporters and skillfully forming alliances with various strongmen in the region, he gradually amassed sufficient power to surpass his competitors. Emerging victorious among them, he appointed personal followers and family members to serve in key political positions, linking their advancement to his own and so assuring their obedience. By placing authority in the hands of men he could trust, Timur created a new military and ruling class loyal directly and exclusively to him.

This strategy afforded Timur the freedom to extend his control further through campaigns and conquests, to which he devoted the rest of his life. Crisscrossing Eurasia from Delhi to Moscow, from the T'ien Shan Mountains of Central Asia to the Taurus range in Anatolia, he vanquished a host of nations.[10]

The Tatar manner of fighting was very dangerous, as a fourteenth-century observer recorded:

> in one Tatar battle or skirmish there are more slain or
> wounded than in any great conflict between other nations,
> which results from their archery, for they shoot strongly
> and surely, . . . pierce all kinds of armor, and if they happen
> to be routed . . . they shoot arrows backwards in their flight
> . . . wounding both men and horses that pursue them.[11]

Timur's armies, moreover, consisted not only of men, but also women who, according to Ibn Arabshah, "overcame mighty heroes in combat with the thrust of the spear, the blow of the sword and

shooting of arrows." They gave birth to their children on the march and promptly returned to battle.[12]

With the help of this indomitable army and the terrible uses to which he put it Timur subjugated vast and disparate lands. By ordering his soldiers to kill most of the inhabitants of the cities that resisted his sieges he warned others to submit and pay vast ransoms to avoid a similar fate. As he left the humbled towns for his next target, he did not set up strong local governments to safeguard his victories. Instead, if the towns rebelled after his departure, he returned and exacted a still more savage toll. Thus he controlled his subjects, keeping his soldiers too busy and his victims too dispirited to threaten or thwart him.

It is hard to imagine such a man moved by beauty—and by such a refined object as the *Tazza*. And yet Timur had a taste for art, and he apparently acquired and cherished the ancient Ptolemaic bowl.

Timur aspired to more than military triumphs. A man of astute intelligence, he was, in the words of Ibn Arabshah:

> a debater, who by one look and glance comprehended the matter aright, . . . he discerned keenly between truth and fiction, and caught the sincere counselor and the pretender by the skill of his cunning, like a hawk trained for the chase, so that for his thoughts he was judged a shining star.[13]

The Arab historian Ibn Khaldun, who met Timur in 1401 during the siege of Damascus, was likewise impressed by the conqueror's active mind: "he is highly intelligent and very perspicacious, addicted to debate and argumentation about what he knows and also about what he does not know."[14] Ibn Arabshah—not a fan of the destroyer of his native city of Damascus who forced him to relocate to Samarqand—wrote admiringly:

Timur loved learned men, and admitted to his inner recep-
tion nobles of the family of Mahomed; he gave the highest
honor to the learned and doctors and preferred them to all
others and received each of them according to his rank and
granted them honor and respect; he used towards them
familiarity and an abatement of his majesty; in his argu-
ments with them he mingled moderation with splendor,
clemency with rigor and covered his severity with kindness.[15]

Timur understood the symbolic importance of high culture and
made full use of it to turn himself from an erstwhile cattle thief
into a respected ruler. He brought to his court specialists in math-
ematics, astronomy, and medicine and established a position of
Story-Reader, who read to him accounts of great men of the past.
Inb Arabshah praised Timur's interest in history, though with a
tinge of venom. Timur, he wrote:

> was constant in reading annals and histories of the prophets
> of blessed memory and the exploits of kings and accounts
> of those things which had formerly happened to men
> abroad and at home and all of this in the Persian tongue.
> And when readings were repeated before him and those
> accounts filled his ears, he seized hold of that matter and so
> possessed it that it turned to habit, so that if the reader
> slipped, he would correct his error, for repetition makes
> even an ass wise. But he was illiterate, reading, writing and
> understanding nothing in the Arabic tongue, but of Per-
> sian, Turkish and the Mogul language he understood
> enough but no more.[16]

Keen to inscribe himself into the roster of world leaders and to
inform future generations of his achievements, Timur had his own
deeds scrupulously recorded and exalted. Wherever he went, he

was accompanied by secretaries charged with writing down his every utterance and action.[17]

In addition to a written chronicle of his successes, Timur strove to leave a visual mark of his greatness.[18] Unlike his nomadic forbearers, he erected noble buildings, commissioned books, ordered and transported from vanquished cities a range of luxurious objects. Among these signs of his glory appears to have been the *Tazza*.

When Timur captured a city, he looted whatever was valuable in it, including artworks, carting them to Samarqand, his capital, to reflect his power. And while he slaughtered most of the inhabitants, he spared scholars and artists, leading them away to create masterpieces in his honor. Fifteenth-century Arabic, Persian, and European writers commented on the vast numbers of craftsmen forcibly transferred from Iran, Syria, Anatolia, and India. In Clavijo's account,

> during all his conquests . . . he carried off the best men of the population to people Samarqand, bringing thither together the master-craftsmen of all nations. From Damascus he carried away with him all the weavers of that city, those who worked at the silk looms. Further the bow-makers who produce those cross-bows which are so famous; likewise armourers; also the craftsmen in glass and porcelain, who are known to be the best in all the world. From Turkey he had brought their gun-smiths who make the arquebus, and all men of other crafts . . . such as the silver-smiths and the masons. These all were in very great numbers.[19]

From Persia came poets, calligraphers, painters, musicians, and architects. After conquering Delhi, Indian masons and gemcutters added their expertise to the artistry of Samarqand. "In short," wrote Ibn Arabshah, "Timur gathered from all sides and collected at Samarqand the fruits of everything; and that place accordingly had in every wonderful craft and rare art someone

who excelled in wonderful skill and was famous beyond his rivals in his craft."[20] These artisans put at Timur's disposal major artistic and literary traditions of the Eastern world, endowing him with their culture.

Timur actually saw Samarqand only sporadically, arriving there loaded with plunder from his conquests, celebrating his victories at sumptuous banquets, giving personal instruction to his builders and artists, and departing for the next war. But he took keen interest in the beautification of the city. His biographer Sharaf ad-din Ali Yazdi, in *Zafarnama* (The Book of Victory), commended Timur's patronage of the arts among his accomplishments: "Courage raised him to be the supreme Emperor of Tartary, and subjected all Asia to him, from the frontiers of China to those of Greece. He governed the state himself, without availing himself of a minister. . . . He esteemed learning and learned men. He labored constantly to aid the fine arts."[21] Ibn Arabshah echoed that praise: "He was devoted to artists and craftsmen and to works of every sort if they had dignity and nobility."[22]

"Samarqand," writes Timur's modern biographer Justin Marozzi, "was a tribute to his undefeated military career and a monument to his imperial vanity. Over four decades the city soaked up Timur's offerings like an avaricious mistress. There was gold, silver, precious stones, marble, exotic beasts, fabulous cloths, silks, tapestries, slaves and spices; yet still she was not satisfied. Each time he returned with more, she sent him back out into battle. Her glorification required ever increasing spoils from countless victories. Only constant campaigning could deliver them."[23] Harold Lamb put it still more sensually when he commented that Timur loved Samarqand "as an old man loves a young mistress."[24] In fact, he became infatuated with her early in his career, when in 1366, together with his then ally Husayn, he wrested the city from the Sarbadars. Clavijo noted that Samarqand "was the first of all the cities that he had conquered, and the

one that he had since ennobled above all others, by his buildings making it the treasure house of his conquests."[25]

"Let he who doubts our power look upon our buildings," Timur declared.[26] It was not an idle boast. Timur's tastes veered toward opulence and ostentation. He laid out enormous palaces and parks, erected colossal mosques and splendid madrassas, commissioned great metal vessels and cups of hard stones. The *Tazza* fit perfectly into his aesthetic.

At the center of Samarqand he built Gok Sarai (Blue Palace)—a heavily fortified citadel that also served as a prison, armaments factory, state archives, and a treasury filled with loot from across Asia. Timur's Cathedral Mosque, a vast and towering edifice, surpassed most monuments in the Islamic world. He began constructing it in 1399, after conquering Delhi, and when he was away from the capital, he insisted on daily progress reports from two amirs appointed to supervise the work carried out by an international team of craftsmen. Ninety-five elephants hauled 200 blocks of marble from Azerbaijan, Persia, and India. Upon returning to Samarqand in 1404, Timur was enraged by the meager size of the portal. His chief wife had built a college for architects and geometers opposite the mosque that exceeded its height. He ordered the inadequate mosque entry torn down and constructed afresh, and the amirs overseeing the project executed by being dragged face down on the ground until they were torn to shreds. Taking personal charge of construction, he had himself carried daily to the site in a litter and stayed there all day, urging on the workers with words as well as coins and meat that he tossed to them with his own hands.[27]

Under Timur's eyes an incomparably beautiful structure rose up in the center of Samarqand: adorned with marble and other stones, glazed with mosaics of blue and gold tiles, draped with silk hangings and carpets. It sprawled over an area measuring 350 x 500 feet, its portal soared to over 100 feet, its minarets stood 150

feet tall and overlooked a courtyard bordered by a gallery of 400 cupolas. Alas, built too quickly, the mosque began to disintegrate soon after completion. Whether the foundations had been laid too shallowly, or corners had been cut in hasty construction, the falling masonry forced the devout to take their prayers elsewhere.[28] Fortunately for all involved, Timur had by then died.

Before that, however, he also oversaw the building of an enormous bazaar and of an octagonal family mausoleum crowned with a dome of turquoise tiles and adorned inside with gold, onyx, and jasper. He favored grandeur, whether in buildings, books, or decorative arts.[29] For the Shrine of Ahmad Yasawi, a Turkic poet and Sufi teacher who profoundly influenced the spread of Muslim mysticism in the Turkic-speaking world, he ordered a bronze basin measuring 62 x 95 inches and an oil lamp of brass inlaid with silver and gold measuring 84.5 x 58 inches.[30] The message inscribed on these objects spoke clearly of Timur's ambitions: "Of what was made on the order of the Excellency, the great, the master of the learned, the just, axis of the world and religion, Amir Timur Gurgan, may God perpetuate his sovereignty."[31]

Qazi Ahmad, a sixteenth-century artist and biographer, related that the calligrapher Umar al-Aqta transcribed for Timur a copy of the Koran in a complicated *ghubar* script and on such a tiny scale that the book fit under the socket of a signet ring. When he presented this remarkable technical and artistic feat to Timur, the ruler refused to accept it. "Omar Aqta wrote another copy, extremely large, each of the lines being a cubit in length, and even longer. Having finished, decorated, and bound the manuscript, he tied it on a barrow and took it to the palace of the Lord of the Time. Hearing that, the sultan came out to meet him, accompanied by all the clergy, dignitaries, amirs, and pillars of the state, and rewarded the calligrapher with great honors, marks of respect and endless favors."[32]

The large and splendidly carved *Tazza*—an object unlike any other in Timur's possession—must have equally delighted him

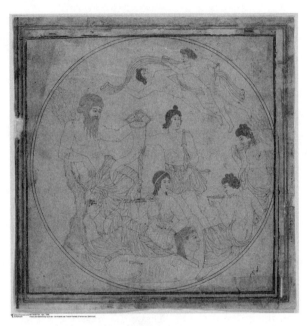

Figure 5-2. Mohammed al-Khayyam, drawing of the interior of the *Tazza Farnese*, black ink on paper, early 15th century.

and fit into his self-aggrandizing program. How he got it is a mystery. But a surviving drawing by the court calligrapher Muhammad b. Mahmudshah al-Khayyam carefully replicates the interior of the *Tazza* and attests to its sojourn with Timur (fig. 5-2).[33] This drawing, in fact, is the first secure historical record of the *Tazza*.

How could the phiale have come into Timur's hands? A few scenarios may be considered.

One scholar has proposed that the *Tazza*, removed from the Ptolemaic treasury by Mithradates in 88 BC, was presented by him to his ally Tigranes II, King of Armenia, whose possessions might have been then inherited by the Parthians. When the Parthians were deposed by the Sassanians in 428 AD, the bowl, according to

this theory, would have been brought to Ctesiphon (on the Tigris in modern Iraq) and kept there until 637, when that city was conquered by the Muslims. Before that, however, part of the royal treasury was taken east, to China—a Hellenistic agate *rhyton* (a drinking vessel) has been found in Xian. Or the *Tazza* was carried off by the Muslims after they defeated the Sassanians at Nihavand in 642 and brought to Damascus or Baghdad, whence it was eventually plundered by Timur. These suggestions are arguably more speculative than the ones proposed in earlier chapters, for no records of any kind intimate such a journey of the *Tazza*, but they are intriguing to contemplate.[34]

Another possibility is that the bowl went to Rome, Constantinople, and Italy, and then returned to Byzantium via Genoese traders (having been pawned in Genoa by Frederick's son). Perhaps they brought the regal vessel as a gift to the Byzantine Emperor Michael VIII Palaiologos with whom they signed the Treaty of Nymphaeum in 1261, a trade and defense pact that laid the foundation of the Genoese commercial empire in the East. Over the course of the 1300s more and more of the Byzantine territory was conquered by the Ottomans, including Bursa, which became their capital. Sultan Bayezid I intended to assault Constantinople, but Timur intervened, though not out of any humanistic impulse. Timur defeated Bayezid at Ankara in 1402, then sacked Bursa and carted off to Samarqand the Sultan's treasures. Among his loot was a set of stunning doors described by Clavijo. At the time of the Spaniard's visit, they decorated the inner portal of the enclosure of Timur's chief wife, Saray Mulk-khanum. Clavijo was smitten by them:

> these double doors were covered with plates of silver gilt
> ornamented with patterns in blue enamel work, having
> insets that were very finely made in gold plate. All this was
> so beautifully wrought that evidently never in Tartary nor

indeed in our western land of Spain could it have been come to. In the one door was figured the image of Saint Peter while in the other was Saint Paul, and each saint had a book in his hands, the entire work being of silver. They afterwards told us that these doors had been brought from Bursa, where Timur found them when the treasure of the Turkish sultan had come into his hands.[35]

Influenced by Persian culture, which allowed figurative images, Timur was used to decoding visual stories. He may have interpreted the two saints as depictions of sages. The Christian subject matter of the doors, their costly materials, and fine craftsmanship, meanwhile, suggest their origin in Constantinople.

Inside the enclosure Clavijo observed another marvel:

> a golden tree that simulated an oak, and its trunk was as thick as might be a man's leg, while above the branches spread to right and left, bearing leaves like oak leaves. This tree reached to the height of a man. . . . The fruit of this tree consisted of vast numbers of balas rubies, emeralds, turquoises, sapphires and common rubies with many great pearls. . . . These were set all over the tree, while numerous little birds, made of gold enamel in many colors, were to be seen perching on the branches. Of these some with their wings open seemed ready to fly and some with closed wings seemed as though they had just alighted on the twigs from flight, while some appeared about to eat of the fruits of the tree.[36]

This tree recalls one described by Liutprand of Cremona at the court of the emperor Constantine VII. Quite likely it also came from Byzantium.

Sultan Bayezid had on various occasions compelled Byzantine emperors to pay him tribute, and the doors and the tree may

have been part of those forced offerings. Could he also have obtained the *Tazza* in such a transaction and brought it to Bursa, from which Timur appropriated it upon conquering the Ottoman capital?[37]

Or perhaps the Byzantine emperor himself presented the *Tazza* to Timur. He had appealed to him for help against the Ottomans when Bayezid was poised to attack Constantinople, and after Timur's victory at Ankara hastened to send envoys with letters of submission, priceless jewels, and gold florins.[38] The *Tazza* would have made an excellent gift under the circumstances, its rarity, beauty, and imposing size perfectly suited to appease the feared conqueror with grand artistic pretensions.

Alternatively, if the *Tazza* had remained in Europe, Timur may have received it as a present from one of the embassies that trekked to Samarqand from distant lands.[39] His victory at Ankara threw many into panic. Until then Bayezid had been the dreaded force. Now that Timur had defeated him, he was clearly a more dangerous foe. Sultan Faraj of Egypt and Syria, Timur's former enemy, rushed an embassy to declare his obedience, sweetening the message with gold and silver, jewels, and beautifully attired horses. The Ming emperor of China sent a delegation laden with costly stones, porcelain vessels, banknotes, and other luxuries.[40] King Charles VI of France dispatched lavish praise to "the most victorious and serene Prince Themur" together with thanks for treating well Christian merchants in his lands. King Henry IV, newly installed on the throne of England, offered congratulations to Timur on his victory. The Venetians, ever pragmatic, sent laudatory missives, while the Genoese professed their allegiance and hoisted Timur's pennant at Pera, their colony on the Bosporus. If the *Tazza* had stayed in Genoa after Frederick II's death and not been presented to the Byzantine emperor in 1261, might the Genoese have dispatched it east now, to secure good relations with the new power in the region from which they drew their prosperity?

Archbishop Jean of Sultaniyya, in his 1403 tract about Timur, compiled a list of "The things that Timur Beg likes more than any other: Firstly, fine and delicate textiles . . . ; branches of coral; cups of crystal and other vessels ornamented with gold and silver."[41] The *Tazza* would have been a wise gift to him.

Clavijo, a member of a delegation from King Henry III of Castile and Leon, penned a vivid account of his embassy at Timur's court and of the profusion of artworks with which Timur framed himself—a setting in which the *Tazza* would have vied with myriad other treasures.[42] Clavijo's mission traveled for fifteen months, traversing nearly 6,000 miles from Cadiz before, dust-covered and worn out, they reached Timur's capital in September 1404. As they entered the city, they passed through its "extensive suburbs," each one named after Timur's conquests: Baghdad, Damascus, Cairo, Shiraz, Sultaniyya—at once a boast and a humiliation. In these densely populated districts lived the craftsmen and scholars from those faraway places, whom Timur forcibly brought to Samarqand.

The city's periphery was verdant with gardens. "Among these orchards outside Samarqand," Clavijo recorded,

> are found the most noble and beautiful houses, and here Timur has his many palaces and pleasure grounds . . . the great men of the government also here have their estates and country houses, each standing within its orchard: and so numerous are these gardens and vineyards surrounding Samarqand that a traveler who approaches the city sees only a great mountainous height of trees and the houses embowered among them remain invisible.[43]

Timur had laid out some sixteen parks on the outskirts of Samarqand, giving them such names as Garden of Paradise, Model of the World, Sublime Garden, and Heartsease. Each one included

a rich palace, lush meadows, babbling streams or lakes, orchards and flowerbeds, and silk tents draped with colored tapestries. During his stays in the capital, Timur passed from one park to another. A few days after Clavijo's arrival, the Spaniards attended an imperial banquet in the Northern Garden. The royal pavilions, Ibn Arabshah wrote, had been painted with scenes showing Timur's portraits:

> now smiling, now austere, and representations of his battles and sieges and his conversations with kings, . . . and Sultans offering homage to him and bringing gifts to him from every side and his hunting nets and ambushes and battles in India, Duscht and Persia, . . . and his public feasts . . . and his love-meetings and the concubines of his majesty and the royal wives . . .[44]

In another garden Clavijo saw an opulently furnished palace with Timur's sleeping alcove, lined in colored tiles and hung with rose-colored silk drapes ornamented with silver spangles shimmering with emeralds, pearls, and other gems. Timur's mattress, encased in gold brocade, lay in front of a silver and gilt screen. In the center of this palace stood two tables of gold laden with gold flasks and cups set with pearls, emeralds, turquoises, and balas rubies.[45] The *Tazza* may well have appeared alongside these vessels and moved with Timur as he progressed from one park to the next. He loved precious stones. Clavijo's account glimmers with these minerals brought in the baggage of foreign ambassadors and carted back from campaigns abroad. Timur acquired some of them, like the *Tazza*, already carved; others were worked by his craftsmen, who used stones to ornament everything, from costumes and tents to tableware and buildings.[46]

Timur was very fond of jade, widely prized in the East for its beauty and purported magical properties—its power to produce

rain, protect against earthquakes and lightning, and detect poison (tainted food placed in a jade dish was said to split it). Some said jade was the frozen semen of a celestial dragon. Though widely associated with China, jade's primary source in Asia was the Kunlun Mountains near Khotan in Central Asia, a region under Timur's control. Abdul-Razzaq Samarqandi, traveler, author, and savant from Herat, claimed that sorcerers used a stone called *yada* (probably jade) to produce cold, snow, and rain during a hot season in 1451 as the Uzbek troops allied with the Timurid prince Abu-Sa'id were crossing the waterless Hunger Steppe. Al-Biruni, Persian scholar and scientist, wrote that "It is said that jade or one variety of it is called the victory stone and for this reason the Turks decorated their swords, saddles, and belts with it, desirous of gaining victory over their contestants and opponents."[47] Timur's tomb in Samarqand was made of jade obtained by his grandson Ulugh Beg in 1425 while campaigning against the tribes of Moghulistan in the region of Issik-kul. The Chinese emperors had previously sought that very slab, offering 100,000 dinars for it.[48]

Timur favored other stones as well. The Gur-i-Mir, an octagonal mausoleum in which his sarcophagus stood, had walls lined not only with red, blue, and gold tiles arranged in rich patterns, but also onyx with inscriptions in gold-painted carved jasper.[49] The Friday Mosque of Samarqand was likewise attired in onyx and jasper. Timur's eastern lands were rich in many minerals, and he transported them from the territories he conquered.[50]

What did he make of the *Tazza*? Though a man of sharp intelligence—evident in his political and military strategies and successes, and in his astute manipulation of visual symbols—Timur is unlikely to have possessed much understanding of Greco-Roman antiquity. It was too far removed from him culturally and physically. He was familiar with the story of Alexander the Great from *Shahnama*, the Book of Kings, but there the Macedonian general appeared as a world conqueror rather than a representative of classical culture,

and most other epics read at Timur's court celebrated Eastern heroes. Ancient Mediterranean artifacts were virtually nonexistent in Central Asia. No eyewitnesses report seeing cameos or other Greek or Roman objects in Samarqand during Timur's rule or that of his heirs, though a few such works crop up elsewhere in the region in the later 1400s. A Venetian traveler Josafa Barbaro, who visited Iran in 1471 in the company of the "ambassador of Persia" and paid court to Uzun Hasan in Tabriz in 1474, recounted how that ruler showed him, among other jewels, a cameo with "two heads of dead birds . . . , which seemed very strange in respect of the fowl of our regions"; and "a cameo the breadth of a grote, wherein was a woman's head graven; her hair backward, and a garland about her head. He bade me look 'is this not Mary?' I answered 'no.' 'Why who is it then?' he said. I answered, it was the figure of some ancient goddess that the Burpares worshipped, that is, to wit, the Idolaters."[51] Even in that case, the gem, though recognized by its owner as Western, was interpreted by him as a contemporary Christian subject, rather than as an ancient pagan one.

Carved stones best known in Timur's circles came from China. Could he have thought that the *Tazza* was created in Asia? Chinese visual culture also influenced the arts of Iran, crucial models for Timur's court. Indeed, the drawing style in which Muhammad al-Khayyam depicted the *Tazza* was inspired by Chinese art.

Whatever Timur may have thought of as the country of origin of the *Tazza*, he likely prized it chiefly for its size, exoticism, and richness of decoration. A truly regal work, and for him a trophy of conquest or a symbol of the international prestige he had attained—depending on how he obtained it—it fit perfectly with his taste: its stone was more beautiful than jade, its luster brighter than rock crystal, its carving finer than that achieved by any craftsman under his command. Was it to keep a record of it, or to try to replicate it in some way that Muhammad al-Khayyam made a drawing of the *Tazza*?

This artist is better documented at Herat, at the court of Timur's grandson Baysunghur. But he appears to have been at Samarqand previously. In his signature he acknowledged his debt to other artists, of whom he mentioned especially Khvaja 'Abd al-Hayy, active in the late fourteenth century under the Jalayirid Sultan Ahmad and taken to Samarqand by Timur probably after the conquest of Baghdad in 1393.[52] Muhammad al-Khayyam likely moved to Herat after Timur's death. Did the *Tazza* go there as well? It would have received a rather different attention.

After Timur died in February 1405 en route to conquering China, his heirs fought for the throne. During his reign he had precluded threats to his sovereignty by installing his sons and grandsons in territories throughout his empire and appointing as their "guardians" amirs loyal to him—to make sure his authority would be unchallenged. After his death the royal princes promptly engaged in a contest for power. Timur's son Shahrukh, the governor of Khurasan, emerged as the chief contender, though he was challenged by his nephew Khalil-Sultan, lord of Transoxiana. The latter had seized Samarqand and the royal treasury, and "like the April rain, nay like the mines of Badakhshan and the sea of Oman, scattered silver and jewels over soldiers and subjects"—trying to buy their support. [53] But they deserted him nonetheless, and Shahrukh triumphed as his father's successor, entering Samarqand in May 1409.

Shahrukh proved a very different ruler from Timur. Instead of far-spread conquests, he focused on preserving the territorial integrity of his kingdom. His long reign (1405–47) brought tenuous stability and great cultural and artistic flowering.[54] Shahrukh based his court at Herat, an oasis city in western Afghanistan, 500 miles southwest of Samarqand. Situated in the desert plain, it straddled one of Asia's busiest trade routes, and it was famed for its fine textiles—silks, tapestries, hangings, and carpets. Its markets offered a profusion of gold, silver, rubies, turquoise, and lapis lazuli.

The melons, grapes, pomegranates, apricots, and apples grown around the city refreshed the palates of inhabitants and travelers.[55]

When Timur conquered Herat in 1383, he had gathered its treasures with ruthless efficiency. He sealed all the gates to keep his soldiers from entering and looting without his permission and to keep citizens from escaping. The torturers and tax collectors moved in and proceeded to search houses, confiscate property, and extract confessions from those suspected of concealing valuables or unwilling to disclose the possessions of neighbors and friends. The amassed goods were brought to collection centers and registered by the amirs, who received a portion of the revenues. Once the official requisition was completed, soldiers were allowed into the city to plunder what remained. Sharaf ad-din Ali Yazdi, the author of *Zafarnama*, an official history of Timur, wrote that "It is remarkable that there were in this city all sorts of treasures, as silver money, unpolished precious stones, the richest thrones, crowns of gold, silver vessels, gold and silver brocades, and curiosities of all kinds. The soldiers, according to imperial order, carried away all these riches upon camels." The intellectuals and artisans were also rounded up and sent to Samarqand.[56]

Shahrukh and his queen, Gawharshad, both generous patrons, restored the prosperity and dignity of Herat. They erected mosques, palaces, and dynastic tombs, vast in size and opulent in decoration, ushering in a new, complex, and theatrical building style based on an ingenious system of proportions and geometric progressions that made possible dramatic vaults and soaring domes. They also encouraged poetry, painting, calligraphy, and other arts.

We do not know if the *Tazza* left Samarqand when Khalil-Sultan dispersed Timur's treasury, or if it was transferred to Shahrukh's court at Herat. Muhammad al-Khayyam could have drawn it in either place. As artists moved between Timurid cities—later Persian writers commented on the competition for talent among the princes and courts of Samarqand, Herat, and Shiraz—they

brought their sketchbooks with them.[57] So Muhammad al-Khayyam may have arrived at Herat from Samarqand with his drawing of the *Tazza*, or drawn it in the new capital. In any case it is clear that he had seen the bowl personally: his other drawings indicate direct observation of his models as his general practice, and his image of the *Tazza* reveals how carefully he studied and sought to reproduce its every detail, down to the size of the figures, capturing them on a virtually one-to-one scale. His royal patrons, in their turn, would have appreciated both the *Tazza* and his rendition of it with sophistication alien to Timur.

Whereas Timur had sought to aggrandize himself through big and ostentatious artworks, his heirs cultivated more refined tastes. Shahrukh's transfer of the capital to Herat, long a center of Persian urban civilization, helped shape his and his son Baysunghur's sensibilities.[58] Shahrukh ruled his domains not as a Turco-Mongol warlord-conqueror but as a Persian sultan. Dynastic chronicles extol his piety, diplomacy, and modesty, depicting him as a model Islamic ruler who repaired much of the physical and psychological damage caused by his father.

Shahrukh's son Baysunghur furthered these political and intellectual pursuits with intelligence and sensitivity. Brought up to be a ruler—Timur took very seriously the grooming of his sons and grandsons for their future roles as sovereigns of his territories, and personally supervised their education—the boy learned to wield equally well the pen and the sword, to be a discerning judge of the subtleties of poetry and the merits of horses, to excel in literary disputes and in hunts, to listen to music with a fine ear and to political discussions. At the age of sixteen or seventeen he was made governor of Astarabad, Tus, and Nishapur, towns on the eastern shore of the Caspian Sea, and of the province of Khurasan (which spanned parts of Iran, Afghanistan, Turkmenistan, and Uzbekistan). When he was nineteen, his father appointed him

chair of the supreme council of Herat. From his teenage years Bay-sunghur fought in various military campaigns and took part in diplomatic missions. Remaining most of his life in Herat, he acted as his father's right-hand man, never trying to grab power for himself.[59] He would die before Shahrukh, of alcoholism.

Timurids were generally a drinking lot (apparently wine was the immediate cause of Timur's death), but Baysunghur seems to have deliberately sabotaged his life. Sometime before his demise he had ordered court astrologers to divine his destiny from the motions of the heavens. Having completed their calculations, the astrologers brought the prince their reply: "We have determined that the rest of your noble and fortunate life will be endowed with happy qualities and dustiness (affliction) will never settle upon the edge of the brilliant princely heart." Sensing some caginess in their answer, Baysunghur pressed them for an explanation: "the true picture is embellished, so say what you know from your findings—there is nothing to fear." Eventually the astrologers revealed the truth: the lifetime of their master would not exceed forty years. Baysunghur, distraught by this news, took to drink. In the poetic words of the Persian historian Khwandamir:

> Every morning when the gold-painted cup of the sun became bright in the heavens, he asked for sweet wine from the sun-faced cupbearers and every evening, when the silver-bodied cup of the new moon began to turn in the assembly of fixed and wandering stars, he took from the fair hand of the moon-faced one the cup of beloved wine. He exceeded the bounds of moderation and became totally dependent and it became the cause of his falling sick.[60]

He died at age thirty-six.

Despite his sad end, Baysunghur appears in contemporary records as a decent and able man: decisive and brave, purposeful

and gifted as a leader, good at judging people's motivations and choosing capable assistants. Fifteenth-century historians praise him for his sense of justice and clemency, his learning and fine taste in poetry and art.[61] Indeed, he became the leading patron of his generation. As his biographer Dawlatshah wrote:

> Alike in talent and the encouragement of talent, he was famous throughout the world. Calligraphy and poetry were highly esteemed in his time, and scholars and men of talent, attracted by his renown, flocked from all regions and quarters to enter his service. . . . He showed favor to men of talent, loved poets, strove after refinement and luxury, and entertained witty courtiers and boon companions.[62]

Contemporary opinion judged a ruler on his ability to attract the best talent of the age—not by force, as Timur had done—but by the inducement of a brilliant milieu. Literary sources from this era start mentioning artists' names—an indication of their status and importance in augmenting their patrons' prestige.[63] A prince's own cultural abilities also mattered in this cultivated atmosphere. While Persian was not the native tongue of Timur's descendants, mastering it was de rigueur for any sovereign in the region. Baysunghur, corresponding regularly with his brothers Ulugh-Beg in Samarqand and Ibrahim-Sultan in Shiraz, exchanged with them Persian poetry and debated cultural matters in that language.[64] He himself possessed poetic gifts, and even more so those of a calligrapher. The artist Dust Muhammad recorded that "his majesty Baysunghur Mirza was completely inclined toward writing and he pursued it with a penetrating mind, and he also raised the standard of the pen on the battlefield of calligraphy." Another writer, Qadi Ahmad, commented that the prince "wrote with great excellence and was a master of the age."[65]

Calligraphy, a preeminent art form in the Persian world, became a major preoccupation of the Timurid princes. Baysunghur mastered "six different hands"—the six cursive calligraphic styles—and encouraged the flowering of this art at Herat. He founded a great *kitabkhana*, a royal workshop, staffed with forty scribes under the direction of the celebrated master Ja'far al-Tabrizi.[66] Muhammad al-Khayyam apparently belonged to that elite corps. His drawing of the *Tazza*, along with other works by his hand, was preserved in an album of paintings, drawings, and calligraphy assembled for Baysunghur at that workshop.

Kitabkhanas were artistic centers of the court. Here royal craftsmen gathered, developed their designs, and transformed them into a multitude of creations: manuscripts, textiles, ceramics, metalwork, luxury furnishings, and building decorations. A surviving letter from Ja'far al-Tabrizi, the head of Baysunghur's artistic establishment, apparently directed to his patron, describes the beehive-like activity of the *kitabkhana*. The text opens with a florid encomium to the prince: "Petition from the most humble servant of the royal library, whose eyes are as expectant of the dust from the hooves of the regal steed as the ears of those who fast are for the cry of *Allahu akbar*, and whose joyful and gleeful shout of 'Praise be unto God who hath taken away sorrow from us! verily our Lord is ready to forgive and to reward' reaches the apex of the celestial sphere." Then follows a progress report on twenty-two current projects: manuscript illumination and binding, copying of texts, carving of a "little chest" for a princess, facing a saddle with mother of pearl, construction of royal buildings and grounds (including a pavilion for artists and calligraphers), painting of poles and embroidering with gold thread the textile panels for the royal tents. The letter gives the names of the artists engaged on each project, some working individually, others in teams.[67] The album in which Muhammad al-Khayyam's drawing of the *Tazza* was included came from this environment and may have been used at the

kitabkhana as a model for other creations, before becoming an artwork in its own right.[68]

Albums, which became increasingly popular among Timur's descendants, began as gatherings of designs for artists working at the *kitabkhana*. Many of these drawings depicted old artworks: ceramics, metalwork, textiles, manuscript illuminations going back to the late twelfth century and including many Chinese and Persian prototypes. There was a definite antiquarian sensibility in this milieu, and the *Tazza* likely resonated with it, though its Timurid owners may not have been able to gauge its actual origin or age. Muhammad al-Khayyam's surviving drawings show that he was clearly fond of looking to the past for inspiration.

Creases, folds, and pounce marks in many of the *kitabkhana* drawings, as well as signs of wear and tear, reveal their practical use before they were bound into albums.[69] Timurid artists tended to rely extensively on models.[70] A passage in Ja'far Al-Tabrizi's *kitabkhana* report shows the use of models by successive generations of craftsmen: "There was a design by Mir Dawlatyar for a saddle. Khvaja Mir Hasan copied it, and Khwaja Mir Hasan's son Mir Shamsuddin and Ustad Dawlat-Khwaja are busy executing it in mother of pearl."[71] In other words, an esteemed drawing by an old master was reproduced by a draftsman working at Herat and then transformed into a luxury object by his son. The *Tazza* drawing may have originated as a model for other works. One can imagine its design transferred to a ceramic plate, a tile, or a textile, its Egyptian deities turned into characters from Persian history or mythology, though none has yet been identified.

Having been produced for practical reasons, Timurid drawings began to be collected as artworks early in the fifteenth century. Removed from circulation, they were assembled into albums along with paintings on paper and calligraphies.[72] Heightened historical awareness that fostered genealogical and historical works at Timurid courts underpinned these gatherings.[73] The albums preserved

calligraphies, drawings, and paintings in a range of techniques and styles produced at different artistic centers, chief among them Samarqand, Herat, and Shiraz.[74] And so Muhammad al-Khayyam's drawing of the *Tazza* became a valuable artwork in itself.

Some fifteen of Muhammad al-Khayyam's drawings have survived this way, and in addition to his own interests, they reflect the wide-ranging tastes of his patrons.[75] They depict both old and current artworks he had seen in the royal collections (he tended to work from direct observation, and some of his sources were included in the same album as his drawings after them). And they reveal his working methods: favoring simple black lines, tightening the graphic marks, distilling the designs to their essence. In his *Tazza* drawing he did his best to capture as carefully as possible every element of the relief, from the knots of the tree trunk on which the Nile sits, to the flowing draperies worn by different deities, to the ribbed collar of the sphinx. But he also made slight alterations, simplifying the anatomy of secondary figures, such as the winds flying through the sky, and placing greater emphasis on the interaction among the characters by making their eyes and glances toward each other more pronounced.

Muhammad al-Khayyam's eclectic and eccentric choice of subjects, often far removed from the images found in contemporary illuminated manuscripts, and the uneven quality of his execution intimate that drawing was not his profession, but rather a recreational activity, his chief expertise being calligraphy.[76] The inclusion of his *Tazza* drawing into Baysunghur's album, however, suggests that it was deemed valuable, and it may have given the prince pleasure in a more sophisticated way than simple viewing.

If the *Tazza* itself came from Samarqand to Herat after Timur's death, Baysunghur could examine it alongside Muhammad al-Khayyum's drawing, comparing the original and the copy. The notion of such a comparison was current in Persian culture and quite likely at Baysunghur's court. He owned, for example, two

manuscripts of *Kalila wa Dimna* (an Arabic collection of fables)—
an earlier version made for Jalayirid patrons, and a slightly later
one produced at Herat. In the latter book the Timurid artist subtly
altered the compositions of his predecessor. Just as Baysunghur
studied and compared different lines of calligraphy and poetry, he
could have examined the two books side by side, evaluating the
aesthetic decisions made by each master, enjoying their differences,
and honing his own visual acuity.[77]

A well-known story in Persian literature reinforced such an
exercise. In his book *Khamsa* the poet Nizami recounted how Al-
exander the Great judged the merits of Greek and Chinese art
during his visit to China. Alexander and the Emperor of China,
predictably, disagreed on the relative excellence of their painters.
So they decided to resolve their dispute in a contest. Dividing a
room by a curtain, they bid teams of Greek and Chinese artists
each to create a work on opposite walls. When the masters finished
their assignment and the curtain was pulled aside, Alexander saw
two identical depictions. After a few confused moments, he ordered
the curtain pulled back across the room. The Greek painting
remained, but the Chinese one vanished and instead the wall
showed the reflection of the curtain. Whereas the Greeks had
painted their wall, the Chinese had polished theirs to a mirror-like
sheen. Alexander pronounced the Greeks superior in painting and
the Chinese in polishing, with both works being "an aid to vision."[78]
Could the *Tazza* and Muhammad al-Khayyam's drawing have pro-
vided a similar intellectual and aesthetic challenge and delight to
Baysunghur, inviting him to judge the relative merits of each?
Might the drawing have been interpreted as a "reflection" of the
bowl? Baysunghur owned manuscripts of Nizami that told and
illustrated another story of the mesmerizing quality of depiction:
Shirin falling in love with the portrait of Khursaw Parviz painted
by the master Shapur; and the artist having to explain to her that
the painting does not constitute reality, but is a "reflected image."[79]

These ideas about the nature of vision and representation circulated in the learned Persian milieu in which Baysunghur took part. The *Tazza*, with its exotic materials, intriguing imagery, and superb craftsmanship, would have added further texture—and sophisticated pleasure—to such discussions.

Having arrived in Timur's possession and been used by him as a lavish trophy of his power, the *Tazza* likely became an object of refined meditation in the hands of his successors, mirroring their transformation from savage warlords to urbane aristocrats.

How and to where did the bowl move from the Timurid court? Its journey from Central Asia is as mysterious as the one to it. It may have left Herat after the death of Shahrukh in 1447, though some scholars have proposed its departure as late as 1458, when Herat was plundered by the Kara Koyunlu, also known as the Black Sheep Turkomans, who ruled the territory of modern Armenia, Azerbaijan, northwest Iran, eastern Turkey, and Iraq. Taking advantage of the civil war between the Timurid princes, they attacked and occupied Herat, pillaged what still remained of the royal treasure, and carted it off to their sultan, Jahan Shah, in Tabriz. In 1467 Uzun Hasan, the sultan of Ak Koyunlu, or the White Sheep Turkomans, attacked and took Tabriz, and two years later he ransacked Herat. So, the argument goes, he could have laid his hands on the *Tazza* in either city (if the bowl had survived the sack of 1458). In 1471, according to this theory, he presented the bowl to the Venetians as part of his diplomatic rapprochement with them as both sides strove to counter the Ottoman expansion. And so the *Tazza* would have arrived in Italy and into the possession of the Venetian pope Paul II.[80] The problem with this suggestion is that the *Tazza* was already in Italy in the 1450s, an object of keen competition among leading Renaissance collectors.

RENAISSANCE COLLECTORS
AND THIEVES

> In every kind of magnificence Lorenzo had surpassed not
> only himself but any King you might name. [Galeazzo
> Maria Sforza] could not help marveling at the extraordi-
> nary wealth and abundance of everything for someone of
> private means: the gold, the gems, the royal household
> furnishings . . . the most noble objects had flowed to-
> gether into Lorenzo's private domicile from all over the
> world.
>
> —Niccolò Valori, *Life of Lorenzo de' Medici*[1]

S ome time in the 1450s a Genoese or a Venetian merchant—
the records are fuzzy about the exact date and his origin—
arrived in Naples with the *Tazza* in his baggage and offered it to
King Alfonso of Aragon. The asking price was 2,000 ducats—two
to four times the annual salary of humanists in the royal service.
The king paid it without qualms.[2]

A Spaniard by birth, Alfonso (fig. 6-1) grew up in Castile and as a child had watched his father, Ferdinand I of Aragon, receive ambassadors returning from Timur's court.[3] He inherited the throne in 1416, at age nineteen—still a youth, but already endowed with princely qualities. A French ambassador recorded that "he wields a two-handed sword to perfection, is a fine horseman and delights in jousts and tournaments . . . [he] is very elegant in his dress, plays all kinds of instruments and dances admirably. Yet is as grave as any man of fifty."[4]

Alfonso—lean, pale, with black hair, hooked nose, and bright eyes—was deeply pious and serious about learning, but also resolute and ambitious for territory and power. Within three years of becoming king of his native land he embarked on a struggle for the throne of Naples, which he claimed by right of inheritance from the descendants of Frederick II Hohenstaufen and for which he competed with a French contender, Louis III of Anjou. For two decades Alfonso campaigned in Italy while his wife administered his Spanish domains. In 1443, having put half his life into the contest, he finally entered Naples as its king.[5]

Figure 6-1. Antonio Pisanello, *Alfonso of Aragon*, bronze medal, 1449.

As soon as he settled into his new capital sprawled on the Bay of Naples, with Mount Vesuvius looming to the south and the island of Capri rising across the water to the west, Alfonso began a new campaign—this time a cultural one—of turning the provincial city into a flourishing capital. While other Italian states, such as Rome, Florence, Milan, and Venice, had been cultivating and using the humanistic movement to define themselves as heirs of the ancient Romans, the Kingdom of Naples, torn by foreign invasions and feuds among local barons, had remained an intellectual and artistic backwater. Eager to gain parity with other Italian rulers, Alfonso undertook its transformation.

As a boy he had studied theology, Latin, geometry, astronomy, philosophy, poetry, and the natural sciences. Now he founded the University of Catania, instituted a school of Greek, and lured eminent scholars to his court, men such as Lorenzo Valla, Pier Candido Decembrio, Giovanni Pontano, Antonio Panormita, Bartolommeo Fazio, and Aeneas Sylvius Piccolomini (who would become Pope Pius II). To make Naples attractive to them, he offered high salaries and paid further stipends for works they produced for him: 1,000 gold coins to Panormita for writing *The Sayings and Deeds of King Alfonso*, modeled on Xenophon's *Life of Socrates*; 500 to Poggio Bracciolini for translating Xenophon's *Cyropedia* into Latin.[6] A roster of brilliant minds bestowed luster and legitimacy on the new dynasty Alfonso was trying to root on Italian soil.

The king's sponsorship of literature and art stemmed from a genuine interest in these subjects, and he encouraged his savants to engage in pure scholarship in addition to the works they wrote at his request. But his patronage also constituted a strategy for gaining authority and prestige in Italy, where he was a foreigner. Employing humanists to compose eloquent diplomatic missives and chronicles of their masters' deeds became a norm among fifteenth-century Italian rulers. To participate in peninsular politics Alfonso needed spokesmen able to present his policies and accomplishments in the

manner expected in these circles. By reputedly spending 20,000 ducats a year on his humanists, he turned Naples into one of the best places for men of letters.[7]

To foster his scholars' pursuits and his own, Alfonso built a library of hundreds of volumes, earning the praise of the biblio-phile Vespasiano da Bisticci, who in the later fifteenth century named the king one of two outstanding benefactors of learning in his lifetime, the other being Pope Nicholas V.[8] Another writer, Giacomo Curlo, commented, "All Italy is witness that he was a patron and friend of letters without peer. Whoever took such care and pains in acquiring books? He has, or had, in his service men of every branch of learning. Anyone who displayed the spark of genius he never failed to summon, to cherish, and load with reward and honors."[9]

Moderate in his personal conduct—Piccolomini described Alfonso as "very frugal in his eating and drinking, taking only wine mixed with a lot of water"—the king spent lavishly on cultural pursuits.[10] Dressing chiefly in black clothes accented with a jeweled clasp or a gold chain so as to appear a king by his manner more than by his ostentation, Alfonso did not stint on scholars, books, and artworks. No wonder the merchant with the *Tazza* for sale headed to Naples and did not blush at asking for a hefty sum.

Alfonso became captivated by antiquity during his initial sojourn in Italy in the 1420s. The very setting of his desired kingdom, with the remains of Greek and Roman monuments dotting it here and there, spurred his imagination. Three weeks after setting foot in Naples for the first time he bought copies of Seneca's tragedies and Livy's histories from a Pisan merchant. The city was then a barren ground for humanists. Traders in ancient artifacts passed through, but there were no shops where one could browse a selection of classical volumes, and their acquisition was a chance and piecemeal affair, though all the more exciting for that.

Alfonso's exposure to Southern Italy's classical past laid the foundation for an enduring passion. In 1426 he issued a decree banning the export and dispersal of ancient books from his Spanish kingdom. These books, he declared, "make [the ancients] seem alive to us" and they must, therefore, be guarded "as a precious store of arts and science in which may be found the key to everything that touches the human condition." The royal edict sought to forestall "the plundering of such treasure"; it forbade private citizens from selling books to merchants, and traders from removing any volume from the kingdom without a special license. Even students traveling abroad had to put down a surety to guarantee that they would return together with their books, or bring back "better ones." At the same time Alfonso adopted as his personal heraldic device an open book inscribed with the motto *Vir sapiens dominabitur astris* (A wise man will rule over the stars).[11] He was the first Renaissance ruler to make learning his dictum.[12]

Back in Italy in 1432, Alfonso poured himself with zeal into the study of the past, learning Latin and working through a passage of classical text every day, first under the tutelage of Tommaso Chaula and then Antonio Beccadelli (Panormita) who became the royal literary mentor and chief intellectual at court in 1434.[13] Under Panormita's guidance and inspiration, Alfonso hosted a classical salon, gathering courtiers, scholars, and interested townsmen to discuss Virgil and Livy, or to debate philosophical matters. To fuel these meetings—and his own studies—Alfonso continued to expand his library through every possible means. He asked a notary of Agrigento to sell or lend to him for copying the complete works of Virgil in his possession; a diplomat dispatched to visit the Emperor Sigismund in Siena was ordered to buy the *Decades* of Livy, the *Ethics* of Aristotle, and the works of Lucan available for sale there. Whenever important figures in Spain or Italy died, Alfonso's agents rushed to acquire their books. The king carried his favorite authors—Caesar, Livy, Seneca, and Cicero—on his campaigns, giving them temporary shelter in a

tent pitched next to his own and turning to them whenever he had time, often in the middle of the night. He even continued his salon on the battlefield, to the astonishment of visitors to his camp.[14] Back in Naples, Alfonso's books resided in the palace of Castelnuovo, overlooking the Bay of Naples. Staffed by copyists, miniaturists, and a binder, the library was not only a repository, but also a workshop that filled the royal shelves. The palace itself, a massive medieval fortress, received a classical facelift with the addition of a marble triumphal arch modeled on Roman examples on which Alfonso was depicted entering Naples in triumph in 1443—a procession that emulated ancient Roman practice.

One of the earliest collectors of Roman coins, Alfonso dispatched agents to find them across Italy. He took his coins, alongside his books, on military campaigns, carrying his most cherished pieces—minted by Caesar and Augustus—in an ivory case, for they "did marvelously delight him and in a manner inflame him with a passion for virtue and glory."[15] Panormita, encouraging Alfonso's support of scholarship, compared him to Augustus for his liberality and assured him that such conduct would bring him immortality.[16]

Not surprisingly, Alfonso was interested in all kinds of ancient works. Archaeology was at that time still in its infancy, so his understanding and recognition of ancient monuments was spotty, but he was keen to preserve Roman remains. He would not allow the stones of "Cicero's villa" to be used as projectiles during the siege of Gaeta. When his soldiers sacked a city, they sought out books and artifacts in hope of receiving royal reward. Alfonso also gladly accepted such offerings from other rulers. Cosimo de' Medici dispatched to Naples a manuscript of Livy that had once belonged to Petrarch. Naples and Florence being then on bad terms, Alfonso's doctors warned him to reject the gift, fearing that its leaves were bathed in poison. The king would not pass up the precious volume—and lived to read it and many others besides.[17] And he

gave warm welcome to merchants who came to his kingdom with antiquities for sale, thus purchasing Ptolemy's *Cosmographia* and a volume of Aquinas from Florentine businessmen for ten ducats, and the *Tazza* for a great deal more.

Though expensive, the phiale was irresistible to him, combining as it did so much of what he adored: antiquity, masterful craftsmanship, and precious material. According to Alfonso's court humanist Bartolomeo Fazio, "In gold and silver dishes, statuettes, jewels, and other regal ornaments he far surpassed all other kings of his age."[18] A jewel offered to him for sale by Spinola, a Lucchese merchant, so delighted the king that he declared it to be "a gift rather than a purchase" and bestowed on the seller the privilege of emblazoning the arms of Aragon on his house. In 1455 Alfonso paid a Frenchman, Guillaume le Mason, over 12,000 ducats for a gold cross, a gold salt cellar posed on the shoulders of eight men and covered with a lid shaped like a queen holding a banner and a diamond, and another salt-cellar borne by an enameled elephant and adorned with jewels. Alfonso was equally pleased to acquire from Venetian merchants in 1443 a bowl of crystal set in silver and offered at 4,000 ducats, twice the price of the *Tazza*. He was used to paying great sums for precious objects that caught his fancy, and his jewels and coins, kept in the Tower of Gold in Castelnuovo, filled 430 caskets.

How the unknown vender of the *Tazza* obtained it is a mystery. Being a Venetian or a Genoese, he likely had business dealings in the East, and may have come by the bowl somewhere around the Mediterranean or the Black Sea. Did it travel from the Timurid to the Byzantine court? Might the merchant have acquired it from someone in the entourage of the Byzantine emperor John VIII Palaeologos in Constantinople on the eve of the Ottoman assault? Or could the *Tazza* have arrived in Italy after Mehmet the Conqueror captured the Byzantine capital in 1453 and its inhabitants fled to Europe, bringing treasures of art and literature with them?

Wherever the *Tazza* came from, Alfonso doubtless doted on it, scrutinizing it in his treasury within the Tower of Gold. One can picture him sitting there, the Bay of Naples outside, his jewels before him, savoring the bowl's fine carving and seeking to interpret the meaning of its figural scene—perhaps consulting classical books from his library for clues. He gladly showed off his prized possessions to his visitors, confident that few of his contemporaries could rival him. One of his guests, however, was allowed not only to admire the *Tazza*, but to take it away.

Ludovico Trevisan was a man of many talents: skilled as a clergyman, banker, warrior, and bon vivant. Having made an outstanding career in the church, he indulged freely in a life of splendor, fine cuisine, and luxury arts.[19] Born in Venice, he had followed the footsteps of his father and studied medicine at the University of Padua. Around 1430 he obtained a position as a personal physician to the Venetian cardinal Condulmer, the future Pope Eugenius IV. Recognizing Trevisan's political gifts, Eugenius promoted him to a succession of ever loftier posts: chamberlain, commander of all fortresses in the Roman dominion, Bishop of Trau (modern Trogir) in 1435, Archbishop of Florence in 1437, Patriarch of Aquileia in 1439, and papal treasurer. After Trevisan had led the papal forces to victory over the Milanese at the Battle of Anghiari in 1440, Eugenius bestowed on him the dignity of Cardinal of San Lorenzo in Damaso in Rome. Ambitious and ruthless, but also an excellent administrator and military commander, Trevisan became one of the most important figures in the church.

Andrea Mantegna captured his hard-edged personality in a portrait now in Berlin (fig. 6-2), and a contemporary chronicler, Andrea Schivenoglia, described him as "a small, dark man, hairy, very proud, and stern."[20] Driven and decisive, Trevisan did not shy from enjoying his power and fortune, his luxurious ways earning him the nickname "Cardinal Lucullus," after the ancient Roman

Figure 6-2. Andrea Mantegna, *Cardinal Ludovico Trevisan*, tempera on panel, 1459–60.

general famous for extravagant living. At his home in San Lorenzo in Damaso, Trevisan assembled a menagerie of exotic animals, including white asses, Indian hens, goldfinches, and lapdogs; cultivated rare fruit; and gave magnificent banquets cooked by Maestro Martino, a Renaissance "celebrity chef" who wrote the first cookbook to specify ingredients, measurements, cooking tools, and times for his dishes.[21]

Trevisan took very seriously the quality of his table. He hunted after the best ingredients and the most unusual foods and wines, often devoting more room to gastronomy than to politics in his correspondence, even as major diplomatic events were taking place. In a letter to his friend (and perhaps illegitimate son) Onorato Caetani, he requested at length, and for the third time, the finest

possible sea fish for the upcoming banquet he was planning for Pope Nicholas V, and mentioned only in one line at the end of the dispatch the news of enormous import to all of Italy—that the condottiere Francesco Sforza had conquered Milan and become its lord.[22]

Paolo Cortesi, in his treatise *On Cardinalship*, commented on Trevisan staging sybaritic feasts and spending twenty ducats daily for his meals (one-tenth of the price Alfonso paid for the *Tazza*); following Trevisan's example, Cortesi complained, "no one in Rome dined frugally anymore."[23] Raffaele Maffei, in his turn, scoffed in his *Books of Refined Commentaries* that "forgetting his origins, Trevisan took on such airs that he was the first among the cardinals to raise dogs and horses, and he introduced a magnificence in his sumptuous banquets and in his household furnishings that was well above his station."[24] Indeed, a Gonzaga courtier reported that Trevisan "wears the crown in all things. His house truly seems like Paradise."[25]

Trevisan may have hunted for luxury arts with a lesser zeal than for his gastronomic pleasures, but he was certainly keen to obtain exquisite works. He likely acquired some ancient pieces while campaigning in Greece as the commander of the papal navy against the Ottomans; he made other purchases through the antiquarian Cyriacus of Ancona and fellow collectors in Italy. In 1434 Trevisan arrived in Florence in the retinue of Pope Eugenius IV (expelled from Rome by its citizens) and met the city's humanists, among them the preeminent scholar Niccolò Niccoli.[26] Opting for the life of the mind, Niccoli was financially supported by Cosimo de' Medici, whose generosity left Niccoli the leisure to study ancient texts (he amassed a superb collection of books which, upon his death, became the core of Florence's public library) and to gather ancient coins, gems, statues, and vases. Niccoli loved and praised everything ancient, wore plum-colored garments in imitation of the purple robes of Roman patricians, and ate only from the

finest antique vessels. He may have spurred Trevisan's desire to surround himself with such artifacts—including one from Niccoli's own collection.

One day, walking through Florence, Niccoli had spotted a boy wearing a stunning gem on a cord around his neck: a red-brown agate intaglio depicting the Greek hero Diomedes with the Palladion of Troy—the sacred statue of Athena that protected the city and whose capture assured the Greeks victory.[27] This gem (which is today lost, but is known from other ancient versions and later copies) was a masterpiece of carving, rendering in meticulous detail the lithe and muscular Diomedes, divine image in one hand, sword in the other, perched on an altar (fig. 6-3). How a humble

Figure 6-3. Bernard Picart, *Intaglio of Diomedes and the Palladion by Dioskourides*, engraving in M. Philippe de Stosch, *Pierres antiques gravées.* Amsterdam, 1724.

Florentine boy came to possess it is unknown. It may have been found in an accidentally uncovered ancient tomb. In those early days of antiquarianism one could chance on such treasures and get them for a bargain. Niccoli paid the boy's father five florins for the stone: the man thought he got twice what it was worth; Niccoli recognized it as a steal. Soon antiquities would fetch ever increasing sums. When Trevisan laid eyes on Niccoli's gem a few years later, he offered 200 florins for it. Niccoli, a poor scholar, parted with the gem reluctantly, and Trevisan added it to his possessions.

Trevisan also obtained a carnelian gem depicting the contest between Apollo and Marsyas, a satyr who had foolishly challenged the god to a music contest. Marsyas lost and was skinned alive as a punishment for his presumption. The gem, depicting this scene with great mastery, has in our time been attributed to Dioskourides, Augustus's carver. Augustus, claiming Apollo's aid during the battle against Antony and Cleopatra, may have commissioned this intaglio to celebrate his victory at Actium. In the Renaissance the stone's connection with Augustus was lost, but a legend arose that it once served as the personal seal of the Emperor Nero, which enhanced its value. In the 1430s the sculptor Lorenzo Ghiberti, who thought that the scene represented the three ages of man and that it must have been carved by the great ancient master Polykleitos, or Pyrgoteles, mounted it in a gold setting shaped like a dragon holding the gem between its wings, and accompanied it with an inscription mentioning Nero (as he described in his *Commentari* II 20).[28] Trevisan may have commissioned this mount.[29] The cardinal's most spectacular acquisition, however, awaited him in Naples.

In the summer of 1456 he arrived in Alfonso's capital as the admiral of the papal fleet headed to combat the Turks in the Aegean. The Crusade against the Muslims had been an ongoing preoccupation of Europeans for centuries, but it gained new urgency after the Ottoman conquest of Constantinople in 1453,

which stoked fears that Sultan Mehmed would use his new capital as a launching point for an attack on Italy. In 1454 Pope Nicolas V began a diplomatic campaign to convince Alfonso to lead a united Christian force against the Turks. Nicolas V's successor, Pope Calixtus III, made a naval crusade the central passion of his papacy, building galleys himself and barraging Alfonso with appeals to contribute ships to the war. In June 1456 the papal secretary Niccolò Perotti praised Alfonso's virtues and asked him to add fifteen triremes to the papal fleet that was getting ready to depart from Rome. Orazio Romano, too, dedicated to the king a long poem in which he deplored Turkish cruelty and called Alfonso the only hope for the survival of Europe and Christendom.[30] Alfonso was not moved. Failing to obtain his written commitment, Calixtus dispatched Trevisan to Naples to negotiate for the galleys in person and proceed with them to the Aegean, to fight the Turks.

Trevisan himself was not convinced of the Crusade, but he was an avid gambler and a skillful player of political games. He had been instrumental in the election of Calixtus III to the papacy and exercised great influence at the Vatican early in his reign. The humanist Lodrisio Crivelli commented that the cardinal "thought he could use the poor old man as he wished."[31] But Trevisan's quest for power soon alienated the pontiff and his relatives who had their own ambitions, and the cardinal risked falling from grace entirely. Seeing how keen the pope was on the Crusade, Trevisan offered to lead an expedition against the Turks. Calixtus accepted with delight. When it was time to sail for the Aegean, however, Trevisan balked at the inadequacy of the resources he was given for the task: the pope had promised him thirty galleys, but produced only seven, not a number with which to face the Ottomans. Calixtus, incensed at Trevisan's refusal to depart with the available ships, summoned and assailed him "with the bitterest words," even threatening him with an ecclesiastical tribunal. Trevisan succeeded in convincing the pontiff that additional galleys were indispensable,

and by the late spring of 1456 Calixtus had nine more built and readied for action. He appointed Trevisan legate to Sicily, Dalmatia, Macedonia, Greece, the Aegean islands, and western Asia, as well as governor of whatever places he should seize from the Turks. On June 11 Trevisan set sail for Naples with sixteen galleys and hope of receiving almost as many more from Alfonso.[32]

But the king was not eager to provide ships, or to have anything to do with the Crusade. He had spent twenty years at war already, trying to capture Naples, and knew that European efforts to defeat the Ottomans in the previous decade had failed. In his mind, the Turks did not present a real threat to Italy, and there was no need to provoke them with a Crusade. The war in the Mediterranean, moreover, would likely disrupt Catalonian trade in the Levant and Egypt, from which Alfonso derived significant revenues. He did not care about the Turkish danger to the markets and shipping routes in the Aegean—where the papal navy was headed—since his competitors, the Genoese, the Venetians, and the Florentines traded there.[33]

Of course Alfonso could not declare his lack of enthusiasm for the Crusade outright—though none of the European rulers were any keener for it, really, except for the pope. So he dodged action through various excuses. He promised to provide fifteen galleys, but never delivered. He tried to persuade Calixtus that the papal fleet should cooperate with the Aragonese forces already present in the Adriatic. Calixtus would not budge, his heart set on the Aegean expedition and Alfonso's triremes. So Trevisan's assignment was to get Alfonso to comply with the pope's wishes. They had been easy to evade from afar. Now, with Trevisan disembarking in Naples in late June 1456, Alfonso was faced with a challenge.

The two men were not strangers. They had known each other for many years and enjoyed each other's company. In fact, they were happy to stretch out their negotiations. Trevisan was not burning to sail off to war and dallied so long in Naples that after

two months Calixtus dispatched an envoy, Jaume de Perpinyà, to request that Trevisan set sail immediately, even if Alfonso's galleys were not ready. In a personal letter to Trevisan the pope insisted: "If our fleet invades the Turkish shores and seacoast territories as soon as possible, the troops and striking force of the enemy, gathered for an attack upon Hungary, will be withdrawn and divided. On the speed of the fleet, therefore, the safety of the Hungarian kingdom depends, nay, the safety of all Christianity."[34] The pope also wrote to Alfonso, trying to impress him with the urgency of the situation. Before the arrival of Calixtus' impatient directives, however, the cardinal and the king spent so many leisurely hours together each day that Alfonso's secretary Panormita had to submit urgent private advice to his master in writing. His recommendation was not to give Trevisan any ships because the naval campaign would be detrimental to Alfonso's interests. The Christian forces would be outmatched by the mighty Sultan Mehmet, and if Alfonso were to provoke the Turks without defeating them, they would likely attack the Neapolitan fleet. Panormita suggested that the king ask the pope to defer the expedition until Alfonso could assemble adequate resources—in other words, that he continue to stall.[35]

Alfonso heeded his secretary's words, which matched his own inclinations. But he still needed to appease Trevisan for sending him off nearly empty-handed, and leaving it to him to explain to Calixtus why he got only a few Neapolitan ships when Alfonso clearly had more (soon thereafter he deployed them against Genoa, his commercial rival in the East). It would appear that Alfonso offered Trevisan the *Tazza* as compensation for the failure of their official negotiations.

Gift giving was not new between them. In 1446 Trevisan had presented Alfonso with an image of a woman representing the city of Naples—likely an ancient statue, among other works.[36] Now was a perfect moment for Alfonso to return the favor. The *Tazza*

would have certainly thrilled the luxury-loving cardinal who one like Alfonso, admired antiquities, and helped him accept Alfonso's unwillingness to provide the galleys, especially since Trevisan shared the king's misgivings about the Crusade. The rare beauty of the sardonyx bowl sparked the lust to possess it in everyone who saw it. One can picture the gleam in the eyes of the cunning cardinal as the king held the *Tazza* in his hands and hinted at coming to a mutual understanding. Whether Alfonso presented the *Tazza* to his guest as a gesture of friendship, or sold it to him for a good price, Trevisan ended up with the bowl—far more valuable to him personally than the royal ships.

Soon thereafter the cardinal set sail for the Aegean, heading first to Rhodes, to deliver money and supplies to the Hospitallers there, then to Lemnos, Samothrace, and Thasos, which he seized from the Ottomans, raising banners with the keys of Saint Peter over the islands' ramparts. He also won a victory over the Turkish fleet at Mytilene in August 1457, capturing more than twenty-five ships. And he harried the enemy positions along the coasts of Cilicia, Syria, and Egypt. Aggravated by the cardinal's actions, Sultan Mehmed II sprung into action and reconquered the islands taken by Trevisan. For the next few decades the Aegean would be a war zone between the Ottomans and the Hospitallers of Rhodes. Trevisan's military efforts thus proved futile, but his expedition enhanced his prestige back home.[37]

When the cardinal died in 1465, he was one of the richest men in Italy, and his inventory recorded an array of treasures, including antiquities: gold, silver, and bronze coins which he kept in little cloth sacks; gems stored in little boxes. The *Apollo and Marsyas* carnelian had its own little silver case, the *Diomedes* intaglio a gilt-silver one. The *Tazza* reposed in a black box, probably made of leather. This hoard was now greedily appraised by other hungry antiquarians.

The foremost contender for Trevisan's possessions was his long-time rival, Pope Paul II, who made collecting antiquities a fashion in Renaissance Rome in the days when it was still a novel concept. As soon as Trevisan died—and his death was said by some to have been precipitated by the election of Pietro Barbo to the throne of Saint Peter the previous year—the pope sent his agents to the cardinal's Florentine residence to take his objects. Paul II ordered the cardinal's money, rich clothing, gold rings, numerous jewels, carpets, tapestries, silver plate and lances, as well as antiquities brought to Rome. (He also appropriated Trevisan's Roman residence while refurbishing his own palazzo.) A portion of Trevisan's artworks had been placed in the care of the convent of Sant' Apollonia in Florence. Paul II bid the abbess, Piera Guasconi, to cooperate with the transfer of the cardinal's property to Rome. Complying, he indicated, would spare her monastery the fate suffered by several sister institutions in the neighborhood: reduction or elimination. The pope was dead set on getting his hands on Trevisan's masterpieces, especially the *Diomedes* gem, the *Apollo and Marsyas* carnelian, and the incomparable *Tazza*.

Pietro Barbo hailed from a family of Venetian patricians and had been made cardinal at age twenty-three by Pope Eugenius IV, his maternal uncle (the same man who had promoted Trevisan in the church).[38] Tall and well-built, Barbo had a dignified bearing, and according to one chronicler, for half a century a handsomer man had not been seen in the Senate of the Church. He could be generous and affable when it pleased him, or harsh and distant when facing opposition; he was also given to jealousy, vanity, and an exceeding love of pomp.[39]

Cultured and rich, Barbo began to indulge his taste for antiquities early on—though not just as an aesthete: his sensibilities were reinforced by his family's claim of descent from the ancient Roman family of Domitii Ahenobarbi. Barbo's approach to the past reflected the era's increasingly more sophisticated engagement

with the heritage of the ancients, and especially with their material culture.[40] In 1457, while still a cardinal, Barbo started an inventory of his objects (leaving blank pages for future acquisitions, which continued throughout his life). The list included nearly 600 intaglios kept loose so that they could be viewed against a light source that would reveal their carved details. The cameos, over 250 of them, were arranged on 60 silver-gilt trays inscribed with Barbo's arms and Latin verses declaring his ownership.[41] The inventory also enumerated hundreds of gold and silver coins, antique bronzes, vases and other objects carved from hard-stones, early Christian ivories, Flemish tapestries, and Byzantine icons.[42] The latter, as well as many of the antique pieces, probably came to Europe with the Greeks fleeing Constantinople after its Ottoman conquest.[43]

Barbo took pains to organize his holdings, especially his coins and gems, by subject matter and chronology. He knew his Roman emperors by heart and could recognize at a glance which one was represented. Like other Renaissance lovers of the past, he wanted to see before his eyes the men and women described by ancient writers, and coins offered this opportunity most directly, bringing history to life. He was also able to distinguish rare from common pieces and genuine antiquities from fakes. Barbo became not only the first large-scale collector in Rome, but the greatest compiler of ancient coins and gems of his generation. Carlo de' Medici (the natural son of Cosimo), wrote to his brother Giovanni that ancient coins were becoming scarce because Barbo was buying them all.[44] And Abbot Athanasius Chalceophilos, who translated the homilies of Gregory of Nyssa into Latin for Barbo, complemented the cardinal's collection when he declared that Gregory's wisdom surpassed in splendor even Barbo's jewels and gems.[45]

Curiously, Barbo's command of ancient mythology was spotty compared to his understanding of ancient history. He knew of Hercules and commissioned frescoes showing his deeds for one of

the rooms of his Palazzo di San Marco in Rome. But other figures evaded him. He owned a version of the Diomedes gem, valued at 100 ducats in his inventory, compared to other intaglios priced at one to five ducats, but could not identify the characters on it, calling the Palladion Mars.[46] He was shaky on ancient gods in general, writing uncertainly about an old bearded man with a thunderbolt, "I think it's Jupiter."[47] The *Tazza* must have baffled but engrossed him nonetheless.

Upon becoming Pope Paul II in 1464, Barbo embraced unabashedly the lifestyle of a secular prince, adopting a haughty manner—making even good friends wait for fifteen to twenty days to see him (for strangers access was almost impossible)—and idiosyncratic behavior, such as granting audiences only at night. A German ambassador complained that "His Holiness gives no more audiences by day, and as mine was the first, I sat all night in the Pope's chamber until 3 o'clock in the morning."[48] The ambassador of the duke of Milan, Antonio de' Rossi, scoffed at "the manners and intolerable pomp of all this court, and most of all that the pope spends all day counting and sorting money and threading pearls instead of paternosters." He decried that the pope was carried around on a gestatorial chair that "had cost more than a palace."[49] Actually, the palace Barbo built for himself in Rome cost far more.

Situated on the Piazza San Marco, across from the Capitol, the seat of ancient Roman government (and now opposite the colossal white monument of Vittorio Emmanuele), Barbo's residence claimed attention by its location, size, and splendor.[50] An entire quarter was raised to make room for it. The main structure looked like a fortress, but the adjacent Benedictine loggia was embellished with classical arches springing from elegant half-columns, the abutting palazzetto took on a Renaissance aspect, and the garden was populated by ancient sculptures. Inside, huge reception halls came alive with tapestries, gilded coffered ceilings shined overhead, a grand marble staircase led to the second story, and showcases displayed

gems, coins, and vases. All this was financed by the Apostolic Chamber headed by Barbo's nephew, Cardinal Marco Barbo, and by indulgences granted for the rebuilding of the adjacent church of San Marco.[51] Not only was the construction of the palace enormously costly, its staffing required vast sums as well. A cardinal's household, according to Cortesi's treatise on the subject, was to include at least sixty close and eighty lesser attendants: people such as chamberlains, chaplains, notaries, and physicians; stewards for the lord's table, cooks, and servants not only for the cardinal, but for his senior staff; squires, masters of the stable, grooms, tailors, and barbers; and other personnel, all needing to be housed and fed.[52] In a sense, a person of lofty rank, such as Barbo, had to acquire a massive palace just to accommodate his domestics.

Having built his palace while still a cardinal, Barbo continued to live there as a pope. The Vatican stood at the edge of the city; his residence sat at the heart of Rome where he could display his power and magnificence far more prominently. Following the example of ancient emperors, he put on lavish entertainments for his subjects and visiting dignitaries both inside and outside the palazzo: he celebrated the ancient festival of Saturnalia with carnivals and banquets on the Piazza San Marco and races along the ancient Via Flaminia, which stretched before his palace. As the humanist Platina described the scene, "the elderly ran, the young ones ran, the middle-aged ran, Jews ran . . . horses ran, mares, donkeys and buffaloes to the pleasure of all, and for laughing the people could hardly remain on their feet."[53]

Barbo also showed himself an heir of imperial Rome by actively interacting with its monuments.[54] He undertook to restore the bronze equestrian statue of Marcus Aurelius, the arches of Titus, Septimius Severus, and Domitian, the *Dioscuri* on the Quirinal, and the column near the baths of Diocletian.[55] He transferred to the Piazza San Marco, in front of his residence, the porphyry sarcophagus of Constantia from the church of Santa Costanza and a large

stone basin that had stood in front of the church of San Giacomo al Colosseo.[56] He used marble and travertine blocks from the Colosseum to construct his palace; and his contracts with his builders stipulated that any artifacts found by workmen while digging the foundations—columns and architectural blocks, images made of marble or metal, gold and silver coins—would belong to him.[57] And he promoted the revival of ancient crafts. As Giorgio Vasari wrote, the "art of engraving hard-stones and gems, which was lost ... after the ruin of Greece and Rome ... did not ... attain excellence [again] until the time of Pope Martin V and Paul II."[58]

Barbo had doubtless eyed Trevisan's collection and especially the *Tazza* for a while, wondering how he might pry it out of the hands of his rival. He stopped at nothing to get ancient works, neither force, nor flattery, nor bribes. He did get some pieces legitimately and civilly. Maffeo Vallaresso, Archbishop of Zara (Dalmatia), hunted assiduously on his behalf for small antiquities, coins, and engraved gems.[59] Cyriacus of Ancona, the merchant who visited Syria, Egypt, and Greece, among other places, sketching, copying, and writing descriptions of ancient monuments, may have supplied Barbo as well. Cyriacus, the first European to draw the Parthenon in Athens, bought manuscripts, ancient sculptures, gems, and coins for humanist clients back in Italy. Since he was a close friend of Eugenius IV, Barbo probably had many conversations with him about these relics of the past and surely asked him to keep an eye out for them on his travels.[60] Closer to home, in 1468, upon hearing that a hoard of 300 Roman coins had been unearthed at Pienza, Barbo instantly wrote to Cardinal Ammannati, ordering him to secure the treasure.[61]

He was prepared to pay handsomely when necessary. Learning that the city of Toulouse owned a superb ancient cameo—the *Gemma Augustea*, akin to the *Tazza* in its large size and complex figural composition—the pope offered not only to give the city 50,000 ducats for it, but also to double the compensation received

by the canons at the Basilica of St. Saturnin, and to underwrite the building of a new stone bridge across the Garonne. The townspeople rejected his offer. Antiquities were becoming prized possessions not just for individuals, but for cities keen to link themselves to a glorious past.[62]

When words or monetary inducements failed, Barbo resorted to brute force. Carlo de' Medici complained to his brother Giovanni:

> In recent days, I have bought around thirty very good ancient silver coins from a servant of [the painter] Pisanello, who died recently. I do not know how, but Monsignor di San Marco [Barbo] learned of this and, finding me one day in Santo Apostolo, took me by the hand and would not let me go until he had led me into his chamber, and there he took rings and seals and money that I had in my purse from me, to the value of twenty florins, and would not return them until I handed over the above-mentioned coins.[63]

The humanist Bartolomeo Platina—admittedly a bitter enemy of Barbo—recorded that Paul II would do anything to achieve his goals: burst into tears, or throw a fit of rage, for which his predecessor, Pope Pius II, called him *Maria pientissima* (Mary weep-a-lot).[64] Distrustful and indecisive in papal affairs, which drove ambassadors crazy, Barbo moved swiftly when it came to the objects he coveted. His scale of collecting drove up the prices for antiquities. Giovanni Tornabuoni wrote to Giovanni de' Medici (Lorenzo's uncle) that he found about thirty ancient coins for sale in Rome, "but they are extremely expensive, which seems to me a shame, and the cause of it is monsignore Pietro Barbo who is gathering all of them, and he is quite a naughty man."[65]

Barbo certainly coveted Trevisan's possessions, but the cardinal was no push-over, and, while he was alive, he was not going to

cede any of his treasures to his enemy. Once he was dead, however, Barbo lost no time. The *Tazza* alone was an irresistible magnet. Its great size and superb carving doubtless thrilled the pope, and he could take pleasure in figuring out at least some of its imagery. Although shaky on classical mythology—as we have seen—he was fond of certain characters, such as the allegory of Abundance. He owned an amethyst carved with this figure which he had set as a seal, his arms incised into the mount below the stone.[66] The Nile holding the horn of plenty on the *Tazza* may thus have delighted him, as did the head of Medusa on the reverse of the vessel— another image which he identified specifically among his ancient works. The spectacular bowl likely became a crowning jewel of Barbo's collection once he had brought it from Florence, though no inventory survives to reveal how highly he prized it in monetary terms.

Barbo's period of enjoyment of the *Tazza* proved relatively brief. He himself died in 1471. And now another man, who had dreamt of Trevisan's antiquities for at least six years, and probably longer, plotted how to make them his own.

A few days after Barbo's passing, his successor, Pope Sixtus IV, spent the entire day of August 13, 1471 inspecting Barbo's gems.[67] Wondering anxiously what to do with the jewels and *objets d'art* left behind by his spendthrift predecessor, he appointed a commission to dispose of them and discharge Paul II's debts. One member of it was Cardinal Francesco Gonzaga, a lover of the past, another Lorenzo de' Medici, the papal banker.[68]

Perhaps the youngest collector of his era, Lorenzo (fig. 6-4) began buying ancient coins, medals, and marbles by the time he was sixteen years old, carrying on the family tradition. His grandfather, Cosimo, and father, Piero, had purchased gems and vases carved from rock crystal, jasper, agate, and other hard-stones—in imitation of Roman patricians whose habits they knew from

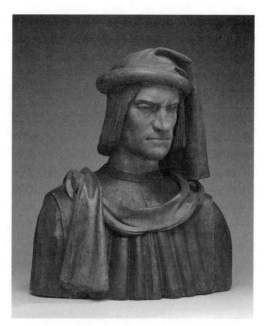

Figure 6-4. Lorenzo de' Medici, painted terracotta, 15th or 16th century, probably after a model by Andrea del Verrocchio and Orsino Benintendi.

reading Pliny the Elder.[69] Piero, crippled by arthritis and gout and unable to enjoy such aristocratic pastimes as riding and hunting, devoted his leisure hours to studying his jewels, coins, and stones.[70] Lorenzo inherited this passion, along with the family vases and gems, and the bank with branches and agents across Italy, France, and the Levant that made possible further acquisitions. But the determination to make the Medici collection the best in its time was his own.

Lorenzo was a complicated man: a statesman and a poet, a lover of classical literature and of bawdy songs, pious yet skeptical, mixing easily with simple folk, yet behaving like a prince. He had received a superb education and early training in diplomacy with introductions to foreign courts. But in his youth he was

riotous and chased women. As he was being groomed for political leadership, the elders of the Medici party took him in hand, admonished him to follow in the wise and measured footsteps of his grandfather Cosimo, and sent him to study moral philosophy with the celebrated humanist Marsilio Ficino, under whose tutelage Lorenzo wrote a philosophical poem on the Supreme Good. That did not preclude him from composing rude carnival ditties and staging opulent chivalric tournaments, in which, naturally, he was the star.

"In ordinary conversation," Francesco Guicciardini recorded, "he was very witty and agreeable; in domestic life, refined rather than sumptuous. . . . He was licentious . . . [but] constant in his loves, which usually lasted several years. . . . Lorenzo was of medium height, his countenance coarse and dark . . . yet with an air of dignity; his pronunciation and voice were harsh and unpleasing because he talked through his nose."[71] His death mask, preserved in the Palazzo Pitti, shows a broad face with high cheekbones, a nose broken and askew, and a jaw protruding slightly forward. He looks like a thug.

Yet his tastes in art and living were exquisite and his knowledge of classical texts and artifacts more sophisticated than most—thanks to the tutelage of leading humanists. Leon Battista Alberti had taught him how to decipher Roman inscriptions, Angelo Poliziano and Pandolfo Collenuccio how to read history in coins.[72] Niccolò Valori noted that Lorenzo "loved architecture, but particularly that which smacked of antiquity . . . he was so much a lover of antiquity that it possessed him more than anything else."[73]

In Renaissance Italy acquiring antiquities was a means of ennobling oneself. Poggio Bracciolini had Lorenzo de' Medici say in his book *On Nobility*: "we do see nobility being conferred with the aid of paintings and various images . . . and it is hungered and sought after by outstanding talents, for it is well known that the most learned men have devoted much labor and study to buying

statues and paintings."[74] Though Fra Sabba da Castiglione commented that "I have known many great men; great men, I say, in riches and dignity, but for the rest, ignorant, gross and stupid . . . these men, in order to demonstrate their talent and spirit to the common people, used to make great show of delighting in antiquities, especially in the medals of men who have been worthy and famous in the world, though their taste and understanding of these matters was like that of an ass faced with music played on the lyre."[75]

Lorenzo cherished his antiquities more than any other possessions, and pursued them with discrimination.[76] While we think of him as a great art patron of his day, he commissioned very few works from contemporary masters and gave most of his attention and resources to ancient hard-stone vases and gems. As Francesco Malatesta would report to Isabella d'Este, who was interested in purchasing these objects after Lorenzo's death, "They are rare and lordly things, which the late magnificent Lorenzo de' Medici regarded as objects most dear."[77]

Lorenzo was keen on lordliness. One of his early biographers, Francesco Guicciardini, commented that he "desired glory and excellence beyond that of anyone else."[78] Gems and vases conveyed his grandeur and echoed his virtues, as well as delighted his eye and mind. As Giorgio Vasari explained in his *Ragionamenti*, an elucidation of the decorations he devised at the Palazzo Vecchio for a later Medici ruler:

> hard stone is a material from which one can carve any kind
> of work and in that way it retains more of antiquity and the
> past than do other materials, as one sees in porphyries, jas-
> pers, cameos, and in other kinds of hard stones which,
> when they are on the shores of the sea and the lonely cliffs,
> resist all the assault of the water, wind, and other accidents
> of fortune and time. Such one could say of our Duke

Cosimo who in the face of many contretemps of his reign, with the constancy and *virtù* of his soul resists and resolves with temperance every misfortune.[79]

Attribution of moral and spiritual qualities to stones went back to antiquity and remained strong throughout the Middle Ages and the Renaissance.[80] Lorenzo, though, went further in reinforcing the connection between his stones and himself than any other princely collector: he had his name incised into his vases and gems. Guicciardini commented on Lorenzo's pride as a major trait: "he was very proud by nature, so much so that besides desiring that men should not oppose him, he even wished them to understand him intuitively, using few and ambiguous words in important affairs."[81] The signature Lorenzo put on his gems was certainly intriguing: "LAV.R.MED"—the R in the middle still puzzling scholars. Did it refer to his leadership of the Florentine Republic (likening him to Augustus ruling the Roman Republic)? Did it allude to his aspirations to be a king (Rex) or to his kingly artistic pursuits? Did it compare him to the great Roman art patron Maecenas who bore the title "Rex paterque"?[82] And why did he not put these letters on the *Tazza*—his most treasured ancient masterpiece?

Lorenzo loved cameos above any other carved stones. They were rarer and more visually arresting because of their intricately sculpted layers of different colors. Among his most prized gems was the *Noah's Ark* cameo that he may have taken for an ancient subject and manufacture—though it had been created at the court of Frederick II. Lorenzo preferred mythological subjects to all others because they brought to life the world of poetry he cherished and the great deeds celebrated by ancient writers.[83] Naturally he was intrigued by the *Tazza* and yearned for it from the moment he first saw it among Trevisan's possessions in Florence.

Luck smiled on him, or he made it do so, when Paul II died. The new pope, Sixtus IV, did not share his predecessor's passion

for antiquities and was eager to sell them off to pay Barbo's enormous debts. Lorenzo was in a perfect position to make a bid for them. As he recorded in his diary:

> In September of 1471 I was elected ambassador to Rome for the coronation of Pope Sixtus IV, where I was honored, and from there I carried away two ancient marble heads with the images of Augustus and Agrippa, which the said Pope gave me; and, in addition, I took away our dish of carved chalcedony [the *Tazza*] along with many other cameos and coins which were then bought, among them the chalcedony [the *Diomedes* gem].[84]

The Medici were papal bankers, and Sixtus entrusted Lorenzo to sell off Paul II's estate so as to recoup the vast sums of money Barbo had spent on luxuries, restore the health of papal coffers, and possibly finance a war against the Ottomans. As Niccolò Valori recorded in his biography of Lorenzo, Sixtus IV immediately put Lorenzo "in charge of the treasury of the Camera Apostolica, and he treated his business partners in such a way that in a short time all of them, and especially his uncle Giovanni Tornabuoni, acquired enormous wealth. Indeed, many of the gems and pearls, which Pope Paul collected with single-minded zeal, he [Sixtus] conceded to them either for nothing or for a very small price."[85] Lorenzo, seemingly, orchestrated a transaction that suited both him and the new pope: the Roman branch of the Medici bank canceled some of Paul II's debts and loaned money to Sixtus IV; in exchange Lorenzo got Barbo's best cameos, intaglios, and vessels, including the *Tazza*.

It was a perfect object for Lorenzo in so many ways: a cameo and hard-stone vase in one, figured on two sides as no other gem, the quality of its carving superior to any other work in his, or anybody else's collection. The iconography of the bowl, too, would

have intrigued him, for, like other Florentine humanists, he delighted in erudite subjects in poetry and art.

A learned approach to ancient imagery was relatively novel in those days, and one that elevated Lorenzo and his fellow humanists above the less educated masses who saw pagan depictions as dangerous and evil. Three days before Lorenzo's death, on April 5, 1492, a great storm swept through Florence and lightning struck the cathedral, dislodging stones from the cupola and sending them crashing to the pavement below. Many Florentines read in this fury the sign of Lorenzo's impending death, and rumored that the tempest was caused by the spirit he had kept imprisoned for years in a ring and which he released from its confinement on his death bed. Most likely the ring they had in mind was set with an ancient intaglio; perhaps it was the *Diomedes* gem. A line in Lorenzo's inventory seems to describe it: "a gold ring in which is set a carnelian engraved with a figure who sits before a column on which there is an idol."[86] An idol may have meant an ancient god to Lorenzo, but it was a demon for many of his contemporaries.

Lorenzo himself was not immune to belief in the numinous powers of stones. He and his circle read and followed treatises on the magical and healing properties of minerals and metals such as Pliny's *Natural History* (Book 37), Theophrastus's lapidary, and Marbode's eleventh-century *On stones* (a practical guide to the therapeutic uses of stones published in French, Provencal, Italian, Irish, Danish, Hebrew, Spanish, and Anglo-Norman translations and used widely by apothecaries, physicians, goldsmiths, and rulers). Albertus Magnus' mid-thirteenth century *On minerals* was also reissued repeatedly.[87] During Lorenzo's last illness in 1492 his physicians treated him with a potion composed of ground gems. And Marsilio Ficino, his tutor and renowned humanist philosopher who first translated all extant works of Plato into Latin, outlined an entire program of mineralogical and astrological medicine best suited for the health of an intellectual. Drawing on ancient

and medieval authorities, Ficino's *Three Books on Life* (1489) pre-scribed gold and gems as potent curatives. Being incorruptible, gold could impart such quality to man; thus Ficino offered a recipe for magical gold pills that were meant to strengthen individual bodily parts and sharpen and illuminate the spirit.[88] Ficino further elucidated how to use metals and gems to call down the beneficial influence of the planets, for each celestial body was attracted to and acted through terrestrial matter:

> If you want your body and spirit to receive power from some member of the cosmos, say from the Sun, seek the things which above all are most Solar among metals and gems, still more among plants, and more yet among animals, especially human beings. . . . These must both be brought to bear externally and, so far as possible, taken internally, especially in the day and the hour of the Sun and while the Sun is dominant in a theme of heavens. Solar things are: all those gems and flowers which are called heliotrope because they turn towards the sun, likewise gold, chrysolite, carbuncle, myrrh, frankincense, musk, amber, balsam, yellow honey, sweet calamus, saffron, spike-nard, cinnamon, aloe-wood and the rest of the spices. . . .
>
> . . . In the same way, so that your body may not be deprived of Jupiter, take physical exercise in Jupiter's day and hour and when he is reigning; and in the meantime use Jovial things such as silver, jacinth, topaz, coral, crystal, beryl, spodium, sapphire, green and airy colors, wine, sugar, white honey . . .[89]

Lorenzo's relationship with his gems, including the *Tazza*, was thus layered: at once learned and superstitious, intellectual and sensual, inquisitive and greedy. We can gauge just how be-sotted he was with the bowl from the inventory of his possessions

taken at his death in 1492: in it, the *Tazza* is valued at 10,000 florins, thousands more than any other object.[90] Even if this valuation was inflated—and Lorenzo seemed to prize his objects more highly than other collectors—it reflected how much the *Tazza* meant to him. Paintings and statues by such masters as Sandro Botticelli, Giotto, Masaccio, Donatello, Fra Angelico, Antonio and Piero Pollaiuolo, Andrea Verocchio, and Jan van Eyck were valued in his inventory at two to thirty florins; ancient sculptures at fifty to 100 florins; gems ranged from fifty to 2,000 florins; and hard-stone vases from 150 to 2,000 florins. Nothing came close to the *Tazza*.

Lorenzo knew well what was truly outstanding versus merely good or not worthwhile at all. Whenever he contemplated a new acquisition, he requested a given piece on approval and rejected it if the quality was poor. He also trained his agents to scrutinize objects with a discriminating eye. In 1490 Nofri Tornabuoni, his agent in Rome, wrote to Lorenzo about a gem he was considering for purchase: "I see what you say about the Hercules, and because, as I said to you, it does not seem to us a very worthy object; on the contrary, we call it mediocre, and therefore, we shall follow your advice to let it go."[91] Luigi da Barberino described to Lorenzo an intaglio depicting Phaeton in words that could well have been applied to the *Tazza*:

> The carnelian [itself], I say [even] without carving, is most beautiful.... To me it seemed a very artistic object, but after this man who owned it ... showed me the artistry and difficulty of each single detail, it seems to me still more wonderful. One has to consider every particular, and one will see what a hand and what an eye and conception the artist had.... There are so many things and so perfectly finished.[92]

The luminosity of gems and ways in which light revealed their carving was something Lorenzo and his agents also considered

with care. Nofri Tornabuoni wrote regarding the Phaeton gem: "It seems to me it has this subtlety, so that one can enjoy it by night as well as by day, because it is no less beautiful to see it by candlelight than in daylight"—a comment that evokes an image of Lorenzo viewing his treasures and showing them to his guests sometimes during daytime and at other times after supper, by the flickering flame.

The sellers of gems, too, were sensitive to how light augmented their properties. Paolo Antonio Soderini wrote to Lorenzo that he was trying to see gems offered for sale in Venice:

> Domenico di Piero has the objects . . ., but he does not want to show them in weather that makes them look different from what they actually are. Several times I cleverly solicited him in order to be able to satisfy you completely; he responds that he wants to show them on a clear day. Over here it has been more than a month without sun, and in wintertime it appears seldom. I shall keep watching the weather and shall do something as soon as possible.[93]

The wait was worth it: in the right light carved gems appear like theater, their figures drawing the viewer in, the relief of their carving endowing the images with a sense of movement and an unfolding story. The *Tazza* certainly came to life in proper illumination, captivating, intriguing, and awing its beholders.

And there were a number of its admirers in Florence as Lorenzo showed his treasure to those capable of appreciating it. Angelo Poliziano, the humanist who tutored the Medici children, extolled the *Tazza* in his *Orations*, declaring it "already an excellent thing owing to its own brilliance, a gift of Nature, but the hand of the craftsman made it worthier still."[94] He was, of course, using a literary trope going back to antiquity that praised an artist for improving on nature. But the *Tazza* justifiably invited such evaluations,

and Renaissance theorists, artists, and patrons were keenly attuned to ways in which nature could inspire creativity. Leon Battista Alberti, for example, wrote:

> I believe that the arts of those who attempt to create images and likenesses from bodies produced by Nature originated in the following way. They probably occasionally observed in a tree-trunk or clod of earth and other similar inanimate objects certain outlines in which, with slight alterations, something very similar to the real faces of Nature was represented. They began, therefore, by diligently ... studying such things, to see whether they could not add, take away or otherwise supply whatever seemed lacking to effect and complete the true likeness. So by correcting and refining the lines and surfaces as the particular object required, they achieved their intention and at the same time experienced pleasure in doing so.[95]

Leonardo da Vinci, too, advised artists to look at stained walls, differently colored stones, clouds, mud, and ashes for images of landscapes and human figures they may contain.

Lorenzo was interested in both, marvels created by nature and nature enhanced by artists. Next to his antique gems he kept an amethyst with an air bubble trapped inside it. And he cherished hard-stone vases and gems whose natural properties had been perfected by outstanding masters. As Francesco del Vieri put it a century later, some arts "not only imitate Nature and her works but aid Her, and these are the arts of medicine, agriculture, and that of refining jewels and metals and other ones which are similar."[96] In the *Tazza* Lorenzo could admire how the carver made a beautiful stone immeasurably more satisfying by turning the nuances of the material into a subtle color composition.[97]

Not content with collecting ancient masterpieces, Lorenzo encouraged contemporary masters to create modern examples of

such work, particularly fostering those who could revive the crafts of bronze and medal casting, mosaic work, and gem carving.[98] As Vasari wrote:

> Of this work, whether engraved in intaglio or in relief, we have seen examples discovered daily among the ruins of Rome, such as cameos, cornelians, sardonyxes, and other most excellent intagli; but for many and many a year the art remained lost, there being no one who gave attention to it, and even if any work was done, it was not in such a manner as to be worthy to be taken into account. ... Lorenzo and his son Piero collected a great quantity of ... chalcedonies, cornelians, and other kinds of the choicest engraved stones, which contained various fanciful designs; and ... wishing to establish the art in their own city, they summoned thither masters from various countries, who, besides restoring those stones, brought to them other works which were at that time rare.[99]

Lorenzo commissioned engraved gems from Pier Maria Serbaldi di Pescia, called "Tagliacarne," who mastered the carving of porphyry, and from Giovanni delle Opere, aka Giovanni delle Corniole, famed for his skill at working carnelian. He made an intaglio portrait of Lorenzo in this material preserved in the Palazzo Pitti. In 1477 Lorenzo exempted Pietro di Neri Razzati from taxes on condition that he teach gem carving to the youth of Florence.[100] Other artists were encouraged to study and learn from the Medici antiquities. Leonardo and Michelangelo drew inspiration from them, and Botticelli borrowed directly from the *Tazza* the figures of the two winds flying through the sky in his *Birth of Venus* (fig. 6-5).[101]

Getting a hold of the *Tazza* and Barbo's other outstanding pieces did not quench Lorenzo's desire for antiquities: he went on acquiring them at an ever increasing pace. His collection, fed by his avid intellect and the Medici bank, became the broadest in scope in

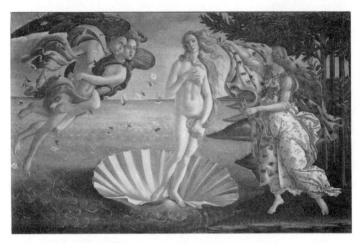

Figure 6-5. Sandro Botticelli, *The Birth of Venus*, tempera on canvas, ca. 1484.

his time. In addition to sixty-three hard-stone vases (both ancient and modern), 127 gems, and 5,527 coins, he owned forty-three sculptures, ancient Arretine pottery, Greek vases found in Etruscan tombs, arrowheads, and even nails from ancient shipwrecks.[102] He was happy to resort to deviousness when necessary, illegally smuggling inscriptions, architectural blocks, and sculptures out of Rome and its environs, contrary to the city's and papal bans on such exports. In November 1488 his agent Nofri Tornabuoni sent a shipment of marbles from Rome via Civitavecchia under the name of Francesco Cibo, Lorenzo's son-in-law and son of Pope Innocent VIII, who enjoyed diplomatic immunity—thereby avoiding "the outrage of these Romans"; from Civitavecchia the pieces were transferred to a grain ship owned by Lorenzo's relative by marriage, Virginio Orsini.[103] Whenever a notable collector died, Lorenzo pounced to get his antiquities, with unseemly haste. A mere eight days after Cardinal Francesco Gonzaga died on October 22, 1483, Lorenzo sent an envoy to procure his gems. The man overseeing the cardinal's estate, Giovanni Pietro Arrivabene, was unwilling to send

the objects to Lorenzo. When he went away on a trip, Lorenzo's representative, Antonio Tornabuoni, snuck into Arrivabene's home, took the gems, and dispatched them to Lorenzo for inspection.[104] Lorenzo's agents also stole into Giuliano della Rovere's excavations at San Lorenzo in Panisperna in Rome in the middle of the night to spirit away an ancient sculpture unearthed there.[105]

Lorenzo's antiquities entranced him with their beauty, craftsmanship, numinous properties, and connections to the past. They also turned him into a cultural leader. He showed them to his guests to impress them with his taste and knowledge, for he was a greater expert in this material than most. The garden of the Palazzo Medici was populated by ancient sculptures; marble replicas of the Medici gems carved by Donatello's workshop decorated the courtyard; Lorenzo's study contained his coins, cameos, intaglios, and vases, including the *Tazza*.[106] When Cardinal Giovanni of Aragon (son of King Ferrante of Naples and grandson of Alfonso), a notable collector, visited Lorenzo in August 1480, his host took him around the palazzo and displayed before him his ancient masterpieces: "vases, cups, hard-stone coffers mounted with gold, of various stones, jaspers and others . . . a dish carved inside with diverse figures, which was a worthy thing, reputed to be worth 4,000 ducats [the *Tazza*]. Then he had brought out two large bowls full of ancient coins, one of gold coins and the other full of silver, then a little case with many jewels, rings and engraved stones."[107]

To assert that his vases and gems were his and would forever be associated with him, Lorenzo marked them with his name: LAV.R.MED. As his brother-in-law, Bernardo Rucellai noted, "Witness the letters incised on the gems themselves, displaying the name Lorenzo, whose carving he charged to be done for his own sake and that of his family, as a future memorial for the posterity of his royal splendor."[108] But he did not dare inscribe the *Tazza*, perhaps fearing damaging or marring it. Instead, uncharacteristically, he contented himself with being its temporary custodian.

IN WOMEN'S HANDS

The emperor's representative . . . took as part of Margaret's claim on her husband's estate all his property, chattels of every sort, and among them the most rare and precious objects, the *Tazza*, or rather the agate vase.

—Benedetto Varchi, *Storia Fiorentina*[1]

Two years after Lorenzo died in 1492 at the age of forty-nine of gout, the hereditary Medici disease, Florence was invaded by the French king Charles VIII. The city's government took this opportunity to overthrow the Medici party, and Lorenzo's son Piero had to flee into exile. In the upheaval that swept the city, the Medici houses and property (as well as those of their partisans) were sacked and looted. Lorenzo's brother-in-law, Bernardo Rucellai, wistfully recorded: "All these things, acquired with the greatest effort and expense, enjoyed for generations and of which there was nothing more noble and more worth seeing in Florence—all these were given up to plunder in a single moment of time. Such was the avarice of the French, such was the treachery of our own people."[2]

As news of the events in Florence spread across Italy, collectors scrambled to procure Lorenzo's antiquities. The Duke of Ferrara, Ercole d'Este, the Marchesi of Mantua, Francesco II Gonzaga and his wife Isabella d'Este, the Duke of Milan, Ludovico Sforza, all dispatched their agents to inquire what could be bought. Isabella asked Leonardo da Vinci to examine the Medici crystal, agate, amethyst, and jasper vases offered for sale by some merchants. He reported that he liked four of them, particularly one crystal piece. But Isabella did not have sufficient funds, so the purchase fell through.[3] Ludovico Sforza instructed his ambassador, Giovanni Stefano Castiglione, to look for "the precious and portable objects, that is, cameos, carnelians [intaglios], coins, books, and similar valuables, not the marbles."[4] Anxious not to lose his chances, the duke also sent the artist Caradosso Foppa to Florence with instructions: "I would expect you to find something beautiful and especially some beautiful dishes [hard-stone vases]." Caradosso reported that the best artifacts were gone.

In fact, the most precious pieces had been saved by the family, its supporters, and city officials. Piero packed a few valuables into his luggage as he fled the city; the Florentine government confiscated some of the jewelry, ancient coins, hard-stone vases, and gems; and Medici loyalists spirited away a number of works—at a grave personal risk. The Signoria had issued an order that anyone who knew the whereabouts of the Medici's and their partisans' possessions had to report them "within this present day, the 10th of November, 1494, under the penalty of the gallows."[5] A few people came forth with denunciations, and a number of steadfast Medici allies were imprisoned, tortured, and hanged. Still some of them managed to hide and safeguard the family's treasures. Caradossa reported to Sforza that "they find every day some things [that were] taken, in observance of the bans which have been made. And one citizen told me he has a very beautiful object, and he does not want it publicized for two months, and he has promised me to

give preference to Your Excellency."[6] The work in question was the *Tazza*. And one of the key family loyalists had a plan for it.

Lorenzo Tornabuoni, who managed the Florentine branch of the Medici bank, took part in the underground movement to rescue his bosses' precious artifacts and to get them out of the city. The Signoria had taken control of the Medici bank and instructed its managers, Lorenzo in Florence and his uncle Giovanni in Rome, to sell the family valuables in order to pay the debts owed to the bank's creditors. A whole batch of these goods was to be sent to Rome for sale. Lorenzo Tornabuoni obtained the *Tazza* from a fellow Medici ally who had secured it—likely the very man who promised it to Caradosso, perhaps as a distraction—and had it officially included in the shipment to Rome—where Piero de' Medici could take possession of it. Lorenzo paid for his allegiance with his life. Denounced under torture by another Medici supporter, he was seized and executed. The diarist Luca Landucci recorded, "I could not hold back my tears when shortly before dawn I saw carried past [the Canto de'] Tornaquinci, in a coffin, that young Lorenzo."[7]

Meanwhile, many other artworks from the Medici palace— "statues of ancient workmanship, carved objects, gems and various stones remarkable for the wonderful carving of ancient craftsmen, Myrrhine [hard-stone] vases, coins of gold, bronze, and silver with images of distinguished leaders"—were auctioned off by the Signoria. Bought by many of the Medici adherents, most of them were restored to the family in 1512 when it came back to Florence.[8] The *Tazza*, too, returned to the city and remained there until the grim demise of Duke Alessandro de' Medici.

Alessandro, nicknamed Il Moro (the Moor), was, officially, an illegitimate son of Lorenzo II de' Medici (grandson of the Magnificent). But most likely, and so it was rumored around Florence, he was a bastard of Giulio de' Medici (son of the Magnificent's murdered

brother Giuliano), conceived when the future pope Clement VII was seventeen years old and fooling around with a Moorish slave, Simonetta da Collavechio, who toiled in the Medici household. Alessandro's dark complexion, curly hair, wide nose, and thick lips bespoke his mixed heritage.

Black slaves, imported into Europe since the fifteenth century, served as fashionable additions to prosperous Italian households. Their popularity, alas, did not protect them from abuse. Masters so frequently took advantage of their female slaves that Florentine statutes of 1415 granted children born of such unions the free legal status of the father. And slaves who gave birth to their master's children were often freed to give their offspring full citizenship rights. Simonetta, Alessandro de' Medici's mother, was manumitted after his birth, though she spent the rest of her life in poverty and regularly beseeched him for help.

Alessandro was installed as a ruler of Florence by Clement VII in 1530. But he did not enjoy an easy reign. Opposition to the Medici was rife, and his enemies decried his despotism, incompetence, and depravity: he was said to have seduced innumerable women. Alessandro's supporters, however, complemented his political skills, generosity, informal ruling style, and concern for the poor, to whose problems he listened personally at regularly held audiences. What really tipped the balance in his favor, however, was the backing of the Holy Roman Emperor Charles V. Keen to consolidate his authority in Italy and to counter that of his archenemy King Francis I of France, Charles V cultivated relations with Pope Clement VII. To bind the pontiff closer to his wishes, Charles betrothed his own illegitimate daughter, Margaret, to Alessandro de' Medici.

Margaret (fig. 7-1)—the product of Charles' brief affair with Johanna van de Gheynst, a maid in the household of the governor of Oudenaarde where the young ruler stayed briefly in 1521—was not spoiled by love either as a child or as an adult. She saw her cold,

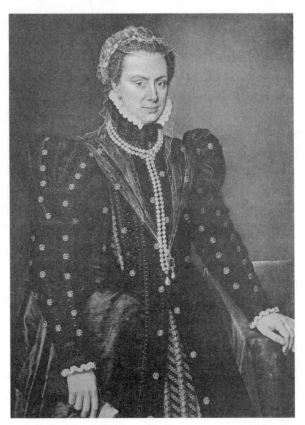

Figure 7-1. Antonis Mor, *Margaret of Parma*, oil on canvas, ca. 1562.

somber, self-assured father only a few times in her life. And her
mother even less. Early on, Charles decided to use the child as a po-
litical tool, and so he entrusted her upbringing to a series of women.
Her first mentor was his aunt, Margaret of Austria, a strong-willed
and highly cultured lady who ruled the Netherlands on Charles'
behalf from her court at Malines (in Belgium). A significant pa-
troness of arts and letters, she imparted their importance to her
charge, together with a sense of her Habsburg dignity.[9] After the
elder Margaret died, Charles's sister, Mary of Hungary, took over

the girl's education. A vivacious and extroverted woman, Mary was both a skilled governor of her brother's northern provinces and a lover of books. She, too, fostered in the girl an appreciation of learning and culture. In 1533, in preparation for her marriage to Alessandro de' Medici, the eleven-year-old Margaret was shipped to Naples to be taught Italian manners, language, and courtly behavior by Madame de Lannoy, the widow of Charles de Lannoy, the viceroy of Naples and loyal Habsburg servant.

After years of eagerly anticipating her new, happy life with the handsome Alessandro, Margaret finally arrived in Florence in 1536. The couple was wed in a solemn ceremony in the Medici church of San Lorenzo. The whole city rejoiced and celebrated with them. But a bad omen clouded the festivities. During the nuptial banquet the sun was suddenly eclipsed for a few minutes. Many worried about this portent. The thirteen-year-old bride was too delighted and innocent to pay it heed. Still a child, she did not even have to assume her full conjugal duties. Her father had stipulated that the twenty-six-year-old Alessandro had to wait until Margaret turned sixteen to consummate the marriage (which was no hardship for Alessandro: he had a steady lover, Taddea Malespina, who bore him two children). Margaret was left free to enjoy cultured Florentine life, hunt in the countryside, and revel in the kindness of her spouse. Alas, her bliss proved brief.

Just six months after the wedding, Alessandro was assassinated by his poor, proud, and bitter distant cousin Lorenzino, nicknamed "Lorenzaccio" (bad Lorenzo), who resented the young duke's position and dreamt of unseating him. To achieve his devious goal, Lorenzino entrapped Alessandro with a promise of a rendezvous with his beautiful sister. The duke, perhaps inebriated, fell asleep on his bed while awaiting the assignation, his sword set aside. Taking advantage of his vulnerability, Lorenzino slew him on the spot. To prevent a citywide uprising once the murder was discovered, the Medici supporters wrapped Alessandro's corpse in

a carpet and secretly spirited it away to the cemetery of San Lorenzo. And so Margaret turned into a widow before properly becoming a wife.

Though she lost her heart in Florence, she gained a great deal of Medici property by rights of marriage. According to Benedetto Varchi's *Istoria Fiorentina* (1538), while the young widow wept day and night her father's agents moved quickly to secure her person and possessions. Alessandro Vitelli, the commander of the imperial troops stationed near Florence, transferred the tearful Margaret, robed in black and surrounded by a heavy guard, to the Fortezza da Basso. At the same time the emperor's representatives took the Medici valuables, including the *Tazza*, and removed them from Florence.[10]

They did leave behind most of the Medici hard-stone vases. Some years earlier Leo X and Clement VII had turned them into reliquaries and dedicated them in the Medici church of San Lorenzo—a clever way of assuring that they would not be dispersed again. Michelangelo was commissioned to design a special cabinet for them between 1525 and 1532, called *la Tribuna delle reliquie*, initially planned as a baldachin raised on porphyry columns over the main altar, but later moved to the balcony over the main portal, just inside the church. In two bulls issued in 1532, Clement VII specified that the *Tribuna* was to be locked for most of the year with three keys: the first held by the reigning Medici duke, the second by the prior of the church, and the third by the prior of the Ospidale degli Innocenti. The *Tribuna* was to be opened and its reliquaries displayed to the public once a year, on the vespers of the Easter Sunday, and those who came to see them were to be granted indulgences.[11] The vases remained in San Lorenzo until 1785, when many of them were desacralized and transferred to the Gabinetto delle Gemme in the Uffizi; in 1861 they were temporarily moved to the Sala delle Niobe; and in 1921 sent to the Museo degli Argenti in Palazzo Pitti. A few nonecclesiastical pieces stored

in the Uffizi were taken in 1775 to the Museum of Physics and Natural History to form part of the mineralogical collection. A handful of vases that stayed in San Lorenzo now reside in its treasury.[12] Had they and their companions not been "secured" by their sacralization, all the Medici hard-stone vases would have probably left Florence with Margaret. The *Tazza*, having remained at the Medici palace, was appropriated by Margaret along with ancient gems and other nonsacred valuables.

Cosimo I de' Medici, who succeeded the murdered Alessandro, wanted to marry Margaret: she was young and pretty, the emperor's daughter, and the possessor of much of the Medici's property—not just the gems, but the residences in Florence and its countryside, and in Rome. Margaret herself, having grown fond of Florence and her in-law family, was keen on the match. But by 1537 the Medici pope had died and Charles V sought an alliance with a new pontiff, Alessandro Farnese, who ascended the throne of Saint Peter as Paul III.

The Farnese had risen to prominence over the course of the previous century by serving as *condottieri* (mercenary captains) to several popes. By the later fifteenth century they married into the Roman aristocracy and began to climb higher. Alessandro Farnese, the founder of the family's sixteenth-century greatness, had been educated in part at the court of Lorenzo de' Medici. Returning to Rome, he became the protégé of Rodrigo Borgia, the future pope Alexander VI, whose lover Giulia, *Julia sua* as contemporaries called her, was Alessandro's beautiful sister. In fact, many attributed Alessandro's ascent to her. Borgia bestowed on Alessandro a series of promotions in the church, making him a cardinal in 1493. This religious appointment in no way curbed Alessandro's worldly lifestyle. His house was splendid, staffed by some 360 servants of all kinds; and he kept a mistress who bore him four children, whom he legitimized. A shrewd politician, he managed to remain

on good terms with Borgia's successors, including the Medici popes Leo X and Clement VII, and in 1534 was elected to the papal throne himself.[13]

Once in power, Paul III proceeded to dispense church offices to family members on a shocking scale—"he is very much inclined to promote his relatives," Matteo Dandolo reported to the Venetian government. He made his grandson, also called Alessandro, a cardinal at age fourteen (fig. 7-2). The young Alessandro bitterly resented his enforced clerical career and resisted taking priestly orders for decades. He was handsome and dignified, a great aesthete and humanist, and an aficionado of women, his amorous exploits gossiped about all over Rome and beyond. While attending the wedding of his brother Orazio to Diane of Poitiers, the illegitimate daughter

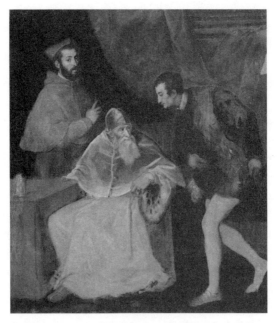

Figure 7-2. Titian, *Pope Paul III Farnese with Alessandro and Ottavio Farnese,* oil on canvas, 1545.

of the French king Henry II, the young Alessandro reputedly broke many hearts at the French court.[14] And his affair with a Roman courtesan produced a masterpiece: Titian painted for him a beguiling likeness of his paramour in the guise of Danaë.[15]

But Paul III was set on his plans. Carnal pleasures did not stand in the way of his own ecclesiastical advancement, and so his grandson's affairs need not preclude his role in strengthening the Farnese grip on the Church. Meanwhile, to solidify the family's position internationally, Paul III married his nonecclesiastical grandsons to the offspring of the King of France and the Holy Roman Emperor. And thus Margaret arrived in Rome in 1538— to wed Ottavio Farnese.

To say she was not keen on her second marriage would be an understatement. The small, pimply, awkward, shy fourteen-year-old Ottavio, two years her junior, was a far cry from Margaret's first husband. She viewed the boy with disdain. Pressured to marry him by her father, she refused to consummate the union, hoping to annul it on the grounds that she failed to utter "yes" at the crucial moment in the ceremony. Paul III endured her uncooperative disposition with kindly patience and showered her with jewels. She was his great prize, the hoped-for font of the glorious Farnese dynasty. Charles V, less tolerant of his daughter's whims, admonished her in stern letters to do her conjugal duty. For two years the travails of this marriage made international news, with diplomats discussing them among other major political developments, such as the Counter-Reformation and the Ottoman threat.

Margaret's insubordinate behavior cut against the norm expected of a Roman noblewoman. According to Giovanni Battista de Luca's treatise *The gentleman and the lady* (1675), a wife was meant to be subservient and humble before her husband.[16] Margaret, though, was not an ordinary woman, and she felt entitled to her freedom, even in the face of her august father's displeasure. She was not the easiest person in the first place—introverted, aloof, and

touchy—and her unhappiness with her wretched fate made her more difficult still.

Though Margaret eventually caved in to her father's pressure and admitted her husband to her bedroom, she insisted on her independence, living separately from him most of their married life. In Rome she dwelled in the Palazzo Madama, a Medici residence next to Piazza Navona, where she held tightly to her first husband's memory and possessions: the *Tazza* and other carved gems. The bowl's modern name, *Tazza Farnese*, however, stems from Margaret's second marriage, for it passed into the Farnese family through her son, Alessandro, born in 1545 and named in honor of Alessandro de' Medici and Pope Paul III.

Margaret lived briefly with her second husband in 1550 in his capital of Parma (hence her title Margaret of Parma, though she was also called Margaret of Austria), but soon moved to Piacenza on her own. From 1559 to 1567 she settled in Brussels to govern the Netherlands on behalf of her half-brother, King Philip II of Spain. It proved a miserable tenure. Local nobility resented foreign administration. Protestants fought against Philip's repressive religious policies, a struggle that boiled over into the Iconoclastic Fury of 1566 when hundreds of churches and monasteries across the Netherlands were attacked and plundered. Margaret, kept by her half-brother from making any political decisions of her own, was forced to implement his decrees aimed at squelching any resistance to Spanish rule—contrary to her own milder position. She finally resigned her regency in 1567 when Philip sent an army headed by the Duke of Alva to suppress the Dutch revolt. Seeing this harsh approach as a mistake, Margaret returned to Italy, worn out by stress and wracked by gout. Instead of joining Ottavio after years of separation, she settled in Abruzzo, first in the towns of Cittaducale and l'Aquila, then at Ortona on the Adriatic coast, where her ladies in waiting pined for some excitement while she savored the peace and quiet.

What seemed to give Margaret a degree of solace in all the sorrowful years since Florence were her first husband's treasures (which the Medici tried repeatedly to get back, but which she would not cede[17]). When she departed from Rome in 1550, she left behind the ancient sculptures gathered in the Palazzo Madama.[18] She considered transferring them to Parma, but never did. But she took to Piacenza, Brussels, and Ortona her carved gems, the *Tazza* foremost among the relics of her brief happiness.

Margaret did not have a particular passion for antiquities.[19] Her art patronage followed in the footsteps of her Habsburg clan. She built and refurbished her residences, particularly Palazzo Madama in Rome and the Piacenza palace, and engaged painters to decorate her apartments, produce devotional pictures, and portraits: in addition to at least four likenesses of Alessandro de' Medici and many of her son Alessandro, she gathered images of various members of her Farnese and Habsburg families. Her first role model, Margaret of Austria, had such a dynastic portrait gallery at Malines. Like her father, Margaret devoted a great deal of attention to tapestries. One of the keenest tapestry collectors of her day, she commissioned and acquired several hundred hangings woven by the best Netherlandish masters (her mother, incidentally, was a daughter of a tapestry weaver). Margaret was also passionate about music. She employed musicians of her own in Rome in the 1540s, unlike most female rulers of her time; kept singers and instrumentalists during her governorship of the Netherlands; and brought prized northern performers back to Italy to serve in her chapel in Abruzzo.[20] Her inventory, taken on her death, listed an inlaid walnut organ with seven registers, two sackbuts, nine recorders, four *cornamuses*, eight flutes, some bassoons, two large cornets and three small ones, and five large music books.[21]

Antiquities, unlike tapestries and music, were not something Margaret pursued and acquired—unlike her brother-in-law Cardinal Alessandro Farnese. During Margaret and Ottavio's wedding, at the

moment when the groom embraced the bride, an eyewitness reported that Alessandro went deathly pale.[22] Did he wish he were getting Margaret and her treasures, particularly the *Tazza*?

Alessandro had received a thorough humanist education, learned Latin and Greek, and developed an avid interest in ancient art. In fact, he became one of its foremost collectors in sixteenth-century Rome, amassing a spectacular array of works in the Farnese family palace.[23] It is quite probable that he regretted not marrying the Habsburg princess with her hoard of Medici antiquities. His possessive and competitive spirit showed through now and then from under his polished façade. Later in life he would boast that he had the three most beautiful things in Rome: the church of *Il Gesù* that he commissioned and built—the largest one in the city at the time apart from St. Peter's; the opulent Palazzo Farnese; and his daughter Clelia.[24] He would have gladly added the *Tazza* and the emperor's daughter to this list.

His grandfather, though, had loftier plans for him. A year after giving Alessandro a cardinal's hat, Paul III bestowed on him the lifelong office of Vice Chancellor of the Roman Church, which made him second to the pope within the ecclesiastical hierarchy. For the following half a century Alessandro would be the most powerful person in the Sacred College. But while he would elect a number of popes, he never attained the supreme office himself, to his enormous disappointment. It seems that his opponents felt that one Farnese pope had been enough. Though Alessandro remained for years ambivalent about the career imposed on him by his grandfather, his failure to attain the papacy tormented him in his later life.[25] It did not, however, curb his appetite for pleasures of all kinds.

Aside from pursuing his many romances, Alessandro became a preeminent cultural patron. Possessed of fabulous wealth, he poured enormous sums into art and architecture. His tastes had

been shaped by his grandfather, who, intent on bringing glory to Rome and to himself, hired Michelangelo to paint the *Last Judgment* in the Sistine Chapel and to redesign the Campidoglio around the statue of Marcus Aurelius; he also bid Antonio da Sangallo the Younger to remodel the basilica of St. Peter.[26] Cardinal Alessandro oversaw many of Paul III's projects and learned from him the ins and outs of art patronage. Among the genres Paul III favored were decorative arts, and these became Alessandro's special joy.

The spectacular scale of Alessandro's artistic undertakings earned him the title *il Gran Cardinale*. It was at one of his dinner parties, attended by various luminaries of the art world, that Giorgio Vasari was encouraged to write the *Lives of the most illustrious painters, sculptors, and architects*, which would become the preeminent encyclopedia of Renaissance art. Alessandro turned Palazzo Farnese—a majestic structure near Campo dei Fiori—into a veritable museum and study center, with a superb library, a picture gallery, and an unmatched collection of antiquities, on a par with the Belvedere and the Capitol. Displayed in the garden, the courtyard, and inside the building, his ancient objects ranged from coins and portraits of statesmen and philosophers to a colossal marble Hercules and the sculptural group depicting the myth of Dirce—the actual work described by Pliny the Elder as the masterpiece carved from a single block of marble in the second century BC by Apollonius of Tralles and his brother Tauriscus.[27] Though he owned these giant statues, Alessandro was particularly fond of miniatures, medals, and engraved gems.[28] As one contemporary wrote, "The most illustrious Farnese . . . has always favored every virtuoso and every rare intellect."[29] He formed close friendships with the miniaturist Giulio Clovio and the gem-engraver Giovanni Bernardi.[30]

Bernardi, who had previously served the Medici Pope Clement VII, began working for Alessandro when the cardinal was still a young man and remained in his employ until his own death in 1553. He executed commissions initiated by his patron and came

up with ideas of his own. In 1546 he informed the cardinal of his plans to go to Venice, a major market for hard-stones, to buy a crystal bowl that he wished to engrave with a scene of Noah's Ark. "I desire," Bernardi wrote, "before I die, to make a work from my hand in your memory and my own.... I have made up my mind to make you a tazza, which will be a grand thing to see."[31] Bernardi added that it will be at once an "ancient and a modern thing."[32] Was this dish intended to give Alessandro his own splendid tazza, since he could not have the one held tightly by Margaret? Bernardi may have also created for Alessandro a more direct replica of the *Tazza*: a bronze cast of its interior that survives in several versions (fig. 7-3).[33] And he fashioned for the cardinal a cameo portrait of Margaret, perhaps sculpting her likeness and taking the cast of the ancient vessel

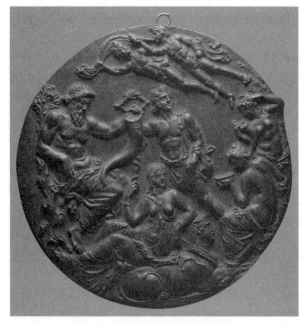

Figure 7-3. Giovanni dei Bernardi, *Tazza Farnese* bronze cast, 16th century.

on the same visit, though at which of her residences is impossible to know.[34]

In collecting art Alessandro relied a great deal on the sophisticated advice of his erudite secretaries and humanists, men such as the poet and writer Annibale Caro, highly knowledgeable and friendly with many artists; the bantering historian Paolo Giovio who was "always there to amuse [Alessandro] with beautiful and honorable discussions"; the antiquarian Onofrio Panvinio; the architect Pirro Ligorio; and above all the classical scholar Fulvio Orsini, an avid connoisseur of ancient coins and engraved gems.

Orsini, the illegitimate offspring of an illustrious Roman family, had previously served as a secretary to Alessandro's brother, Cardinal Ranuccio, and had traveled widely in the latter's entourage. During these journeys he had met many Italian and European intellectuals with whom he would correspond for the rest of his life. Through this network of men of letters and collectors Orsini searched for and acquired artworks for Alessandro Farnese and himself.[35] He was particularly instrumental in finding for Alessandro high-quality ancient gems. Margaret's *Tazza* served as a frame of reference for Orsini and his patron when they evaluated the pieces that came up for sale, as happened with the *Three Kings* cameo.

Since the twelfth century this large cameo, thought to represent the Magi, had been affixed, along with many smaller gems, to the casket enclosing the relics of the Three Kings in the Cologne Cathedral (as we saw earlier in chapter 4). The reliquary, secured inside a structure of iron lattice, stood in the chapel behind the high altar. The shrine was precious and well protected for more than its religious and monetary value: it drew countless pilgrims to the city, boosting the local economy and enhancing Cologne's international prestige. Most visitors probably paid little attention to the carved stones on the casket, but with the growing enthusiasm for antiquities in the sixteenth century, they were noticed by one enterprising man. Daring and crafty, he pried the cameo and its

companions off the shrine literally behind the priest's back during the 5 a.m. mass in January 1574 and vanished as quickly as his fingers did the work. The theft was discovered very soon, and the city authorities ordered all the gates shut. For the next twelve days everyone who went in and out of Cologne was searched. But neither the robber nor the gems were discovered.

Twelve years went by, and suddenly, in October 1586, the year of Margaret's death, the *Three Kings* cameo turned up in Rome, offered by a Flemish dealer to Fulvio Orsini in hopes of selling it to Alessandro Farnese.[36] Orsini promptly wrote to the cardinal: "I believe it is difficult to find a better object, being the work of a most excellent craftsman and carved from beautiful stone, besides the *tazza* that belonged to Madam of happy memory."[37] The asking price was 500 scudi—the annual salary of a university professor. Alessandro told Orsini that he did not want to pay more than 300. The dealer, sure that he could get the full amount, wasted no time and approached another avid collector, Duke Vincenzo Gonzaga, who bought the gem without haggling. In the early seventeenth century Peter Paul Rubens, another keen buyer of ancient coins, sculptures, and cameos, admired it while serving the Gonzaga duke in Mantua.[38]

According to Rubens' biographer, Roger de Piles, the artist's greatest pleasure lay in studying gems.[39] He acquired ancient pieces as well as casts and impressions of the works he wished were his, and sketched cameos and intaglios he saw while on diplomatic trips around Europe. Together with the French antiquarian Nicolas-Claude Fabri de Peiresc, Rubens intended to publish a book on the most magnificent ancient gems (a project that sadly never materialized due to Rubens' commitments and Peiresc's inability to stop gathering more and more material).[40] In addition to the *Three Kings* gem, Rubens was quite taken with the *Gemma Augustea* that Pope Paul II had failed to extract out of the city of Toulouse. In 1533 King Francis I of France gained possession

of that cameo and brought it to Fontainebleau. After the Hugue-
nots looted the chateau in 1590 and the royal treasury was dis-
persed, the *Gemma Augustea* surfaced in Venice and was bought by
agents of the Holy Roman Emperor Rudolph II. Rubens himself
ended up with another ancient masterpiece from Fontainebleau: a
carved agate vase he purchased at the Fair of St. Germain in Paris in
1619 for 2,000 gold scudi. Rubens's vessel (fig. 7-4) had probably
been carved in fifth-century Constantinople by a skillful master
who rendered in high relief the heads of Pan on the shoulders of
the vase and acanthus and grape leaves on its body. Like the *Tazza*,
this piece was likely looted by the crusaders in the Byzantine capital
in 1204 and brought to France, where it entered the collection of
the Duke of Anjou in the fourteenth century and of Francis I in the
sixteenth. Rubens was extremely fond of this object and planned to

Figure 7-4. The Rubens Vase, agate, 5th century?

include it in his book on ancient cameos. In the same volume he would have illustrated the *Three Kings* cameo that Alessandro Farnese lost to the Gonzaga, but not the *Tazza*, which remained largely hidden from view in the hands of Margaret and her successors.

Cardinal Alessandro and Fulvio Orsini seem to have been among the very few antiquarians who got to see the *Tazza* and make it their gold standard for antique gems and hard-stone vases. They apparently thought that the *Tazza* may have once belonged to Alexander the Great—the cardinal's namesake and the model for his grandfather, Paul III.[41] Orsini was fascinated by ancient portraiture and iconography and encouraged this interest in his patron, and Alessandro favored images that displayed *difficoltà* and *varietà*. The *Tazza*'s erudite imagery doubtless intrigued them both.

Orsini kept a sharp eye out not only for gems, but also for ancient vessels. He acquired five agate vases for his own collection from a remarkable source. In 1544, during the reconstruction of St. Peter's, workmen unearthed the sarcophagus of the Empress Maria, wife of Honorius (reigned 395–423 AD), laid to rest in such splendor as had never before been seen in rediscovered ancient tombs. Dressed in a veil and robes woven with gold threads and wrapped in a golden shroud (the weight of gold extracted from these garments alone was said to have been some 40 pounds), she reposed in a red granite coffin and was flanked by two caskets. The first, of solid silver, enclosed thirty vessels carved from crystal, agate, and other hard-stones, including two cups decorated with figures in high relief; a crystal lamp in the shape of a sea-shell, the hole for the oil being protected by a golden fly; and four gold vessels studded with gems. The second casket of gilded silver contained gold rings set with engraved gems; gold earrings, brooches, neck-laces, and hair-pins covered with pearls, emeralds, and sapphires; and an emerald engraved with the bust of the empress's husband Honorius. Pope Paul III quickly appropriated the gold and the

gems, using them in his tiara, as well as some of the vases. Others went into different collections, including that of Orsini. There was an avid interest in such vessels among Roman humanists.[42] But most of them were not able to admire and study the *Tazza*.

Alessandro gladly shared his collection with artists and scholars. With Orsini's help, he established a *studiolo* in the Palazzo Farnese that became *the* place to study ancient art in Rome—a "public school" as Orsini put it. It also gave the cardinal a haven from church politics and disappointments. As one of his advisors wrote while the *studiolo* was being planned, "by gathering together an ensemble of so many gems and objects of extraordinary beauty and richness, and not omitting to put in their places some little antique vases of agate and other precious stones, you will give pleasure to yourself regularly and to others on occasion, besides its serving as an antidote to your worries."[43]

Margaret felt differently about her gems. They were her personal property to be cherished privately. She had a warm rapport with her brother-in-law—they regularly exchanged gifts—and she would probably let Alessandro see her Medici gems whenever he wished. But after the first decade of her Farnese marriage, she lived far from Rome. And though she knew well Alessandro's passion for cameos and intaglios, she would not cede the *Tazza* and its carved companions to him, even as she neared death. She was not being greedy. She left bequests to a long list of beneficiaries (and Alessandro would essentially—if not officially—inherit the Medici sculptures left in the Palazzo Madama, transferring them to the Palazzo Farnese and adding them to his collection).[44] But the *Tazza* and the other Medici gems meant more to Margaret than any of her other valuables. The spectacular carvings certainly reflected her imperial dignity which she zealously upheld, and her culture acquired at the courts of Margaret of Austria and Mary of Hungary and honed in Italy. Above all, though, these objects served as links to her

Florentine happiness which had vanished so quickly: to her beloved first husband and his lively intellectual and artistic milieu. The gems were deeply personal to Margaret in a way they were not to other owners of the *Tazza*.

Which is why she left them to her son Alessandro—even though he was a military man with little interest in art. As Margaret lay dying in agony in Ortona, consumed by stomach cancer, she not only bequeathed the Medici gems to the man she loved most after her first husband, but carefully specified how they were to be passed on through his family. Decreeing these objects the inalienable property of her direct descendants, Margaret stipulated that after Alessandro the pieces were to go to his son Ranuccio, and after him to his male heirs down the line. The collection was never to be sold or dispersed, even in time of need. Only if the entire family died out was it to be put on the market and the proceeds divided between two orphanages for girls, one in Parma, the other in Piacenza.[45] Margaret's meticulous instructions underscored her degree of attachment to the *Tazza*, listed second among her most prized possessions (after a richly adorned reliquary); the other Medici cameos and intaglios followed immediately after.[46]

Margaret died in 1586 far away from her family—her son, husband, and brother-in-law—her end as lonely and tormented as she had felt for much of her life. Once the inventory of her property had been completed by her court officials, the duchess's valuables and her corpse left Ortona in a convoy led by priests bearing lit torches and forty mounted arquebusiers sent by Cardinal Alessandro to guard her treasures during transport. The goods, born by twelve mules, were taken to the Farnese palace in Parma. Margaret's mortal remains proceeded to burial in the church of San Sisto in Piacenza, as had been her will.

For the next century and a half the *Tazza*, one of the most spectacular examples of ancient art, remained largely hidden from view in

an era of increasing study of classical monuments. It was not an atypical situation: seventeenth-century scholars frequently lamented the difficulty of visiting aristocratic collections. Peiresc, Rubens' antiquarian friend, had to procure endless permissions to view the Borghese holdings. And even the famous Vatican antiquities in the Cortile Belvedere became difficult to see. The Farnese dukes of Parma did not seem to favor access to and popularization of their glyptic collection for reasons of privacy or relative disinterest on their part. The obscuring of the Vatican statues was ideological.

The Cortile, designed to house and display papal antiquities— the Apollo Belvedere, the Belvedere Torso, the Laocoön, and other sculptures—drew numerous visitors during the pontificates of Julius II and Leo X. The austere Dutch pope Adrian VI (1522–23), disapproving of these pagan idols, temporarily shut down the area, but Clement VII opened it again. Pius IV (1559–65), anxious to protect the rare and precious works from vandalism by the ignorant or ill-intentioned, closed off the niches containing the statues with wooden doors. Visitors to the Cortile had to find a custodian with a key and tip him to see the ancient masterpieces.

The situation worsened during the Counter-Reformation. Pius V (1566–72), a few weeks into his pontificate, announced his intention to disperse the Belvedere collection "because it was not suitable for the successor of St. Peter to keep such idols at home."[47] He dismantled the statues displayed in Pius IV's cortile and donated them, and others, to the Roman people, to be housed on the Capitol. He was dissuaded from doing away with the pieces in the Cortile Belvedere—they were too famous—but he had new shutters placed in front of them to conceal them from view. The antiquities were allowed to remain, but access to them was forbidden.[48] Sixtus V (1585–90) also considered taking them away and demolishing the whole area in order to build his library there. Fortunately, he, too, did not carry out his plan. With the move of the papal residence to the Quirinal in the seventeenth century, the Cortile and its sculptures

fell into relative neglect. The grand tourist Charles de Brosses complained in 1740 that the court looked like a dingy stable yard. He suggested that the marbles would be better off in the corridor used to heat the cardinals' dinner during conclaves: "Would it not be better that the cardinals ate cold food and even had a bit of stomach trouble than to leave such antique statues in poor order?"[49]

Despite curtailed access, the Cortile sculptures were still visited and periodically discussed by scholars in print—unlike the *Tazza*, which was not drawn or described in any book until the eighteenth century.[50] Only the penultimate Farnese duke, Francesco, became interested in making the Medici gems, and the *Tazza* in particular, known to the wider public. His plan to publish engravings of them was likely inspired by Baron Philipp von Stosch.[51]

Stosch, a son of an impoverished Prussian nobleman of Küstrin, began his career by reading theology at the University of Frankfurt-an-der-Oder. But falling under the spell of ancient coins, he left school and embarked on a journey to see them in collections in Germany, Holland, and England. He was not always a trustworthy visitor. A British man of letters, Isaac d'Israeli (father of the British Prime Minister), recorded in his *Curiosities of Literature* (1791):

> ... looking over the gems of the royal cabinet of medals ... the keeper perceived the loss of one; ... he insisted that Baron Stosch should be most minutely examined ... this erudite collector assured the keeper ... that the strictest search would not avail "Alas, sir! I have it here within," he said, pointing to his breast. An emetic was suggested by the learned practitioner himself.[52]

Arriving in Rome in 1715, Stosch entered the circle of Pope Clement XI and his nephew, Cardinal Alessandro Albani, both avid connoisseurs and collectors of antiquities. For two delightful

years Stosch explored Roman remains with Albani, his near contemporary, and hunted for pieces to buy. Sadly, he was recalled from this paradise to attend to family affairs at home. In 1718 Stosch secured an appointment as the Royal Antiquarian to Augustus the Strong of Saxony and Poland, and his career seemed on the rise. But after a few years in Dresden, he fell somewhat out of favor (and into debt as a result of his insatiable acquisition of gems, coins, books, and drawings), and began to cast around for opportunities to improve his circumstances elsewhere. Which led him back to Rome and to an occupation that combined style and danger.

The Pretender to the English throne, James Francis Edward Stuart, held his court in the eternal city, having been given refuge by Stosch's old patron, Clement XI. The British government needed to keep an eye on the Pretender's doings, on foreign ministers treating with him, and on Englishmen who, while on a Grand Tour of Italy, went to pay him their respects. Stosch undertook to spy for the British government for a generous salary and a government pension for life. His reputation as an art expert and collector gave him cover and an entrée into elite Roman and English Grand Tourist circles. Settling in Rome in 1722, Stosch dove into his clandestine activities, penning regular reports to the British Secretary of State under the pseudonym John Walton and coding the most sensitive information in numeric cipher. Stosch's official persona, meanwhile, was that of a connoisseur and savant, and he kept a pet owl as a symbol of his knowledge. Thanks to his new financial security, he could now indulge fully in acquiring topographical prints and drawings, ancient coins, cameos, and intaglios—or paste and sulfur impressions of gems in other collections. These formed the basis of the book that brought him lasting fame.

Carved Ancient Gems (Gemmae Antiquae Caelatae/Pierres antiques graveés) was written in Latin and French and printed in Amsterdam in 1724. It was not only a gorgeous folio illustrated

with seventy plates of ancient gems drawn by several artists engaged by Stosch and engraved by Bernard Picart, but a groundbreaking publication. For while gems began to be published in the sixteenth century, previous books tended to focus on the subject matter depicted on them and to illustrate them with fairly uniform line drawings that erased individual artistic and chronological styles. Stosch's ambition was to present a coherent history of gem engraving and to capture the characteristics of different eras and carvers.[53] By concentrating on stones bearing signatures of their makers (some of them named in ancient sources), Stosch aspired to compose a systematic history of ancient art. Many of the signatures would later be proven fake, but that's another story. Stosch's book became an instant classic, boosting the publication of ancient gems and the fame of named carvers, and spreading far and wide a repertory of their motifs—to be used in a profusion of decorative ways in Palladian and Neoclassical houses.[54]

To ensure the accuracy of his illustrations Stosch based them on actual gem casts, which gave him an opportunity to see important collections. He probably visited Parma to view the Farnese pieces that, by that time, included not only the Medici legacy, but also that of Alessandro Farnese and Fulvio Orsini. The latter had left his coins and stones to his pupil Cardinal Odoardo Farnese, Cardinal Alessandro's grandnephew, and they became Farnese property.[55] In the mid-seventeenth century, when the Farnese dukes had lost the power struggle against the papacy, they left Rome for good and transferred to their family seat in Parma most of their art holdings, including those from the Palazzo Farnese. Stosch's passionate interest in gems and his upcoming volume likely spurred Francesco Farnese, the penultimate member of that line, to envision his own book illustrating the family treasures. He commissioned the gem-cutter Giovanni Caselli (1698–1752) to draw his carved stones with an eye to publication.[56] The planned book never materialized, but the Farnese collection became known to the cognoscenti in

another way thanks to Stosch's fellow gem-lover and spy William Dugood.

Little is known of the Scotsman Dugood's beginnings.[57] He made his first documented appearance in 1716–17, running errands and supplying engravings to the young English nobleman, Thomas Coke of Holkham, on a Grand Tour in Italy. While in Rome, Dugood entered the circle of Jacobite exiles (the Stuart supporters who took their name from Jacobus, the Latin for James II, the last Catholic King of England dethroned in 1688) and was recommended to the Pretender as a jeweler, obtaining this post in August 1718. Stosch, admiring of Dugood's artistry, praised him as "the most excellent jeweler in Europe."

Dugood's access to "His Majesty" made him privy to secrets of the Pretender and his inner circle, and thus extremely useful to Stosch. Indeed, he became Stosch's primary source of information, and they collaborated as spies for several years. Eventually, one of the Pretender's closest advisors, Colonel John Hay, grew suspicious, and in November 1722 Dugood was arrested and thrown into the terrifying prison of the Inquisition on trumped up charges of heretical speech. Stosch, dreading that Dugood might reveal their joint activities under torture, appealed to every source he knew for his release. Cardinal Albani used his connections and influence to set Dugood free. Fearing for his life, the jeweler fled Italy, only to be hounded across Europe by Jacobite agents for his treachery against the Pretender. Finally Dugood made it to London, where his skills as a jeweler and his love of ancient gems brought him into the circle of freemasons, at that point a fraternal group of antiquarians, natural philosophers, and freethinkers, to which Stosch also belonged. Dugood was initiated into their midst and through his connections in London was elected a Fellow of the Royal Society in 1728. But Italy still beckoned, and in 1731 Dugood traveled to Florence, where he was instantly spotted by the Jacobite residents of the city. To stay out of trouble he secured

a commission (perhaps with Stosch's recommendation) that would place the *Tazza* into his hands.

The Farnese invited Dugood to appraise their jewels. Antonio Farnese, the last Duke of Parma, had recently died and the duchy, as well as the family's art holdings, passed to Don Carlos, the son of Elizabetta Farnese—Antonio's niece and wife of king Philip V of Spain.[58] Don Carlos was still a minor, and his grandmother, Dorothea, ruled Parma on his behalf. Perhaps needing to take stock of the Farnese possessions at this juncture, she bid Dugood, reputed to be "very skillful in diamonds," to "esteem the Jewels of the Farnese House." Dugood clearly did an excellent job because upon completing his initial task, he was retained as Don Carlos' jeweler and granted a good pension. And as a special favor, Dorothea—not at all a pushover, but an arrogant, authoritarian, and humorless lady—gave Dugood permission to take casts from the Farnese coins and gems.

Over the course of two years, 1732–33, Dugood made thousands of casts in sulfur, wax, plaster, and lead-alloy, including two reproductions of the *Tazza*: a red sulfur cast (fig. 7-5) of the bowl's interior scene and a papier-mâché replica (fig. 7-6) of the whole vessel that even rendered the hole at its center. To capture the sculptural subtleties of the *Tazza's* high-relief figures, Dugood meticulously undercut the forms on his cast. To record the chromatic qualities of the piece, he painted the papier-mâché version, showing both the reliefs on the inside and outside and the veining of the stone.

That Dugood was allowed to make these reproductions was indeed a mark of high favor, for he was doing so more for his own than his employer's profit, although the dissemination of his casts would publicize this spectacular assemblage at a time when cabinets of gems and their replicas became particular marks of prestige. Dugood's molds would serve as an invaluable resource for Christian Dehn, who started as Stosch's assistant and established a business in Rome producing plaster casts of gems, and James Tassie, whose

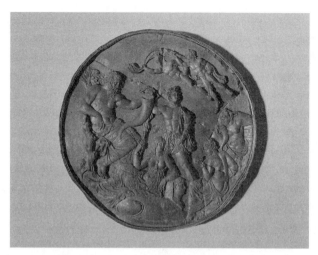

Figure 7-5. William Dugood, *Tazza Farnese*, sulfur cast, 1732–33.

Figure 7-6. William Dugood, *Tazza Farnese*, papier mache, 1732–33.

glass paste versions became a must for cognoscenti across Europe. Dugood later sold his casts to William Constable of Burton Castle Hall in Yorkshire, where they remain to this day, along with the two *Tazza* replicas, which may have been the basis for several eighteenth- and nineteenth-century bronze casts of the bowl's interior.

Jacobite agents finally caught up with Dugood in Parma and pressured Duchess Dorothea to terminate his employment. She must have done so reluctantly because she granted him a handsome pension upon his departure and sent him off with glowing letters of recommendation, one written by herself to the Pretendress, another by her secretary of state to the Farnese minister in Rome. Dugood did not go to Rome right away but proceeded to Florence. There he was quickly spotted by the Jacobites, denounced to the Medici Grand Duke on a spurious charge of stealing a diamond button from Don Carlos in Parma, and "tyed with Ropes Like a Criminal & dragged to a horrid & Vile Dungeon."[59] Stosch, who had fled to Florence in 1731 after his spying activities had been unmasked, once again used his connections to intervene on Dugood's behalf and liberate him. Hoping that the Farnese letters might protect him in Rome, Dugood went there—only to be arrested as he entered the city. This time it was much harder to obtain his release, but he did eventually walk out of prison. Escaping to Lisbon, he secured a post as the jeweler to King John V and spent the rest of his life in Portugal.

Shortly after Dugood left Italy for good, the Farnese gems left Parma. And it is in its next abode that the *Tazza* finally came into broad daylight and became accessible as never before to lovers of antiquities.

GEMS AND RUINS IN
BOURBON NAPLES

The King plans to build a museum in Naples where all his art collections—the Herculaneum collection, the Pompeii murals, the paintings from Capodimonte, the whole Farnese legacy—will be housed and exhibited.

—Goethe, *Italian Journey*[1]

W hen Antonio Farnese, the last Duke of Parma, died without issue in 1731, the family treasures, including the *Tazza*, passed to the son of Elizabetta Farnese, the final member of that line. Another strong and ambitious woman in the *Tazza*'s path, Elizabetta had intrigued for years to secure her son's position. Her task had not been easy: she was the second wife of King Philip V of Spain and he had older sons from his first marriage. To assure the success of her plans, Elizabetta instilled in her boy, Charles, absolute obedience to his parents so that when the time came he would accomplish what she had in mind. His strict tutors, meanwhile, had prepared the child for his role by schooling him in dignified conduct, several languages—Latin, Italian, German, and French, in addition to his native Spanish—history, geometry, naval science, and military

tactics. Charles was not a handsome youth: short, thin, stooping, he had bad teeth that gave him much trouble, and an enormous nose that hung low and ended in a bulbous tip (fig. 8-1). But he possessed a genial and unruffled disposition, was frugal and prudent, and when not doing something dutiful, diverted himself with hunting, fishing, billiards, and carpentry.

In October 1731, the fifteen-year-old Charles was dispatched by his mother from Spain to Italy to take possession of his Farnese inheritance—including the cities of Parma and Piacenza, which would be administered by his grandmother Dorothea until he turned eighteen, and the family art collection. Charles was also to regain control of Naples, which the Spanish crown had lost to the Austrians in 1707 (his claim to this kingdom also deriving from his Farnese lineage).

Fulfilling his parents' expectations, as soon as he came of age in

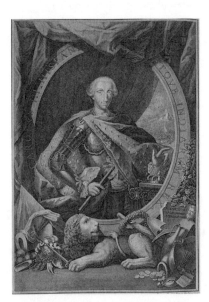

Figure 8-1. Filippo Morghen, *King Charles III of Spain*, engraving in O. A. Bayadri, *Delle antichità di Ercolano.* Vol. 1. Naples 1757.

1734, Charles led the Spanish army to the conquest of the Kingdom of Two Sicilies. The Austrians, unpopular with the local population and poorly equipped, did not resist very much, and the repossession of Naples proceeded in a rather civilized manner. The castle of Sant' Elmo surrendered after five days and the victorious general, Count de Charny, invited his defeated foe, the Count of Lossada, to dinner, the latter reciprocating with a reception later the same night. Similar courtesies were exchanged after the surrender

of the Castel dell' Ovo, which was assaulted "with the utmost humanity." Observing the siege of Castel Nuovo, the Florentine agent Intieri noted:

> the besieged, no less considerate of the city than the be-
> siegers, make signs with a handkerchief when they decide
> to fire and give warning in a loud voice so that the populace
> can withdraw, and when these are out of danger they pro-
> ceed. Before destroying a small house, they allowed time
> for the furniture to be removed. As soon as a cannon is
> fired the lowest people run up to search for the ball, and
> the garrison waits before firing again.[2]

The total damage during this operation amounted to three casu-
alties on each side.

And so Charles gained Naples with ease. It was said that the
congealed blood of the city's patron, San Gennaro, stored in an
ampoule in the cathedral, liquefied for him as a sign of divine favor,
since this miracle usually happened only on set days in May and
September. The populace, too, joyfully acclaimed the new king,
glad to finally have a ruler in their midst who cared about their
well-being after two centuries of unsympathetic domination by
the distant monarchs of Austria and Spain.[3] Realizing his mother's
long-cherished and schemed-for dream, Charles was officially
crowned King of the Two Sicilies in 1735. He would dutifully
report to his parents on every aspect of his reign, and they would
control his every decision as long as they lived.[4]

The young king began at once to transform his new home, de-
rided by contemporaries as a provincial backwater populated by the
shocking race of "eaters of garlic and catchers of vermin" (in Boswell's
words), into a brilliant cultural capital.[5] The *Tazza*, along with other
family art masterpieces, would prove instrumental in his program.

Naples was a place of contrasts, mingling great opulence with
amazing squalor. On the one hand, it was adorned with a profusion

of splendid churches. As the English traveler Misson wrote in the late seventeenth century:

> That which seemed to us most extraordinary at Naples was the number and magnificence of the churches. It may be justly said, that in this respect it surpasses imagination. . . . If you would look upon rare pictures, sculptures, and . . . vessels of gold and silver, you need but go to the churches: the roofs, the wainscots, the walls are all covered with pieces of precious marble, . . . or of joiner's work gilded, and enriched with the works of the most famous painters. There is nothing to be seen but jasper, porphyry, mosaic of all fashions, all masterpieces of art.[6]

In fact, there were so many churches in the city—some 400 of them—that in the early eighteenth century a petition had been sent to the Austrian viceroy asking him to stop the clergy from acquiring any more property.

Contrasting with this magnificence was the vast poor population of Naples. The mass of *lazzaroni* (their name probably deriving from lepers whose patron was Saint Lazarus) seemed to lead a remarkably carefree and cheerful life of begging in the streets, disporting themselves in shameless nudity at the port, and sleeping under the stars. The French traveler Président de Brosses called them "the most abominable rabble, the most disgusting vermin which had ever crawled on the surface of the earth"; and Henry Swinburne scoffed that "there is not such another race of rogues as the common people of Naples."[7]

The German writer and polymath Johann Wolfgang von Goethe, however, observed the *lazzaroni* with a sympathetic eye. In a letter from Naples in 1787, he wrote: "I watched the common people both in motion and at rest, and though I saw a great many who were poorly dressed, I never saw one who was unoccupied . . . and though,

now and then, I came upon people who were resting or standing around, they were always those whose occupation permitted it at that moment." They were, Goethe, went on, engaged in all manner of jobs: as porters waiting till someone may need their services, as carriage drivers standing beside their one-horse chaises in anticipation of customers, as fishermen biding their time until a favorable wind would carry their boats to sea, as beggars who were either very old or crippled and thus no longer capable of work, as garbage collectors taking refuse out of the city on donkeys, as peddlers wheeling around baskets of pastries or fruit or barrels of iced water and lemon glasses, ready to proffer passersby instant lemonade. "I would say, though this may seem like a paradox, that, in Naples, it is the poorest class which works hardest." What's more, "all of them work not merely to *live* but to *enjoy* themselves: they wish even their work to be a recreation." While this rendered the *lazzaroni* less productive and cultured than the northerners, they seemed to lead a freer and happier life.[8]

As the new sovereign of these people, Charles was keen to ameliorate their condition and to turn Naples into a handsome and thriving capital. He tore down old city walls, laid out new wider streets, and constructed a huge residence for the poor, Reale Albergo dei Poveri (its façade stretching to more than 350 meters), where orphans, vagabonds, and the unemployed could be housed, fed, and educated. "I hope to make this kingdom flourish again and relieve it from taxes," he told the Sardinian ambassador Monasterolo.[9] He was true to his word: his reign would come to be called "the Golden Age of Naples."[10]

Charles' Farnese heritage brought his city an instant cultural cache. Soon after becoming king, he began to transfer to Naples the family art collection, and the very first items shipped south were the *Tazza* and other cherished Farnese heirlooms. In October 1735, some thirty cases packed with gems, coins, and other precious objects were wheeled out of Parma, embarked at Genoa, unloaded at the port of Naples, and delivered to the Palazzo Reale. Three years later, when as a result of the War of the Polish Succession,

Charles was forced to cede Parma and Piacenza to the Austrian emperor, he brought to Naples the Farnese paintings, books, archives, and even the marble staircases from the Parma palace.

As he refurbished the royal palace in Naples to accommodate the collection and himself with new splendor, the furious pace of work caused some of the Farnese pieces to fall between the cracks: for a while the paintings moldered in the dark staircase where workmen went to relieve themselves: "they made water next to Guido and Correggio!" exclaimed Président de Brosses.[11] But by the late 1730s the pictures, books, medals, coins, and "other antiquities," including gems, were displayed all together in a "Museo Farnese"—a set of special rooms at the palace curated by the Florentine antiquarian Niccolò Marcello Venuti with the assistance of Bernardino Lolli, who had served as the custodian of the collection in Parma and knew it well.[12]

Charles augmented his reputation as a cultured monarch by building San Carlo, the first opera house in Europe (less from personal interest in music, than to keep up with other rulers who patronized it with largess). He also founded the first Neapolitan Academy of Art, the Royal Academy of Design, and the Academy of Architecture, as well as established the factories of tapestry, porcelain, and hard-stones (where new cameos, engravings, and mosaics were made). And he deployed a means of enhancing his prestige—and of adding to the glory that the *Tazza* and its companions had brought him—in a way that no other ruler was able to do, an endeavor in which he was aided and encouraged by his wife, Maria Amalia of Saxony, whom he married in 1738.

The new Queen of Naples was the daughter of Augustus III, King of Poland, Elector of Saxony, and an art lover whose collection in Dresden included three sculptures from Herculaneum. These draped female figures had been discovered around 1711 and sent by their excavator, Prince d'Elbeuf, to his distant cousin Prince Eugene of Savoy in Vienna, whence they were sold in 1736 to the Dresden court.[13] The statues handsomely augmented the assembly of ancient

statues gathered by Augustus III's father who had acquired over 200 marbles from the Chigi and Albani families in Rome. Augustus III's chief interests lay in paintings, prints, jewelry, and luxury arts, but the three Herculanean statues certainly added luster to his art holdings. Maria Amalia—a tall, fair, blue-eyed, and dignified young woman with a hot temper (she scolded and slapped her pages and ladies-in-waiting when they contradicted or annoyed her)—was brought up in her father's cultured milieu. It is unclear whether she actually spurred her new husband to sponsor royal excavations at Herculaneum, but Charles ordered them to proceed a few months after she came to Naples, and she took a keen interest in what came out of the ground.

Antiquity reached new importance in eighteenth-century Europe as a fount of models for the arts, letters, and various aspects of a civilized society.[14] The *Antiquarian Repertory* declared in 1775, "without a competent fund of Antiquarian knowledge no one will ever make a respectable figure."[15] Young aristocrats and men of culture flocked to Italy on the Grand Tour to visit Rome and Naples and to familiarize themselves first hand with classical remains. Goethe, living in Rome in 1786–87, wrote eloquently about the joy of face-to-face encounter with monuments of both the distant and more recent past:

> All the dreams of my youth have come to life; the first engravings I remember—my father hung views of Rome in the hall—I now see in reality, and everything I have known for so long through paintings, drawings, etchings, woodcuts, plaster casts and cork models is now assembled before me. Wherever I walk, I come upon familiar objects in an unfamiliar world; everything is just as I imagined it, yet everything is new.[16]

The German art historian and archaeologist Johann Joachim Winckelmann famously commented that "Rome is the school for the whole world," and Goethe concurred: "No one who had not been here can have any conception of what an education Rome is. One is, so to speak,

reborn and one's former ideas seem like a child's swaddling clothes. Here the most ordinary person becomes somebody, for his mind is enormously enlarged even if his character remains unchanged."[17] The Bourbon excavations at Herculaneum and later at Pompeii turned Naples as well into a crucial learning ground for Grand Tourists and other men of culture. The spectacular finds unearthed from the buried Vesuvian cities allowed them to study more directly than ever before the "manners and customs" of the ancients.

Herculaneum (in those days known as Resina, the town built over the ancient city) had been first explored, illicitly, in 1709–11 by Prince d'Elbeuf, the lieutenant general of the Austrian cavalry in Naples. He had been building a residence at the nearby Portici and looking for nice materials to decorate it. Learning that laborers cutting a well in the area came across a marble statue, d'Elbeuf paid them to dig further. In the course of these excavations, conducted like a treasure hunt, without any attempt to record the finds properly and aimed solely at finding beautiful objects, d'Elbeuf's men discovered the three female figures that ended up in Dresden. After d'Elbeuf was transferred back to Austria in 1716, no more excavations took place at Resina for two decades. Then, in 1738, shortly after Maria Amalia arrived in Naples, the king's military engineer Roque Joaquín Alcubierre, engaged in surveying Portici in preparation for building a new royal palace there (the area being good for hunting and fishing), rediscovered d'Elbeuf's well. The king, likely at the queen's urging, gave Alcubierre a small crew of workmen and ordered him to dig, and to report weekly on his finds.[18]

Alcubierre was not an antiquarian: Winckelmann scoffed that the engineer was "as familiar with antiquity as the moon is with crabs."[19] He had been chosen for the task because of his skills at mining and tunneling. The ancient city had been buried by a pyroclastic flow that had solidified into fifty to sixty feet of cement-like mass, and the modern town of Resina stood over this encasement. To look for antiquities one had to tunnel. Alcubierre, eager

to uncover quickly as many treasures as possible, did not bother recording the context in which he came upon various objects, and neither did their majesties. Together with their archaeological counselor, Marchese Venuti, Charles and Maria Amalia examined with delight their ancient paintings, sculptures, and artifacts (all the finds from the Vesuvian cities were considered royal private property). And even after Charles moved to Spain, Camillo Paderni, Keeper of the Portici Museum, sent him regular notes and drawings of new discoveries. Like the Farnese collection, all the finds were kept together in one place, at the Portici Museum, as Charles realized that such unified displays helped boost his image.

Paradoxically, he jealously guarded access to his Herculanean artifacts even though they greatly enhanced the prestige of his kingdom, while the *Tazza* and other Farnese treasures were made more accessible by their transfer, in the mid-1750s, to the Museo di Capodimonte, another hunting lodge, but closer to the center of Naples.[20] At Capodimonte, the gems, showcased in glass-covered tables, were visited and marveled at by both locals and foreigners. The Neapolitan Giuseppe Sigismondo noted that the *Tazza*, displayed in its own crystal case that allowed it to be seen from all sides, drew the greatest admiration.[21] And an album of engravings celebrating and popularizing the attractions of Naples and its environs, *Vedute nel regno Napoli* published around 1780 but composed of prints going back to the early 1760s, featured the *Tazza* as the only artwork (fig. 8-2). It appeared immediately after the portraits of the king and queen and two maps of Naples and vicinity, and was followed by the views of ancient architectural monuments in the region as well as the erupting Vesuvius.[22] The *Tazza* was thus presented as the most spectacular artwork to be seen in Southern Italy. The Farnese sculptures had not yet arrived from Rome, and the Herculanean antiquities remained closely guarded at Portici. What was visible and worthy of attention were the king and queen, the picturesque Bay of Naples, the volcano, the noble ruins in its environs, and the *Tazza*.

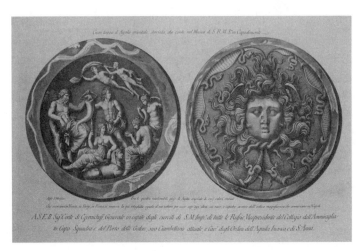

Figure 8-2. Filippo Morghen, *Tazza Farnese*, engraving in F. Morghen, *Vedute nel regno Napoli*. Naples 1765–79.

The album was created by the Florentine-born Filippo Morghen who had studied in Rome before settling in Naples and making a successful career as a printmaker and publisher, favored by the Bourbons with the title "Engraver to the King of the Two Sicilies."[23] Morghen specialized in fine depictions of the monarchs, maps of Naples and surroundings, architectural views, and antiquities discovered at Herculaneum (he was a leading engraver of *Delle Antichità di Ercolano*, a multi-volume publication of the finds).[24] Each beautiful, large-scale plate in Morghen's *Vedute nel regno Napoli* album was printed on expensive blue paper and dedicated to a different illustrious person: foreign ambassadors at the Neapolitan court, Grand Tourists, and other notables. It was a strategy, common among engravers, to boost their sales and reputation by dedicating prints to important patrons who also stood to benefit by having their name and fame spread far and wide. Morghen dedicated the *Tazza* image to Count Ivan Grigoryevich Chernyshov (Czernicheff), a Russian Navy field marshal and Vice-President of the Admiralty College, who served first the Empress Elizabeth, whose cousin he married, and then Catherine the Great.

MARINA BELOZERSKAYA

Chernyshov came from a distinguished family that traced its roots to the fifteenth century and enjoyed the trust of a succession of Russian rulers (his grandfather was one of Peter the Great's generals). Amiable, quick, and crafty, Ivan Chernyshov became, in his day, one of the most highly placed men at the Russian court. Though schooled in military arts, he made his career as a courtier and diplomat, serving at the Russian missions in Copenhagen and Berlin, and holding the post of the Ambassador Extraordinary from the Empress of Russia in London. As the Vice-President of the Admiralty he refurbished and greatly strengthened the Russian navy, gaining Catherine the Great's praise. Unfortunately, he suffered from poor health and convalesced for several years in Italy, apparently spending some time around Naples, since Morghen knew him and his interests well enough to dedicate an engraving of the *Tazza* to him.

Having taken part in court life in a number of countries, Chernyshov had, according to his contemporary Prince Mikhail Mikhailovich Shcherbatov, observed all the splendor and voluptuousness in which European royalty indulged, and brought back such opulent tastes and habits to Russia. Catherine the Great, though fond of him, often chided him for his ways, giving him the moniker "Barin," a luxurist. Shcherbatov commented that Chernyshov's clothes were particularly elegant and rich, as well as numerous—he ordered twelve robes at a time from abroad; his table was set with uncommon refinement and expense, and the food was delicious and flavorful; his wines were the best and most costly; his carriages sparkled with gold; even his pages' liveries were sewn with silver.[25] Chernyshov was able to enjoy such sensuous living thanks to a combination of resources that made him one of the wealthiest noblemen in Russia: his family estates, the dowry from his imperial wife, the posts he occupied, and the copper factories he bought cheaply through his connections in high places, exploited for several years, and, having exhausted them, sold back to the government at a profit of nearly 800 percent.

As well as rich, Chernyshov was intelligent and cultured, patronizing music with delight (he kept a private orchestra), and

serving on the administration of the imperial theaters. In paintings he favored classical themes: among other works he bought a canvas by Luca Giordano depicting the battle of Lapiths and Centaurs. A number of ancient bronzes from the Chernyshov collections were acquired by Richard Payne Knight and bequeathed to the British Museum.[26] Chernyshov's interests and propensity for luxury made him an ideal dedicatee of the *Tazza* engraving. And Morghen honored the ancient masterpiece and the Russian count further by adding an inscription above the image that compared and pronounced the cup superior to other famous agate cameos—the *Gemma Augustea* in Vienna, the *Grand Camée de France* in Paris, and the *Triumph of Bacchus* then in the Roman collection of Cardinal Gasparo di Carpegna.[27] Count Chernyshov could not but have been pleased to be so directly linked with the superlative ancient masterpiece that he, like other cultured Europeans, must have admired in Naples.

While the *Tazza* remained available to the cognoscenti at Capodimonte, the Portici collection presented a challenge. Visitors had to obtain the king's personal permission to be admitted, and no one was allowed to draw or write down a single description of the exhibited works. Goethe, with his characteristic open-mindedness, saw these limitations in a positive light: "Perhaps this made us pay attention all the more closely to what we saw, so that we were all the more vividly transported into the past, when all these objects were part and parcel of their owners' daily life. They quite changed my picture of Pompeii."[28]

But the restricted access to Portici antiquities frustrated many other Europeans, all the more so since the publication of the finds was slow and problematic. *Disegni Intagliati di Pitture Antiche* (1746) presented ninety engravings of marbles, bronzes, and paintings found at Herculaneum. The book, apparently published for the king, came out in a very small print run and offered only short descriptions of the objects, making almost no attempt to identify their material, function, or imagery. Inadequate for serious study, it was quickly forgotten.[29] The next, exceedingly pedantic, five-volume edition entitled *Prodromi* (1752) and authored by Monsignor Ottavio

Baiardi, undertook to prove, with great prolixity, that the city found underneath Resina was indeed Herculaneum, and to narrate stories about Hercules. The actual artifacts were hardly discussed. The Neapolitan diplomat Marchese Domenico Caracciolo quipped: "So far Monsignor Baiardi has delighted to bury the antique world of Herculaneum beneath a much denser shroud than that spread over it by the lava."[30] In 1755 the king founded the fifteen-member Royal Herculanean Academy tasked with publishing the material properly. It took thirty-five years to produce eight of the projected forty volumes of *Delle Antichità di Ercolano* (1757–92). The beautiful tomes, richly illustrated with engravings of the finds by, among others, Filippo Morghen, were presented only to select dignitaries.

The more concise unofficial accounts by those lucky enough to have visited the Vesuvian cities and the Portici Museum spurred the imagination of cultured Europeans. Horace Walpole wrote rapturously about Herculaneum:

> This underground city is perhaps one of the noblest curiosities that ever has been discovered . . . the path is very narrow, just wide enough and high enough for one man to walk upright . . . they have found all the edifices standing upright in their proper situation . . . some fine statues, some human bones, some rice, medals, and a few paintings extremely fine. . . . There is nothing of the kind known in the world; I mean a Roman city entire of that age, and that has not been corrupted with modern repairs.[31]

Cardinal Angelo Maria Quirini, correspondent of Montfaucon, Newton, and Voltaire, and the Librarian of the Vatican Library, praised the royal collection:

> As they were Building, about Fifty Years ago, a Palace near the present Opening, they found some curious Statues that had been secretly conveyed out of the Kingdom [by d'Elbeuf]:

On this Discovery, the King ordered that they should begin to sink (at his Expense) a large and very deep Pit near that Part: On doing which, they dug up so many Pieces of Antiquities of all Kinds, as formed, in five or six Years Time, such a fine Museum, that no other Monarch could have collected the like in many Ages; and as the mine is vast, and untouched, there is hardly a Day passes, but they turn up some Statue, or other antique Vessels, and Furniture.[32]

In addition to digging at Herculaneum, Alcubierre began to excavate Pompeii in 1748 (not identified as such right away and called Città until 1763). His job was much simpler there, since that city was only buried by the ash from Vesuvius, a substance far easier to clear and requiring no tunneling. Soon this open-air site became more popular with visitors who could stroll around the uncovered streets of the ancient town, instead of having to descend into the dark, suffocating, and dangerous tunnels of Herculaneum. Charles Bourbon, though not a scholarly type himself, saw the importance of underwriting these excavations. As the English minister Sir James Gray reported, "The King of Naples . . . is unread and unlearned, but retains an exact knowledge of all that has passed within his own observation, and is capable of entering into the most minute detail."[33] Charles was not as excited as the antiquarians about the ancient remains, but he was glad to benefit from the luster they imparted to his monarchy, and from the depth they added to his Farnese collection, including the *Tazza*.

Indeed Naples drew a cosmopolitan crowd of diplomats and savants, people like Count Chernyshov, Sir William Hamilton, Goethe, and Winckelmann, as well as artists like Angelica Kauffman, Johann Heinrich Wilhelm Tischbein, Elisabeth Vigée Le Brun, and Philip Hackert. They came to admire the scenic beauty of the Bay of Naples and the mesmerizing Vesuvius that obliged them with periodic eruptions: "That brilliant sun, that stretch of sea, those islands

perceived in the distance, that Vesuvius from which rose a great column of smoke, and the crowds so animated and noisy," gushed Vigée Le Brun.[34] They marveled at the gaiety of the city's inhabitants and the luxury of the Neapolitan court with its gilt carriages drawn by teams of six or eight horses, its vast numbers of servants, lavish receptions, and operas at the Teatro di San Carlo.[35] They eagerly examined whatever they were able to at Herculaneum and Pompeii.[36] As Goethe exclaimed upon seeing the remains of the latter, "There have been many disasters in this world, but few which have given so much delight to posterity."[37] He called the Portici Museum "the alpha and omega of all collections of antiquities."[38] Meanwhile the fame of the *Tazza* and other Farnese gems began to spread through further channels.

Shortly after the *Tazza* arrived in Naples, it was published for the first time (fig. 8-3). Marchese Scipione Maffei, a Veronese-born

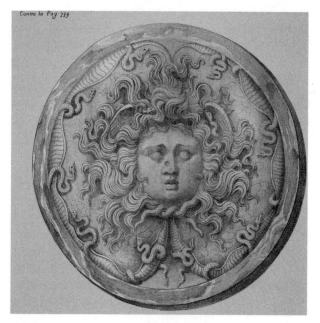

Figure 8-3. *Tazza Farnese*, engraving after Carlo Gregori, in Scipione Maffei, *Osservazioni letterarie*, vol. 2, Verona 1738.

litterateur and archaeologist, offered an extensive account of the bowl in his *Osservazioni letterarie che possono servir di continuazione al giornal de' letterati d'Italia* (1738).[39] Maffei had not seen the *Tazza* himself; he relied on an engraving made by Carlo Gregori for Duke Francesco Farnese of Parma in preparation for the never realized book on the family gems. But as an antiquarian, he knew the class of material to which the *Tazza* belonged and he prefaced his interpretation by situating it among comparable works. Three other cameos, he wrote—one in the Imperial Museum in Vienna, another in Saint Chapelle in Paris, and the third in the house of Cardinal Gasparo di Carpegna in Rome—have long been considered inestimable treasures and have been discussed in several books. Now he was publishing for the first time the *Tazza* from the Farnese collection, housed in the Royal Gallery in Naples.

Maffei then presented his opinions on the dating and interpretation of the vessel. Judging by the nudity of the figures, he suggested, it was a Greek work. The presence of the sphinx placed it in Egypt. Because the Greeks depicted sphinxes with wings, while the Egyptians did not, he thought the cup must have been carved in Ptolemaic Egypt. Based on the shape of the vase, Maffei opined, it was a *patera*, a shallow libation bowl. Scholars today would accept his conclusions about the general origins and function of the vessel, if not all of his reasoning. As for the figures, Maffei thought that they were a family group: the seated bearded father, the mother leaning on the sphinx, a striding son in the center, two daughters to the right, and two deceased children flying through the sky. Since the family was Greek and situated in Egypt, Maffei proposed that the father was Ptolemy Auletes (Cleopatra's father), because he had two daughters as well as sons, and that the cup was carved in the early, peaceful years of his reign, when Ptolemy freely indulged in luxurious living, as described by ancient authors, on whom Maffei drew extensively and learnedly.

Though the first to publish the *Tazza*, Maffei was neither the first, nor the last connoisseur to grapple with its iconography. Indeed, he refuted a previous hypothesis, possibly believed by Alessandro Farnese and certainly by Francesco Bianchini, Maffei's fellow-Veronese philosopher, scientist, and archaeologist, that the scene at the center of the bowl depicted the apotheosis of Alexander the Great. Maffei declared that there was no indication of this imagery on the *Tazza* whatsoever. After him, the collector and savant Pierre Jean Mariette interpreted the central female as Cleopatra VII; while Giuseppe Bartoli, professor of Greek at the University of Turin and antiquarian to the King of Sardinia, believed that the vessel showed the return of Emperor Trajan from Germany. All these scholars relied on prints of the *Tazza*, rather than on direct observation, but even personal viewing led to divergent readings. The nineteenth-century Neapolitan archaeologist and epigrapher Bernardo Quaranta, a perpetual secretary of the Accademia Ercolanese who saw the *Tazza* in person, identified the seated figure as Ptolemy Soter, the woman below him as Berenice, and the standing man as Alexander the Great. And James Millingen argued that the latter was Emperor Hadrian arriving in Egypt and being received by its tutelary divinities.[40]

Ennio Quirino Visconti, papal Prefect of Antiquities, based his analysis of the *Tazza* on a line drawing likely done after the engraving published by Maffei, but he put forth the interpretation of the *Tazza* that is accepted by most scholars today. In the third volume of his *Museo Pio-Clementino* (1790) Visconti adduced the Nile figure on the *Tazza* as a parallel for the Vatican Nile statue, and stated simply and succinctly that the bowl represented an allegory of the Nile and its beneficial inundations.[41] In a footnote he attacked Maffei's interpretation as capricious and unsatisfying even to the most ignorant. And so the *Tazza* entered scholarly debates, turning, for the first time in its long life, into a public object—and a launching pad for academic squabbles.

Once published, the *Tazza* became accessible to connoisseurs and artists in a new way. Filippo Morghen may have known Maffei's article because he, like Maffei, prefaced his print by stating that "among the four inestimable gems of oriental agate with various colored veins that one can see in Vienna, Paris, and Rome, this one [engraved here equal to its size] is, above all others, a rare and superb remnant of ancient magnificence that we can admire in Naples." Engravings, in their turn—prints like Morghen's and illustrations in museum catalogues—further disseminated the fame of the *Tazza*. The 1824 publication entitled *Real Museo Borbonico* presented the bowl on a foldout plate, showing it from both front and back at close to real size. In the 1869 *Museo Nazionale di Napoli: Collection of the Most Remarkable Monuments of the National Museum*, a four-volume edition which consisted exclusively of plates, the *Tazza* opened the volume devoted to gems.

Knowledge of the Farnese gems spread still further through their three-dimensional reproductions. In that age of encyclopedias, educated Europeans eager to understand the progress of history, the full range of mythology, and the many facets of ancient life, hunted not only for classical gems and engravings of them, but also for casts, which offered advantages over prints.[42] As Tommaso Puccini, the Director of the Uffizi, explained, "They [engravings] always leave something to be desired in respect to accuracy and style . . . because in all periods the good draughtsmen are rare. As perfect as they may be, they are never able to forego completely their own manner."[43] Casts conveyed more faithfully every particular of the original (except for the color of the stone) and thus presented a more immediate opportunity to experience ancient art.

The Farnese gems, secluded in Parma for two centuries, had been scarcely reproduced until now. But this changed in 1780, when Catherine the Great of Russia asked the King of Naples for casts of his cameos and intaglios, perhaps after hearing from Chernyshov about the collection.[44] The request would honor both the

empress and the king. As Tommaso Puccini wrote to the Grand Duke of Tuscany in 1796 in response to a similar demand for casts of the Medici gems, "By making known so many objects [engraved gems] until now unknown except to a few travelers, there is no doubt that we can hope for an increase in the reputation of our Royal Gallery."[45]

Catherine the Great (born Sophia Frederika Augusta, daughter of the Prince of Anhalt-Zerbst) had been married to her second cousin, Karl Peter Ulrich of Holstein Gottorp—heir to the Empress Elizabeth of Russia—in August 1745 at the age of sixteen. Peter, one year her senior, was and remained mentally and emotionally immature, and Catherine (the name she took in Russia) characterized her marriage as "18 years of boredom and loneliness [which] forced her to read many books."[46] And read she did, becoming a passionate admirer of Voltaire, Diderot, and the Encyclopédistes. She also developed an eye and an appetite for art. In 1790, in a letter to her friend and agent Melchior Grimm, she boasted that her holdings surpassed that of any other ruler of her day: "Besides the paintings and the Raphael loggia [her 4,000 Old Masters and copies of Raphael's Vatican frescoes], my museum in the Hermitage contains 38,000 books . . . 10,000 engraved gems, roughly 10,000 drawings, and a natural history collection that fills two large galleries."[47] She omitted to mention her 16,000 coins and medals and a superb assembly of decorative arts. Catherine's avid collecting was all the more impressive for occupying only a small portion of her remarkable energy and ability. Having ousted her husband from the throne six months after he ascended it, and likely arranged his assassination, she became a hard working and dedicated monarch who brought the spirit of the Enlightenment to Russia and made St. Petersburg one of the most civilized capitals in Europe; extended Russia's borders to the Black Sea and annexed much of Poland; and improved the country's government and legal structures. Plus she kept a succession of accomplished younger lovers.

Catherine lived on a grand scale—she liked to play cards for diamonds, laying them in heaps in special boxes on the gaming table—and she held particular affection for gems. In her own words, she was "gripped by a gluttonous greed" for them, calling their acquisition "an Imperial Affair." Through agents, diplomats, and friends abroad she bought individual glyptic masterpieces and whole collections. In 1785 she described to Grimm the relocation of her gems to the Small Hermitage: "My little collection of engraved stones is such that yesterday four men had difficulty in carrying it in two baskets filled with drawers containing roughly half of the collection; so that you should have no doubts, you should know that these baskets were those used here in the winter to carry wood to the rooms."[48] She examined these treasures—the originals, casts, and engravings—with real joy: "God knows how much pleasure there is in touching all this every day; they contain an endless source of all kinds of knowledge," she wrote to Grimm. And she took them to her summer residence at Tsarskoe Selo, spending three hours after lunch on her "antiques" and making casts from her stones in papier-mâché.[49]

In addition to acquiring ancient gems, Catherine patronized leading contemporary engravers in Rome, Dresden, and London, and encouraged domestic production—at the imperial stonecutting factories in Peterhof near St. Petersburg, at Ekaterinburg in the Urals (where hard-stone vases were carved for her), and at Kolyvan in the Altai. The latter two towns lay near mineral deposits—the Urals yielding a particularly wide array of striated and multicolored agates and jaspers. Catherine issued special decrees to search for many-layered stones and sent regular expeditions to the Urals starting in 1781. At the imperial factories only the most talented carvers were entrusted with cutting gems, or "antiques" as they were called. They usually drew inspiration and models from casts of gems from major European collections.[50] The empress augmented her holdings enormously by ordering from James Tassie of Edinburgh, a dealer in such casts, a complete set of his

stock, consisting of 16,000 items and accompanied by a five-volume manuscript catalogue written by the German numismatist and archaeologist Rudolf Erich Raspe, now best known as the author of *The Adventures of Baron Munchausen*.[51]

Catherine ordered her set of 600 Farnese gem casts directly from Naples. Their execution was entrusted to Bartolomeo Paoletti who kept a studio in Piazza di Spagna in Rome and, together with his son Pietro, catered to a variety of clients: artists, royals, and Grand Tourists. An advertisement printed in Count Hawks Le Grice's *Walks through the Studii of the sculptors at Rome* read:

> Paoletti begs to inform the Public that he has arranged a collection of impressions (Impronte in Scajola) of many of the works in sculpture executed by distinguished artists, whose works are described by the Count Hawks le Grice in the above interesting and instructive 'Walks'. . . . The impressions are bound up in 3 vol. 4°., and form an appropriate companion, to the Count's work. Although the Impronte are but miniature copies; yet they exhibit all the fidelity and beauty of the original, and convey to the eye a better idea of sculpted works of art than the most finished engravings. The studio of Paoletti is Piazza di Spagna Num. 49, where collections in Impronte may be had of all the works existing in the different Museums of Rome.[52]

Bartolomeo Paoletti's skills earned him the esteem of the pickiest customers. Giovanni Pichler, a famous engraver "jealous of his glory" in the words of a contemporary, commissioned Paoletti to publish (in casts) all his gems.[53]

In 1796–97 Paoletti was called to Florence to make casts of the Grand Ducal gems intended for exchange with a comparable set from the Cabinet des Antiques of the Bibliothèque Nationale in Paris. Recommending him to Ferdinand III, Grand Duke of

Tuscany, Tommaso Puccini wrote: "I have reason to flatter myself that I have found a most suitable artificer and one of greatest probity in the person of Bartolomeo Paoletti, a Roman, who was entrusted with the Gabinetto of Capodimonte in Naples"—the casts of the Farnese gems ordered by Catherine the Great.[54]

Paoletti's assistant in Naples was the Florentine cameo engraver Giovanni Mugnai, then the director of the Bourbon Royal Factory of Hard-Stones. He recorded that he compiled an inventory of the ancient gems and stones in the Museo di Capodimonte and helped make the collection of colored glass paste replicas of all the most beautiful cameos and intaglios of the museum, which were sent as a gift to the Sovereign of Moscovia.[55] It took Paoletti eight months to cast 600 Medicean gems, so he and Mugnai probably spent a comparable amount of time on the replicas of the Farnese pieces.

Cameos, of course, are much harder to cast than intaglios because their relief makes it more challenging to take their impression. The task is still more complicated with large and intricate cameos such as the *Tazza*. Manuscript catalogues describing cast series might enumerate them, but in the actual trays with the casts their place is often occupied by labels "could not be made."[56] This likely happened with the *Tazza*. In fact, it is not even listed in the written catalogue that accompanied Catherine's Farnese set, and though the curators at the Hermitage seem to recall seeing the *Tazza* cast, it has not been located in recent times.[57] Whether it was never created, or was fashioned separately from other gems but broken due to its large size and thus greater fragility, is difficult to ascertain.

Still, reproductions made for Catherine played an important role in the diffusion of knowledge about the Farnese gems. Copies of casts from the "Museum of Naples" entered the sets made for international collectors. Goethe, who acquired some 8,000 casts, described the excitement of hunting for them in Rome: "I have bought a collection of two hundred wax impressions of ancient carved gems. They are among the most beautiful examples of antique craftsmanship and have been partly selected for the charm

of their motifs. The impressions are unusually fine and distinct, and I could not come away from Rome with anything more precious."[58] Among Goethe's casts were those made from Paoletti's Florentine matrices. Perhaps he also had some of the Farnese ones.

The diffusion of such replicas nurtured not only the studies of connoisseurs, but also the activities of forgers. Responding to the enormous demand for carved gems, they deftly imitated actual stones, often "authenticating" their creations with names of ancient masters, and invented new compositions inspired by ancient works. Casts served as their sources of images, styles, and signatures. The Rome-based engraver Thomas Jenkins, according to the contemporary sculptor Joseph Nollekens, "followed the trade by supplying the foreign visitors with intaglios and cameos made by his own people, that he kept in a part of the ruins of the Coliseum . . . he sold 'em as fast as they made 'em."[59] Jenkins acknowledged some pieces as his own, but sold others as antiques. With the hunger for gems reaching its height in the 1780s, Jenkins gave up dealing in other artworks, such as pictures and marbles, and focused solely on cameos and intaglios, real and fake.

The forgery of gems was not a new peril for collectors. Lorenzo de' Medici's agent Nofri Tornabuoni wrote to his patron in November 1491:

> The cast of the Augury of Romulus and Remus that Your Magnificence says you have received is the work of Pier Maria [Serbaldi], who wanted to experiment [to see] if it could pass as ancient.... Then it came into the hands of these experts, and some believed it ancient and some had their doubts. Ciampolini, as soon as he saw it, said he thought it was modern, or, even if ancient, that it had been retouched.[60]

Serbaldi carved gems and hard-stone vases as well as designed medals and coins (he was appointed to head the Roman mint in 1499). At one point he created a porphyry tazza. When the French

king Charles VIII invaded Rome in 1494, Serbaldi buried his vessel for safekeeping. Once the danger passed, he unearthed it and found it broken. Seeing an opportunity in the mishap, he repaired the piece and sold it at a high price as an antique.[61]

Carrying on this timeworn tradition, the nineteenth-century carver Benedetto Pistrucci capitalized on the fashion for cameos by creating both modern versions and fake ancient ones. Among the latter was a beautiful head of Flora, her flowing hair wreathed with flowers picked out in different colored layers of the stone. The famous British collector Richard Payne Knight fell in love with the gem and bought it as an antique in 1812 for £100. One day Pistrucci happened to be at the house of Sir Joseph Banks, making his portrait, when Payne Knight stopped by to show the botanist his acquisition. Pride got the better of Pistrucci and he declared to the collector that he had carved the gem. Payne Knight, furious, insisted that the gem was an antique depiction of Persephone, whose annual return to earth made all vegetation bloom. Pistrucci demanded formal acknowledgment of his authorship. Paine Knight refused and walked away "like a drenched flea."[62] The much publicized feud between the two men brought the carver more commissions.

Payne Knight's contemporary Clayton Mordaunt Cracherode, educated in classics at Oxford, also spent a fortune on antiquities, and was also duped. His most treasured gem, for which he paid £50, was a small sardonyx cameo depicting a brown lion striding in profile against a white background. Lorenzo de' Medici had owned it and had inscribed it with his name. Lorenzo, like Cracherode, thought the piece ancient. Today scholars believe that it is a fifteenth-century fake.[63]

While forgeries thus plagued collectors from the Renaissance (and earlier) to the Enlightenment, they did not trouble one man: Ferdinand I Bourbon (fig. 8-4), who inherited the Kingdom of the Two Sicilies in 1759, at age eight, when his parents left to rule Spain (he was also called Ferdinand IV of Naples). Ferdinand

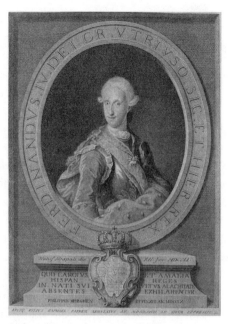

Figure 8-4. Filippo Morghen, *King Ferdinand IV of Naples*, engraving in
F. Morghen, *Vedute nel regno Napoli.* Naples 1765–79.

regularly received freshly excavated artifacts from the cities buried
by Vesuvius, and he owned the most spectacular, and certainly
authentic gem, the *Tazza.* These treasures, however, were wasted
on him.

Ferdinand had been raised like a wild weed. Fearing hereditary
insanity (his older brother was completely retarded), his caretakers
channeled the young king's energy into active outdoor pastimes, such as
riding and hunting, and avoided academic pursuits—either because
they feared that the boy's mind could not cope with them, or because
they figured that it would be easier to control an ignorant sovereign.
When they did try to teach him a bit of Latin, French, or German, their
efforts failed. The youth only spoke Neapolitan and hung out with the
lazzaroni. William Hamilton, arriving in Naples in 1764 as the English
ambassador and spending close to the rest of his life there, recorded:

Unhappily for himself and his people, he has neither had masters capable of instructing him nor governors who have studied to inspire him with ideas worthy of his rank. He is beloved by the vulgar Neapolitans . . . and [seeks] the company of menial servants and people of the very lowest class.[64]

Ferdinand grew into an affable but entirely uncouth creature. Abhorring reading and writing, he used a stamp with his signature instead of penning it himself and disapproved of books not only for himself, but others around him. He spent most of his time hunting, playing childish games, and horsing around with the *lazzaroni*. He relished summoning his guests after dinner to entertain him while he sat on the chamber pot. As his brother-in-law, the Holy Roman Emperor Joseph II, recounted with horror:

I found him on this throne with lowered breeches, surrounded by five or six valets, chamberlains and others. We made conversation for more than half an hour, and I believe he would be there still if a terrible stench had not convinced us that all was over. He did not fail to describe the details and even wished to show them to us; and without more ado, his breeches down, he ran with the smelly pot in one hand after two of his gentlemen, who took to their heels.[65]

Joseph II visited Naples soon after his sister, Maria Carolina, married Ferdinand, and described the king and his behavior in close detail:

He must be five feet seven inches . . . very thin, gaunt and raw-boned . . . his knees always bent and his back very supple, since at every step he bends and sways his whole body . . . [his] nose . . . begins in his forehead and gradually

swells in a straight line as far as his mouth, which is very large with a jutting lower lip. . . . Although an ugly Prince, he is not absolutely repulsive . . . and at least he does not stink . . . he seldom speaks without shouting and has a piercing voice like a shrill falsetto.[66]

Joseph found in the king "so great an indolence of mind and a distaste for all reflection, that I almost dare assure you that the man has never reflected in his life either about himself or his physical or moral existence, his situation, his interests, or his country. He is quite ignorant of the past and present and has never thought about the future; in fact, he vegetates from day to day, merely engaged in killing time."[67]

Ferdinand's wife, Maria Carolina, a willful and impetuous daughter of the formidable Habsburg empress Maria Theresa, arrived in Naples in 1768 as a self-possessed young woman of sixteen. Taking the measure of her husband, she soon began to gather the reins of government into her own hands. Her task was not easy. Unlike her father-in-law, who promptly fell in love with his wife when she came to Naples and remained devoted to her all his life, ruling in harmony with her, Ferdinand was not smitten with Maria Carolina. The morning after the nuptials, asked how he liked her, he replied, "She sleeps as if she had been killed, and sweats like a pig." Maria Carolina, in her turn, found him ugly, irritating, disgusting, and boring. She dutifully tried to conceal her feelings and win his affection and trust. But as soon as she began to produce royal progeny (she would give birth to eighteen children, seven of whom would survive into adulthood), she became the de facto ruler of Naples, the king's immaturity giving her greater scope for power.[68] As Goethe wryly remarked in 1787: "Naples proclaims herself from the first as gay, free, and alive. A numberless host is running hither and thither in all directions, the King is away hunting, the Queen is pregnant, and all is right with the world."[69]

Thanks in large measure to Maria Carolina's efforts, Naples became an even bigger magnet for cultured Europeans. Although Ferdinand preferred his outdoor sports to all else, with Maria Carolina's prodding he continued his father's projects. Despite his ignorance, or out of a child-like sense of marvel, he delighted in the excavations of his ancient cities. As the British envoy to the court of Naples, Sir James Grey, remarked, "When anything curious is discovered, the king usually shews it to us after his Dinner."[70] Maria Carolina's brother, Joseph II, having detected Ferdinand's interest during a visit to Pompeii, tried to nurture this impulse in his uncivilized brother-in-law:

Having found a spot where they were just digging up some pots and antique vases, he seemed to take infinite pleasure in it and was amused. I did not fail to encourage this inclination and explain all the advantages and prestige connected with it. He expressed a wish to return there more often and ordered the director to advise him whenever there were new discoveries.[71]

Between 1787 and 1800, Ferdinand had brought to Naples from the Palazzo Farnese, the Villa Madama, and other Roman family properties the Farnese ancient sculptures, including the colossal, over-muscled Hercules and the Farnese Bull group. The pope and the Roman artistic community were outraged by the removal of these celebrated works and preeminent attractions of their city.[72] In a letter of January 16, 1787, Goethe wrote: "Rome is threatened with a great loss. The King of Naples is going to transport the Farnese Hercules to his palace. All the artists are in mourning."[73] The statues' original owner, Cardinal Alessandro Farnese, had prohibited the removal of any part of his collection from the family palazzo, but some of the works had previously been taken to Parma, and now the remaining sculptures were shipped to Naples. By transferring these famous masterpieces to

their capital, Maria Carolina and Ferdinand asserted their kingdom's superiority as a center of culture—a new Rome, home to the great Farnese treasures, and possessor of the finds from Herculaneum and Pompeii.[74]

The Farnese sculptures joined the family paintings and gems at Capodimonte, and Goethe commented on their effect there:

> Today we visited . . . the Palazzo Capodimonte, which houses a large collection of paintings, coins, etc., not too well displayed, but including some precious things. What I saw clarified and confirmed many traditional concepts for me.
>
> In our northern countries we know such things, coins, carved gems, vases . . . only from single specimens; seen here, where they belong, and in profusion, they look quite different. For where works of art are rare, rarity itself is a value; it is only where they are common, as they are here, that one can learn their intrinsic worth.[75]

Seeking further visibility for their collections, starting in 1805 the king and queen began to move the Capodimonte holdings, as well as the antiquities from Portici, to the Palazzo degli Studi in Naples, in the center of the city. The new museum—which was also to house the royal library, the Laboratory of Hard-Stones, the Academy of Painting, the Academia Ercolanese, and the restoration labs—was envisioned as a palace of culture and the central node in a system of artistic education spanning the whole kingdom. An enlightened monarch had to civilize his subjects (even if he himself was barely civilized). The new establishment, moreover, while still royal private property, was a gift not only to Naples, but also to Italy and all of Europe.[76] The *Tazza* and its companions, however, were not to enjoy a peaceful life there.

In 1798, in the aftermath of the French Revolution, which prompted the monarchies of Europe to declare war on France and

in turn made Naples a target of French aggression (Maria Carolina was the sister of Marie Antoinette), Ferdinand and his queen fled to Palermo just before the French invaded their capital. They took along their most precious possessions, including the *Tazza* and other Farnese gems. The beguiling wife of the British ambassador, Emma Hamilton, a close friend of Maria Carolina, orchestrated their removal. Emma's lover, Lord Nelson, the commander of the British fleet which evacuated the Bourbon family, reported admiringly on her help to his superior, the Admiral Earl of St. Vincent: "Lady Hamilton . . . every night received the jewels of the Royal Family" and, despite danger to her own life in a city violent with unrest, she used a subterranean passage between the palace and the seaside to carry the royal treasures, paintings, and sculptures to the English ships.[77]

The *Tazza* and its royal owners returned to Naples in 1802— for a brief interlude. Napoleon was crowned King of Italy in 1805, and the following year the Bourbons were deposed and driven out of the city once more. Again they fled to Palermo with their most valuable antiquities, including the *Tazza*, 413 cameos, and 733 intaglios from the Museo di Capodimonte.[78] Maria Carolina died in exile in 1814. After Napoleon's defeat, Ferdinand returned to Naples, and to his throne the next year. As part of reclaiming his authority, he had the Museo del Palazzo degli Studi refurbished and renamed Real Museo Borbonico. In 1817 the *Tazza* went on display there together with the rest of the Farnese patrimony and the artifacts unearthed in the region.[79] At last, all the royal art-works were displayed under one roof. "The great museum at Naples is one of the most wonderful collections of curiosities in the world," wrote Jacob Abbott in his children's book *Rollo in Naples*, intended to entice young tourists to the new institution. "It is contained in an immense building, which is divided into numerous galleries and halls, each of which is devoted to some special department of art."[80]

At its new location, the collection was inventoried and systematized for the first time—a mammoth task undertaken by Michele Arditi, Director General of the Museum between 1807 and 1839.[81] In his inventory Arditi gave a full description of each gem, including its stone, form, measurements, imagery, date, and provenance, noting whether it came from Parma, Herculaneum, Pompeii, or elsewhere. The gems were still shown in the same glassed-in tables in which they had appeared at Capodimonte, but they now stood in the center of the *Gabinetto degli oggetti preziozi* (Cabinet of Precious Objects), arrayed around the mosaic of *Phrixus and Helle*, listed first in Arditi's inventory. The *Tazza*, named second, had been fitted with an elaborate and somewhat gaudy mount, shaped like a pair of gilded snakes intertwined around the bowl (fig. 8-5)—the costly frame a sign of its special significance.[82] The mount was placed on a wooden base with an internal device that, activated with a key, made the vase turn. The

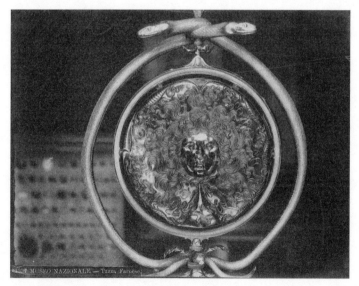

Figure 8-5. Tazza Farnese in gilded silver mount, 19th century.

MEDUSA'S GAZE

whole room was a kind of a cabinet of wonders, containing ancient and modern gems; Etruscan, Greek, Roman, and Oriental jewelry; vessels made of precious metals and hard-stones; carved amber and ivory pieces; statuettes of silver and gold and elaborately wrought table centerpieces; and natural marvels such as carbonized food remains, pigments, and other organic materials found at Pompeii. On the walls hung frescoes from Pompeii and Herculaneum—at that time the only ones shown in the museum—and rare ancient monochrome paintings on marble, and some mosaics.[83] These were the most precious antiquities in the royal collection and they were grouped together on that principle, rather than by chronology or typology.

In 1841 the gems were reinstalled in a room decorated *all'antica* style, which became fashionable in major European museums such as the Munich Glyptothek and the Sculpture Galleries of the British Museum. The room's ceiling had painted coffers, the walls were articulated with faux pilasters, Pompeian mosaics decorated the floor, and an elegant white, gray, and gold color scheme completed the ambience. The gems and other precious artifacts were arranged in neoclassical vitrines. Aside from the new form, however, the room did not change much in content. It still mixed objects of different periods, cultures, and materials without offering much instructional value to the visitors, as critics were quick to point out.[84] Nonetheless, many deemed the Naples Museum the finest in Europe and its collection of objects superlative and unique.

Curiously, in its new surroundings the *Tazza* acquired a new myth. Late nineteenth-century museum guidebooks declared that the bowl had been discovered at Hadrian's Villa. *A Complete Handbook to the National Museum in Naples* described it as follows:

Cup of Oriental sardonyx, known as the *Tazza Farnese*. The intrinsic value of this *tazza* is inestimable, and its artistic

merit renders it unique. It is said to have been found at *Rome* in the *Mausoleum of Hadrian*, now called the *Castel Sant' Angelo*; but it seems more probable that it was found in the ruins of Hadrian's villa by a soldier, who gave it to the Duke Charles of Bourbon when he was besieging Rome. Unfortunately, prior to its reaching the Farnese Collection, its owner caused a hole to be bored in the centre, so that a foot might be fitted to it.

This incomparable relic has been the subject of many discussions among savants, and articles have been published about it by Maffei, Winckelmann, and others.[85]

The guidebook was wrong about the provenance of the *Tazza* and its publication record. Winckelmann did not discuss the bowl in any of his printed works. He visited Naples in 1758, 1762, 1765, and 1767, but apparently focused his attention solely on Pompeii and Herculaneum. During his first visit he spent two months studying the antiquities there and "saw and observed more than had ever been done previously by a stranger; for he went round like a sly thief, in order to spy out what they wished to keep secret."[86] He said nothing about the *Tazza*, despite his keen interest in gems. Perhaps he intended to write something about it, but was murdered first in his hotel room in Trieste on June 8, 1768 by a criminal tempted by his collection of coins. Or he disapproved of the *Tazza's* baroque style of carving and thus passed it in silence. In any case, the author of the guidebook invented a Winckelmann publication.

The *Tazza* changed hands once more, perhaps least dramatically for it, if not for its owners, in 1860. That year Giuseppe Garibaldi led his revolutionary expedition to Sicily and Southern Italy, defeating the Bourbon army and overthrowing the King of Naples. As part of the newly unified Italy, the Real Museo Borbonico was renamed Museo Nazionale di Napoli, and the royal holdings came into the possession of the Italian state.

The new museum director, Giuseppe Fiorelli (1863–75), undertook to reorganize the collection to give it a more rational basis. He put particular thought into the *Gabinetto degli ogetti preziozi*. Fiorelli proposed separating gems from gold and silver objects and dividing them into ancient and modern pieces. He did not have time to realize his vision, having been summoned to Rome in 1875 to become the general director of the *Scavi e Musei del Regno*, so the reorganization was carried out by Ettore Pais, director between 1901 and 1904. Following Fiorelli's ideas, Pais partitioned the museum objects into four sections: sculpture, ancient painting, modern painting, and antiquarian collections. He moved the last to the second floor of the building and displayed the gems on their own, separately from gold, silver, glass, coins and medals, arms, terracottas, and Greco-Italic ceramics, which now occupied other rooms. The four-volume catalogue by Raphaël Gargiulo, *Collection of the Most Remarkable Monuments of the National Museum* (1870) reflected Pais' organization.[87] Volume one was devoted to marble sculptures; two to bronzes; three to engraved stones, objects of gold and silver, mural paintings, and mosaic; and four to terracotta sculptures and Italo-Greek vases. The *Tazza*, shown in a frontal and back view, opened the third volume.

In its overhauled setting the *Tazza*—no longer a private possession but a national treasure—came to illustrate the art and industry of the ancients who provided models for modern Italians as they forged their new state.[88] As happened with many antiquities in the nineteenth century, nationalization tied this ancient masterpiece to a land where it had not been "born" and made it a cultural symbol of a country that now claimed its ownership—a process that continues to this day and is hotly debated under the rubric "who owns the past?" The *Tazza*'s adventures, however, were far from over.

THE NIGHT WATCHMAN

The *Tazza Farnese*, an Alexandrian work of the Greek period, and one of the most treasured works of art in the world, has been damaged by a watchman at the National Museum because he was reprimanded for negligence.

 —*Port Arthur News*, Texas, October 30, 1925

I n 1903 the *Tazza* again became a target of greed. A day laborer working at the National Museum of Naples decided to make a move on the bowl. Secreting himself under the roof of the building, he waited until the museum closed for the night. Then, emerging from his hiding place, he made straight for the *Tazza*. Breaking into the case, he proceeded to wrench the vessel out of its gilt-bronze snake frame. Moving fast, he grabbed the mount and ran out of the building, leaving the *Tazza* behind. Neither he, nor the snakes were ever found.[1]

As ridiculous as it may seem to choose the setting over the masterpiece, the thief probably made a wise decision. The *Tazza* was too famous to be disposed of. But he could, and presumably did, melt down and sell the costly metals of the stand.

Learning about the crime from the newspapers, the renowned Neapolitan firm of J. Chiurazzi & Sons, which had cast replicas of the Herculanean bronzes for various lofty clients, among other works, wrote to the museum, offering to make a copy of the stolen stand. The director, politely, but firmly turned down the proposal. The old mount was, in his view, of bad taste, and he preferred to order a more understated version that would not distract the attention of visitors from the monument itself. He commissioned a more classicizing and modest support of burnished silver from Giacinto Melillo, winner of the Grand Prix and Legion d'Honneur at the 1900 Universal Exposition in Paris.

The assault on the *Tazza*, as well as a spate of thefts at several institutions in Naples and elsewhere, prompted the museum administration to institute a night guard. A team of watchmen was to patrol the galleries and make sure no attacks on the collection occurred again. Ironically, this measure would lead to the worst calamity suffered by the *Tazza* in its storied life.

On the night of October 1st to 2nd 1925 there were four guards on duty.[2] They had reported for their shift as usual, but, as the investigation would later reveal, failed to perform the required circuits of the building after 1 a.m. and did not resume their posts until some five hours later. They would give conflicting and unsatisfying accounts of their absence from the museum floors. Most likely they spent the night snoozing away in some quiet corners.

Whatever they were doing, they later declared that around 6 a.m. they heard two loud bangs coming from one of the upstairs galleries. Rushing to investigate, they discovered that the case in which the *Tazza* had been displayed was shattered, and the bowl itself lay on the floor, broken into bits. For more than 2,000 years it had survived nearly intact, the chipped feet of one of the flying winds at the top of the tondo, and the drilled hole in the middle, being the only marks of time. Now the vessel was in shards. Three of the guards pointed fingers at their fourth colleague, a man called Salvatore Aita.

Aita, a forty-three-year-old veteran of World War I, called "crippled" in the museum documents but "not physically disabled by any grave infirmity," had a history of misbehavior. He failed to show up for his shifts, and was repeatedly reprimanded for leaving his post in the rooms to which he was assigned and following visitors to other halls to tell them about the collection and ask for tips. Volatile and choleric, he could be insolent, inveighing against or even attacking his fellow guards when he thought they denounced his conduct, hitting them hard enough with his umbrella to break it on their shoulders. At other times, sensing his job in jeopardy, he would drop to his knees and kiss the hands of his superiors, begging them not to report his misdeeds. The national association of war invalids had written to the museum administration at the beginning of that year asking it to excuse Aita from night duty due to the state of his health, so perhaps the museum was slightly to blame for not heeding that request. But Aita's other transgressions during his day shifts pointed to a greater problem.

On the night of the assault on the *Tazza*, Aita was angry at the disciplinary actions taken against him (yet again) by the administration: his privilege to sell postcards and catalogues, a source of revenue for the guards, had been suspended for a month for his infractions. He apparently decided to vent his anger on the preeminent piece in the collection.

His plan was aided by the slothfulness of his fellow night watchmen. While they slept instead of patrolling the museum, Aita attacked the *Tazza*. Since other guards reported hearing two blows, it is likely that he first smashed the glass case that protected the bowl, using an umbrella as his weapon, then hit the exposed *Tazza*. The robust silver mount that held the vessel in its vertical position was bent by 60 degrees, testifying to the violence of Aita's strike.

The other guards, woken up by the noise, hurried to discover its cause. Finding the *Tazza* smashed on the floor of its gallery, they

promptly summoned the administration. The director, Amedeo Maiuri, horrified, instantly telegrammed the museum conservator, Michelangelo Puccetti, at that time out of town, urging him to return to Naples at once. Puccetti responded immediately, "I beg you to tell me the reason to calm my anxiety." Shortly thereafter he hastened to Naples to see for himself what had happened and what he could do to salvage the priceless masterpiece.

The *Tazza* was broken into two large and ten small pieces. Luckily, though scattered across the room, no fragments were lost. The shards were carefully photographed to document both the breaks and the criminal act (fig. 9-1). Then Puccetti set to work. He labored over the reconstruction for ten days, re-assembling the pieces and figuring out how to make the museum's celebrated artwork appear whole again. The one line documenting his efforts is rather vague: he is said to have used a "glass fusion technique in order to obtain organic unity and greatest possible transparency of joins by which the broken pieces were linked."

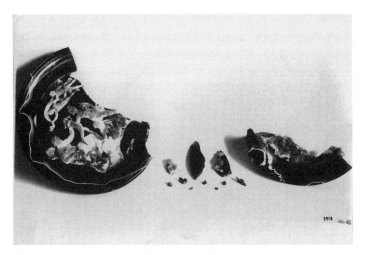

Figure 9-1. Tazza Farnese in fragments, 1925.

A modern-day museum conservator helped me decipher this statement and understand what probably took place.[3] Puccetti apparently selected a gap-filling material that was adhesive enough to hold the heavy stone pieces, yet flexible enough to recreate the depth and translucency of the stone and match its varied coloration. The most favored restoration medium at that time was celluloid, a clear and transparent plastic that transmits light—which is why it was also used to record images on film. Celluloid can be mixed effectively with various additives to achieve many textures and colors. It was employed in the late nineteenth and early twentieth centuries, for example, to replicate the look and feel of ivory and shaped into piano keys, billiard balls, and other such articles. To attain the look of a particular material, one could add such varied things to celluloid as pigment, ground stone, or horse-hair, which was employed in making faux alabaster. Highly adhesive and easily molded, celluloid was very popular with museum conservators at the time of the *Tazza*'s breakage. So Puccetti probably used it to fix the bowl.

The problem with celluloid is that it is inherently unstable and weakens with exposure to the sun and variations in temperature and humidity, which is why the *Tazza* would need another restoration after World War II. But in 1925 celluloid was still viewed as something of a miracle substance. The museum was thrilled with Puccetti's work, hailing it as a great success and rewarding him with a premium of 500 lire. And on October 16 it issued a press release declaring that the newly mended *Tazza* was back on display.

The return of the battered beauty, brought back to life by a skillful restorer, was received with enormous enthusiasm by the Neapolitans, the wider museum and scholarly communities, and art lovers around the world (the story was covered in *The New York Times*). The crowds flocking to see the revived *Tazza* were so great that the museum administration decided to close the entire upper

floor of the building, where the bowl resided, on Sundays, a day of free entrance and thus of particularly large throngs.

The assault on the *Tazza* recalled to some observers another such mishap. As one newspaper article recounted, a similar incident took place twenty-five years previously at the Archaeological Museum of Florence. There, on September 8, 1900, a deranged guard attacked the François Vase, named after the archaeologist who discovered it in an Etruscan tomb near Chiusi in 1844. The pride of the Florentine Museum, this sixty-six centimeter tall Greek volute krater had been painted in the sixth century BC with over 200 mythological figures, many of them identified by inscriptions, and signed by its creators with the words "Ergotimos made me" and "Kleitias painted me." The stories, rendered on the vase in the black-figure technique and arranged in six bands, presented something of an encyclopedia of Greek mythology: here were the Calydonian Boar Hunt and the exploits of Theseus; episodes from the Trojan War—the funeral games for Patroclus, Achilles ambushing Troilus outside the gates of Troy, and Ajax carrying the dead Achilles; the battle of Lapiths and Centaurs; the procession of the gods at the wedding of Peleus and Thetis; Hephaestus returning to Olympus; the battle of pygmies and cranes; as well as sphinxes, griffins, and a gorgon still alive and running, before its head had been severed and turned into an apotropaic symbol carved on the bottom of the *Tazza*.

On that fateful day in 1900, a forty-five-year-old Giuseppe Maglioni, serving as a guard at the Florentine Museum and known for his mental instability, flew into a rage at the director who had reprimanded him for not showing up to work for twelve days. Maglioni drew a knife, stabbed the director three times, then turned his anger on the masterpiece of the collection, throwing a stool at the case in which it was displayed. Crashing to the ground, the vase smashed into 638 pieces. It took rather longer than the *Tazza* to put back together: the krater was not back on show until

1902, and had to undergo another restoration later to incorporate more pieces.

Following the attack on the *Tazza*, the Neapolitan Museum took swift action against the four guards on duty the night of the assault. Esposito Carmine, who had served as a regular custodian, was suspended and referred for disciplinary action to the Ministry. Three others—Rocco Busciolano, Federico Eboli, and Salvatore Aita, the "extraordinary" (supplemental) employees—were expelled. All were brought to trial and condemned by the criminal tribunal of Naples to four years and six months in prison and a fine of 4,500 lire.[4] The four men appealed this ruling in late February 1926. The Court of Appeals absolved three of the guards for lack of sufficient evidence, but confirmed the sentence against Aita. The museum had vigorously argued for Aita to be punished.

In the long life of the *Tazza*, we have glimpsed it fleetingly in records and documents. But what Cleopatra, Augustus, Lorenzo de' Medici, or Timur may have actually said about it is lost forever. Ironically, the only words related to it that we have from a person directly in contact with the *Tazza* come from the man who nearly destroyed it. In letters written from Poggioreale Prison, Aita tried to excuse his attack on the bowl and begged for clemency:

Naples 9 March 1926

To His Excellency,

The First President of the Naples Civil and Criminal Tribunal

I, Salvatore Aita di Luigi, detainee in the prison of Poggioreale, declare to His Excellency the following: together with three other companions on 2nd October 1925 I was arrested and charged with damaging the Tazza Farnese. On the 10th of the same month, the four of us were tried with urgency and each sentenced to four years

and six months in prison and a fine of two thousand lira [apparently reduced from 4,500].

An appeal was raised against the sentence, heard on 27th February 1926 and the 5th Court of Appeal, which confirmed the verdict pronounced previously by the 10th Section of the Tribunal, and absolved the other three due to lack of evidence. . . .

But a scapegoat had to be held responsible for the crime, which was I myself. Resting on the fact that the undersigned had exhibited various medical certificates which attested that he had been interned several times in asylums for mental estrangement, I was accused by everyone of being the only perpetrator of the damage, alleging that in a moment of madness, heedless of what I was doing, I could well have broken the Tazza Farnese. Their defense was thus based on this declaration, since all the charges against the other three came to naught and they succeeded in their intent, because I was the only one to pay for the crime.

But even granting that I have to be considered guilty, I should have been allowed the extenuating circumstance of partial mental infirmity, on the basis of the various certificates presented, including one from the special military commission, which confirmed my madness and gave me a pension for life. . . .

So it is not humane to make a poor wretch weep, especially one who has loyally served the Fatherland, continuing to be tormented both in spirit and in the flesh, for which he still bears with resignation the terrible consequences, the crimes that others have committed; it is not humane to throw onto the street a whole family and loving children who from one day to the next awaited the return of the head of the family since they

were regrettably sure of his innocence; it is not humane, no, to make a wretch suffer for as many as fifty-four months for a crime not committed and without him being able to defend himself; further, it is not humane that the real culprits enjoy their freedom, while he suffers in harsh confinement.

The undersigned thus hopes that complete justice will be done and in this expectation, he remains for his Excellency, his most Humble Salvatore Aita di Luigi.

Aita's words failed to move the magistrate, and he resumed his pleas a few weeks later:

29.03.1926

Your Excellency. I beseech you that this injustice done to me is in some way alleviated and ask you to review my trial concerning the damage of the Tazza Farnese in the National Museum of Naples. . . .

Your Excellency, there were four of us that damaged the Tazza Farnese, at the same time the most illustrious President Lustich acquits the real culprits and god only I had my sentence confirmed. . . .

Excellency, please in your heart remember me, wretched Salvatore Aita, invalided from the war, pensioner for life, for unsound mind, an injury sustained on the front, as befits your person, and the First President of Justice, may I have mercy from you, I that have a sister afflicted with paralysis and a mother of 86 years. . . .

I hope that Your Excellency will take to heart the injustice done to me, and to receive justice from your Person. Ever obedient to your person, I am your most humble
Salvatore Aita of Luigi
Poggioreale Prison waiting for your reply.[5]

We do not know what happened to Aita from that point on, as no more documents referring to him have come to light. Dr. Salemme at the Archivio di Stato di Napoli thought it likely that Aita succeeded in having his term shortened by a quarter, to 39 months in prison, based on legal practices of the time.

Meanwhile, the novelty of the *Tazza*'s latest adventure wore off and the bowl entered another peaceful phase . . . until World War II.

In September of 1943, just before the Allied bombing of Naples, crates of artworks were rushed from the museum to the Abbey of Monte Cassino for safekeeping. On February 15, 1944, the Allies bombed the Abbey into a heap of rubble.[6] Thankfully, in October of 1943 the museum masterpieces had been moved to the Vatican—except for the *Tazza*.

Contrary to the directives of the Ministry of Culture, in August 1943 Amedeo Maiuri, the director of the Naples Museum, immured the bowl in a cavity within the massive walls of the building in his care.[7] With the help of two trusted assistants and an old master mason, he conducted this operation secretly, at night, securing the *Tazza* in a padded, zinc-plated box, "like a treasure in the tombs of the Pharaohs," he wrote later. "Having finished the job, we looked at each other: will all four of us be here, present at the moment of exhumation?" In the following days and weeks, one of them would go by the spot and secretly knock on the wall to reassure themselves that the vessel was still there.

The building, fortunately, was not bombed, and the *Tazza* weathered the war fairly intact. When the museum reopened to the public on June 1, 1945, it went back on display, though it had to be re-restored in July 1951 because its seams came unglued as a result of the movement and humidity it had experienced.

With the change in art tastes over the course of the twentieth century, ancient gems and hard-stone vessels fell out of fashion and

became overshadowed by the paintings that dominate museums and art galleries across the world.[8] The *Tazza* has faded from being a preeminent attraction of the Naples Museum, yielding its place to frescoes from Pompeii and Herculaneum, the Farnese sculptures, and painted pottery unearthed in South Italian tombs. Today the bowl, along with other Medici, Farnese, and Orsini gems, resides in a small suite of ground floor rooms tucked away behind the Farnese Hercules. It is often closed to visitors due to a shortage of guards and limited interest. Which may explain in part why no story of its adventures has been written, and why this extraordinary object, so prized by its illustrious owners for 2,000 years, has become a historical footnote.

Of course, given its past, the *Tazza*'s current quiescence might be a temporary lull, another pause in its action-packed existence. After all, none of the custodians of this timeless treasure, as it traversed the world from Alexandria to Rome to Constantinople to Samarqand and back to Italy—not the Ptolemies, not Frederick II, not Lorenzo de' Medici, not the Farnese—imagined that their holdings would be dispersed so soon after their lifetimes and their precious *Tazza* would slip away into someone else's hands. Yet, as Li Ch'ing-Chao, a twelfth-century Chinese poetess, wrote in her *Records on Metal and Stone*, "Where there is possession, there must be loss of possession; where there is gathering together, there must be a scattering—this is a constant principle of things."[9]

Notes

Introduction

1. Quoted by Cynthia Zarin, "Green Dreams." *The New Yorker*, November 21, 2005.

Chapter 1

1. Plutarch, *Caesar*, 49; Roller, *Cleopatra*, 61. Plutarch wrote in the later first century A.D., but used sources from Cleopatra's era; and though he was affected by Octavian's negative propaganda of the queen, he relied on authors outside the Roman viewpoint. Roller, *Cleopatra*, 7–8.
2. Lucan, *Pharsalia*, 10.4; Suetonius, *Julius Caesar*, 50.
3. Suetonius, *Julius Caesar*, 45.
4. Goudchaux, "Cleopatra's subtle religious strategy"; Grant, *Cleopatra*; Kleiner, *Cleopatra and Rome*; Meadows, "Sins of the fathers"; Roller, *Cleopatra*; Schiff, *Cleopatra*; Williams, "'Spoiling the Egyptians'"; Wyke, *The Roman Mistress*.

5. Plutarch, *Life of Antony*, 27.

6. Philostratos, *Lives of Sophists*, 5.

7. Lucan, *Pharsalia*, 10.110–150. Excavations of the Persian royal palace at Persepolis brought to light fragments of plates and cups made of alabaster and rare stones.

8. It is today in the National Archaeological Museum of Naples, n. 1782, inv. 27611, maximum diameter 21.7 cm, internal scene 15.7 cm, medusa carving 18.1 cm, on the brief history of the *Tazza* see Dacos, Giuliano, & Pannuti, *Il Tesoro di Lorenzo*, 69–72.

9. Bastet, "Untersuchungen zur Datierung"; Charbonneaux, "Sur la signification et la date"; Dwyer, "The Temporal Allegory"; Furtwängler, *Die antiken Gemmen*; Plantzos, "Ptolemaic Cameos"; Pollini, "The Tazza Farnese"; La Rocca, *L'età d'oro di Cleopatra*; Zwierlein-Diehl, *Antike Gemmen*, 66–67, 247.

10. The cameos now in the Kunsthistorisches Museum in Vienna and at the Hermitage Museum in St. Petersburg may depict Ptolemy II and Arsinoe II or other members of the dynasty, though some scholars propose a Roman date. Other sardonyx vessels found in Egypt are discussed by Habachi, "An Agate Bowl from Egypt" and Engelbach, "Recent Acquisitions."

11. The Cup of the Ptolemies is 8.4 cm tall and 12.5 cm wide; it was transformed in the Middle Ages into a chalice at the Abbey of St. Denis. Today it is in the Cabinet des Médailles in Paris. Bühler, *Antike Gefässe*, discusses these and other ancient stone vessels. Zwierlein-Diehl, *Antike Gemmen*, is another key authority on the subject.

12. Obsidian cups from Stabiae (Italy) now in Naples, numerous Roman silver cups, and the gilt silver and gold vessels from the Rogozen and Panagyurishte treasures now in Sofia. I am grateful to Kenneth Lapatin for this suggestion.

13. Athenaeus, *Deipnosophistae*, 5; Rice, *The Grand Procession*.

14. See chapter 2 below.

15. Pliny, *Natural History*, 37.1.

16. Fabrizio Slavazzi, "Vasi in pietra dura."

17. Nicholson and Shaw, *Ancient Egyptian Materials*; Penny, *The Materials of Sculpture*.

18. Pliny, *Natural History*, 37.XXIII.89, distinguished the appearance of Arabian and Indian sardonyx.

19. Diodorus Siculus as per Plantzos, *Hellenistic Engraved Gems*, 106.

20. Pliny, *Natural History*, 37.LIV.140–141.

21. Lapatin, "Intaglio to Cameo"; Schmidt, "Erfahrungen und Fragen," 2008; Schmidt, "Erfahrungen und Fragen," 2010. Schmidt dipped agate in honey as he prepared stone for carving a replica of the *Tazza*. Different lengths of soaking and heating to different temperatures resulted in variations in the colors obtained. The geologist Ralf Schmidt has located sources of agate in Thrace.

22. *Periplus*, 48 and 49; Casson, *The Periplus Maris Erythraei*.

23. Agatharchides of Knidos, *On the Erythrean Sea*, 84.

24. Fraser, *Ptolemaic Alexandria*; *La Gloire d'Alexandrie*.

25. The Mohs' scale of hardness was created in 1822 by the German mineralogist Friedrich Mohs. It groups stones into categories based on how easily they can be scratched by harder materials: 1, talc, is the softest stone; 10, diamond, the most scratch resistant. While the scale may be modern, the understanding of these properties goes back to antiquity and was addressed by Theophrastus in his treatise *On Stones* in ca. 300 BC and by Pliny the Elder in his *Natural History* of the first century AD.

26. Personal interviews with hard-stone carvers at Idar-Oberstein, Germany. Modern-day carvers at Idar-Oberstein have been quite obsessed with the *Tazza*, several of them making replicas of the bowl, though none matching the original's excellence.

27. Diodorus Siculus, 17.52.5.

28. Strabo, *Geography*, Book 17, 798.13; 793.7.

29. La Rocca, *L'età d'oro di Cleopatra*, argues that the *Tazza* was produced for Cleopatra and depicted her in the guise of Isis, the goddess with whom she linked herself. Only Cleopatra, he states, had herself depicted in a royal diadem and with her head uncovered by a veil—as Isis appears on the *Tazza*. And though a co-ruler with her brother/husband, Cleopatra took a dominant role and obscured her consort.

30. This is one version of the myth (Gantz, *Early Greek Myth*, 20–22; *LIMC*, v. 4, pt. 1, 285–287 s.v. "Gorgo, Gorgones"). Greek myths' variants are explored by Calasso, *The Marriage of Cadmus and Harmony*.

31. He has alternately been identified as Hades, Dionysos, or Serapis.

32. Plantzos, "Ptolemaic Cameos." Other interpretations have been suggested by Bastet, "Untersuchungen zur Datierung"; Charbonneaux, "Sur la signification et la date"; Dwyer, "The Temporal Allegory"; Furtwängler, *Die antiken Gemmen*; Pollini, "The Tazza Farnese," etc.

33. Charbonneaux "Sur la signification et la date"; Bastet "Untersuchungen zur Datierung."

34. Suetonius, *Julius Caesar*, 54.

35. Weinstock, *Divus Julius*.

36. Huzar, *Mark Antony*.

37. Roller, *Cleopatra*, 79–80.

38. Plutarch, *Life of Antony*, 26.7.

39. Socrates of Rhodes quoted by Athenaeus, *Deipnosophistae*, IV, 147–148.

40. Goldsworthy, *Antony and Cleopatra*; Roller, *Cleopatra*, 90–92.

41. Plutarch, *Life of Antony*, 4.

42. Plutarch, *Life of Antony*, 29.

43. Plutarch, *Life of Antony*, 24.

44. Plutarch, *Life of Antony*, 10, 3–4.

45. Plutarch, *Life of Antony*, 58.

46. Plutarch, *Life of Antony*, 54; Roller, *Cleopatra*, 99–100.

47. La Rocca *L'età d'oro di Cleopatra*.

48. Cassius Dio, *Roman History*, 50.3–4. Cassius Dio wrote in the early third century A.D. and was thus far removed from the events he described, but he is important as the only surviving continuous history of Cleopatra's era. Roller, *Cleopatra*, 8.

49. Cassius Dio, *Roman History*, 50.4–5; Roller, *Cleopatra*, 129–136.

50. Roller, *Cleopatra*, 137–140.

51. Cassius Dio, *Roman History*, 51.5.

52. Grant, *Cleopatra*, 218–219; Roller, *Cleopatra*, 142.

53. Plutarch, *Life of Antony*, 74, 2.

54. Livy, Fragment 54.

55. Plutarch, *Life of Antony*, 85.

56. Suetonius, *Augustus*, 17.4; Cassius Dio, *Roman History*, 51.14.3; Roller, *Cleopatra*, 146–149.

Chapter 2

1. Pliny, *Natural History*, 36.II.

2. Pliny, *Natural History*, 36.I.

3. Pliny, *Natural History*, 37.VI; Appian, *Roman History*, 12.115.

4. See most recently Mayor, *The Poison King*.

5. Pliny, *Natural History*, 37.VIII.

6. Pliny, *Natural History*, 37.VII.

7. Loewental and Harden, "Vasa Murrina"; Harden, "Vasa Murrina again"; Vickers, "Hamilton," "Glassware," and "Ancient Murrhine Ware."

8. Pliny, *Natural History*, 37.III.

9. Pliny, *Natural History*, 37.XXIII.

10. Pliny, *Natural History*, 37.LXXV.

11. Roller, *Cleopatra*, 4, 71–74.

12. Cassius Dio, *Roman History*, 43.27.3.

13. Cicero, *Letters to Atticus* 15.15.2.

14. Lo Sardo, *La lupa e la sfinge*; Grant, *Cleopatra*, 89–90; Roller, *Cleopatra*, 72.

15. Appian, *Roman History*, 2.102; Cassius Dio, *Roman History*, 51.22.3; Richardson, *New Topographical Dictionary*, 165–167; Kleiner, *Cleopatra and Rome*, 149–150; Gruen, "Cleopatra in Rome," 259.

16. Pliny, *Natural History*, 36.XXIV.103; Westall, "The Forum Iulium."

17. Pliny, *Natural History*, 35.XL.136; 37.V.11.

18. Suetonius, *Julius Caesar*, 46, 47.

19. Pliny, *Natural History*, 37,VI.14–16; Westall, "Forum Iulium," 90–91.

20. Pliny, *Natural History*, 37.V. Appian, *Roman History*, II, 102 records that "Caesar erected the temple to Venus, his ancestress, as he had vowed to do when he was about to begin the battle of Pharsalus." So the entire edifice, inside and out, was about triumphing over Pompey.

21. Suetonius, *Julius Caesar*, 59.

22. Suetonius, *Augustus*, 71.

23. Cassius Dio, *Roman History*, 51.21.5–9; Gurval, *Actium and Augustus*, 29–30.

24. Suetonius, *Augustus*, 41.

25. Cassius Dio, *Roman History*, 51.22.3.

26. Cassius Dio, *Roman History*, 51.21.8.

27. Westall, "Forum Iulium," argues that Cleopatra's statue was dedicated by Augustus, not Caesar.

28. Suetonius, *Augustus*, 79.

29. Suetonius, *Augustus*, 72.

30. Suetonius, *Augustus*, 71, 72.

31. Pliny, *Natural History*, 37.IV.10. Later he used the image of Alexander the Great on his seal; and after that, his own portrait carved by Dioskourides. Suetonius, *Augustus*, 50.

32. Suetonius, *Augustus*, 79.

33. Suetonius, *Augustus*, 70.

34. Walker and Higgs, *Cleopatra of Egypt*, 263. On Actium gems in contemporary literature see Zachos, *Nicopolis B*. The cameo is in Vienna, Kunsthistorisches Museum Antikensammlungen, IX A 56. On Vienna cameo, see Zwierlein-Diehl, *Magie*, 92–97 no. 5.

35. This gem is in Boston, Museum of Fine Arts 27.733, see Zwierlein-diehl, *Magie*, 96 fig. 34.
36. It is in Vienna, Kunsthistorisches Museum Antikensammlungen, IXa 79. Zwierlein-Diehl, *Antike Gemmen*, 149–154, and *Magie*, 98–123 no.6.
37. This convincing dating and interpretation was proposed by Fullerton, "Roma and Augustus on the *Gemma Augustea*."
38. On Augustan cultural politics in general the best source is Paul Zanker, *The Power of Images in the Age of Augustus* (Ann Arbor: University of Michigan Press, 1988).
39. Pollini, "The Tazza Farnese."

Chapter 3

1. Eusebius, *Life of Constantine*; Grant, *Constantine the Great*; Kousoulas, *The life and times of Constantine the Great*; Stephenson, *Constantine*.
2. On Constantinople's transformation see Bassett, *The Urban Image*.
3. Bassett, *The Urban Image*, 49.
4. On the discovery of a treasure of eight sardonyx vessels at Qift in Egypt see Engelbach, "Recent acquisitions," 126–127.
5. Bassett, *The Urban Image*, 43.
6. Bassett, *The Urban Image*, cat. 122 and 141.
7. Cameron, "The Construction of Court Ritual," 127–129.
8. This period of revival of classical studies is examined among others by Treadgold, "The Macedonian Renaissance."
9. Mango, *The Art of the Byzantine Empire*, 181; Treadgold, *Byzantium and Its Army*, 33.
10. Ousterhout, *Master Builders of Byzantium*, 34–35.
11. Toynbee, *Constantine Porphyrogenitus and his World*; *Constantine VII Porphyrogenitus and His Age*; Treadgold, "The Macedonian Renaissance"; Magdalino, "The Bath of Leo the Wise"; Maguire *Byzantine Court Culture*.
12. *De Administrando* contains advice on running the ethnically mixed empire and fighting external enemies. He did not write the book by himself, but spurred its composition. Constantine Porphyrogenitus, *De Administrando Imperio*.
13. Mathews, *Byzantium*, 138.
14. Liudprand, *The Works of Liudprand*, 207–208; Constantine Porphyrogenitus, *De ceremoniis*; Cameron, "The Construction of Court Ritual," 106–136.
15. Maguire, "Epigrams," 112–114; Kalavrezou-Maxeiner, "The Cup of San Marco"; Cutler, "On Byzantine Boxes."

16. The inkpot is discussed and interpreted by Henry Maguire, "Epigrams."
17. Quoted by Maguire, "Epigrams," 113.
18. Maguire, "Epigrams," 114.
19. London, Victoria & Albert Museum, 216–1865. Williamson, *European Sculpture*, 191; Beckwith, *The Veroli Casket*; Culter, "On Byzantine Boxes." The classical mode was not considered superior to other modes in Byzantine cultural circles at this time, but rather chosen when suitable. One and the same book could contain abstract and hieratic Byzantine depictions of Christ and classicizing portraits of philosopher-like apostles. Weitzmann, "The Classical Mode."
20. Diller, "The Text History," 300.
21. Choniates, *O City of Byzantium*, 34, 63–64.
22. Paoletti, "Gorgones Romanae," 360–361.
23. Tenth-century courtiers and visitors admired 500-year-old thrones commissioned by Arcadius and Maurice, and a great silver platter inscribed with the name of Licinius; Constantine VII consulted Justinian's work on protocol. Kazhdan and McCormick, "The Social World of the Byzantine Court," 195; Mango, "Daily Life in Byzantium."
24. Flusin, "Les reliques de la Sainte-Chapelle," 28, n. 80.
25. Dalton, *Byzantine Art and Archaeology*, 637–641; Evans and Wixom, *The Glory of Byzantium*, 182–191, 218–253.
26. Kalavrezou-Maxeiner, "The Cup of San Marco," 167–174; Cutler, "The Mythological Bowl." The flesh-colored men posed against dark ground recall Greek vases, though it is unlikely that such lowly objects, by ancient standards, were preserved for centuries in the imperial palace. Classical gems or images in books on ancient mythology must have served as visual models for the cup maker.
27. Mathews, *Byzantium*, 46 illustrates this icon, destroyed in WWII.
28. Trilling, "Daedalus and the Nightingale," 226.
29. Bassett, *The Urban Image*, 112.
30. Bassett, *The Urban Image*, 111–112.
31. Quoted by Bassett, *The Urban Image*, 113.
32. Mango, "Antique Statuary and the Byzantine Beholder"; Dawkins, "Ancient Statues in Medieval Constantinople"; James, "'Pray Not to Fall into Temptation and Be on Your Guard'"; Saradi-Mendelovici, "Christian Attitudes."
33. *Trésor de Saint-Denis*, 90–95; Heckscher, "Relics of Pagan Antiquity."
34. It resides in Vienna, alongside other prized possessions of the dynasty. *Kunsthistorisches Museum Vienna*, 111–114.

35. *Treasury of San Marco*, 129–135. San Marco preserves other chalices of Romanos II, similarly composed of ancient sardonyx cups mounted in Byzantine settings.

36. In his *Liber de rebus in administratione sua gestis* (Report on Administration), Suger described acquiring "a precious chalice made of a block of sardonyx" along with eight other liturgical vessels. Suger, *Abbot Suger*, 55. The Chalice is now in Washington, National Gallery, No. C–1. Distelberger, *Western Decorative Arts*, 4–12.

37. Suger, *Abbot Suger*, 20–21, 63–65.

38. Suger, *Abbot Suger*, 65.

39. Suger, *Abbot Suger*, 67.

40. Suger, *Abbot Suger*, 79.

41. Clari, *The Conquest of Constantinople*; Villehardouin, "The Conquest of Constantinople"; Choniates, *O City of Byzantium*, 300–320; Andrea, "Devastatio Constantinopolitana"; Phillips, *The Fourth Crusade*.

42. Clari, *The Conquest of Constantinople*, 101.

43. Nicholas Mesarites, quoted by Phillips, *The Fourth Crusade*, 259.

Chapter 4

1. Kantorowicz, *Frederick the Second*, 446.

2. Pannuti, "La 'Tazza Farnese'"; Barbanera, "Alcune considerazioni." Thomas Aquinas received one ounce of gold per month as the professor of theology at the University of Naples.

3. Abulafia, *Frederick II*; Cattaneo, *Federico II di Sveva*; Masson, *Frederick II of Hohenstaufen*; Runciman, *The Sicilian*; Kantorowicz, *Frederick the Second*; Van Cleve, *The Emperor Fredrick II*.

4. Spaniard ibn Jubayr, who visited Sicily in 1184–1185. Quoted by Abulafia, *Frederick II*, 18.

5. Abulafia, *Frederick II*, 59. Frederick would have himself buried in a porphyry sarcophagus in the Cathedral of Palermo.

6. Ayyubids, a Sunni Muslim dynasty of Kurdish origin, ruled much of the Middle East from Cairo and Damascus in the twelfth and thirteenth centuries.

7. Abulafia, *Frederick II*, 257–260.

8. Kantorowicz, *Frederick the Second*, 452.

9. Meredith, "The Arch of Capua"; Kantorowicz, *Frederick the Second*, 437; Gregorovius, *History of the City of Rome*, vol. 5: 185–186.

10. One of the rams, remarkably life-like, still survives in the Museo Archaeologico Regionale di Palermo.

11. Greenhalgh, *The Survival of Roman Antiquities*, 121, 185, 240.

12. De Stefano, *La cultura alla corte*; Giuliano, "Motivi classici." Fusco and Corti, *Lorenzo de' Medici*, 334–338, 357, 384, publish various documents mentioning the *Tazza* without details.

13. Heckscher, "Relics of Pagan Antiquity," 210.

14. Heckscher, "Relics of Pagan Antiquity," 211.

15. London, British Museum, P&E 1890,0901.15. Jenkins and Sloan, *Vases and Volcanoes*, 197; Tait, *Seven thousand years of jewellery*, 218; Robinson, *Masterpieces: Medieval Art*, 288–289. This gem, too, passed through the hands of Lorenzo de' Medici who inscribed his name LAV.R.MED on the doors of the Ark.

16. Giuliano, ". . . la luce de la gran Constanza"; Byrne, "Some Medieval Gems."

17. Kantorowicz, *Frederick the Second*, 404.

18. Abulafia, *Frederick II*, 398; Kahsnitz, "Kameen."

19. Pannuti, "La Tazza Farnese," 210–214.

20. Abulafia, *Frederick II*, 329.

21. Soeda, "Gods as Magical Charms."

22. Giuliano, "Sulle gemme e sugli," 35 suggests that the gem eulogized Frederick's Constitution of Melfi—the new laws of Sicily whose Introduction refers to this Biblical moment. The Poseidon and Athena gem is now in Naples, National Archaeological Museum, inv. 253837, having passed through the Medici and Farnese collections. The Adam and Eve gem is in Paris, Bibliothèque Nationale, Cabinet des Medailles. Sena Chiesa, *Gemme*.

23. The cameo is now in Vienna, Kunsthistorisches Museum, no. IX a 81. It measures 11.5 × 11.3 cm. Scholars debate the identity of these figures. Zwierlein-Diehl, *Der Dreikönigenschrein*; Plantzos, "Hellenistic Cameos."

24. Zwierlein-Diehl, "'Interpretatio Christiana.'"

25. Albertus Magnus, *De mineralibus*, 131.

26. Many ancient vases were adapted to Christian uses in the West. Frederick II owned an ancient agate cup set in an Ottonian gold mount that served as a reliquary of St. Elisabetta, Schramm, "K. Friedrich II," 17, fig. 2. The Cathedral of Genoa possesses to this day an ancient agate plate with the thirteenth-century enameled gold head of St. John the Baptist. Marcenaro, *Il Museo del tesoro della cattedrale*, tav. II with bibl.; Grosso, "Il Tesoro della Cattedrale di Genova."

27. Marbode, *De Lapidibus*, 37, 46, 127.

28. Byrne, "Some Mediaeval Gems," 1935. It may not be the same vessel, but given the laconic and imprecise nature of medieval inventories in general and this one in particular (it does not specify the subject matter of incised gems), it may refer to the *Tazza*.

Chapter 5

1. Ibn Arabshah, *Tamerlane*, 307–309.

2. Fischel, "A New Latin Source"; Burns, *Damascus*, 218–220.

3. Imber, *The Ottoman Empire*, 52–52, 56; Jackson and Lockhart, *Cambridge History of Iran*, vol. 6, 55.

4. Manz, *The Rise and rule of Tamerlane*, 15.

5. Clavijo, *Embassy to Tamerlane*, 191–192.

6. Clavijo, *Embassy to Tamerlane*, 212.

7. Shortly after the body was re-interred in 1942, the Germans surrendered at Stalingrad.

8. Gerasimov, *The Face Finder*.

9. Ibn Arabshah, *Tamerlane*, 295.

10. Manz, *The Rise and Rule of Tamerlane*; Marozzi, *Tamerlane*; Ibn Arabshah, *Tamerlane*; Jackson and Lockhart, *Cambridge History of Iran*.

11. Marozzi, *Tamerlane*, 101–102.

12. Ibn Arabshah, *Tamerlane*, 324.

13. Ibn Arabshah, *Tamerlane*, 295–296.

14. Ibn Khaldun, *Ibn Khaldun and Tamerlane*, 47.

15. Ibn Arabshah, *Tamerlane*, 298.

16. Ibn Arabshah, *Tamerlane*, 299.

17. Timur also encouraged the production of historical narratives about the Chaghatayid khanate of Transoxiana and Mughulistan. Woods, "Aja'ib al-Maqdur," 82.

18. Thackston, *A Century of Princes*; Lentz and Lowry, *Timur and the Princely Vision*.

19. Clavijo, *Embassy to Tamerlane*, 287–288. Ibn Arabshah, *Tamerlane*, 161.

20. Ibn Arabshah, *Tamerlane*, 314. A cauldron of many nations, Samarqand gathered within its walls Turks, Arabs, and Moors; Catholics shared the streets with Armenian and Greek Orthodox, Jacobites and Nestorians; Zoroastrians rubbed elbows with Hindus.

21. Marozzi, *Tamerlane*, 85.

22. Ibn Arabshah, *Tamerlane*, 298.

23. Marozzi, *Tamerlane*, 107.

24. Lamb, *The Earth Shakers*.

25. Clavijo, *Embassy to Tamerlane*, 171.

26. Marozzi, *Tamerlane*, 33.

27. Clavijo, *Embassy to Tamerlane*, 280–281; Ibn Arabshah, *Tamerlane*, 222–223.

28. Marozzi, *Tamerlane*, 225–228.

29. Grube, "Notes on the Decorative Arts."

30. Lentz and Lowry, *Timur and the Princely Vision*, 29 and cat. 5. Both are in St. Petersburg, State Hermitage Museum, SA-15930 and SA-15931.

31. Lentz and Lowry, *Timur and the Princely Vision*, 45.

32. Lentz and Lowry, *Timur and the Princely Vision*, 45.

33. Blanck, "Eine Persische Pinselzeichnung."

34. Parlasca, "Neue Beobachtungen" and "Ein hellenistiches Achat-Rhyton."

35. Clavijo, *Embassy to Tamerlane*, 269.

36. Clavijo, *Embassy to Tamerlane*, 270.

37. Ibn Arabshah also described a "curtain" of Bayezid I in Timur's possession that was, actually, a tapestry sent by the Burgundian Duke Philip the Bold as part of a ransom for his son John the Fearless, captured by the Ottomans at the Battle of Nicopolis in 1396.

38. Jackson and Lockhart, *Cambridge History of Iran*, 79.

39. Marozzi, *Tamerlane*, 340–341.

40. Bretschneider, *Medieval Researches*.

41. Jean of Sultaniyya came to Paris in 1403 to tell the King of France Charles VI about Timur's victory over Bayezid at Ankara. During that time he composed a treatise on Timur. Cited in Roxburgh, "Ruy Gonzalez de Clavijo's Narrative," 127–128.

42. Clavijo, *Embassy to Tamerlane*.

43. Clavijo, *Embassy to Tamerlane*, 286.

44. Ibn Arabshah, *Tamerlane*, 310.

45. Clavijo, *Embassy to Tamerlane*, 227–228.

46. Aside from their ornamental use, these stones were often inscribed with the prince's name and prized as objects in their own right by Timur and his descendants. Lentz and Lowry, *Timur and the Princely Vision*, 221.

47. Lentz and Lowry, *Timur and the Princely Vision*, 221.

48. Ulugh Beg's name is also inscribed on a jade cup now in the British Museum—an oval olive-green vessel with a handle carved in the shape

of a tiger clinging to the lip. Pinder-Wilson & Watson, "An Inscribed Jade Cup."

49. Lentz and Lowry, *Timur and the Princely Vision*, 36.
50. Lentz and Lowry, *Timur and the Princely Vision*, 221; Bretschneider, "A Chinese Medieval Account," I: 173–176; Keene, "The Lapidary Arts in Islam."
51. Roxburgh, *Persian Album*, 2.
52. Roxburgh, *Persian Album*, 139. The Jalayirids were a Mongol dynasty that ruled the territory of Iraq and western Persia in the fourteenth century, until Timur put an end to that. Jackson and Lockhart, "Timur in Iran," in *Cambridge History of Iran* vol. 6, 64–65.
53. Lentz and Lowry, *Timur and the Princely Vision*, 68–69.
54. Lentz and Lowry, *Timur and the Princely Vision*, 80.
55. Marozzi, *Tamerlane*, 109.
56. Marozzi, *Tamerlane*, 116–117.
57. The calligrapher Shaykh Muhammad, for example, worked in Samarqand first for Timur, then for Khalil Sultan, and then moved to Herat to serve Sharukh and Baysunghur. Roxburgh, *Persian Album*, 26, 119–120.
58. Lentz and Lowry, *Timur and the Princely Vision*, 74.
59. Akimushkin, "Baisungur-mirza"; Lentz, *Painting at Herat*.
60. Lentz, *Painting at Herat*, 47–49.
61. Roxburgh, *Persian Album*, 39.
62. Cited by Lentz, *Painting at Herat*, 6.
63. Lentz and Lowry, *Timur and the Princely Vision*, 112.
64. Lentz and Lowry, *Timur and the Princely Vision*, 112.
65. Both quoted by Lentz, *Painting at Herat*, 14–15.
66. Lentz and Lowry, *Timur and the Princely Vision*, 113–114.
67. Thackston, *Album Prefaces*, 43–46. The document was transcribed in Herat in 1420 but probably drafted earlier.
68. The original album is now dispersed, part of it preserved in Topkapi Palace, part, including Muhammad al-Khayyam's *Tazza* drawing, in the Staatsbibliothek in Berlin, assembled into the so-called Diez albums. Heinrich Friedrich von Diez, an Orientalist and art collector, served as a Prussian *chargé d'affaires* at the Sublime Porte in Istanbul in 1786–90 where he acquired many artworks, including materials from the Topkapi Palace, Muhammad's drawing among them. Based on stylistic and chronological features, it came from the court of Baysunghur. Roxburgh, "Heinrich Friedrich von Diez."
69. Roxburgh, *Persian Album*, 118.

70. Roxburgh, *Persian Album*, 137–138: "The particular creative processes developed by artists and calligraphers placed a special premium on models, gatherings that represented a creative capital whether in the practitioner's hands or given over to the *kitabkhana* as an artistic resource. . . . Imitation pervaded artistic practice even if we cannot always locate the extant model [or the resultant works]. Timurid artists applied themselves to the study of valued past works."

71. Thackston, *Album Prefaces*, 44.

72. Roxburgh, "Persian Drawings" and *Persian Album*, 9.

73. Roxburgh, *Persian Album*, 121.

74. Roxburgh, *Persian Album*, 93, 100.

75. Roxburgh, "Persian Drawing," 58–59. The drawings bear his signature, written in a chancery script and characterized by a repeated protocol and knotted flourish. Kühnel, "Malernamen"; Blanck, "Eine Persische Pinselzeichnung"; Rogers, "Siyah Qalam," 25. The artist apparently worked in the early fifteenth century because his calligraphy appears right after that of Baysunghur in a calligraphy exercise bound into Baysunghur's album (H.2152, fol. 31b, Topkapi Palace—from which the Diez album is taken in part).

76. Roxburgh, *Persian Album*, 139–140. Muhammad al-Khayyam depicted single figures and animals, combat scenes, landscapes with dragons and simurghs, and narratives, such as Khursaw looking at Shirin bathing.

77. Roxburgh, *Persian Album*, 141–142.

78. Roxburgh, *Persian Album*, 143–144; Roxburgh, *Prefacing the Image*, 178–179. The Persian poets Ghazali and Rumi also recounted this story, but drew a spiritual conclusion: they used the wall polishing as a metaphor for the Sufi whose piety polishes the heart "until the Radiance of God shines in it." Soucek, "Nizami on Painters and Painting," 12–14.

79. Lentz, *Painting at Herat*, 175–176. They are preserved in the Topkapi Palace and the Diez albums. On this story see Soucek, *Nizami on Painters*, 15–18.

80. For these proposals see Brentjes, "Tazza Farnese," 321–324; Rogers, "Mehmed the Conqueror," 93.

Chapter 6

1. Fusco and Corti, *Lorenzo de' Medici*, 147, 342–343.

2. Iasiello, *Il Collezionismo di antichità*, 20 and n. 20; Giuliano, "Novità sul tesoro di Lorenzo"; Fusco and Corti, *Lorenzo de' Medici*, 337–338, document 207.

3. Ryder, *Alfonso*, 292.

4. Ryder, *Alfonso*, 45.

5. Alfonso's struggle for Naples was interwoven with the contests for power taking place in Italy at that time—the ongoing rivalries between various rulers and popes who alternately helped or hindered his cause as befitted their own agendas.

6. Hersey, *The Aragonese Arch*, 13.

7. Ryder, *Alfonso*, 325 points out that at the same time Alfonso maintained some 200 huntsmen and falconers, also indispensable to a great ruler.

8. Bentley, *Politics and Culture*; Bologna, *Napoli e le rotte*; Driscoll, "Alfonso of Aragon"; Hersey, *The Aragonese Arch*.

9. Cited by Rider, *Alfonso*, 306.

10. Ryder, *Alfonso*, 307.

11. Ryder, *Alfonso*, 318.

12. Ryder, *Alfonso*, 317–318.

13. Driscoll, "Alfonso of Aragon," 89; Ryder, *Alfonso*, 317, 319.

14. Ryder, *Alfonso*, 318–319.

15. Ryder, *Alfonso*, 313–314; Alfonso's humanist Antonio Beccadelli quoting the king, translated by Hill, "Classical Influence," 260.

16. Bentley, *Politics and Culture*, 217.

17. Bentley, *Politics and Culture*, 62.

18. Ryder, *Alfonso*, 347.

19. Paschini, *Lodovico cardinal camalengo*; Bagemihl, "The Trevisan collection."

20. Mantegna's portrait of Trevisan is in Berlin, Gemäldegalerie, Staatliche Museen Preussischer Kulturbesitz, no. 9; his description is cited in Maestro Martino, *The Art of Cooking*, 34, n. 26.

21. Maestro Martini, *The Art of Cooking*, 8.

22. Maestro Martini, *The Art of Cooking*, 9.

23. Maestro Martini, *The Art of Cooking*, 34, n. 27.

24. Maestro Martini, *The Art of Cooking*, 34, n. 27.

25. Chambers, "The Housing Problems," 25, 43.

26. Belozerskaya, *To Wake the Dead*, 167–170.

27. Vespasiano, *Renaissance Princes*, 399. That gem, which seems to have passed from Niccoli to Trevisan to Barbo to Lorenzo de' Medici, only survives in a cast, with Lorenzo's initials engraved on the altar. A fuller version, known as the Felix gem, is at the Ashmolean Museum in Oxford, 1966.1808. Boardman, *The Marlborough Gems*, 96–98. Plantzos, "The Price of Sacrilege"; Moret, *Les pierre gravées*; Gennaioli, *Pregio e bellezza*, 99.

28. Massinelli and Tuena, *Treasures of the Medici*, 20–21. Gennaioli, *Pregio e bellezza*, 124–125.
29. Filarete mentioned that the gem belonged to Trevisan. Caglioti and Gasparotto, "Lorenzo Ghiberti"; Fusco and Corti, *Lorenzo de' Medici*, 246, n. 45. After Barbo's death the gem seems to have been bought by the Venetian antiquities dealer Domenico di Pietro from whom Lorenzo bought it in 1487 (Bullard and Rubinstein, "Lorenzo de' Medici's Acquisition." On October 11, 1972, during a photography session at Naples Archaeological Museum, it was dropped and broken into five pieces.
30. Bentley, *Politics and Culture*, 163.
31. Setton, *The Papacy and the Levant*, vol. 2, 169.
32. Bentley, *Politics and Culture*, 167–168; Pastor, *History of the Popes*, vol. 2, 368–376; Setton, *Papacy and the Levant*, vol. 2, 168–171, 184–190.
33. Ryder, "The Eastern Policy."
34. Setton, *Papacy and the Levant*, 186.
35. Bentley, *Politics and Culture*, 167–168.
36. Ryder, *Alfonso*, 344–345 and n. 105; Beyer "' . . . mi pensamiento e invencion . . .'" 93 and n. 2.
37. Setton, *Papacy and the Levant*, vol. 2, 187–190.
38. Verona, *Le vite di Paolo II*.
39. Pastor, *History of the Popes*, vol. 4, 16.
40. On his interest in and possession of historical writings see Weiss, *Un umanista veneziano*, 30–31.
41. Müntz, *Les arts à la cour des papes*, vol. 2, 223–236; Salomon, "Cardinal Pietro Barbo's collection," 11.
42. Salomon, "Cardinal Pietro Barbo's collection," 15–16; Cannata, "Pope Paul II," 230–231.
43. Müntz, *Les arts à la cour des papes*; Salomon, "Cardinal Pietro Barbo's collection," 4, 6.
44. Weiss, *Renaissance Discovery*, 171.
45. Salomon, "Cardinal Pietro Barbo's collection," 7.
46. Barbo had the Felix gem by 1460: Müntz, *Les arts à la cour des papes*, vol. 2, 245. Boardman, *The Marlborough Gems*, 96–99.
47. Salomon, "Cardinal Pietro Barbo's collection," 9.
48. Pastor, *History of the Popes*, vol. 4, 26.
49. Cannata, "Pope Paul II," 230. The Romans gossiped that the pope's death was caused by the demons imprisoned in the settings of his jewels: "he

was found dead at three in the morning and many said that he was strangled by the devils he kept locked up."

50. The Palazzo Venezia, as Paul's palace came to be called, would later serve as the official residence of Mussolini.

51. Frommel, "Francesco del Borgo," 109–120.

52. Chambers, "The Economic Predicament," 293.

53. Pastor, *History of the Popes*, vol. 4, 31–32; Cannata, "Pope Paul II," 231.

54. He was criticized for waging a war on humanists at the Curia and suppressing the Roman Academy in 1468. He did so to curtail the power of these men—including Alberti and Platina—rather than to stem the revival of antiquity.

55. Weiss, *Renaissance Discovery*, 104; Müntz, *Les arts à la cour des papes*, vol. 2, 92–95.

56. Weiss, *Renaissance Discovery*, 104.

57. Müntz, *Les arts à la cour des papes*, vol. 2, 55–77, 92–93; Frommel, "Francesco del Borgo," 79–80.

58. Giorgio Vasari, "Lives of Valerio Vicentino."

59. Weiss, *Renaissance Discovery*, 168, 187.

60. Belozerskaya, *To Wake the Dead* with previous bibliography.

61. Weiss, *Umanista veneziano*, 28; Weiss, *Renaissance Discovery*, 168.

62. Weiss, *Renaissance Discovery*, 188; Cannata, "Pope Paul II," 231; Zwierlein-Diehl, *Antike Gemmen*, 149–154.

63. Syson and Thornton, *Objects of Virtue*, 84.

64. Salomon, "Cardinal Pietro Barbo's collection," 9.

65. Fusco and Corti, *Lorenzo de' Medici*, 185–186.

66. Weiss, *Renaissance Discovery*, 187; Pope-Hennessy, *Renaissance Bronzes*, 77, no. 265, fig. 59; Syson and Thornton, *Objects of Virtue*, 106–108. The gem, now in the Cabinet des Médailles of the Bibliothèque Nationale in Paris (inv. 2080), was replicated in a bronze cast by Cristoforo di Geremia (now in the National Gallery of Art in Washington, D.C.).

67. Pastor, *History of the popes*, vol. 4, 211.

68. Chambers, *A Renaissance Cardinal*, 46–47, 79–81, 162 no. 564; Brown, "Cardinal Francesco Gonzaga's Collection."

69. Gombrich, "The Early Medici," 51–52. Not all the Medici hard-stone vases were ancient; some were Byzantine, Venetian, or Sassanian.

70. Gombrich, "The Early Medici," 51.

71. Guicciardini, "A Portrait of Lorenzo de' Medici," 273–274, 277.

72. Fusco and Corti, *Lorenzo de' Medici*, 109.

73. Fusco and Corti, *Lorenzo de' Medici*, 147, 149.

74. Bracciolini, *La vera nobilità*, 28–35; Rabil, *Knowledge, Goodness and Power*, 64–65.

75. Sabba da Castiglione, *I ricordi* (Venice, Giovanni Bariletto, 1569), 58–59, translated by Thornton, *The Scholar in his Study*, 117.

76. Dacos, et al. *Il Tesoro di Lorenzo.*

77. Fusco and Corti, *Lorenzo de' Medici*, 177.

78. Guicciardini, "A Portrait of Lorenzo de' Medici," 269, 271.

79. Cited by Langedijk, *Portraits of the Medici*, vol. 1, 113.

80. Theophrastus, *De lapidibus* was the earliest surviving treatise on stones, written in 315 BC; Pliny the Elder wrote about the properties of stones in Book 37 of his *Natural History*; in the thirteenth century Albertus Magnus addressed this subject in his *De mineralibus et rebus metallicis.* Evans, *Magical Jewels*; Riddle and Mulholland, "Albert on stones and minerals"; McCrory, "The Symbolism of Stones."

81. Guicciardini, "Portrait of Lorenzo de' Medici," 273.

82. Fusco and Corti, *Lorenzo de' Medici*, 150–155 discuss various interpretations of "R."

83. Pannuti, "La collezione glittica medicea," 64.

84. Fusco and Corti, *Lorenzo de' Medici*, 6.

85. Fusco and Corti, *Lorenzo de' Medici*, 6.

86. This suggestion is proposed by Beck, "Lorenzo il Magnifico," 131–132.

87. Marbode described some sixty stones and their powers. Cardinal Francesco Gonzaga, who helped evaluate and partition Barbo's gems, owned both Pliny's and Albertus Magnus' texts.

88. Ficino, *Three Books on Life*, 1.23.

89. Ficino, *Three Books on Life*, 3.1.

90. Spallanzani and Gaeta Bertelà, *Libro d'inventario.* Lorenzo may have deliberately inflated the value of his objects to make his collection even more impressive. Fusco and Corti, *Lorenzo de' Medici*, 199–200.

91. Fusco and Corti, *Lorenzo de' Medici*, 157.

92. Fusco and Corti, *Lorenzo de' Medici*, 118.

93. Fusco and Corti, *Lorenzo de' Medici*, 120.

94. Fusco and Corti, *Lorenzo de' Medici*, 128.

95. Alberti, *On painting; and, on sculpture*, 121.

96. McCrory, "The Symbolism of Stones," 171.

97. The Medici vases were given further value and opulence through their splendid mounts, many of them stripped in the eighteenth century by the

Uffizi conservator Giuseppe Bianchi, who was eventually unmasked and condemned to exile for removing and melting down the precious metals and pocketing the proceeds. Barocchi and Gaeta Bertelà, "Danni e furti."

98. Fusco and Corti, *Lorenzo de' Medici*, 136–140.

99. Vasari, "Lives of Valerio Belli."

100. Gombrich, "The Early Medici," 56.

101. Yuen, "The Tazza Farnese." Raphael borrowed these figures in his fresco depicting the Meeting of Leo I and Attila the Hun in the Room of Heliodorus in the Vatican palace.

102. Fusco and Corti, *Lorenzo de' Medici*, 106.

103. Fusco and Corti, *Lorenzo de' Medici*, 27.

104. Brown, with Fusco and Corti, "Lorenzo de' Medici."

105. Fusco and Corti, *Lorenzo de' Medici*, 186.

106. Fusco and Corti, *Lorenzo de' Medici*, 110–114.

107. Cited by Syson and Thornton, *Objects of Virtue*, 81–82.

108. Fusco and Corti, *Lorenzo de' Medici*, 151–152.

Chapter 7

1. Benedetto Varchi, *Storia Fiorentina*. Milan, 1803–1804, vol. 5, 374–375, trans. McCrory, "The Symbolism of Stones," 161.

2. Fusco & Corti, *Lorenzo de' Medici*, 161.

3. Fusco & Corti, *Lorenzo de' Medici*, 176, doc. 187.

4. Fusco & Corti, *Lorenzo de' Medici*, 174, doc. 168.

5. Fusco & Corti, *Lorenzo de' Medici*, 162.

6. Fusco & Corti, *Lorenzo de' Medici*, 174.

7. Landucci, *Diario*, 155–157.

8. Fusco & Corti, *Lorenzo de' Medici*, 166, 167.

9. For a detailed account of Margaret's life see Lefevre, *"Madama" Margarita d'Austria*.

10. Lefevre, *"Madama" Margarita d'Austria*, 94; McCrory, "The Symbolism of Stones," 161.

11. Mussolin, "La Tribuna delle Reliquie." Several other Lorenzian vases, sent to Rome by the Medici supporters, remained there and were listed in 1572 among papal treasures in Castel Sant' Angelo.

12. Heikamp, "Le vicende dei vasi"; Venturelli, *Il Tesoro dei Medici*, 31–32; Cipriani et al., "Appunti per la storia."

13. Robertson, *Il Gran Cardinale*, 8–9.
14. Robertson, *Il Gran Cardinale*, 9, 12.
15. Zapperi, "Alessandro Farnese."
16. Waddy, *Seventeenth-Century Roman Palaces*, 25.
17. Lefevre, "Il testamento di Margarita d'Austria," 246; Lefevre, *"Madama" Margarita d'Austria*, 103–106.
18. A list of statues left in Rome is published in *Documenti inediti*, 376.
19. Margaret's husband was interested in hard-stone carving, employing three "jasper carvers," and in antiquities, importing classical sculptures from Rome to Parma. But his engagement with such works was far surpassed by his brother, Cardinal Alessandro.
20. Niwa, "'Madama' Margaret of Parma's patronage of music," 32–33.
21. Denunzio, "Nuovi documenti sul mecenatismo"; Bertini, "Gli arazzi dei Farnese" and "L'inventario dei beni di Margherita d'Austria"; Guerrieri, "Il mecenatismo dei Farnese," 141–143 on Margaret's patronage.
22. Robertson, *Il Gran Cardinale*, 9; Zapperi, "Alessandro Farnese," 159–160.
23. *Palais Farnèse*, vol. I, 2, 331–151.
24. Robertson, *Il Gran Cardinale*, 13.
25. Robertson, *Il Gran Cardinale*, 10–13.
26. Robertson, *Il Gran Cardinale*, 16.
27. Ajello, et al. *Classicismo d'età romana*; Riebesell, *Die Sammlung des Kardinal Alessandro Farnese*, 25–64 on antiquities; *Palais Farnèse*; Navienne, *Rome, le Palais Farnèse*, 457–485, 645–671. The Palazzo Farnese was begun by Paul III and completed by Alessandro, whose primary residences were the Palazzo Cancelleria and the suburban villa at Caprarolla.
28. Robertson, *Il Gran Cardinale*, 24–52.
29. G.A. Gilio (1564) quoted by Robertson, *Il Gran Cardinale*, 13.
30. See Vasari, "Lives of Valerio Vicentino . . ."; Donati, *Pietre Dure e Medaglie*.
31. Robertson, *Il Gran Cardinale*, 36.
32. Venturelli, *Il Tesoro dei Medici*, 116–117. It is now in the Museo degli Argenti in Florence.
33. The London, Victoria and Albert Museum version of the bronze cast of the *Tazza* (R, P. 1930/1044, 17 cm) is dated to late fifteenth century and may have been commissioned by Pope Paul II in Rome or by Lorenzo de' Medici in Florence. The New Haven, Yale Art Gallery version, attributed to Giovanni dei Bernardi (Maitland F. Griggs Fund, 17.2 cm), would have been cast after the *Tazza* came into Margaret's possession. A third

version, listed in the Trinity Fine Art Ltd. auction catalogue in 1998 and dated to eighteenth-century Rome (17.3 cm) and a fourth one, in La Spezia, Museo Civico Amedeo Lia (Inv. Bp45, 16.7 cm), dated to the nineteenth century, may have been based on the earlier Renaissance casts, on one made by William Dugood in the 1730s, or on another taken from the *Tazza* in Naples. Bange, *Die italienischen Bronzen*, II, listed a version in Berlin dated to the sixteenth century, and Kris, *Meister und Meisterwerke*, I, 32, 155, nn. 64–65, tav. 18, described a sixteenth-century Italian version in the Lederer Collection in Vienna; it is now at the Metropolitan Museum in New York. Another example is in Rome, Museo di Palazzo Venezia. See also Cannata 1982, 13–15, 29, fig. 6/M; Avery, *Plaquettes*, 95, n. 44.

34. The cameo is preserved in the Royal Collection at Windsor. Donati, *Pietre Dure e Medaglie*. Piacenti and Boardman, *Ancient and Modern Gems*.

35. Brown, "Le antichità del Cardinale Alessandro Farnese," 50–52.

36. Robertson, *Il Gran Cardinale*, 223–230.

37. Brown, "Isabella d'Este Gonzaga's *Augustus and Livia*," 91; Zwierlein-Diehl, "Interpretatio Christiana," 64–65; Ross, "The Rubens Vase."

38. Belkin, *A House of Art*, 260–297.

39. De Piles, *Conversations*, 215.

40. Van der Meulen, *Petrus Paulus Rubens Antiquarius*, 36–72 and Van der Meulen, *Copies after the Antique*, II, 173–206, nos. 163–173.

41. Robertson, *Il Gran Cardinale*, 242. On Paul III identifying himself with Alexander and the *Tazza* with Apotheosis of Alexander see Buddensieg, "Zum Statuenprogramm," 223, n. 60; Harprathm, *Papst Paul III als Alexander*.

42. These vases are recorded in a rough drawing and mentioned by Cabrol and Leclercq, *Dictionnaire*, X, pt. 2, cols. 2136–2142; Lanciani, *Pagan and Christian Rome*, 203–204; de Rossi, "Disegni d'alquanti vasi"; Ross, "The Rubens Vase," 34.

43. Robertson, *Il Gran Cardinale*, 50.

44. Riebesell, *Die Sammlung des Kardinal Alessandro*, 40–43, 197–198.

45. Pesce, *Gemme Medicée*, 86–87 on the now lost will of Margaret of Austria; Lefevre, "Il testamento di Margarita d'Austria."

46. Margaret had her gems and jewels inventoried several times over the years, but sadly these records, transferred to Naples in the eighteenth century, perished in World War II and the only published account of them mentions only the dates of her inventories—August 1561, June 1566, and

December 1577—but not their contents. Cauchie, "Inventaires des Archives de Marguerite." Piot "Inventaire des joyaux," published the inventory taken at Ortona on February 1586 after Margaret's death. It was very succinct and was also destroyed in the war. But it did list the *Tazza* as the second object.

47. Pastor, *History of the Popes*, XVII, 111, n. 1.

48. Pastor, *History of the Popes*, XVII, 114.

49. Quoted by Collins, *Papacy and Politics*, 144. I owe to Jeffrey Collins the above summary of the changing treatment of the Cortile Belvedere.

50. Erica Simon has argued in "Alexandria—Samarkand—Florenz—Rom," 25–27 that Poussin used the *Tazza*'s sphinx and Isis as models for his sphinx and the Nile in the *Exposition of Moses* in the Ashmolean Museum in Oxford. Since the *Tazza* was in Parma at that time and not readily accessible, and Poussin's figures do not resemble those on the *Tazza* closely enough, the artists more likely looked at the statues of the Nile and the sphinx in Rome, in the Vatican and on the Campidoglio.

51. Lewis, "Philipp von Stosch" and *Connoisseurs and Secret Agents*.

52. Disraeli, *Curiosities of literature*, 350.

53. Whiteley, "Philipp von Stosch."

54. Stosch's own gem collection, which comprised more than 10,000 cameos, intaglios, and their casts, became widely known through its publication by the German art historian Johann Joachim Winckelmann, *Description des Pierres gravées du feu Baron de Stosch* (Florence 1760).

55. Pesce, *Gemme Medicée*, 53–55.

56. Giove & Villone in Dacos, *Il Tesoro dei Medici*, p. 31. Later Caselli would become the chief painter at the Neapolitan royal Porcelain factory at Capodimonte.

57. Dugood's career and involvement with the Farnese gems are detailed by Connell, "William Dugood" and "Recently identified at Burton Constable Hall." The following summary stems from these articles. I am grateful to Mr. Connell for generously sharing with me his studies and the photographs of Dugood's replicas of the *Tazza*.

58. After Margaret's death her gems passed into the possession of her son, Alessandro, then to his son Ranuccio (1592–1622), and then down the Farnese male line to Odoardo (1622–1646), Ranuccio II (1646–1694), Francesco (1694–1727), and finally to Antonio.

59. Connell, "William Dugood," 249–250.

Chapter 8

1. Goethe, *Italian Journey*, 342–343.
2. Acton, *Bourbons of Naples*, 22–23.
3. Acton, *Bourbons of Naples*, 24.
4. On Charles' court structure and its subordination to the will of his mother see Vázquez-Gestal, "The System of This Court."
5. Chaney, "The Grand Tour and Beyond," 143.
6. Acton, *Bourbons of Naples*, 4.
7. These different views of the *lazzaroni* are cited by Acton, *Bourbons of Naples*, 9–10. Charles de Brosses recorded his impressions in *Le président de Brosses en Italie: Lettres familières écrites d'Italie en 1739 et 1740 par Charles de Brosses*. Paris, 1858.
8. Goethe, *Italian Journey*, 312–318.
9. Acton, *Bourbons of Naples*, 68.
10. Jenkins and Sloan, *Vases and Volcanoes*, 25, 30; Burr Litchfield, "Naples under the Bourbons."
11. Acton, *Bourbons of Naples*, 49.
12. On the display of the Farnese collection in Naples see Vázquez-Gestal, "From Court Painting to King's Books," 96–99.
13. Daehner, *Herculaneum Women*.
14. Wilton and Bignamini, *Grand Tour*; Black, *Italy and the Grand Tour*.
15. *The Antiquarian Repertory* 1 (1775), ii.
16. Goethe, *Italian Journey*, 116.
17. Goethe, *Italian Journey*, 138.
18. On the history of these excavations see Parslow, *Rediscovering Antiquity*.
19. Winckelmann, *Sendschreiben*, paragraph 29.
20. Haskell, "Patronage and Collecting in Bourbon Naples."
21. Sigismondo, *Descrizione della città di Napoli*, 1789, vol. 3, 49–50.
22. Morghen, F. *Vedute nel Regno Napoli*. Naples, 1765–1779. Getty Research Institute Library, P980008*, 55 x 40 cm. The album was issued by Filippo Morghen's print shop around 1780, but the individual plates within date between 1765 and 1779. While many of them were engraved by Filippo, others were made by his son Raphael and a few other masters.
23. He was also the father and teacher of Rafaello Morghen (1758–1833), one of the most influential engravers of the late eighteenth and early nineteenth centuries who specialized in, among other subjects, reproductive prints after Raphael and Leonardo. Nagler, *Neues allgemeines Kunstler-Lexicon*, vol. 9, 1–2.

24. Morghen also made, and dedicated to Sir William Hamilton, a set of ten whimsical etchings entitled "A Collection of the most notable things seen by Sir Wilde Scull, and by M. de la Hire, in their famous voyage from the Earth to the Moon" [*Raccolta delle cose più notabili veduta dal cavaliere Wilde Scull, e dal sigr: de la Hire nel lor famoso viaggio dalla terra alla Luna*]. His depictions of that mysterious world and its denizens combined Boschian creatures, Rococo-style grotesques, and Chinoiserie patterns.

25. Shcherbatov, "On the corruption of morals in Russia."

26. Walters, *Catalogue of the Bronzes*; these bronzes represented Zeus, Hera, a Satyr, an Eros, and a triple Hecate and had been found near Dodona in Epirus in the early 1790s.

27. Platz-Horster, *Nil und Euthenia*, 7, n. 6, fig. 2. This first-century AD sardonyx cameo, measuring 25 x 40 cm, shows Dionysus riding in a chariot drawn by centaurs. Found in 1661 in the cemetery at Calepodio outside Rome, on the Via Aurelia, it passed through several hands before ending up at the Louvre (BJ 1740).

28. Goethe, *Italian Journey*, 203, letter of March 18, 1787.

29. Burlot, "*Disegni Intagliati.*"

30. Acton, *Bourbons of Naples*, 93.

31. Acton, *Bourbons of Naples*, 51.

32. Quirini, Cardinal Angelo Maria, "An account of the searches made in the Village of Resina, by Order of the King of the Two Sicilies," in Marquis Niccolò Marcello Venuti, *A description of the first discoveries of the Ancient City of Heraclea found Near Portici . . .* London, 1750, 135.

33. Quoted in Acton, *Bourbons of Naples*, 75.

34. Elizabeth Vigée Le Brun, upon arriving in Naples on April 9, 1790, in *Souvenirs* I, 196, translated in May, *Louise-Elizabeth Vigée Le Brun*, 88.

35. Jenkins and Sloan, *Vases and Volcanoes*, 11; Chaney, "The Grand Tour and Beyond," 143; Brady and Pottle, *Boswell on the Grand Tour*, 19.

36. Bologna, "The rediscovery of Herculaneum and Pompeii," 79–91.

37. Goethe, *Italian Journey*, 195.

38. Goethe, *Italian Journey*, 322.

39. Maffei, *Osservazioni letterarie*, vol. 2, 339 ff.

40. James Millingen. *Ancient Unedited Monuments. Statues, Busts, Bas-Reliefs, and Other Remains of Grecian Art from Collections in Various Museums.* London, 1826, 33–34.

41. Visconti, *Museo Pio-Clementino*, vol. 3, 235, engraving T.c.I.

42. Jenkins and Sloan, *Vases and Volcanoes*, 94; Rudoe, "Engraved Gems."

43. Quoted by McCrory, "A proposed exchange," 281.

44. Neverov, "Gemme delle collezioni Medicei e Orsini"; Pirzio Biroli Stefanelli, "Fortuna delle gemme Farnese."

45. Letter of August 17, 1796 quoted by McCrory, "A proposed exchange," 273 and Document I.

46. Guseva and Phillips, *Treasures of Catherine the Great*, 33.

47. Guseva and Phillips, *Treasures of Catherine the Great*, 29.

48. Guseva and Phillips, *Treasures of Catherine the Great*, 96.

49. Guseva and Phillips, *Treasures of Catherine the Great*, 98. She also purchased casts of ancient sculptures—since export of actual antiquities from Rome was forbidden—getting papal permission to have plaster forms made from the famous works in the Vatican Belvedere, the Capitoline, the Palazzo Farnese, and the Villa Madama (before they were transported to Naples).

50. Kagan, "The Classical Hero."

51. Smith, *James Tassie*; Holloway, *James Tassie*, 13; Rudoe, "Engraved Gems," 134. The 16,000 gems were replicated in glass pastes and plaster casts of each item, so the total amounted to 32,000 pieces.

52. Hawks Le Grice, *Walks through the Studii*, advertisement at the back of vol. 2, 271.

53. Pirzio Biroli Stefanelli, "Le gemme antiche," 456–457; McCrory, "A proposed exchange," 285; Pirzio Biroli Stefanelli, *La Collezione Paoletti*; Bernardini et al., *Calchi e intagli*.

54. McCrory, "A proposed exchange," 285, doc. III, dated November 9, 1796.

55. Spinosa, "Ancora sul Laboratorio," 370, n. 96.

56. McCrory, "A proposed exchange," 277–280 on Paoletti's process of cast making as it is documented in Florence.

57. Hermitage, Inv. NO 46829, *Catalogo delle Pietre originali del Real Museo Farnesiano di Napoli, donde sono tirate le Paste, i Solfi che son rinchiusi nella Cassetta ove è anche il presente, con un ristretto ragguaglio di quel che esse rappresentano*. Published by Pannuti, "Un inventario." Catherine also bought a large set of other gem casts from Paoletti's Roman studio.

58. Goethe, *Italian Journey*, 385.

59. Jones, *Fake?*, 147.

60. Fusco & Corti, *Lorenzo de' Medici*, 157.

61. Fusco & Corti, *Lorenzo de' Medici*, 321; Syson & Thorton, *Objects of Virtue*, 109–110, the story of the porphyry tazza is reported by Marcantonio Michiel. Vasari called Sebaldi the biggest imitator of ancient things.

62. Jones, *Fake?*, 149.

63. Rudoe, "Engraved Gems," 135, 138; Griffiths, "The Reverend Clayton Mordaunt Cracherode," 43–64; Dalton, *Catalogue of Engraved Gems*, no. 232.
64. Acton, *Bourbons of Naples*, 123.
65. Acton, *Bourbons of Naples*, 144–145.
66. Acton, *Bourbons of Naples*, 141–143.
67. Acton, *Bourbons of Naples*, 148.
68. Acton, *Bourbons of Naples*, 134.
69. Goethe, *Italian Journey*, 175.
70. Mattusch, *Villa dei Papiri*, 92.
71. Acton, *Bourbons of Naples*, 148.
72. Gonzales-Palacios, "Il trasporto delle statue Farnesiane."
73. Goethe, *Italian Journey*, 150.
74. Jenkins and Sloan, *Vases and Volcanoes*, 29.
75. Goethe, *Italian Journey*, 187.
76. The plan for the new museum was formed in 1777, but between the ambitious scope of the building and the political unrest of the following decades, the transfer of the objects did not begin until 1805.
77. Nelson, *Dispatches and Letters*, vol. 3, 210–211.
78. Pesce, "Gemme medicee," 55 and n. 31; Pannuti, *Il Tesoro di Lorenzo*, vol. 1, *Le Gemme*, 10 ff. and note 62. Under Napoleon's brother, Joseph Bonaparte, who ruled Naples between 1806 and 1815, the layout of the new museum was finally completed and the collections were opened to the public on a regular schedule, though the most prized objects, such as the *Tazza*, were at that time in Palermo.
79. Finati, *Il Regal Museo Borbonico*. The complete transfer was not completed until 1834.
80. For the history of the museum see Paolini, "Il Museo Archeologico Nazionale di Napoli." Abbott, *Rollo in Naples*, 174.
81. Arditi envisioned the museum as a means of producing culture and educating citizens; he also proposed a network of provincial museums to instruct people across the kingdom, with the Royal Museum serving as an umbrella institution.
82. Milanese, "Dal Gabinetto," 107.
83. These, most prized of the ancient paintings and mosaics uncovered at Pompeii and Herculaneum, had been taken by the royal family to Palermo, while others had remained at Portici.
84. Milanese, "Dal Gabinetto," 109.

85. Monaco, *A Complete Handbook*, 147.

86. Mattusch, *Villa dei Papiri*, 56.

87. Gargiulo, *Collection of the Most Remarkable Monuments*.

88. Spinosa, *National Museum of Capodimonte*, 7–14.

Chapter 9

1. Museum archives, an article in *L'Eco della Stampa* for October 19, 1925, recounting an old event in light of the new assault on the *Tazza*; *The New York Times*, "Farnese Cup Stolen—The Tazza Not Injured," September 4, 1903.

2. The following account is based on previously unpublished documents in the Naples Museum archives.

3. Private conversation with Erik Risser, antiquities conservator at the Getty Villa, January 24, 2006.

4. During WWII the base salary of a generic worker was some 11,000 lire, a newspaper cost 4 lire, coffee, 20, bread, 45, milk, 30. According to modern conversion, 4,500 lire would amount to about 3,200 euros today.

5. I am most grateful to Dott. Ferdinando Salemme at the Archivio di Stato di Napoli for kindly transcribing these documents for me, and to Mark Walters for generously translating them into English.

6. For Monte Cassino's fate see the account of the Abbey's archivist Leccisotti, *Monte Cassino*. For the Museum in the war period see De Franciscis, "Per la storia del Museo Nazionale di Napoli."

7. Maiuri, *Taccuino Napoletano*, 103–104.

8. Belozerskaya, *Luxury Arts*, chapter 1; Lapatin, "The Fate of Plate."

9. Owen, *Anthology of Chinese Literature*.

Bibliography

Abbott, Jacob. *Rollo in Naples*. Boston: DeWolfe, Fiske & Co., 1858.

Abulafia, David. *Frederick II: A Medieval Emperor*. London: Penguin, 1988.

Acton, Harold. *The Bourbons of Naples*. London: Prion, 1998.

Agatharchides of Knidos. *On the Erythrean Sea.*

Ajello, Raffaele, Haskell, Francis, and Gaspari, Carlo. *Classicismo d'età romana: La collezione Farnese*. Naples: Guida, 1988.

Akimushkin, O. "Baisungur-mirza I ego rol' v kul'turnoi I politicheskoi zhizni Khorasanskogo sultanata Timuridov pervoi treti XV veka." *Peterburgskoe vostokovedenie* 5 (1994): 143–168.

Alberti, Leon Battista. *On painting; and, on sculpture: the Latin Texts of De pictura and De statua [by] Leon Battista Alberti*, ed. and trans. Cecil Grayson. London: Phaidon, 1972.

Albertus Magnus. *De mineralibus, Book of Minerals*, trans. Dorothy Wyckoff. Oxford: Clarendon Press, 1967.

Andrea, Alfred J. trans. "Devastatio Constantinopolitana." *Contemporary Sources for the Fourth Crusade*, 205–221. Leiden: Brill, 2000.

Appian, *Roman History*, trans. Horace White. Cambridge, MA: Harvard University Press, 1972–79.

Athenaeus, *Deipnosophistae*, trans. Charles Burton Gulick. Volume II. Cambridge, MA: Harvard University Press, 1928.

Avery, Charles. *Plaquettes, medals and reliefs from the collection L.* London: Christie's, 1985.

Bagemihl, Rolf. "The Trevisan collection." *Burlington Magazine* 135 (1993): 559–563.

Bange, E.F. *Die Italienischen Bronzen der Renaissance und des Barock; Zweiter Teil: Reliefs und Plaketten.* Berlin: Walter de Gruyter & Co., 1922.

Barbanera, Marcello. "Alcune considerazioni su Federico II collezionista di pietre dure e sul destino della Tazza Farnese." *Archeologia classica* 54 (2003): 423–442.

Barocchi, P. and Gaeta Bertelà, Giovanni. "Danni e furti di Giuseppe Bianchi in Galleria." *Labyrinthos* 13/16 (1988–89): 321–336.

Bassett, Sarah. *The Urban Image of Late Antique Constantinople.* Cambridge: Cambridge University Press, 2004.

Bastet, F.L. "Untersuchungen zur Datierung und Bedeutung der Tazza Farnese." *BABesch* 37 (1962): 1–24.

Beck, James. "Lorenzo il Magnifico and his Cultural Possessions." In *Lorenzo de Medici: New Perspectives,* ed. Bernard Toscani. New York: P. Lang, 1993.

Beckwith, John. *The Veroli Casket.* London: HMSO, 1962.

Belkin, Kristin Lohse. *A House of Art: Rubens as Collector.* Antwerp: Rubenshuis & Rubenianum, 2004.

Belozerskaya, Marina. *Luxury Arts of the Renaissance.* Los Angeles: J. Paul Getty Museum, 2005.

———. *To Wake the Dead: A Renaissance Merchant and the Birth of Archaeology.* New York: Norton, 2009.

Bentley, Jerry H. *Politics and Culture in Renaissance Naples.* Princeton: Princeton University Press, 1987.

Bernardini, Luisalla, Caputo, Annarita, and Mastrorocco, Mila. *Calchi di Intagli e Camei dalla Collezione Paoletti all'Istituto d'Arte di Firenze.* Florence: Polistampa, 1998.

Bertini, Giuseppe "Gli arazzi dei Farnese da Paolo III a Dorotea Sofia di Neoburgo," and "L'inventario dei beni di Margherita d'Austria ritrovati alla sua morte nel 1586 nelle resinedze di Ortona e de L'Aquila." In *Gli arazzi dei Farnese e dei Borbone,* ed. Giuseppe Bertini and Nello Forti Grazzini, 41–53, 219–222. Milan: Electa, 1998.

Beyer, Andreas. "'... mi pensamiento e invencion ...' König Alfonso I. von Neapel triumphiert als Friedenfürst am Grabmal der Parthenope." *Georges-Bloch-Jahrbuch des Kunstgeschichtlichen Seminars der Universität Zürich* I (1994): 93–107.

Black, Jeremy. *Italy and the Grand Tour.* London and New Haven: Yale University Press, 2003.

Blanck, Horst. "Eine Persische Pinselzeichnung nach der Tazza Farnese." *Archäologische Anzeiger* 79 (1964): 302–312.

Boardman, John. *The Marlborough Gems.* Oxford: Oxford University Press, 2009.

Bologna, F. "The rediscovery of Herculaneum and Pompeii in the artistic culture of Europe in the eighteenth century." In *Rediscovering Pompeii,* ed. B. Conticello, 78–91. Rome: L'Erma di Brentschneider, 1990.

Bologna, Ferdinando. *Napoli e le rotte mediterranee della pittura: da Alfonso il Magnanimo a Ferdinand il Cattolico.* Naples: Società napoletana di storia patria, 1977.

Bracciolini, Poggio. *La vera nobilità,* ed. and trans. Davide Canfora, 28–35. Rome: Salerno, 1999.

Brady, Frank and Pottle, Frederick A. ed. *Boswell on the Grand Tour: Italy, Corsica, and France.* New York: McGraw-Hill, 1955.

Brentjes, Burchard. "The 'Tazza Farnese' and its Way to Herat and Naples." *Oriente Moderno,* n.s. 15, 76.2 (1996): 321–325.

Bretschneider, E. "A Chinese Medieval Account of Western Precious stones." In *Medieval Researches from Eastern Asiatic Sources,* 2 vols. 1: 173–176. London: K. Paul Trübner, 1910.

———. *Medieval Researches from Eastern Asiatic Sources,* 2: 259–261. London: K. Paul Trübner, 1910.

Brown, Clifford M. "Cardinal Francesco Gonzaga's Collection of Antique Intaglios and Cameos: Questions of Provenance, Identification and Dispersal." *Gazette des Beaux-Arts* 125 (1983): 102–104.

———. "Le antichità del Cardinale Alessandro Farnese e di Antonio, Enea e Mario Gabriele." *Prospettiva* 42 (1985): 50–52.

———. "Isabella d'Este Gonzaga's *Augustus and Livia* Cameo and the '*Alexander and Olympias*' Gems in Vienna and Saint Petersburg." In *Engraved Gems: Survival and Revival,* ed. Clifford M. Brown, 85–107. Washington: National Gallery of Art, 1997.

Brown, Clifford M. ed. *Engraved Gems: Survival and Revival.* Washington: National Gallery of Art, 1997.

Brown, Clifford M. with Laurie Fusco and Gino Corti. "Lorenzo de' Medici and the Dispersal of the Antiquarian Collections of Cardinal Francesco Gonzaga." *Arte Lombarda* 90–91 (1989): 86–103.

Buddensieg, T. "Zum Statuenprogramm im Kapitolsplan Pauls III." *Zeitschrift Für Kustgeschichte* 32 (1969): 177–228.

Bühler, Hans-Peter. *Antike Gefässe aus Edelsteinen.* Mainz: von Zabern, 1973.

Bullard, Melissa Meriam and Rubinstein, Nicolai. "Lorenzo de' Medici's Acquisition of the Sigillo di Nerone." *Journal of the Warbourg and Courtauld Institutes* 62 (1999): 283–286.

Burlot, Delphine. "The Disegni Intagliati: A forgotten book illustrating the first discoveries at Herculaneum." *Journal of the History of Collections* 23 (2011): 15–28.

Burns, Ross. *Damascus. A History.* New York: Routledge, 2005.

Burr Litchfield, R. "Naples under the Bourbons: an historical overview." In *Golden Age of Naples*, ed. Rossen and Caroselli, 1–14.

Byrne, Eugene H. "Some Medieval Gems and Relative Values." *Speculum* 10 (1935): 177–187.

Cabrol, Fernand and Leclercq, Henri. *Dictionnaire d'archéologie crétienne et de liturgie.* Vol. 10. Paris: Librairie Letouzey et Ané, 1932.

Caglioti, Francesco and Gasparotto, Davide. "Lorenzo Ghiberti, il 'Sigillo di Nerone' e le origini della plachetta 'antiquaria.'" *Prospettiva* 85 (1997): 2–38.

Calasso, Roberto. *The Marriage of Cadmus and Harmony.* New York: Vintage, 1994.

Cameron, Averil. "The Construction of Court Ritual: the Byzantine Book of Ceremonies." In *Rituals of Royalty: Power and Ceremonial in Traditional Societies*, ed. David Cannadine, and Simon Price, 106–136. New York: Cambridge University Press, 1987.

Cannata, Pietro. "Pope Paul II, Humanist and Collector in Rome." In *In the light of Apollo: Italian Renaissance and Greece*, ed. Mina Gregori. Vol. 1, 230–31. Milan: Silvana; Athens: Hellenic Culture Organization, 2003.

Cassius Dio. *Roman History*, trans. Herbert B. Foster. Cambridge: Harvard University Press, 1917.

Casson, Lionel. *The Periplus Maris Erythraei: Text With Introduction, Translation, and Commentary.* Princeton: Princeton University Press, 1989.

Cattaneo, Giulio. *Federico II di Sveva. Lo specchio del mondo.* Rome: Newton Compton, 1992.

Cauchie, A. "Inventaires des Archives de Marguerite de Parma, dressés après la mort de cette princesse, précédés d'une liste d'anciens inventaires d'archives et de joyaux conservés aux archives farnésiennes de Naples." *Bulletins de la Commission Royale d'Histoire* 76 (1907): 61–135.

Chambers, David. "The Economic Predicament of Renaissance Cardinals." In *Studies in Medieval and Renaissance History* 3, ed. William M. Bowsky, 287–313. Lincoln: University of Nebraska Press, 1966.

————. *A Renaissance Cardinal and his Worldly Goods: The Will and Inventory of Francesco Gonzaga*. London: The Warburg Institute, 1992.

————. "The Housing Problems of Cardinal Francesco Gonzaga." *Journal of the Warburg and Courtauld Institutes* 39 (1976): 21–58.

Chaney, E. "The Grand Tour and Beyond: British and American Travellers in Southern Italy 1545–60." In *Oxford, China and Italy. Writings in Honor of Sir Harold Acton*, ed. E. Chaney and N. Ritchie, 133–160. London: Thames & Hudson, 1984.

Charbonneaux, J. "Sur la signification et la date de la Tasse Farnèse." *MonPiot* 50 (1958): 85–103.

Choniates, Niketas. *O City of Byzantium: Annals of Niketas Choniates, trans.* Harry J. Magoulias. Detroit: Wayne State University Press, 1984.

Cicero. *Letters to Atticus 15.15.2*, trans. D.R. Shackleton Bailey. Cambridge, MA: Harvard University Press, 1999.

Cipriani, C., Fantoni, L., Poggi L., and Scarpellini, A. "Appunti per la storia del Museo di Storia Naturale dell'Università di Firenze. Le collezioni mineralogiche, nota IV: i precursori." *Atti e Memorie "La Colombaria"* 70 (2005): 155–224.

Clari, Robert de. *The Conquest of Constantinople*, trans. Edgar Holmes McNeal. New York: Columbia University Press, 1936.

Clavijo, Ruy González de. *Embassy to Tamerlane, 1403–1406*, trans. Guy Le Strange. New York: Harper, 1928.

Collins, Jeffrey Laird. *Papacy and Politics in eighteenth-century Rome: Pius VI and the arts*. Cambridge: Cambridge University Press, 2004.

Connell, David. "Recently identified at Burton Constable Hall. The collection of William Dugood FRS—jeweller, scientist, freemason and spy." *Journal of the History of Collections* 21.1 (2009): 1–15.

————. "William Dugood and the Farnese numismatic and glyptic collections." *Annali dell'istituto Italiano di numismatica* 55 (2009): 231–255.

Constantine Porphyrogenitus. *De Administrando Imperio*, ed. Gy. Moravcsik, trans. R.J.H. Jenkins. Washington: Dumbarton Oaks Center for Byzantine Studies, 1967.

————. *De ceremoniis/Le Livre des ceremonies*. Paris: Les Belles Lettres, 1967.

Constantine VII Porphyrogenitus and His Age. International Byzantine Conference, Delphi 1987. Athens: Eurōpaiko Politistiko Kentro Delphōn, 1989.

Cutler, Anthony. "The Mythological Bowl in the Treasury of San Marco at Venice." In *Near Eastern Numismatics, Iconography, Epigraphy and History, Studies*

in Honor of Georges C. Miles, ed. Dickran K. Kouymjian, 235–254. Beirut: American University of Beirut, 1974.

———. "On Byzantine Boxes." *Journal of the Walters Art Gallery* 42–43 (1984–85): 32–47.

Dacos, N., Giuliano, A., Pannuti, U. *Il Tesoro di Lorenzo il Magnifico.* Vol. I. *Le Gemme.* Vol. II, *I Vasi.* Florence: Sansoni Editore, 1973 and 1974.

Daehner, Jens, ed. *The Herculaneum Women: History, Context, Identities.* Los Angeles: J. Paul Getty Museum, 2007.

Dalton, Ormonde Maddock. *Catalogue of Engraved Gems of the Post-Classical Period in the British Museum.* London: British Museum, 1915.

———. *Byzantine Art and Archaeology.* New York: Dover Publications, 1961.

Dawkins, R.M. "Ancient Statues in Medieval Constantinople." *Folklore* 35.3 (1924): 209–248.

De Franciscis, A. "Per la storia del Museo Nazionale di Napoli." *Archivio storico per le province napoletane* 30 (1944–6): 169–200.

De Piles, Roger. *Conversations sur la connaissance de la Peinture et sur le jugement qu'on doit faire des Tableaux.* Paris, 1677.

De Rossi, Giovanni Battista. "Disegni d'alquanti vasi del mondo muliebre sepolti con Maria moglie di Onorio imperatore." *Bulletino d'archeologia cristiana* (1863): 53–56.

De Stefano, Antonio. *La cultura alla corte di Federico II.* Bologna: N. Zanichelli, 1950.

Denunzio, A.E. "Nuovi documenti sul mecenatismo di Margherita d'Austria." *Aurea Parma* 82 (1998): 271–296.

Diller, Aubrey. "The Text History of the Bibliotheca of Pseudo-Apollodorus." *Transactions and Proceedings of the American Philological Association* 66 (1935): 296–313.

Diodorus Siculus. *Library of History. Books 1 and 3,* trans. Charles Henry Oldfather. Vols. I and II. Cambridge, MA: Harvard University Press, 1933, 1935.

Disraeli, Isaac. *Curiosities of literature: and, The literary character illustrated.* London, 1791.

Distelberger, Rudolf et al. ed. "Chalice of Abbot Suger of Saint-Denis." In *Western Decorative Arts,* Part I, 5–12. Washington: National Gallery of Art; New York: Cambridge University Press, 1993.

Documenti inediti per servire alla storia dei musei d'Italia. Ministero della pubblica istruzione, Florence: Tip. Bencini, 4 vols. 1878-80, vol. 2, 1879.

Donati, V. *Pietre Dure e Medaglie del Rinascimento. Giovanni da Castel Bolognese.* Ferrara: Belriguardo, 1989.

Driscoll, Eileen R. "Alfonso of Aragon as a Patron of Art." In *Essays in Memory of Karl Lehmann*, ed. L.F. Sandler, 87–96. New York: Institute of Fine Arts, New York University, 1964.

Dwyer, Eugene J. "The Temporal Allegory of the Tazza Farnese." *American Journal of Archaeology* 96 (1992): 255–282.

Engelbach, R. "Recent Acquisitions in the Cairo Museum." *Annales du Service des Antiquités de l'Égypte* 31 (1931): 126–127.

Eusebius. *Life of Constantine: Introduction, translation, and commentary by* Averil Cameron and Stuart G. Hall. Oxford: Clarendon Press, 1999.

Evans, Helen C. and Wixom, William D. ed. *The Glory of Byzantium. Art and Culture of the Middle Byzantine Era A.D. 843–1261.* New York: Metropolitan Museum of Art, 1997.

Evans, Joan. *Magical Jewels of the Middle Ages and the Renaissance.* Oxford: Clarendon Press, 1922.

Ficino, Marsilio. *Three Books on Life*, ed. and trans. Carol V. Kaske and John R. Clark. Binghamton, NY: Medieval & Renaissance Texts & Studies, Renaissance Society of America, 1989.

Finati, G.B. *Il Regal Museo Borbonico descritto da Giovanbattista Finati.* Naples, G. de Bonis, 1817.

Fischel, Walter J. "A New Latin Source on Tamerlane's conquest of Damascus, (1400/1401): (B. de Mignanelli's 'Vita Tamerlani' 1416)." *Oriens* 9.2 (1956): 201–232.

Flusin, Bernard. "Les reliques de la Sainte-Chapelle et leur passé imperial à Constantinople." In *Le trésor de la Sainte-Chapelle*, 20–31. Paris: Louvre, 2001.

Fraser, P.M. *Ptolemaic Alexandria.* 3 vols. Oxford: Clarendon Press, 1972.

Frommel, Christoph Luitpold. "Francesco del Borgo: Architekt Pius II und Pauls II." *Römisches Jahrbuch für Kunstgeschichte* 21 (1984): 71–164.

Fullerton, Mark. "Roma and Augustus on the Gemma Augustea." Paper delivered on February 28, 2009 at the College Art Association session "The Art and Archaeology of Ancient Greece, Rome, and Etruria," chaired by Karol Wight, held at the Getty Villa.

Furtwängler, Adolf. *Die antiken Gemmen: Geschichte der Steinschneidekunst im klassischen Altertum* II. Berlin, Leipzig: Gesecke & Devrient, 1900.

Fusco, Laurie and Corti, Gino. *Lorenzo de' Medici: Collector and Antiquarian.* Cambridge: Cambridge University Press, 2006.

Gantz, Timothy. *Early Greek Myth.* Baltimore and London: Johns Hopkins University Press, 1993.

Gargiulo, Raphaël. *Collection of the Most Remarkable Monuments of the National Museum.* Naples, 1870, 4 vols.

BIBLIOGRAPHY

Gaspari, Carlo. ed. *Le Gemme Farnese*. Naples: Electa, 1994.

Gennaioli, Riccardo. *Pregio e bellezza. Cammei e intagli dei Medici*. Livorno: Sillane, 2010.

Gerasimov, Mikhail Mikhailovich. *The Face Finder*. London: Hutchinson & Co., 1971.

Giuliano, Antonio. "Motivi classici nella scultura e nella glittica di età normana e federicana." In *Federico II e l'arte del Duecenti italiano*, ed. Angiola Maria Romanini, I: 19–26. Galatina: Congedo, 1980.

———. ". . . la luce de la gran Constanza." *Pact* 23 (1989): 335–339.

———. "Novità sul tesoro di Lorenzo il Magnifico." In *Lorenzo il Magnifico e il suo mondo: convegno internazionale di studi*, ed. Gian Carlo Garfagnini, 319 ff. Florence: L.S. Olschki, 1994.

———. "Sulle gemme e sugli ovali di età federiciana." In *Exempla. La rinascita dell'antico nell'arte italiana. Da Federico II ad Andrea Pisan*, 33–50. Pisa: Pacini Editore, 2008.

Goethe, Johann Wolfgang van. *Italian Journey, 1786–1788*, trans. W.H. Auden and Elizabeth Mayer. New York: Pantheon Books, 1962.

Goldsworthy, Adrian. *Antony and Cleopatra*. New Haven/London: Yale University Press, 2010.

Gombrich, Ernst H. "The Early Medici as Patrons of Art." In *Norm and Form*, ed. Ernst H. Gombrich, 35–57. London: Phaidon, 1966.

Gonzales-Palacios, A. "Il trasporto delle statue Farnesiane da Roma a Napoli." *Antologia di Belle Arti* VI (1978): 168–174.

Goudchaux, Guy Weill. "Cleopatra's subtle religious strategy." In *Cleopatra of Egypt*, ed. Walker and Higgs, 128–141.

Grant, Michael. *Cleopatra*. London: Phoenix, 1972.

———. *Constantine the Great: The Man and His Times*. New York: Maxwell Macmillan, 1993.

Greenhalgh, Michael. *The Survival of Roman Antiquities in the Middle Ages*. London: Duckworth, 1989.

Gregorovius, Ferdinand. *History of the City of Rome in the Middle Ages*. London: G. Bell, 1900, vol. 5.

Griffiths, A. "The Reverend Clayton Mordaunt Cracherode." In *Landmarks of Print Collecting*, ed. Antony Griffiths, 43–65. London: British Museum, 1996.

Grosso, Orlando. "Il Tesoro della Cattedrale di Genova. 1. Le arche di San Giovanni Battista e il piatto di Salome." *Dedalo* 5 (1924–25): 414–442.

Grube, Ernst. "Notes on the Decorative Arts of the Timurid Period." In *Guru-rajamanjarika: Studi in onore di Giuseppe Tucci*, I: 252–256. Naples: Istituto universario orientale, 1974.

Gruen, Erich S. "Cleopatra in Rome: Facts and Fantasies." In *Myth, History, and Culture in Republican Rome*: studies in honour of T.P. Wiseman, ed. David C. Braund and Christopher Gill, 257–274. Exter: University of Exeter Press, 2003.

Guerrieri, G. "Il mecenatismo dei Farnese." *Archivio Storico per la Province Parmensi*, 5e serie, 7–8 (1942–43): 127–167.

Guicciardini, Francesco. "A Portrait of Lorenzo de' Medici." In *The Portable Renaissance Reader*, ed. James Bruce Ross and Mary Martin McLaughlin, 267–78. New York: Viking Press, 1953.

Gurval, Robert A. *Actium and Augustus: The Politics and Emotions of Civil War*. Ann Arbor: University of Michigan Press, 1995.

Guseva, Natalya and Phillips, Catherine, ed. *Treasures of Catherine the Great: Hermitage rooms at Somerset House*. London: Hermitage Development Trust, 2000.

Habachi, Labib. "An Agate Bowl from Egypt." *Muse* 3 (1969): 29–34.

Harden, D.B. "Vasa Murrina again." *Journal of Roman Studies* 44 (1954): 53.

Harprathm, R. *Papst Paul III als Alexander der Grosse*. Berlin, New York: W. de Gruyter, 1978.

Haskell, Francis. "Patronage and Collecting in Bourbon Naples in the 18th century." In *Golden Age of Naples*, ed. Rossen and Caroselli, 15–22.

Hawks Le Grice, Count. *Walks through the Studii of the sculptors at Rome*. vol. 2, Rome, 1841.

Heckscher, William S. "Relics of Pagan Antiquity in Medieval Settings." *Journal of the Warburg and Courtauld Institutes* 1 (1938): 204–220.

Heikamp, D. "Le vicende dei vasi dal Cinquecento ad oggi." In *Il Tesoro di Lorenzo il Magnifico*, ed. Dacos et al., 147–158.

Hersey, George L. *The Aragonese Arch at Naples 1443–1475*. New Haven: Yale University Press, 1973.

Hill, G.F. "Classical Influence on the Renaissance Medal." *Burlington Magazine* 18 (1910–11): 259–268.

Holloway, James. *James Tassie 1735–1799*. Edinburgh: National Gallery of Scotland, 1986.

Huzar, Eleanor Goltz. *Mark Antony: A Biography*. London: Dover, 1978.

Iasiello, Italo M. *Il Collezionismo di antichità nella Napoli dei Viceré*. Naples: Liguori, 2003.

Ibn Arabshah, Ahmad ibn Muhammad. *Tamerlane; or Timur, the Great Amir, from the Arabic Life of Ahmed ibn Arabshah*, trans. J.H. Sanders. London: Luzac, 1936.

Ibn Khaldun. *Ibn Khaldun and Tamerlane: their historic meeting in Damascus, 1401 A.D.*, trans. Walter Joseph Fischel. Berkeley: University of California Press, 1952.

Imber, Colin. *The Ottoman Empire 1300–1481*. Istanbul: Isis Press, 1990.

Jackson, Peter and Lockhart, Laurence. *The Cambridge History of Iran. Vol 6. The Timurid and Safavid Periods*, 50–111. Cambridge: Cambridge University Press, 1986.

James, Liz. "'Pray Not to Fall into Temptation and Be on Your Guard': Pagan Statues in Christian Constantinople." *Gesta* 35.1 (1996): 12–20.

Jenkins, Ian and Sloan, Kim. *Vases and Volcanoes: Sir William Hamilton and his Collection*. London: British Museum, 1996.

Jones, Mark ed. *Fake? The Art of Deception*. London: British Museum, 1990.

Kagan, J.O. "The Classical Hero as Ideal Ruler on Two Early Nineteenth-Century Russian Cameos." In *Engraved Gems: Survivals and Revivals*, ed. Clifford M. Brown, 281–290.

Kahsnitz, R. "Kameen." In *Die Zeit der Staufer*, ed. Eberhard Orthbandt, I: 674 ff. Stuttgart: Württembergisches Landesmuseum, 1977.

Kalavrezou-Maxeiner, Ioli. "The Cup of San Marco and the 'Classical' in Byzantium." In *Studien zur mittelalterlichen Kunst 800–1250. Festschrift für Florentine Mütherich zum 70. Geburtstag*, ed. Katharina Bierbrauer, et al., 167–174. Munich: Prestel-Verlag, 1985.

Kantorowicz, Ernst. *Frederick the Second, 1194–1250*. New York: F. Ungar Publishing Co., 1957.

Kazhdan, Alexander P. and McCormick, Michael. "The Social World of the Byzantine Court." In *Byzantine Court Culture from 829 to 1204*, ed. Henry Maguire, 167–197. Washington: Dumbarton Oaks, 1997.

Keene, Manuel. "The Lapidary Arts in Islam." *Expedition* 24.1 (1981): 26–39.

Kleiner, Diana E.E. *Cleopatra and Rome*. Cambridge, MA: The Belknap Press, 2005.

Kousoulas, D. George. *The life and times of Constantine the Great*. Danbury, CT: Rutledge, 1997.

Kris, Ernst. *Meister und Meisterwerke der Steinschneidekusnt in der italienischen Renaissance*. Vienna: Anton Scroll, 1929.

Kühnel, E. "Malernamen in der Berliner 'Saray'-Alben." *Kunst des Orients* 3 (1959): 66–77.

Kunsthistorisches Museum Vienna. *The Secular and Ecclesiastical Treasuries. Illustrated Guide*. Vienna: Residenz Verlag, 1991.

La Gloire d' Alexandrie. Paris: Musée du Petit Palais, 1998.

Lamb, Harold. *The Earth Shakers*. Doubleday, 1953.

La Rocca, Eugenio. *L'età d'oro di Cleopatra; Indagine sulla Tazza Farnese*. Rome: "L'Erma" di Bretschneider, 1984.

Lanciani, Rodolfo. *Pagan and Christian Rome*. Boston, New York: Houghton, Mifflin, 1892.

Landucci, Luca. *Diario fiorentino dal 1450 al 1516*. Florence: Studio Biblos, 1969.

Langedijk, Karla. *The Portraits of the Medici: 15th–18th centuries*. 3 vols. Florence: Studio per edizioni scelte, 1981–87.

Lapatin, Kenneth. "The Fate of Plate and Other Precious Materials: Toward a Historiography of Ancient Greek Minor (?) Arts." In *Ancient Art and Its Historiography*, ed. A.A. Donohue and Mark D. Fullerton, 69–91. Cambridge: Cambridge University Press, 2003.

———. "Intaglio to Cameo: Changing Materials, Techniques, and Meanings in Greek and Roman Glyptic," paper presented at the AIA Meetings, Anaheim, January 2010.

Leccisotti, Tommaso. *Monte Cassino*, ed. and trans. Armand O. Citarella, 11–143. Montecassino: Pubblicazioni Cassinesi, 1987.

Lefevre, Renato. "Il testamento di Margarita d'Austria duchessa di Parma e Piacenza." *Palatino* 12 (1968): 240–250.

———. "Madama" Margarita d'Austria (1522–1586). *Vita d'una grande dama del Cinquecento, figlia di Carlo V, sposa sfortunata di Alessandro de' Medici e duchessa di Parma e Piacensa con Ottavio Farnese, governatrice dell' Aquila e delle Fiandre, signora di città del Lazio e dell'Abruzzo*. Rome: Newton Compton Editori, 1986.

Lentz, Thomas W. "Painting at Herat under Baysunghur Ibn Sharukh," Ph.D. diss. Harvard University, 1985.

Lentz, Thomas W. and Lowry, Glenn D. ed. *Timur and the Princely Vision. Persian Art and Culture in the Fifteenth Century*. Los Angeles: Los Angeles County Museum of Art; Washington: Smithsonian Institution Press, 1989.

Lewis, Lesley. *Connoisseurs and Secret Agents in Eighteenth Century Rome*. London: Chiatto & Windus, 1961.

———. "Philipp von Stosch." *Apollo* 85 (1967): 320–327.

Liudprand. *The Works of Liudprand of Cremona*, trans. F.A. Wright. London: G. Routledge & Sons, 1930.

Lo Sardo, Eugenio, ed. *La lupa e la sfinge: Roma e l'Egitto dalla storia al mito*. Milan: Electa, 2008.

Loewental A.I. and Harden, D.B. "Vasa Murrina." *Journal of Roman Studies* 39 (1949): 31–37.

Lucan, *Pharsalia*.

Maestro Martino. *The Art of Cooking: The First Modern Cookery Book*, ed. Luigi Ballerini. Berkeley: University of California Press, 2005.

Maffei, S. *Osservazioni letterarie che possono servir di continuazione al giornal de' letterati d'Italia*. Verona, 1738.

Magdalino, Paul. "The Bath of Leo the Wise and the 'Macedonian Renaissance' Revisited: Topography, Iconography, Ceremonial, Ideology." *Dumbarton Oaks Papers* 42 (1988): 97–118.

Maguire, Henry, ed. *Byzantine Court Culture from 829 to 1204*. Washington: Dumbarton Oaks Center for Byzantine Studies/Cambridge, MA: Harvard University Press, 1997.

———. "Epigrams, Art, and the 'Macedonian Renaissance.'" *Dumbarton Oaks Papers* 48 (1994): 105–115.

Maiuri, Amedeo. *Taccuino Napoletano*. Naples: Vajro, 1956.

Mango, Cyril A. *The Art of the Byzantine Empire 312–1453: Sources and Documents*. Toronto: University of Toronto Press, 1986.

———. "Antique Statuary and the Byzantine Beholder." *Dumbarton Oaks Papers* 17 (1963): 53–75.

———. "Daily Life in Byzantium." *Jahrbuch der Österreichischen Byzantinischen Gesellschaft* 31 (1981): 338–353.

Manz, Beatrice Forbes. *The Rise and Rule of Tamerlane*. Cambridge: Cambridge University Press, 1989.

Marbode, Bishop of Rennes. *De Lapidibus*, trans. and commentary John M. Riddle. Wiesbaden: Steiner, 1977.

Marcenaro, Caterina. *Il Museo del tesoro della cattedrale a Genova*. Genoa: Cassa di risparmio di Genova e Imperia, 1969.

Marozzi, Justin. *Tamerlane: Sword of Islam, Conqueror of the World*. London: Harper Collins, 2004.

Massinelli, Anna Maria and Tuena, Filippo. *Treasures of the Medici*. New York: The Vendome Press, 1992.

Masson, Georgina. *Frederick II of Hohenstaufen, a Life*. London: Secker & Warburg, 1957.

Mathews, Thomas F. *Byzantium: From Antiquity to the Renaissance*. New York: Prentice Hall and Abrams, 1998.

Mattusch, Carol C. *The Villa dei Papiri at Herculaneum. Life and Afterlife of a Sculpture Collection*. Los Angeles: J. Paul Getty Museum, 2005.

May, Gita. *Louise-Elizabeth Vigée Le Brun: the odyssey of an artist in the age of revolution*. New Haven and London: Yale University Press, 2005.

Mayor, Adrienne. *The Poison King: The Life and Legend of Mithradates, Rome's Deadliest Enemy*. Princeton: Princeton University Press, 2009.

McCrory, Martha A. "A proposed exchange of gem impressions during the period of Directoire: a Project of the Bibliotheque Nationale in Paris and of the Grand Duchy of Tuscany." In *Studien zum europäischen Kunsthandwerk. Festschrift Yvonne Hackenbroch*, ed. Jörg Rasmussen, 273–287. Munich: Klinkhardt & Biermann, 1983.

——. "The Symbolism of Stones: Engraved Gems at the Medici Grand-Ducal Court (1537–1609)." In *Engraved Gems: Survivals and Revivals*, ed. Clifford M. Brown, 159–179.

Meadows, Andrew. "Sins of the fathers: the inheritance of Cleopatra, last queen of Egypt." In *Cleopatra of Egypt*, ed. Walker and Higgs, 14–31.

Megow, Wolf-Rüldiger. *Kameen von Augustus bis Alexander Severus*. Berlin: De Gruyter, 1987.

Meredith, Jill. "The Arch of Capua: The Strategic Use of Spolia and References to the Antique." In *Intellectual Life at the Court of Frederick II Hohenstaufen*, ed. William Tronzo, 108–126. Washington: National Gallery of Art, 1994.

Milanese, A. "Dal Gabinetto degli oggetti preziosi alla Sezione degli arti industriali: le gemme Farnese nel Museo di Napoli." in *Le Gemme Farnese*, ed. Gaspari, 107–112.

Monaco, Domenico. *A Complete Handbook to the National Museum in Naples*. London: W. Clowes and Sons, Ltd., 1883.

Moret, Jean-Marc. *Les pierre gravées antiques représentant le rapt du Palladion*. Mainz: P. von Zabern, 1997.

Müntz, Eugène. *Les arts à la cour des papes pendant le XVe et le XVe siècle*. 3 vols. Paris: E. Thorin: 1878–82.

Mussolin, M. "La Tribuna delle Reliquie di Michelangelo e la controfacciata di San Lorenzo a Firenze." In *Michelangelo architetto a San Lorenzo. Quattro problemi aperti*, ed. P. Ruschi, 183–226. Florence: Mandragola, 2007.

Nagler, G.K. *Neues allgemeines Kunstler-Lexicon*. Munich: E.A. Fleischmann, 1840.

Navienne, Ferdinand. *Rome, le Palais Farnèse et les Farnèse*. Paris: Librairie Albin Michel, 1914.

Nelson, Horatio, Lord. *The Dispatches and Letters of Vice Admiral Lord Viscount Nelson*. Sir Nicholas Harris Nicolas, ed. 7 vols. London: H. Colburn, 1844–46.

Neverov, Oleg. "Gemme delle collezioni Medicei e Orsini." *Prospettiva* 28 (1982): 2–13.

Nicholson Paul T. and Shaw, Ian. *Ancient Egyptian Materials and Technology.* Cambridge: Cambridge University Press, 2000.

Niwa, S. "'Madama' Margaret of Parma's patronage of music." *Early Music* 33 (2005): 25–37.

Ousterhout, Robert. *Master Builders of Byzantium.* Philadelphia: University of Pennsylvania Museum of Archaeology, 2007.

Owen, Stephen, ed. and trans. *An Anthology of Chinese Literature: Beginnings to 1911.* New York: W.W. Norton, 1996.

Palais Farnèse, Le. Rome: École française de Rome, 1981.

Pannuti, Ulrico. *Cataloghi dei Musei e Gallerie d'Italia. Museo Archeologico Nazionale di Napoli. La collezione glittica,* vol. 2. Rome: Istituto poligrafico e Zecca dello Stato; Libreria dello Stato, 1994.

———. "La collezione glittica medicea." In *Le Gemme Farnese,* ed. Gaspari, 61–69.

———. "Un inventario di gemme farnesiane conservato a Pietroburgo." *Xenia Antiqua* 4 (1995): 159–178.

———. "La 'Tazza Farnese': Datazione, interpretazione e trasmissione del cimelo." *Pact* 23 (1989): 205–215.

Paoletti, O. "Gorgones Romanae." In *LIMC* 4.1, 345–362. Zurich: Artemis Verlag, 1988.

Paolini, E.P. "Il Museo Archeologico Nazionale di Napoli in due secoli di vita." In *Da Palazzo degli Studi a Museo Archeologico,* 1–27. Naples: Museo Nazionale, 1977.

Parlasca, Klaus. "Neue Beobachtungen zu den hellenistischen Achatgefäßen aus Ägypten." *The J. Paul Getty Museum Journal* 13 (1985): 19–22.

———. "Ein hellenistiches Achat-Rhyton in China." *AAsiat* 47 (1991): 280–286.

Parslow, Christopher Charles. *Rediscovering Antiquity. Karl Weber and the Excavation of Herculaneum, Pompeii, and Stabiae.* Cambridge: Cambridge University Press, 1995/1998.

Paschini, Pio. *Lodovico cardinal camalengo.* Rome: Facultas theologica Pontificii athenaei lateranensis, 1939.

Pastor, Ludwig. *The History of the Popes from the close of the Middle Ages,* 40 vols. London: J. Hodges, 1891–1953.

Penny, Nicholas. *The Materials of Sculpture.* New Haven: Yale University Press, 1993.

Periplus. In *Ancient History Sourcebook: The Periplus of the Erythraean Sea: Travel and Trade in the Indian Ocean by a Merchant of the First Century,* ed. and trans. W.H. Schoff. London, Bombay & Calcutta, 1912.

Pesce, Gennaro. "Gemme medicee nel Museo Nazionle di Napoli." *Rivista del R. Istituto d'Archeologia e Storia dell'Arte* 5 (1935): 55 ff.

———. *Gemme Medicée del Museo Nazionale di Napoli.* Naples: Ist Poligraf. dello Stato, 1935.

Phillips, Jonathan. *The Fourth Crusade and the Sack of Constantinople.* London: Jonathan Cape, 2004.

Piacenti, Kirsten Aschengreen and Boardman, John. *Ancient and Modern Gems and Jewels: in the Collection of Her Majesty the Queen.* London: Royal Collections Publication, 2008.

Pinder-Wilson, R. & Watson, William. "An Inscribed Jade Cup from Samarqand." *British Museum Quarterly* 23 (1960): 19–22.

Piot, Ch. "Inventaire des joyaux et autres objets de prix trouvés dans la succession de Margarite de Parme." *Bulletins de la Commission Royale d'Histoire (de Bruxelles)*, 5e ser., 5 (1895): 328–356.

Pirzio Biroli Stefanelli, Lucia. "Fortuna delle gemme Farnese nel XVIII e XIX secolo. Calchi, paste vitrie e riproduzioni in pietra dura." In *Le Gemme Farnese*, ed. Gaspari, 101–106.

———. "Le gemme antiche e la glittica neoclassica: la documentazione della collezione Paoletti del Museo di Roma." *PACT* 23 (1993): 447–458.

———. *La Collezione Paoletti. Stampi in vetro per impronte di intagli e cammei.* Rome: Gangemi, 2007.

Plantzos, Dimitris. *Hellenistic Engraved Gems.* Oxford: Clarendon Press, 1990.

———. "Hellenistic Cameos; Problems of Classification and Chronology." *Bulletin of the Institute of Classical Studies* 41 (1996): 115–131.

———. "Ptolemaic Cameos of the Second and First Centuries B.C." *Oxford Journal of Archaeology* 15 (1996): 39–61.

———. "The Price of Sacrilege: Diomedes, the Palladion and Roman Taste." In *Classicism to Neo-Classicism: Essays Dedicated to Gertrud Seidmann*, ed. Martin Henig and Dimitris Plantzos, 39–47. Oxford: Archaeopress, 1999.

Platz-Horster, Gertrud. *Nil und Euthenia. Der Kalzitkameo im Antikenmuseum Berlin.* Berlin: Verlag Walter de Gruyter & Co., 1992.

———. "Der Capita-iugata-Kameo in Berlin." In *La glyptique des mondes classiques. Mélanges en homage à Marie-Louise Vollenweider*, ed. M. Avisseaut Broustet, 55–90. Paris: Bibliothèque nationale de France, 1997.

———. *Mythos und Macht. Erhabene Bilder in Edelstein.* Berlin: SMB, Antikensammlung, Staatliche Museen zu Berlin, 2008.

Pliny, *Natural History*, Book 36. trans. D.E. Eichholz. Cambridge, MA: Harvard University Press, 1962.

———, Book 37, trans. D.E. Eichholz. Cambridge: Harvard University Press, 1962.

Plutarch, *Caesar*. In *Fall of the Roman Republic. Six Lives by Plutarch*, trans. Rex Warner. Harmondsworth: Penguin, 1958.

———. *Life of Antony, 27–28*. In *The Parallel Lives by Plutarch*, trans. Bernadotte Perrin. Cambridge, MA: Harvard University Press, 1920.

Pollini, John. "The Tazza Farnese: Augusto Imperatore 'Redeunt Saturnia Regna!'" *American Journal of Archaeology* 96 (1992): 283–300.

Pollitt, J.J. *Art in the Hellenistic Age*. Cambridge: Cambridge University Press, 1986.

Pope-Hennessy, John. *Renaissance Bronzes from the Samuel H. Kress Collection*. London: Phaidon, 1965.

Pownall, Thomas. *A Treatise on the Study of Antiquities as commentary to Historical Learning*. London: J. Dodsley, 1782.

Rabil, Albert Jr. ed. and trans. *Knowledge, Goodness and Power: the Debate over Nobility among Quattrocento Humanists*. Binghamton, NY: Medieval & Renaissance Texts & Studies, 1991.

Rice, E.E. *The Grand Procession of Ptolemy Philadelphus*. Oxford: Oxford University Press, 1983.

Richardson, L., Jr. *New Topographical Dictionary of Ancient Rome*. Baltimore, 1992.

Riddle, J.M. and Mulholland, J.A. "Albert on stones and minerals." In *Albertus Magnus and the Sciences: Commemorative Essays, 1980*, ed. James A. Weisheipl, 203–234. Toronto: Pontifical Institute of Mediaeval Studies, 1980.

Riebesell, C. *Die Sammlung des Kardinal Alessandro Farnese. Ein 'studio' für Künstler und Gelehrte*. Weinheim: VCH, Acta Humaniora, 1989.

Robertson, Claire. '*Il Gran Cardinale.' Alessandro Farnese, Patron of the Arts*. New Haven: Yale University Press, 1992.

Robinson, James. *Masterpieces: Medieval Art*. London: British Museum, 2008.

Rogers, Michael J. "Mehmed the Conqueror: Between East and West." In *Bellini and the East*, ed. Caroline Campbell and Alan Chong, 80–97. London: National Gallery Company; Boston: Isabella Stewart Gardner Museum, 2005.

———. "Siyah Qalam." In *Persian Masters: Five Centuries of Painting*, ed. Sheila R Canby, 21–38. Bombay: Marg, 1990.

Roller, Duane W. *Cleopatra: A Biography*. Oxford: Oxford University Press, 2010.

Ross, M.C. "The Rubens Vase, its history and date." *Journal of the Walters Art Gallery* 6 (1943): 9–39.

Rossen, S.F. and Caroselli, S.L. eds. *Golden Age of Naples: Art and Civilization under the Bourbons 1734–1805*. Detroit: Detroit Institute of Arts, 1981.

Roxburgh, David J. "Heinrich Friedrich von Diez and his eponymous albums: mss. Diez A. fols. 70–74." *Muqarnas* 12 (1995): 112–136.

———. *Prefacing the Image: The Writing of Art History in Sixteenth-Century Iran.* Leiden: Brill, 2001.

———. "Persian Drawings, ca. 1400–1450: Materials and Creative Procedures." *Muqarnas* 19 (2002): 44–77.

———. *The Persian Album, 1400–1600: from dispersal to collection.* New Haven: Yale University Press, 2005.

———. "Ruy Gonzalez de Clavijo's Narrative of Courtly Life and Ceremony in Timur's Samarqand, 1404." In *The 'Book' of Travels: Genre, Ethnology, and Pilgrimage, 1250–1700,* ed. Palmira Brummett, 113–158. Leiden: Brill, 2009.

Rudoe, J. "Engraved Gems: the lost art of antiquity." In *Enlightenment. Discovering the World in the Eighteenth Century,* ed. K. Sloan, 132–138. London: British Museum, 2003.

Runciman, Steven. *The Sicilian Vespers.* Baltimore: Penguin Books, 1960.

Ryder, Alan F.C. *Alfonso the Magnanimous: King of Aragon, Naples, and Sicily, 1396–1458.* Oxford: Clarendon Press, 1990.

———. "The Eastern Policy of Alfonso the Magnanimous." *Atti dell Accademia Pontaniana, n.s.* 28 (1979): 7–25.

Salomon, Xavier F. "Cardinal Pietro Barbo's collection and its inventory reconsidered." *Journal of the History of Collections* 15 (2003): 1–18.

Saradi-Mendelovici, Helen. "Christian Attitudes toward Pagan Monuments in Late Antiquity and their Legacy in Later Byzantine Centuries." *Dumbarton Oaks Papers* 44 (1990): 47–61.

Schiff, Stacy. *Cleopatra: A Life.* New York: Little, Brown and Company, 2010.

Schmidt, Gerhard. "Erfahrungen und Fragen beim Nachschneiden der drei grössten Sardonyx-Kameen der Antike: Tazza Farnese, Gemma Augustea und Grand Camée de France." In *Mythos und Macht. Erhabene Bilder in Edelstein,* ed. Gertrud Platz-Horster, 6–12. Berlin: SMB, Antikensammlung, Staatliche Museen zu Berlin, 2008.

———. "Erfahrungen und Fragen beim Nachschneiden des grössten Sardonyx-Kameo der Antike, des Grand Camée de France." In *Ein Geschenk für den Kaiser. Das Geheimnis des Grossen Kameo,* ed. Luca Giuliani and Gerhard Schmidt, 62–96. Munich: C.H. Beck, 2010.

Schramm, P.E. "K. Friedrich II. Herrschaftzeichen." *Abhdl. Göttingen* 36 (1955): 17.

Sena Chiesa, Gemma. *Gemme dalla corte imperiale alla corte celeste.* Milan: Hoepli, 2002.

Setton, Kenneth M. *The Papacy and the Levant 1204–1571*. Philadelphia: American Philosophical Society, 1976–1984.

Shcherbatov, M.M. "On the corruption of morals in Russia." St. Petersburg, 1790.

Sigismondo, Giuseppe. *Descrizione della città di Napoli e suoi borghi*. Naples, 1789, vol. 3.

Simon, Erica. "Alexandria—Samarkand—Florenz—Rom. Statione der Tazza Farnese." In *Bilder Erzählen Geschichte*, ed. H. Altrichter, 15–29. Freiburg im Breisgau: Rombach, 1995.

Slavazzi, Fabrizio. "Vasi in pietra dura nell'età ellenistico-romana." In *Cristalli e Gemme. Realità fisica e immaginario, simbologia, techniche e arte*, ed. Bruno Zanettin, 437–458. Venice: Istituto Veneto di Scienze, Lettere ed Arti, 2003.

Smith, J.P. *James Tassie, 1735–1799, Modeller in Glass: A Classical Approach*. London: Mallett & Son, 1995.

Soeda, Afuri. "Gods as Magical Charms: The Use of Ancient Gems in the Medieval West." In *Survival of the Gods: Classical Mythology in Medieval Art*, 185–192. Providence, RI: Brown University, 1987.

Soucek, Priscilla P. "Nizami on Painters and Painting." In *Islamic Art in the Metropolitan Museum of Art*, ed. Richard Ettinghausen, 9–21. New York: Metropolitan Museum of Art, 1972.

Spallanzani, Marco and Gaeta Bertelà, Giovanni. *Libro d'inventario dei beni di Lorenzo il Magnifico*. Florence: Associazione "Amici del Bargello," 1992.

Spinosa, A. "Ancora sul Laboratorio di pietre dure e sull'Arazzeria . . ." In *Le arti figurative a Napoli nel Settecento*. Documenti e ricerche, ed. S. Abita, N Spinosa, et al., 325–384. Naples: Società editrice napoletana, 1979.

Spinosa, N. *The National Museum of Capodimonte*. Naples: Electa, 1996.

Stephenson, Paul. *Constantine: Unconquered Emperor, Christian Victor*. London: Quercus, 2009.

Strabo. *The Geography of Strabo*, trans. Horace Leonard Jones. Cambridge, MA: Harvard University Press, 1932.

Suetonius, "Julius Caesar." In *The Twelve Caesars*, trans. Robert Graves. Harmondsworth: Penguin, 1957.

Suger, *Abbot Suger on the Abbey Church of St. Denis and its Art Treasures*, ed. and trans. Erwin Panofsky. Princeton: Princeton University Press, 1946/1979.

Syson, Luke and Thornton, Dora. *Objects of Virtue: Art in Renaissance Italy*. Los Angeles: J. Paul Getty Museum, 2001.

Tait, Hugh. *Seven thousand years of jewellery*. London: British Museum, 1986.

Thackston, Wheeler M. *Album Prefaces and Other Documents on the History of Calligraphers and Painters*. Leiden: Brill, 2001.

Thackston, Wheeler M. ed. and trans. *A Century of Princes: Sources on Timurid History and Art*. Cambridge, MA: Aga Khan Program for Islamic Architecture, 1989.

The Treasury of San Marco in Venice. Milan: Olivetti, 1984.

Thornton, Dora. *The Scholar in his Study: Ownership and Experience in Renaissance Italy*. New Haven: Yale University Press, 1997.

Toso, Sabina. *Fabulae Grecae: Miti Greci nelle Gemme Romane del I Secolo A.C.* Rome: l'Erma di Bretschneider, 2007.

Toynbee, Arnold Joseph. *Constantine Porphyrogenitus and his World*. London, New York: Oxford University Press, 1973.

Treadgold, Warren, T. "The Macedonian Renaissance." In *Renaissances Before the Renaissance. Cultural Revivals of Late Antiquity and the Middle Ages*, ed. Warren Treadgold, 75–98. Stanford: Stanford University Press, 1984.

———. *Byzantium and Its Army, 284–1081*. Stanford: Stanford University Press, 1995.

Trésor de Saint-Denis: Musée du Louvre, Paris, March 12–June 17, 1991. Paris: Bibliothèque nationale: Réunion des musées nationaux, 1991.

Trilling, James. "Daedalus and the Nightingale: Art and Technology in the Myth of the Byzantine Court." In *Byzantine Court Culture from 829 to 1204*, ed. Henry Maguire, 217–230. Washington: Dumbarton Oaks, 1997.

Van Cleve, Thomas Curtis. *The Emperor Fredrick II Hohenstaufen, Immutator Mundi*. Oxford: Clarendon Press, 1972.

Van der Meulen, M. *Petrus Paulus Rubens Antiquarius. Collector and Copyist of Antique Gems*. Alphen aan der Rijn: Canaletto, 1975.

———. *Rubens, copies after the antique*. London: H. Miller, 1994.

Vasari, Giorgio. "Lives of Valerio Vicentino (Valerio Belli), Giovanni da Castel Bolognese (Giovanni Bernardi), Matteo dal Nassaro, and Others." In *Lives of the Most Eminent Painters, Sculptors and Architects*, trans. Gaston du C. De Vere. 10 vols. Vol. 6, 1913. London: Macmillan and the Medici Society, 1912–15.

Vázquez-Gestal, P. "'The System of This Court': Elizabeth Farnese, the Count of Santiesteban and the Monarchy of the Two Sicilies, 1734–1738." *The Court Historian* 14 (2009): 23–47.

————. "From Court Painting to King's Books: Displaying Art in Eighteenth-Century Naples (1734–1746)." In *Collecting and Dynastic Ambition*, ed. S. Bracken et al., 85–107. Newcastle upon Tyne: Cambridge Scholars Pub., 2009.

Venturelli, Paola. *Il Tesoro dei Medici al Museo degli Argenti*, Florence: Giunti, 2009.

Verona, Gaspare da. *Le vite di Paolo II di Gaspare da Verona e Michele Canensi*, ed. Giuseppe Zippel. Città di Castello: Coi Tipi dell'editore S. Lapi, 1904.

Vespasiano. *Renaissance Princes, Popes, and Prelates*. William George and Emily Waters trans. New York: Harper Torchbooks, 1963.

Villehardouin, Geoffrey de. "The Conquest of Constantinople." In *Chronicles of the Crusades*, trans. M.B.R. Shaw, 29–160. Harmondsworth: Penguin, 1963.

Vickers, Michael. "Hamilton, Geology, Stone Vases and Taste." *Journal of the History of Collections* 9 (1997): 263–274.

————. "Glassware and the Changing Arbiters of Taste." *Expedition* 39.2 (1997): 4–14.

Vickers, Michael and Tressaud, A. "Ancient Murrhine Ware and its Glass Evocations." *Journal of Glass Studies* 49 (2007): 143–145.

Visconti, Ennio Quirino. *Museo Pio-Clementino*. Rome: Luigi Mirri, 1790.

Waddy, Patricia. *Seventeenth-Century Roman Palace: Use and the Art of the Plan*. MIT Press: New York, 1990.

Walker, Susan and Higgs, Peter, ed. *Cleopatra of Egypt from History to Myth*. London: British Museum, 2001.

Walters, H.B. *Catalogue of the Bronzes, Greek, Roman, and Etruscan, in the Department of Greek and Roman Antiquities, British Museum*. London: British Museum, 1899.

Weinstock, Stefan. *Divus Julius*. Oxford: Clarendon Press, 1971.

Weiss, Roberto. *Un umanista veneziano, papa Paolo II*. Venezia: Istituto per la collaborazione culturale: 1958.

————. *The Renaissance Discovery of Classical Antiquity*. Oxford: Blackwell, 1969.

Weitzmann, Kurt. "The Classical Mode in the Period of the Macedonian Emperors: Continuity or Revival?" In *Byzantina kai Metabyzantina*. Volume 1. *The "Past" in Medieval and Modern Greek Culture*, ed. Speros Vryonis, Jr., 71–85. Malibu: Undena Publications, 1987.

Westall, Richard. "The Forum Iulium as representation of Imperator Caesar." *Römische Mitteilungen* 103 (1996): 83–118.

Whiteley, J.J.L. "Philipp von Stosch, Bernard Picart and the *Gemmae Antiquae Caelatae.*" In *Classicism to Neo-classicism. Essays dedicated to Gertrud Seidmann*, ed. M. Henig and D. Plantzos, 183–190. Oxford: Archaeopress, 1999.

Williams, J.H.C. "'Spoiling the Egyptians': Octavian and Cleopatra." In *Cleopatra of Egypt*, ed. Walker and Higgs, 190–199.

Williamson, Paul, ed. *European Sculpture at the Victoria and Albert Museum*. London: Victoria and Albert Museum, 1996.

Wilton, A. and Bignamini, I. *Grand Tour. The Lure of Italy in the Eighteenth Century.* London: Tate Gallery, 1996.

Winckelmann, J.J. *Sendschreiben von den herculanischen Entdeckungen.* Dresden: Verlegts George Conrad Walther, 1762.

———. *Letter and Report on the Discoveries at Herculaneum,* trans. and commentary Carol C. Mattusch. Los Angeles: Getty Publications, 2011.

Woods, John E. "Aja'ib al-Maqdur fi Akhbar Timur," in "The Rise of Timurid Historiography." *Journal of Near Eastern Studies* 46 (1987): 81–108.

Wyke, Maria. *The Roman mistress: ancient and modern representations.* Oxford: Oxford University Press, 2002.

Yuen, Toby E.S. "The Tazza Farnese as a Source for Botticelli's *Birth of Venus* and Piero di Cosimo's *Myth of Prometheus.*" *Gazette des Beaux Arts* 74 (1969): 175–178.

Zachos, Konstantinos L. *Nicopolis B: Proceedings of the Second International Nicopolis Symposium.* Preveza: Actia Nicopolis Foundation, 2007.

Zanker, Paul. *The Power of Images in the Age of Augustus.* Ann Arbor: University of Michigan Press, 1988.

Zapperi, R. "Alessandro Farnese, Giovanni della Casa and Titian's Danae in Naples." *Journal of the Warburg and Courtauld Institutes* 54 (1991): 159–171.

Zwierlein-Diehl, Erika. *Der Dreikönigsschrein im Kölner Dom.* Cologne: Verlag Kölber Dom, 1998.

———. "Interpretatio Christiana: Gems on the Shrine of the Three Kings in Cologne." In *Engraved Gems: Survival and Revival,* ed. Brown, 63–83.

———. *Antike Gemmen und ihr Nachleben.* Berlin: de Gruyter, 2007.

———. *Magie der Steine. Die antiken Prunkkameen im Kunsthistorischen Museum.* Vienna: Christian Brandstätter Verlag, 2008.

Index

Note: Page numbers followed by *f* or n indicate figures or notes, respectively.

Caracciolo, Domenico, 193
Caradosso Foppa, 153–154
Carlo de' Medici, 133, 137
Carmine, Esposito, 221
Carpegna, Gasparo di, 196
Carved Ancient Gems (Gemmae Antiquae Caelatae/Pierres antiques graveés) (Stosch), 126*f*, 175–176
Caselli, Giovanni, 176, 247n56
Cassius Dio, 28, 30, 42, 230n48
casts, 201, 203–204, 250n61
 for Catherine the Great, 198–199, 202, 250n49, 250n51, 250n57
 of *Tazza*, 166, 166*f*, 202, 245n33
Cathedral of Genoa, 235n26
Catherine the Great (empress), 191, 200
 casts for, 198–199, 202, 250n49, 250n51, 250n57
chalice. *See also* Suger chalice
 Tazza as, 63–64, 64*f*, 68–69, 85
Charles III of Spain (Charles Bourbon), 181, 182*f*, 194. *See also* Herculaneum; *Tazza* in Charles' possession
 culture from, 185–186
 marriage of, 186–187
 Naples for, 182–185
 Two Sicilies for, 183–184
Charles V Habsburg (emperor), 155–156, 159, 161
 Tazza and, 158
Charles VI (king), 101, 237n41
Charles VIII (king), 152
Chernyshov, Ivan Grigoryevich, 190–191, 249n27
 bronzes of, 192, 249n26

China, 99, 101, 105, 114, 239n78
Christianity, 60, 100, 105, 235n26
 for artifacts, 62–68, 65*f*, 80–86, 81*f*–83*f*
 Frederick II Hohenstaufen and, 80–81, 84–86, 235n22
 Tazza and, 61–63, 64*f*, 84–86
Cicero, 37
Clari, Robert de, 70
classics, 57, 120–121
 in Byzantine Empire, 51, 233n19
 Tazza as, 62
Clavijo, Ruy Gonzalez de, 89, 94
 on Bayezid treasures, 99–100
 on gardens, 102–103
Clement VII (pope), 154–155, 158, 173
Clement XI (pope), 174, 175
Cleopatra III (queen), 34
Cleopatra VII (queen), 9*f*, 227n1
 Cassius Dio on, 28, 30, 230n48
 Cicero against, 37
 description of, 10, 11
 as Isis, 21, 23–24, 28–29, 40–41, 229n29
 languages of, 10
 La Rocca on, 229n29
 Medusa and, 20–21
 Octavian's treasure from, 41–43
 Plutarch on, 9, 227n1
 Ptolemy XIII Auletes and, 8, 10–12
 statue of, 38, 40, 231n27
 suicide of, 30
 Tazza after, 30–31, 41–43, 49–50
 Tazza and, 12, 22, 41, 229n29
 on *Tazza*, 197
 as threat to Rome, 27
 wealth of, 11, 24, 29, 41–43

Margaret of Austria (governor of Netherlands), 156, 156f, 163

Maria (empress), 170–171, 246n42

Maria Amalia of Saxony, 186–189

Maria Carolina of Austria, 207–208

Mariette, Pierre Jean, 197

Marsilio Ficino, 140, 144–145

Mary of Hungary, 156–157

Maurice, 233n23

Medici. *See also specific family members*
 auction of property, 154
 French invasion and, 152–154
 hard-stone vases of, 138–139, 158–159, 242n69, 243n97, 244n11

Medusa, 138
 appearance of, 5f, 20f, 63, 64f, 211f
 Cleopatra VII and, 20–21
 color in, 18
 on inkpot, 55, 56f, 58–59
 myth of, 20–21, 229n30

"Meeting of Leo I and Attila and Hun" (Raphael), 244n101

Melillo, Giacinto, 216

Memphis, 21

Michael III (emperor), 52

Michael VIII Palaiologos (emperor), 99

Michelangelo, 149, 158, 164–165

Millingen, James, 197

De mineralibus et rebus metallicis (*On minerals*) (Magnus), 144, 243n80, 243n87

Misson, 184

Mithradates VI (king), 32–35, 98

Mohs, Frederich, 229n25

Mohs' scale of hardness, 17, 19, 229n25

Morghen, Filippo, 198, 248n23
 album of, 188–190, 248n22
 engravings of, 182f, 189–190, 190f, 205f, 248n22, 249n24
 Tazza engraving by, 189–190, 190f, 192

Morghen, Rafaello, 248n23

Mugnai, Giovanni, 202

Muhammad, Dust, 110

Muhammad, Shaykh, 238n57

Museo de Capodimonte, 189, 192, 202, 247n56

Museo degli Argenti, 158, 245n32

Museo del Palazzo degli Studi (Real Museo Borbonico) (Museo Nazionale di Napoli), 209–210, 251n76
 all'antica room in, 212
 handbook on, 212–213
 inventory of, 211–212, 251n81, 251n83
 Tazza at, 198, 211–213, 211f

Museo Nazionale di Napoli. *See* Museo del Palazzo degli Studi

Museo Nazionale di Napoli: Collection of the Most Remarkable Monuments of the National Museum, 198

Museo Pio-Clementino (Visconti), 197

myrrhine, 35

Naples, 212–213, 228n8
 for Alfonso of Aragon, 117, 240n5
 for Charles III of Spain, 182–185